MAKING

CALL OF DUTY®

MODERN WARFARE®

Making *Call of Duty: Modern Warfare*
ISBN: 9781950366026
Manufactured in China

Distributed by Blizzard Entertainment
10 9 8 7 6 5 4 3 2 1
Library of Congress Cataloging-in-Publication
Data available.

Book design by Amazing15

MAKING

CALL OF DUTY

MODERN WARFARE

ANDY McVITTIE

FOREWORD // **JOEL EMSLIE**

CONTENTS

FOREWORD BY // **JOEL EMSLIE**

On a very pleasant warm LA afternoon I was having lunch with Dave Stohl, one of my studio heads. We were discussing the possibility of me returning to Infinity Ward. "Is IW going back to *Modern Warfare*?" I asked. "Yes," he responded. Once I heard that word, I was in.

I was feeling a lot like the gaming community around me. Advanced movement in shooters was the norm by this time–the type of games that made my eyelid start twitching after 15 minutes. I wanted to do something realistic and relatable. A game that would feel like the real world and have its own believable universe that is much more like the one I live in. I wanted to be a part of something that aimed to drive a narrative experience that I'd never seen before in a *Call of Duty* game, with characters that I really cared about.

Infinity Ward was my gateway to realizing those ambitions. In the early part of 2017 we set out to reimagine and build a new *Modern Warfare* game. We knew that we had to create something spectacular that wasn't a sequel and, in the process, not destroy what people loved about it in the first place.

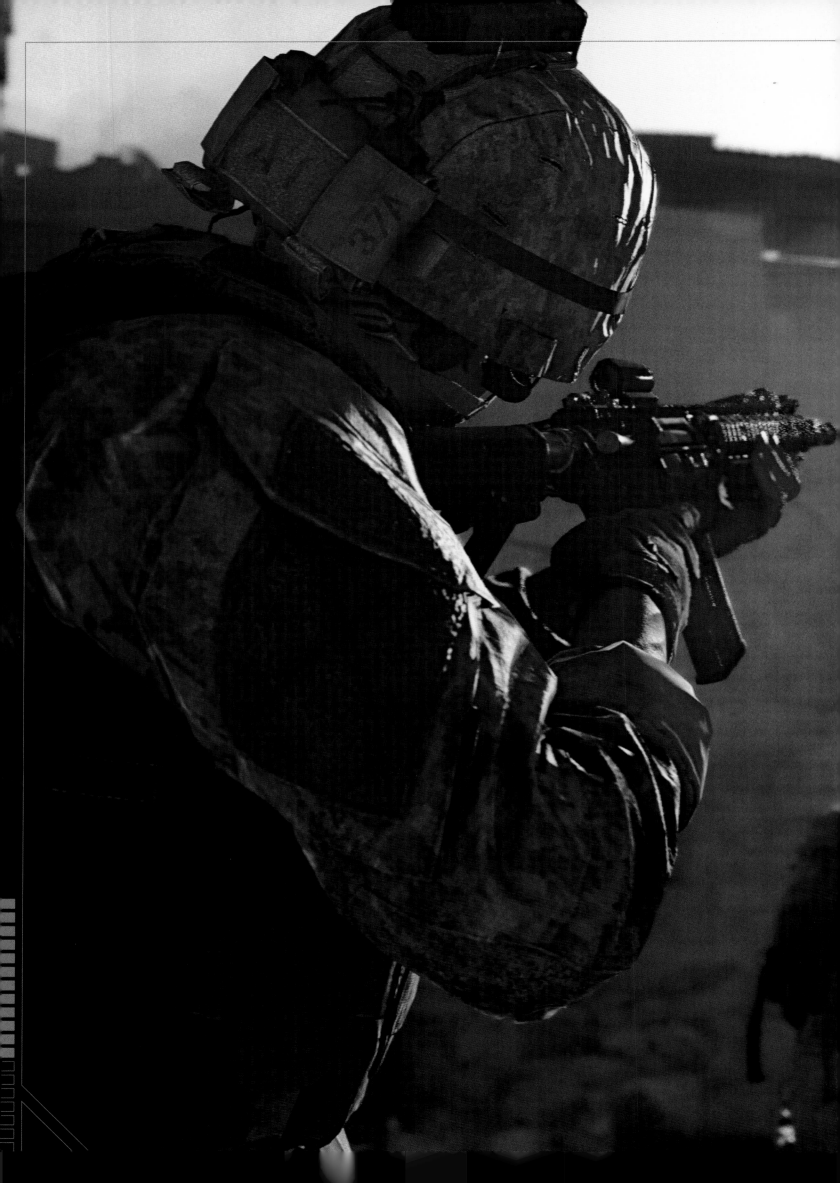

INTRODUCTION

It's hard to believe, but in all the years that various *Call of Duty* games have been in development there was never a 'making-of' or 'art book' published. Not like the one you are holding in your hands, at least. There have been a few CD case-sized booklets before, but nothing like this.

When we started working on the new *Modern Warfare*, we made a deal with ourselves: Do as much as we can in different ways and with new techniques, and take on challenges that seem impossible. Make this game a *tour de force* on every level. This book represents something that has never been done with a *Call of Duty* game at this scope and scale. The game itself is without doubt the largest and most ambitious that Infinity Ward has ever created – in that regard it absolutely deserves a making-of book!

We've experienced countless moments during development where we found ourselves completely blown away by the raw talent within the company. What you are about to read is a collection of the various parts that make *Modern Warfare* what it is. We did our absolute best to include as much as we could so that you could get a better idea of what goes into developing a game like this. From the entire studio at Infinity Ward and our partners, we truly hope you enjoy this book and also the game.

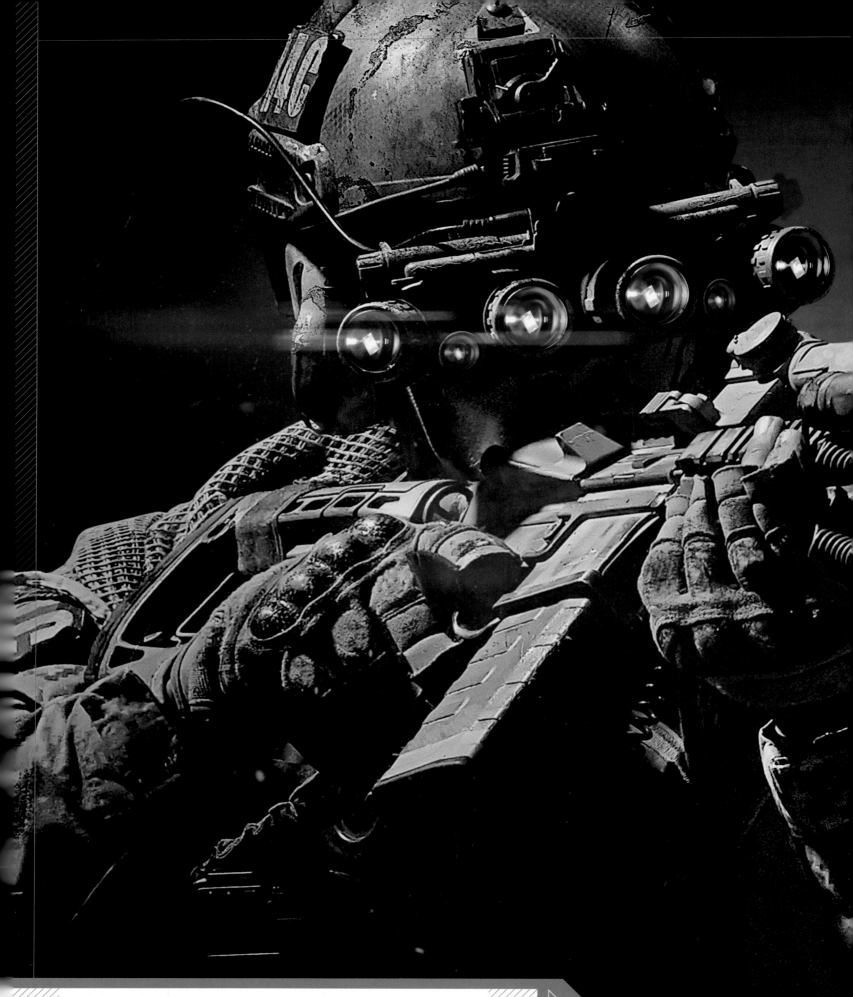

CHARACTERS

WE BEGIN WITH THE dramatis personae of *Modern Warfare*; fair, foul and those whose motivations remain uncertain. To tell the story we wanted to tell we set out to create the most realistic and interesting characters *Call of Duty* has ever seen.

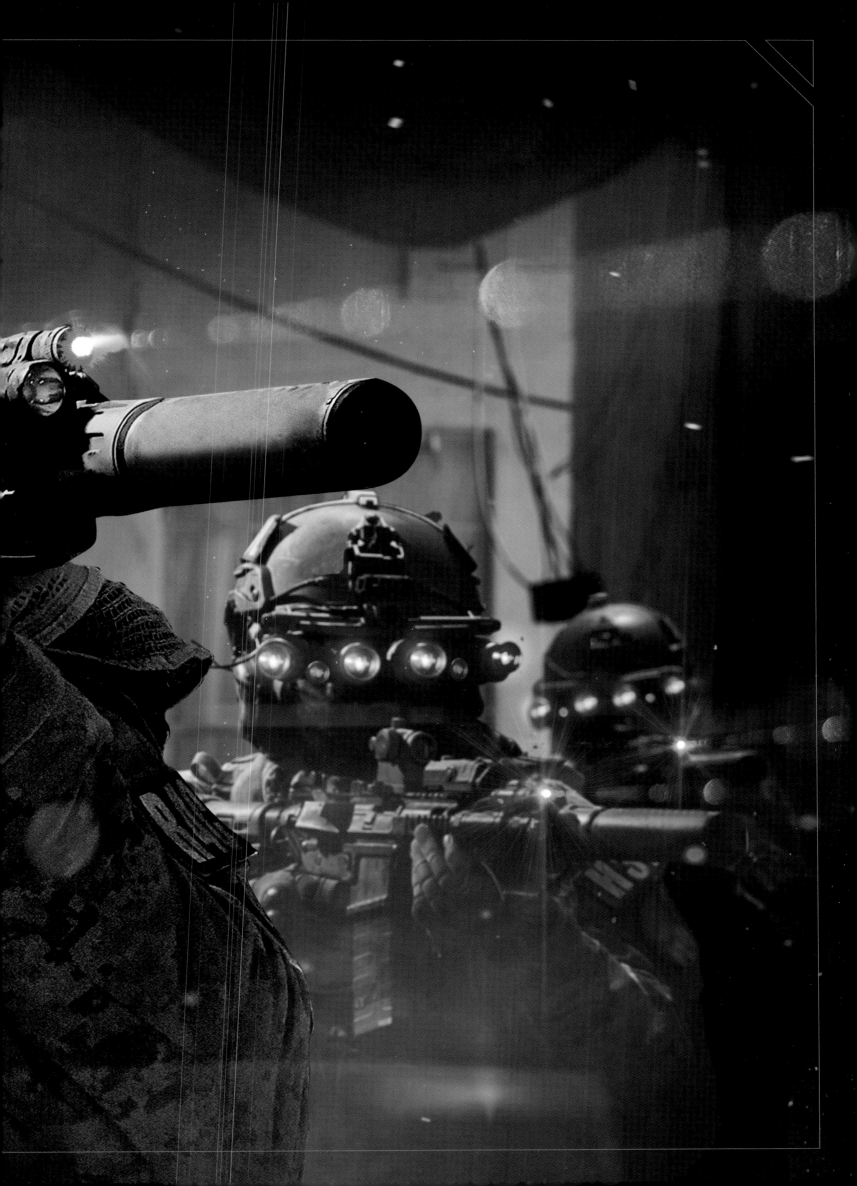

CHARACTERS // **PRICE**

A familiar face, if not always a friendly one, Captain John Price—call sign 'Bravo Six'—has survived with tales to tell of previous skirmishes and a sardonic wit that is borne of the battlefield.

Ever the man to have at your side in a firefight, *Modern Warfare* finds Price embroiled in a wholly new campaign that will span the world, multiple storylines and vividly contemporary scenarios. *Modern Warfare* is not a sequel, as such. It's a brand new game with a new story, and it's set in a *Modern Warfare* universe that is relevant to today.

Bringing this increasingly grizzled commander up to date posed a key challenge during development of the game. We wanted to create a new Captain Price but didn't want to destroy the things that everyone loved about the original character, which is not an easy thing to do.

Below: We explored different types of looks for Captain Price knowing that we were eventually going to cast a flesh and blood actor to play him, although the work on his costumes began almost immediately. The game's narrative underwent many revisions during development, but this urban tactical outfit was one that survived the revision process.

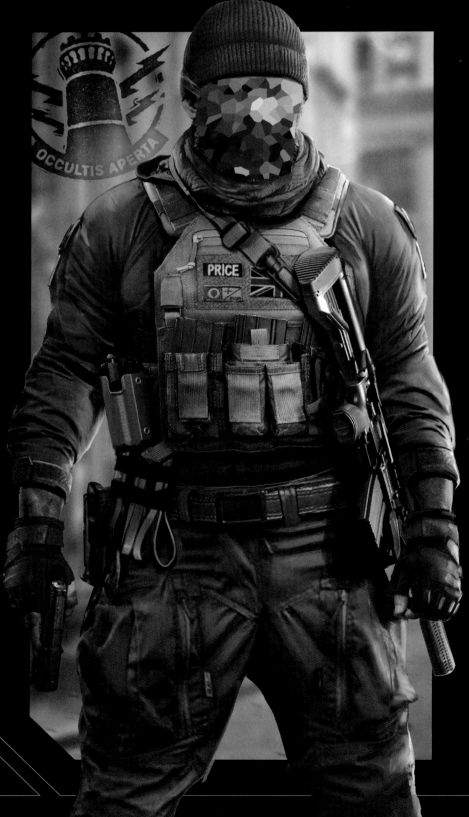

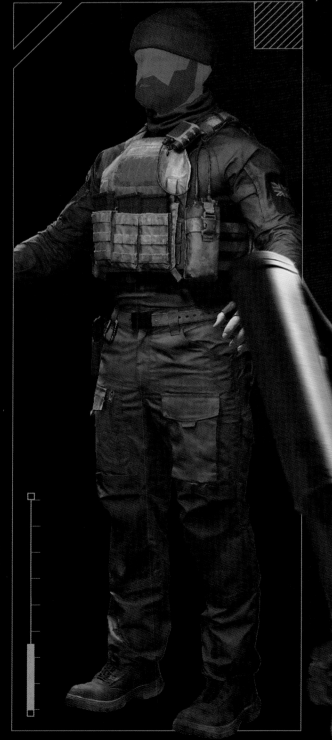

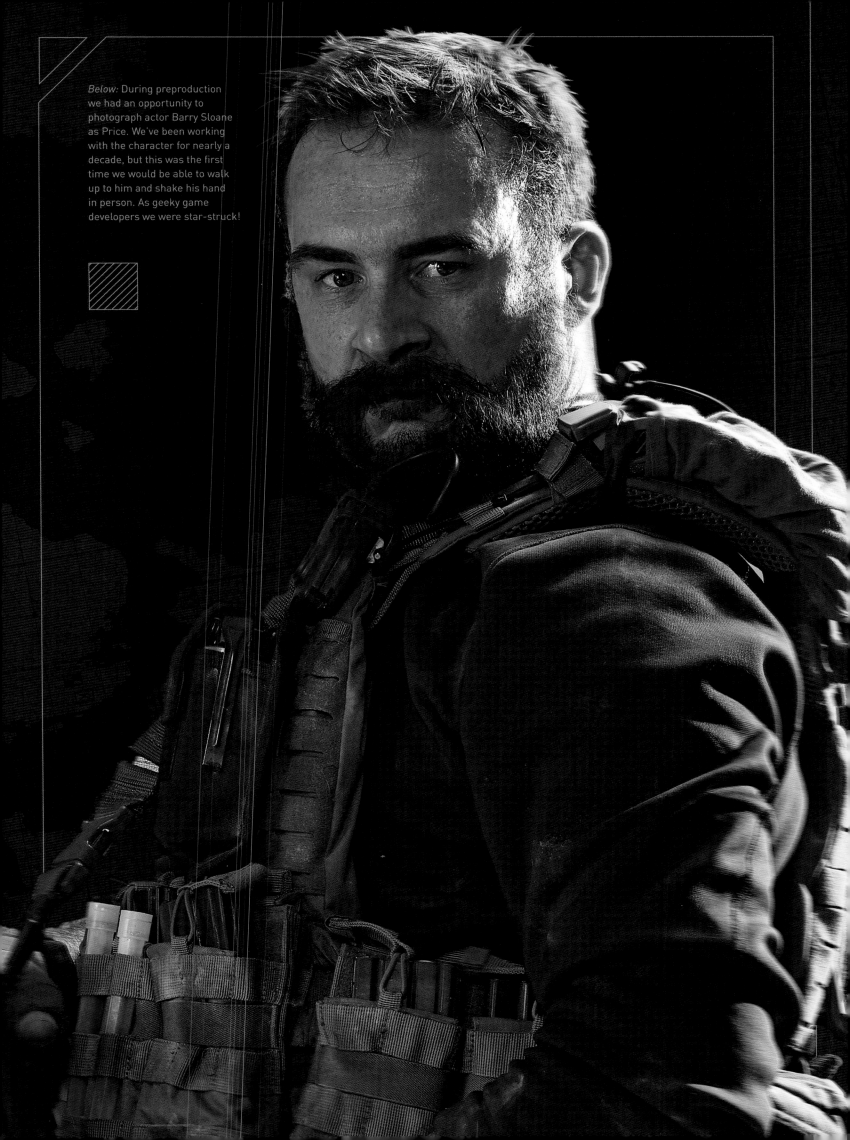

Below: During preproduction we had an opportunity to photograph actor Barry Sloane as Price. We've been working with the character for nearly a decade, but this was the first time we would be able to walk up to him and shake his hand in person. As geeky game developers we were star-struck!

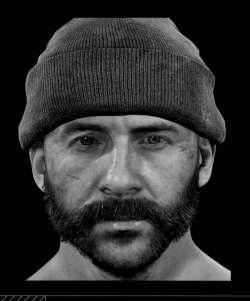
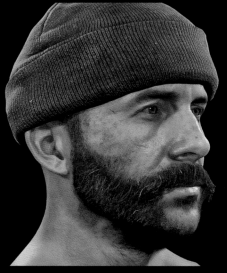
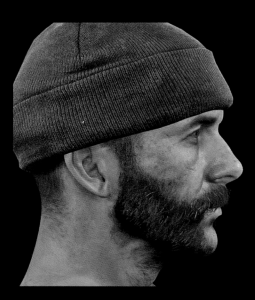

> "We get dirty and the world stays clean…
> That's the mission. You got second thoughts,
> I'll do this alone."
>
> **Captain John Price**

Thanks to the possibilities afforded by advanced technology and, for the first time, a real actor both voicing and portraying Captain John Price, *Modern Warfare* promises not only a thrillingly realistic campaign, but a remarkable depiction of the many players within. As one of the key non-playable characters, Price is seen in many guises within the game—some suited to the trials of combat, others designed to survive specific conditions or for him to blend in with the general population.

With his trademark facial hair–*above*–Price is beginning to look like the character as we have come to know him. Seen *below*, a selection of more recognizable military fatigues. His presentation has to be authentic at all times. However, it was important to us that our characters have different costumes throughout the game—as they travel to different regions their clothing fits the environment.

Right: Seen here in civilian garb, Price intends to pass unnoticed. Part of the story has Price undercover in St. Petersburg. We needed to design a costume that would look rugged but not look too militaristic. These clothing assets are often completed earlier than the in-game assets, so they are a great way to develop looks early on for the game.

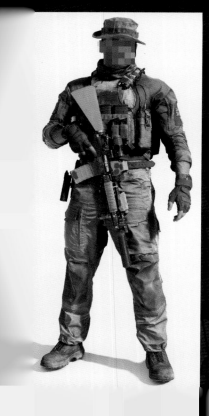
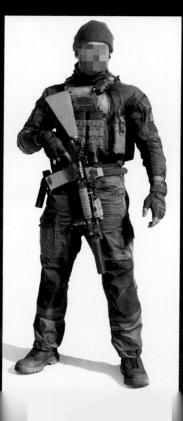
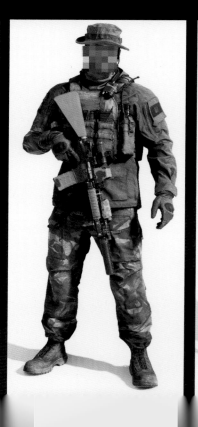
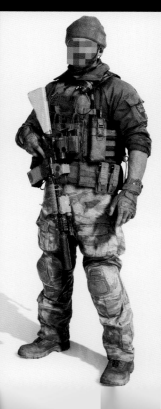
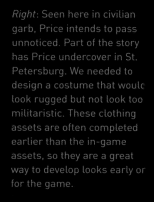

OCCULTIS APERTA

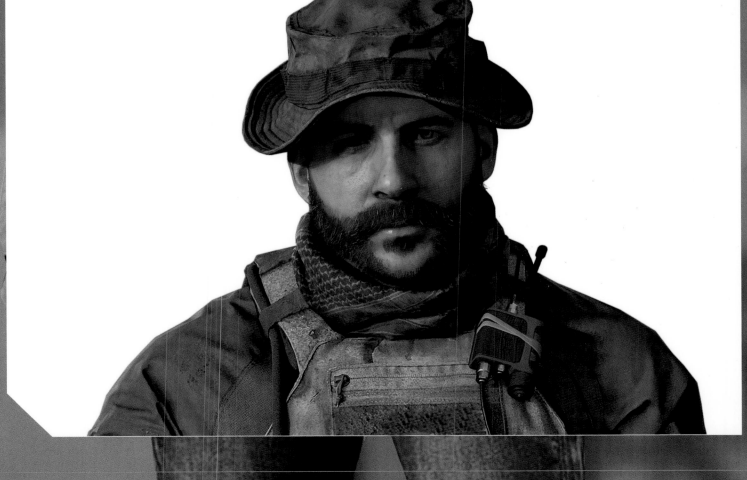

CHARACTERS // **FARAH**

Rebel fighter Farah is new to the *Modern Warfare* universe. She is nevertheless afforded the same attention to detail required not only to illustrate her within the game, but also to make her move and behave convincingly. As with Captain Price, Farah is modeled on a real person– the actress Claudia Doumit. With her performance and the development of her personality, clothing and backstory, Farah became a worthy protagonist in the game.

Seen directly *below*, Farah with a choice headwraps and hairstyles befitting of her personality. *Further down*, these annotated

artworks reveal something of the lengths that designers went to in bringing Farah to life. Her clothes, posture and even her skeletal structure are taken into consideration and then refined as necessary. None of which is quick or especially easy to do. The process of developing a character like Farah takes a lot of time. We will often design, model and texture the art to see how it looks in the game and then go back afterwards and make a redesign pass like this one. This is an example of the types of shorthand notes we use to communicate visual ideas to each other in the art department.

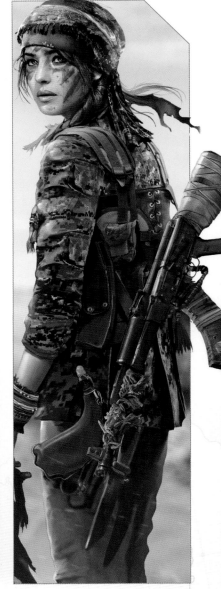

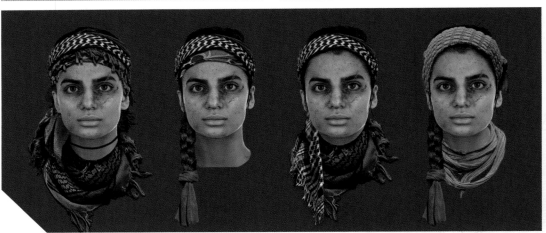

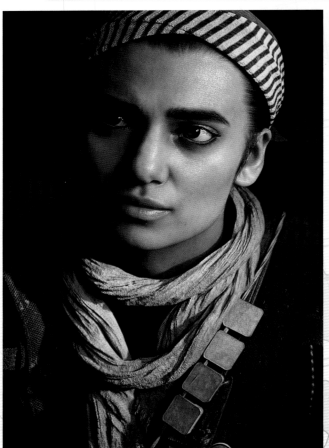

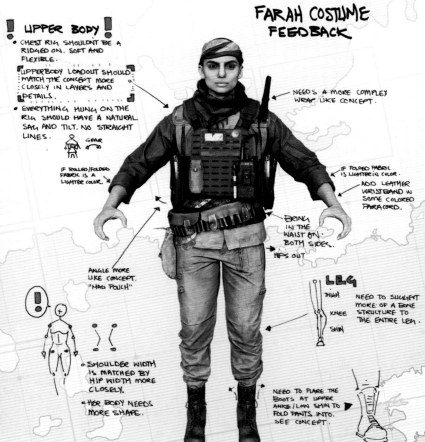

FARAH COSTUME FEEDBACK

! UPPER BODY !
- CHEST RIG SHOULDNT BE A RIDGED ON. SOFT AND FLEXIBLE.
- UPPERBODY LOADOUT SHOULD MATCH THE CONCEPT MORE CLOSELY IN LAYERS AND DETAILS.
- EVERYTHING HUNG ON THE RIG SHOULD HAVE A NATURAL SAG AND TILT. NO STRAIGHT LINES.

GEAR

IF ROLLED/FOLDED FABRIC IS A LIGHTER COLOR.

NEEDS A MORE COMPLEX WRAP LIKE CONCEPT.

IF FOLDED FABRIC IS LIGHTER IN COLOR.

ADD LEATHER WRISTBAND W SOME COLORED PARACORD.

BRING IN THE WAIST ON BOTH SIDES.

HIPS OUT

ANGLE MORE LIKE CONCEPT. "MAG POUCH"

LEG

THIGH

KNEE

SHIN

NEED TO SUGGEST MORE OF A BONE STRUCTURE TO THE ENTIRE LEG.

- SHOULDER WIDTH IS MATCHED BY HIP WIDTH MORE CLOSELY.
- HER BODY NEEDS MORE SHAPE.

NEED TO FLARE THE BOOTS AT UPPER ANKLE/LOW SHIN TO FOLD PANTS INTO. SEE CONCEPT.

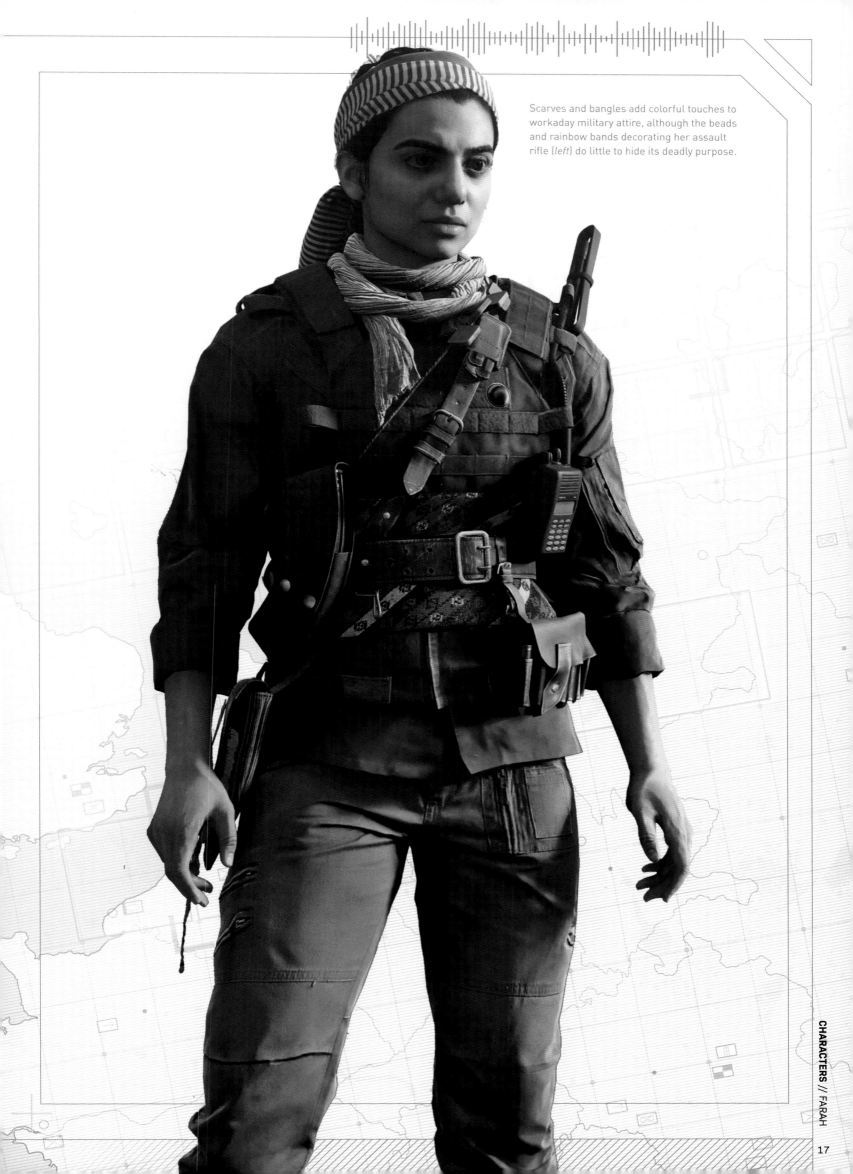

Scarves and bangles add colorful touches to workaday military attire, although the beads and rainbow bands decorating her assault rifle (*left*) do little to hide its deadly purpose.

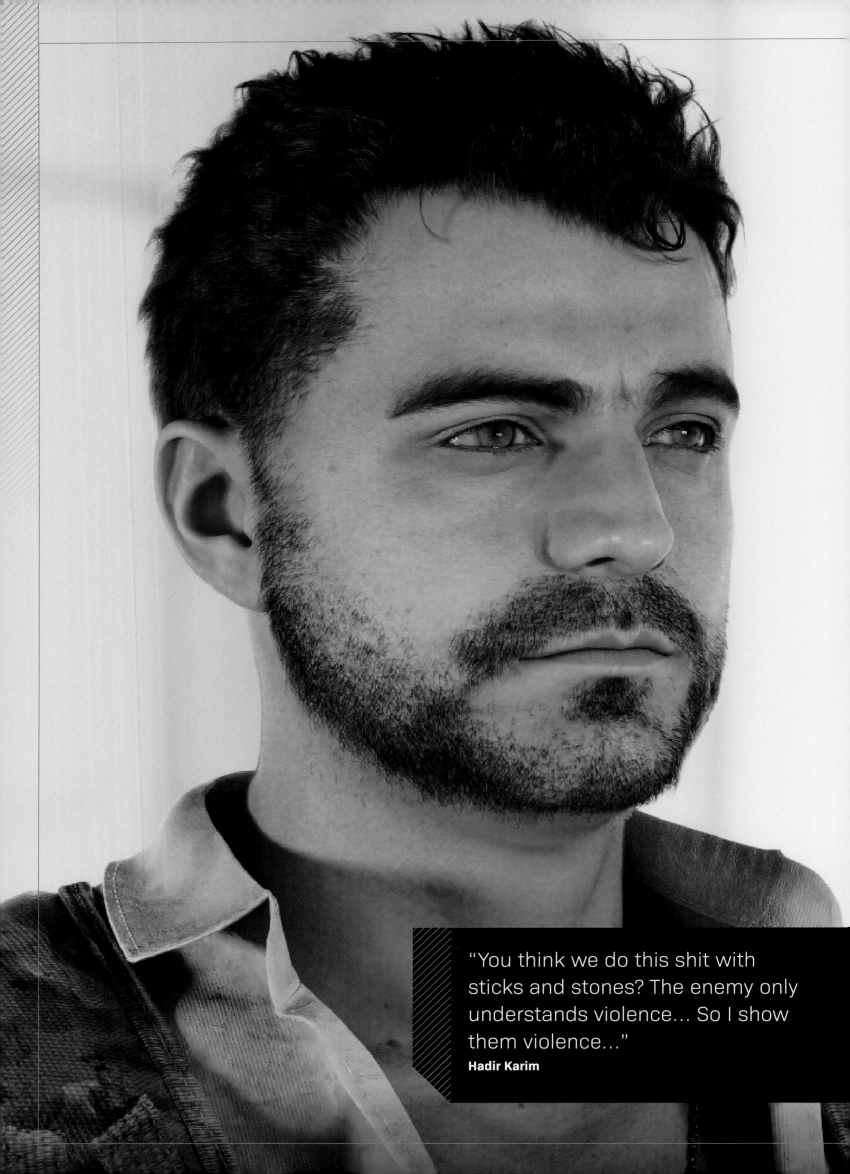

"You think we do this shit with sticks and stones? The enemy only understands violence... So I show them violence..."

Hadir Karim

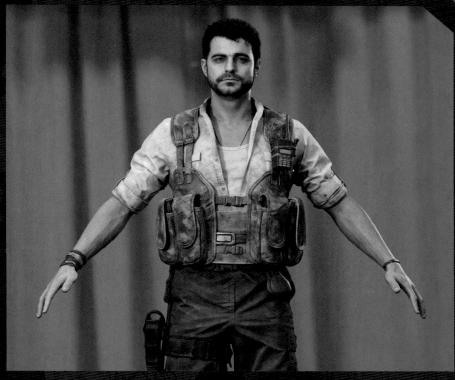

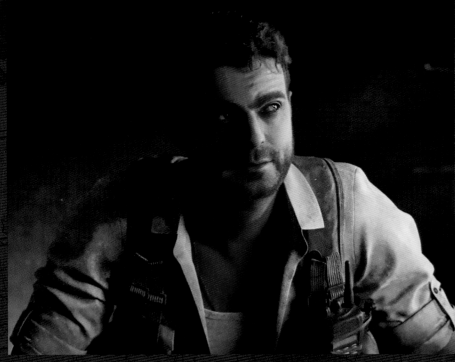

Above: As one of the major players in *Modern Warfare*, Hadir Karim is also modeled on the performance of an actor. Aidan Bristow brings much character to the role.

CHARACTERS // **HADIR**

Many characters have vital roles to play in the *Modern Warfare* narrative. Farah Karim is significant among them, but her brother Hadir is equally motivated to fight for the freedom of his country.

Born into a middle-class family, he and his sister were able to mount a spirited defense when the Russian Army stormed their country. Neither was able to prevent the loss of their father, though; a matter which haunts Hadir to the present day.

Hadir was forced to grow up quickly, becoming a determined and fearless commander in the guerrilla rebels led by his sister, where he also flourishes as a cunning and uncompromising combatant. Both he and his sister share the same goal—nothing less than liberty and the complete expulsion of the occupying Russian forces—although the two differ in terms of their preferred tactics. Hadir favors direct action, with the invaders expelled by any means necessary. He is thus a danger to the plans of the rogue Russian commander, General Roman Barkov.

CHARACTERS // **JUGGERNAUT**

Not so much fully-fledged characters as inscrutable and worryingly unstoppable *entities*. The Juggernauts didn't make an appearance until *Modern Warfare 2*, but are set to make lives difficult all over again for players this outing.

Heavily armed and substantially armoured, these behemoths are not concerned with taking cover during a firefight. Close quarter assaults are their *modus operandi* and, if anything, they're even deadlier this time around.

We designed the original character 10 years ago and it was time for a refresh. The original suit was just supposed to be a big bullet sponge. This time we wanted to give the character the ability to be more flexible from the waist up, so it could make more agile movements with its upper body and weapon. The goal was to make it hard for it to travel, but not to aim and shoot things.

Opposite: It's always interesting to see how ideas develop over the lifetime of a videogame series. This early concept for the new Juggernaut was deemed to look too sophisticated and futuristic, so was not used in the final cut.

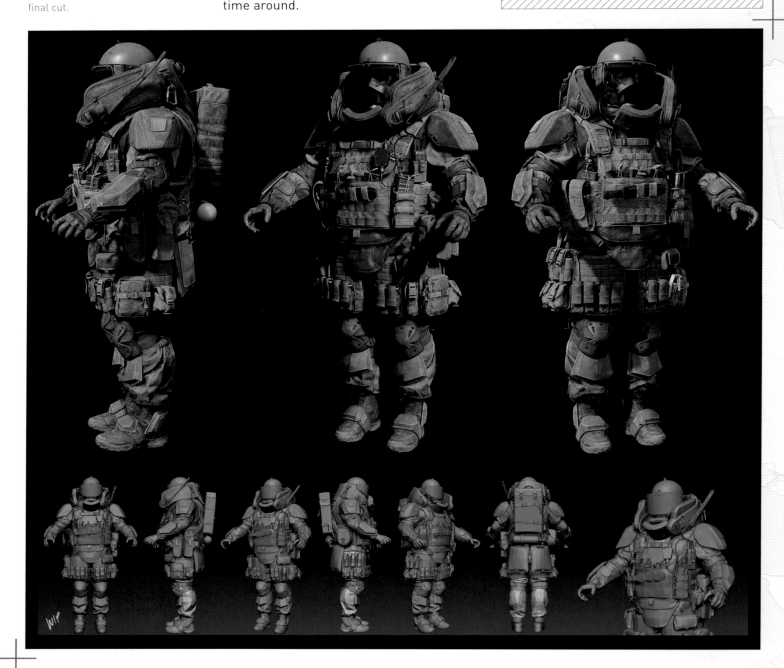

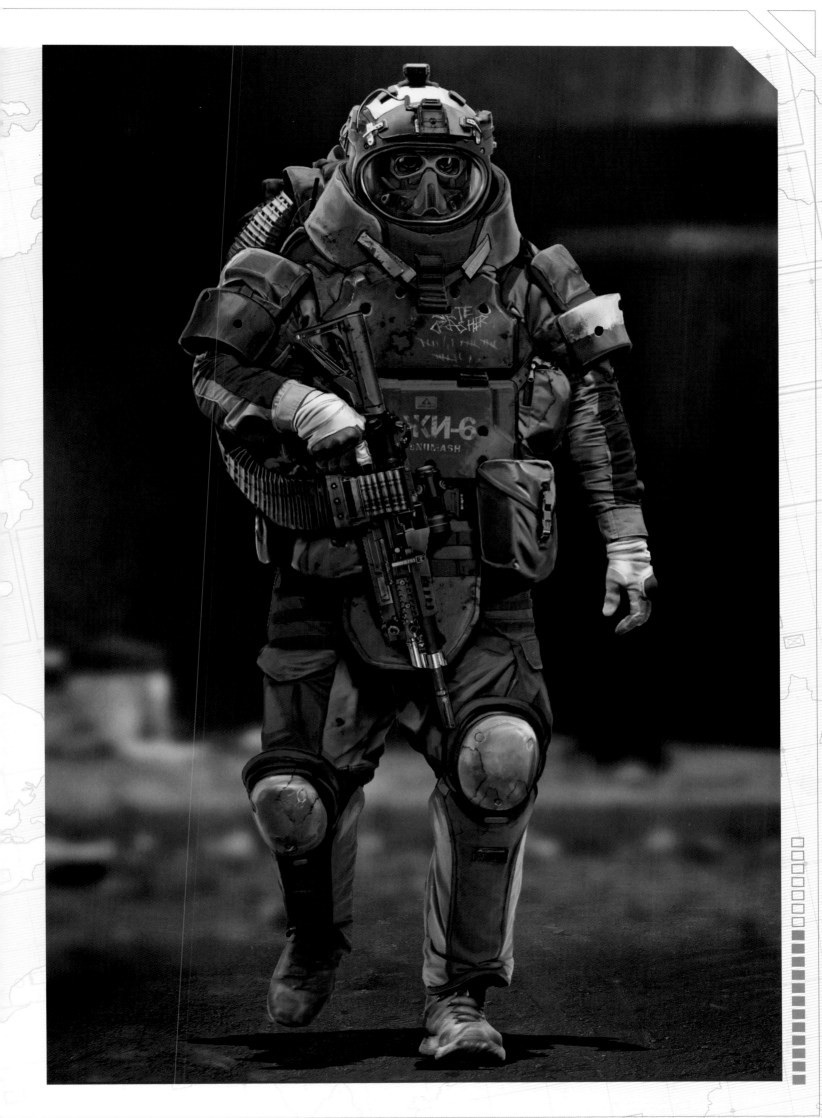

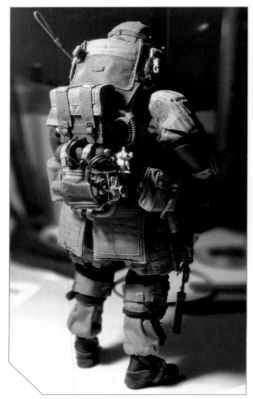
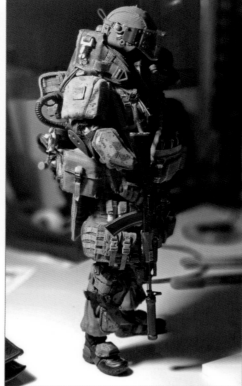
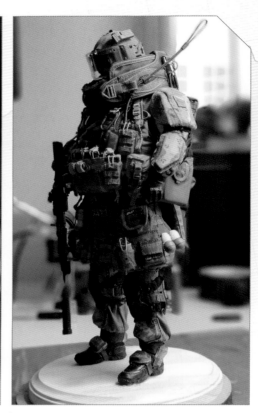

More depictions of the fearsome Juggernaut, this time kit-bashed and realistically painted. Creating a physical model for a digital videogame might seem like a quirky and wantonly laborious solution, although it's quite easy to imagine its use as a tool to instigate conversation and visualization during development. It looks fantastic too, of course.

This is a 1:6 scale maquette created for the final look of the Juggernaut. It is influenced by the concepts we created for the character initially. We used various parts of gear to achieve a new look but also made the design relatable and contemporary. Many discussions took place with the animation department about how the Juggernaut should move. This resulted in visual design changes.

These sketches describe how Juggernauts could be introduced into the game. They are supposed to be wearing biosuits–poison gas is deployed and the Juggernaut enters the arena, guns blazing. What a way to make an entrance!

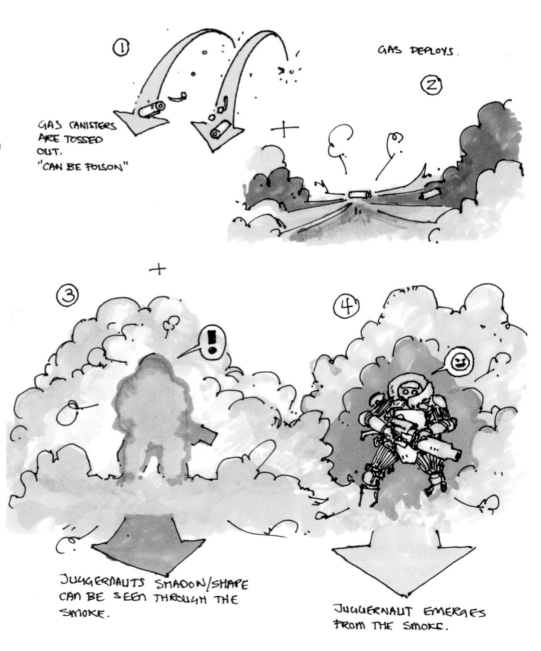

① GAS CANISTERS ARE TOSSED OUT. "CAN BE POISON"

GAS DEPLOYS.

②

③ JUGGERNAUTS SHADOW/SHAPE CAN BE SEEN THROUGH THE SMOKE.

④ JUGGERNAUT EMERGES FROM THE SMOKE.

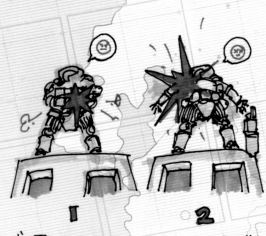

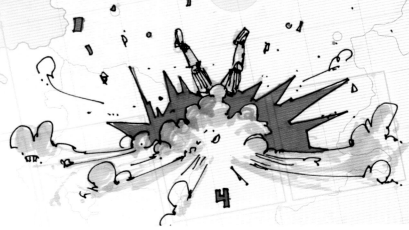

"JUGGERNAUT DEATH SKIT"
- FIRES FROM HIGH POSITION
- TAKES A DEATH HIT
- FALLS OFF LEDGE
- HITS GROUND AND EXPLODES. PRESSURIZED SUIT.

FALL GUY STUNT. ARMS SWIM AROUND.

"We have to reach Echo fast. They've got a lot of hell headed their way."

Captain John Price

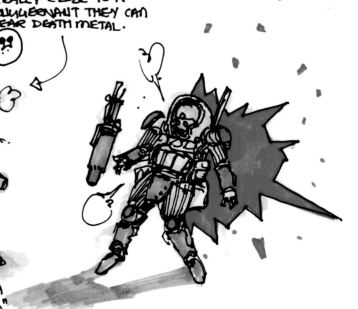

WHEN PLAYERS GET REALLY CLOSE TO A JUGGERNAUT THEY CAN HEAR DEATH METAL.

JUGGERNAUT HAS A BIOSUIT "PRESSURIZED"

SUIT CAN EXPLODE WHEN HIT IN THE RIGHT SPOT OR AN EXPOSED VALVE.

These speedy renderings illustrate Juggernaut behaviors when the player shoots them. Since the suit is supposed to be pressurized we thought it would be fun to have them explode or expel gas when they are shot.

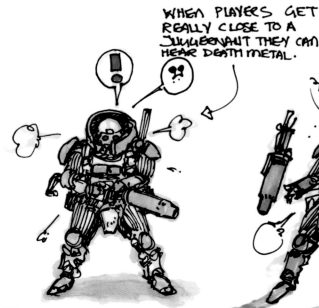

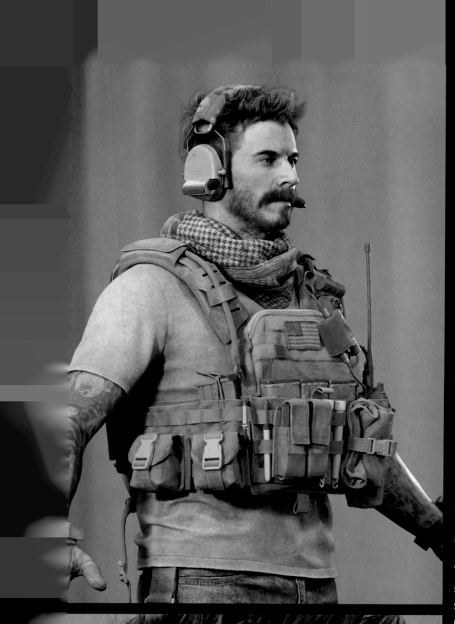

CHARACTERS // **ALEX**

Covert ops specialist, Alex, prefers technology, human intel and remote surveillance to the traditional tools of the battlefield. An officer of the Special Activities Division (SAD) of the CIA, Alex goes where other forces are officially barred from participation.

The character of Alex was designed to fit into Farah's squad from the very beginning. He needed to look a bit sun-bleached, rugged, and still have the look of a Tier On operator. One of the challenges we faced was his facial hair. We had to be careful to not make him look too simila to Captain Price, so the two wouldn't get confused.

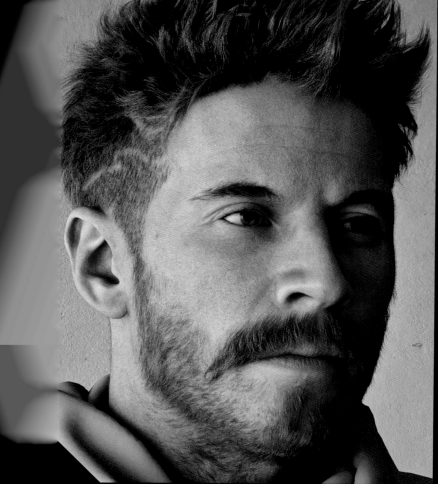

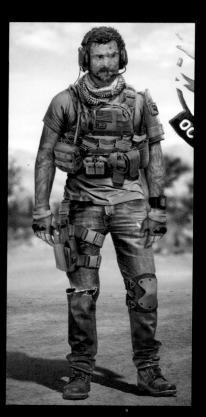

Casually attired and coolly postured, Alex is not a conventional operative but do not ta his easy-going demear for a lack of combat ability. Alex is played b the actor Chad Michae Collins.

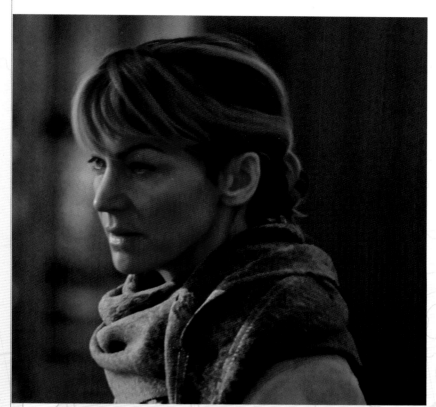

CHARACTERS // **LASWELL**

Kate Laswell has played a key role in the ongoing war on terror, her expertise being communications and strategic intelligence. Ambitious, assiduous and often divisive in her strident opinions, her actions have nevertheless helped to subvert enemy activities and save thousands of lives.

Laswell was a very different character for us to design. She needed to be tough, but not come off like a soldier—and definitely not look like someone who has a desk job. We kicked around a few ideas and went with a mix between archaeologist and adventurer. The actress Rya Kihlstedt brings a lot to the role too.

> "Tracking multiple Russian forces headed your way. Sit tight—We're pushing to you for fast exfil—Watcher out."
> **Kate Laswell**

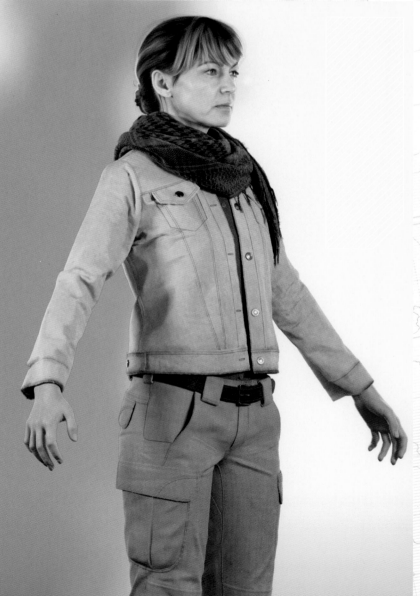

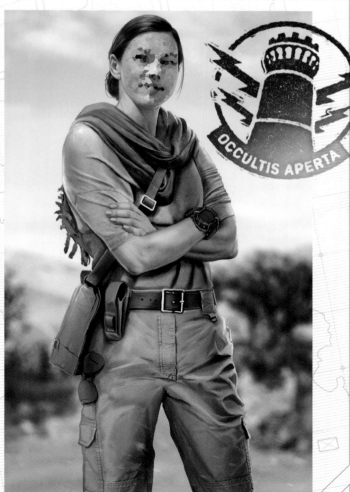

OCCULTIS APERTA

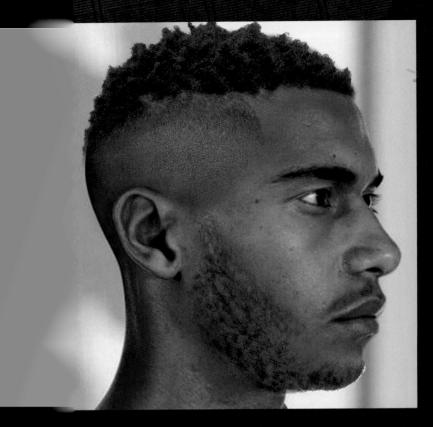

CHARACTERS // **KYLE**

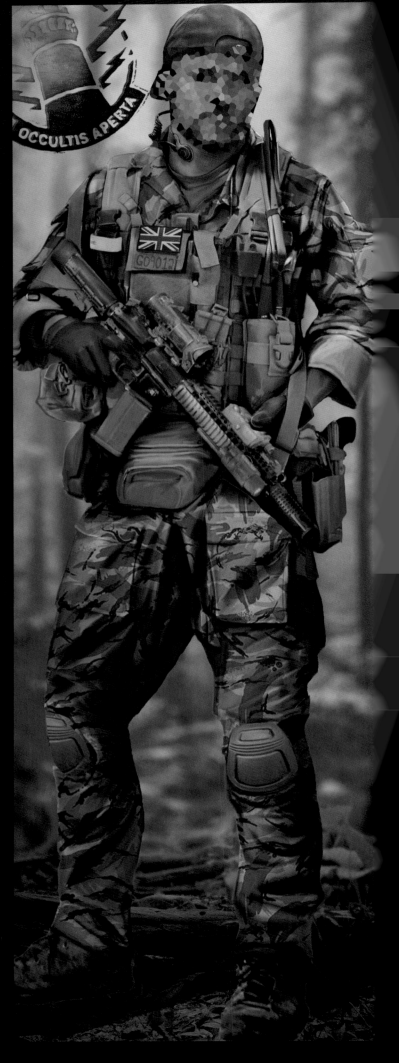

Kyle Garrick, a veteran of multiple campaigns in the British Army, is currently a sergeant in Counter Terrorism Command (CTC), a Specialist Operations branch within London's Metropolitan Police Service. Operations at home and abroad have brought him distinctions, although he is known to value mental fortitude over physical prowess and he takes pride in his ability to withstand many hours of rigorous interrogation.

A skilled and adaptable soldier, Kyle possesses weapons expertise, surveillance skills and a tactical nous. He understands the collateral costs of fulfilling mission objectives, and he is propelled into the narrative after witnessing the horrific events of the Piccadilly mission.

"They sent us in half-arsed, so everyone can keep pretending we're not at war."

Kyle Garrick

Kyle Garrick is a professional soldier, having been awarded for his service in both the UK and abroad. Seen here in a selection of apparel, his stern expression attests to the sights witnessed on the streets and battlefields. He is played by actor Elliot Knight.

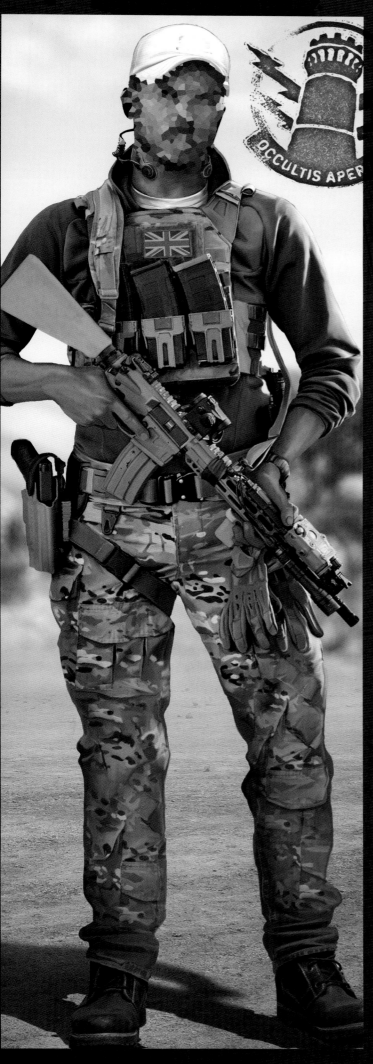

OCCULTIS APER...

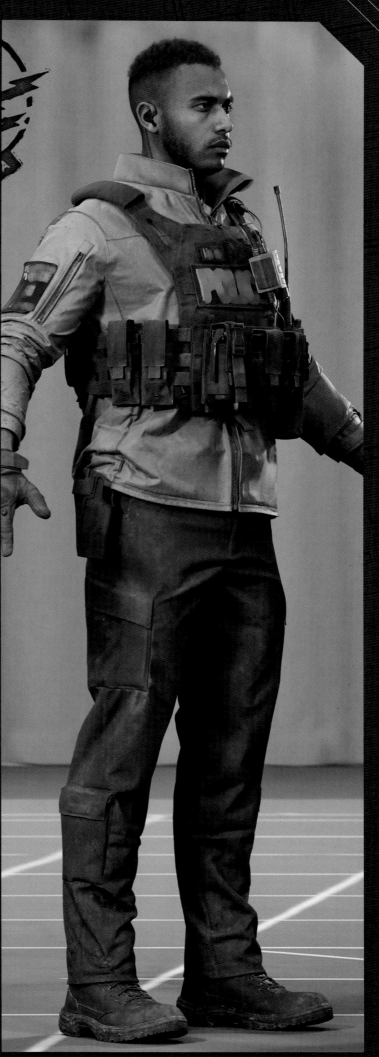

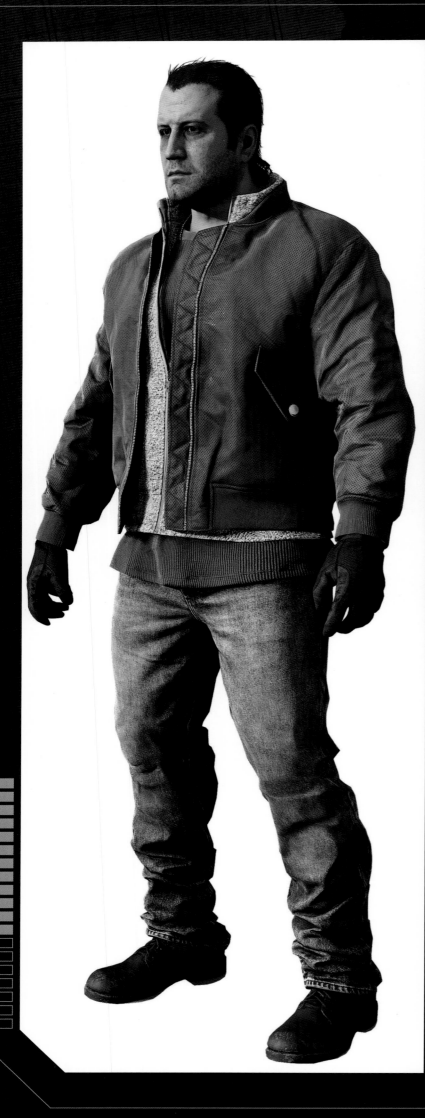

CHARACTERS // **NIKOLAI**

Veterans of the *Modern Warfare* series might recognize Nikolai from the very first iteration of the game. Now more fully realized as a character, his confident swagger and streetwise apparel hint at his function as the 'fixer' in the St. Petersburg mission.

What he's able to fix within this iteration of the *Modern Warfare* series remains for players to discover. His wares, however, are crucial to the events that unfold in Russia's second-largest city. He is played by the actor Stefan Kapičić.

This is the logo of a fictional football team that we created for Nikolai's costume. It's a great way to make the character stand out.

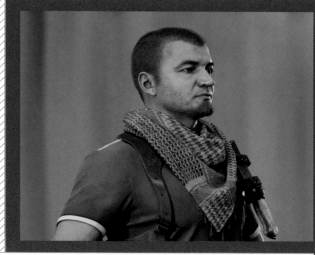

CHARACTERS // **BUTCHER**

A brutal enforcer and second in command to Al-Qatala's leader, the Wolf, the Butcher has a manner befitting his title and the physical stature to back it up–a pistol and knife to hand when all else fails. The use of the actor Nick Tarabay to help visualize the Butcher character led to a minor change in his appearance. Once this character was cast we tried to think of ways to make him stand out in a crowd of his cronies. The glasses were an attempt to give him a visual tell, but ended up not being needed in the final game.

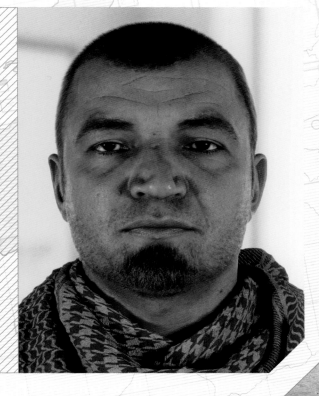

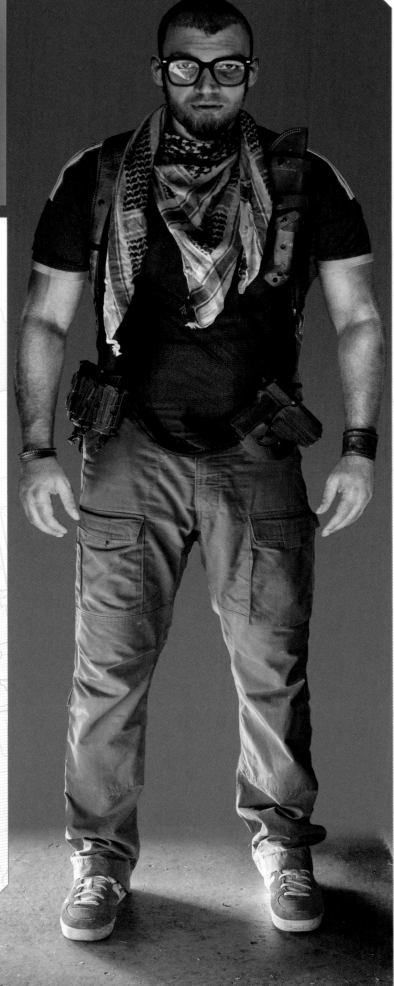

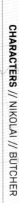

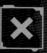

CHARACTERS // **RUSSIAN BEAST**

Lightly armored, but dreadful in every other respect, the Beast is truly the stuff of nightmares. His eyeless, unblinking gaze only adds to his ominous presence. However, this character was actually modeled on a real actor.

When we first planned the moment in the 'Hometown' level, where the story puts two children in a fight for their lives against a soldier invading their home, we wanted to make the soldier as memorable as possible. The concept of the fight was almost like fighting the Minotaur in the Labyrinth from the Greek myth. It seemed wild at the time, but we went with a huge character and dubbed him the Beast. The artist who created the model, Donovan Keele, also happens to be a competitive bodybuilder. So we scanned him and he became the Beast.

> "I will never allow crooks and thieves to terrorize my homeland... There can be no peace without law and order."
>
> **General Roman Barkov**

Below: A fearful symmetry from every angle, these images depict the Beast's modest loadout. The gasmask might impede his vision, but this combatant is sure to prove a substantial challenge.

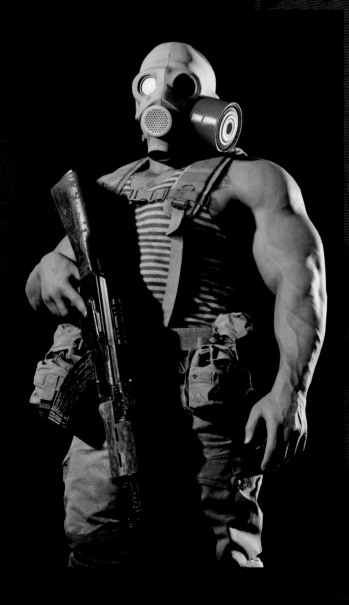
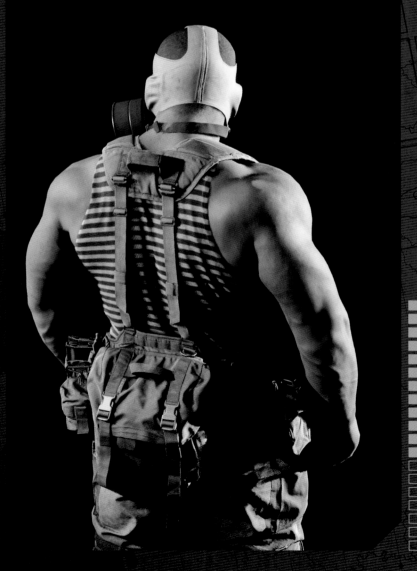

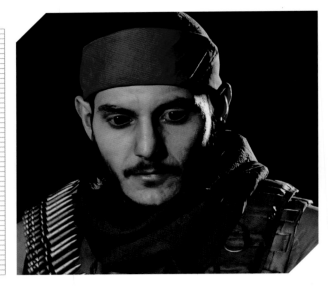

CHARACTERS // **AL QATALA**

The soldiers of Al Qatala fight for the freedom of their homeland, and think nothing of employing the most savage tactics against those who would seek to oppress them.

As the chief bogeymen in the game, these guys proliferate in all manner of guises. Flashes of color help to identify them on arid desert battlefields, but they are harder to spot on the streets when they are wearing civilian clothing.

Al Qatala is the primary enemy force. The design challenge was to make them feel believable and be recognizable to players in the middle of a firefight. Important details had to be considered in their design. We wanted them to be culturally diverse but still fit their regions. We had to get them to fit into many different environments and countries in the game's story.

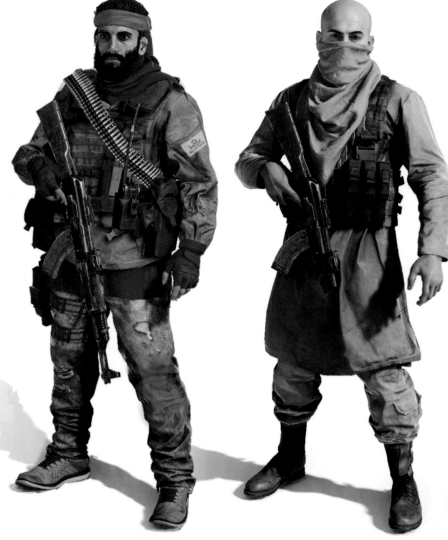

"Our war is not for faith. We fight to remove all foreign power from our soil. We fight without sorrow, we wage war without sympathy. This is the only way to die a true soldier."

Wolf, leader of Al Qatala

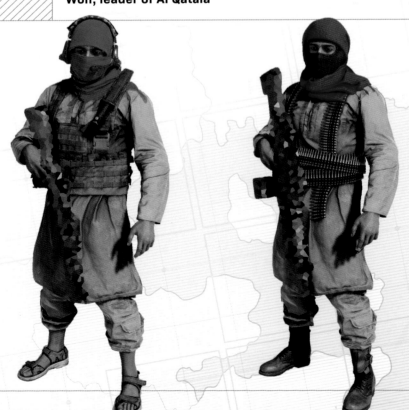

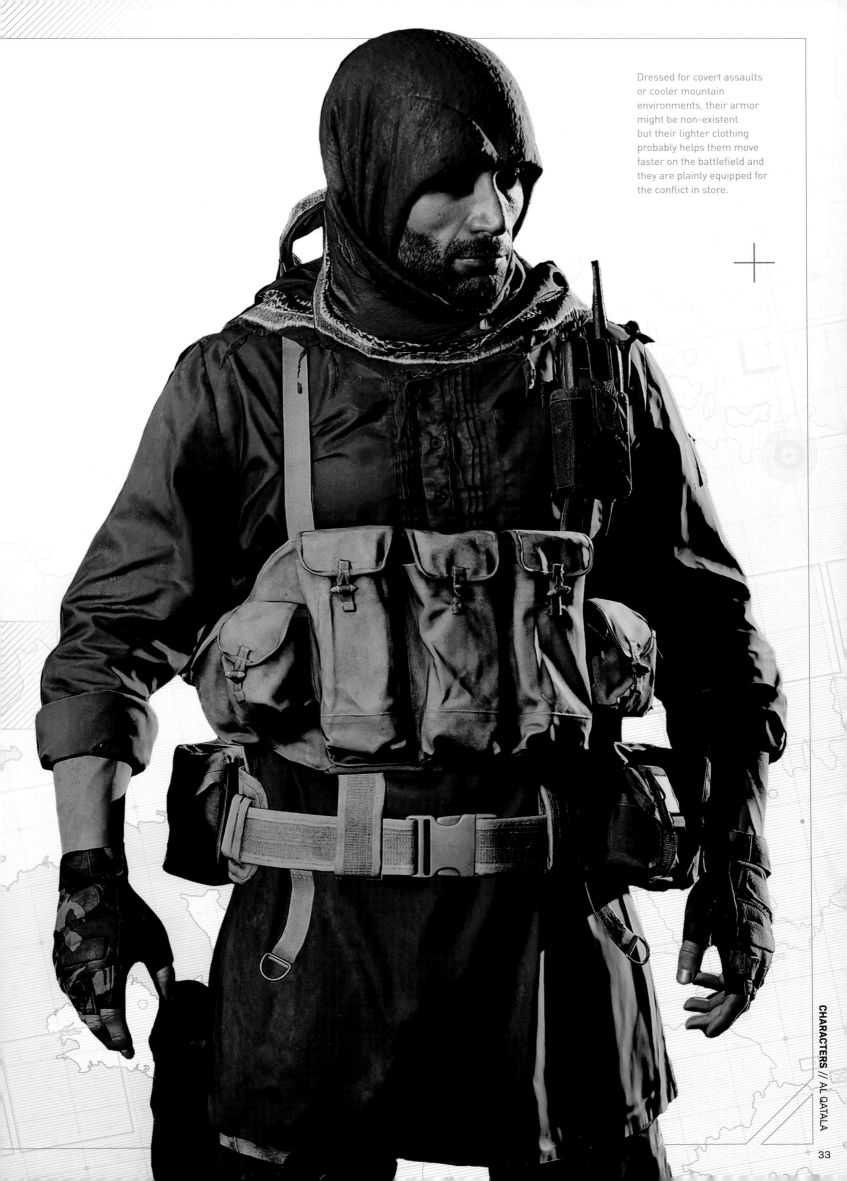

Dressed for covert assaults or cooler mountain environments, their armor might be non-existent but their lighter clothing probably helps them move faster on the battlefield and they are plainly equipped for the conflict in store.

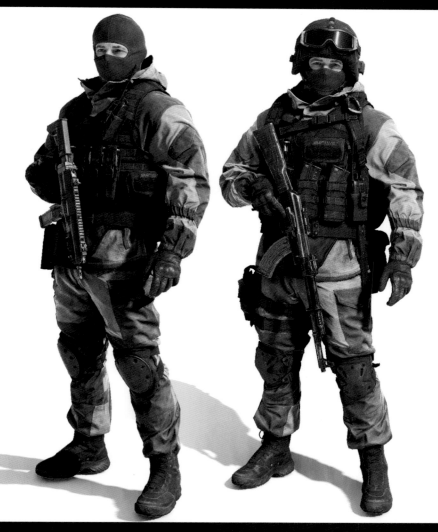

CHARACTERS // **SPETSNAZ**

Under the command of rogue Russian general, Roman Barkov, these soldiers of the 'Spetsnaz' Special Forces unit are not only well equipped and appropriately dressed for battle, they're highly trained as well. All of which is going to make the task of putting them down much harder.

Once again, an impressive amount of detail has been lavished on these non-playable characters— all in the name of creating a credible gameplay experience. The character department's top priority was to create the most realistic characters possible. The design of the Spetsnaz wasn't as much of a challenge as it was to gather and build their costumes. A lot of time and effort went into collecting the right references and building practical assets that the artists would then distress, paint, and scan. The result is as photo-realistic as we could make it.

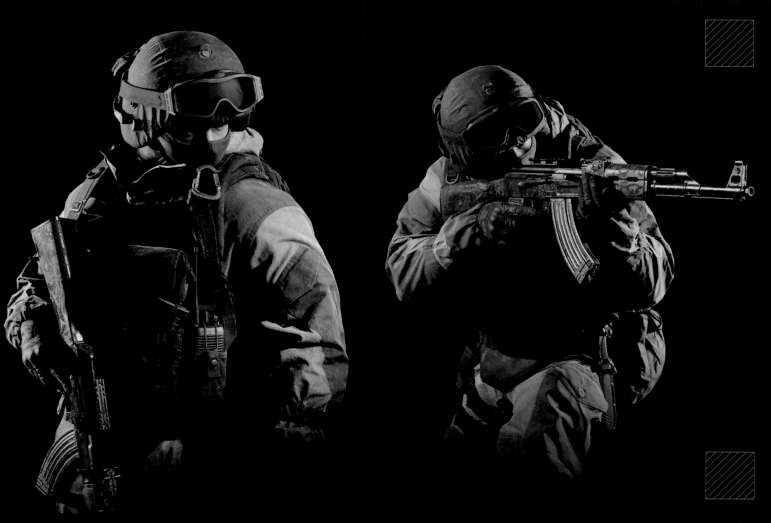

CHARACTERS // **FRIENDLIES**

With many aggressive adversaries in the game, it's perhaps comforting to find a few characters who are not bent on your immediate demise. British police and assorted military personnel are just some of the non-playable characters encountered, all of whom are as fully realized and realistically rendered as possible.

When you raise the bar high in certain aspects of the game it requires you to meet that bar everywhere else. We had to put as much time and effort into side characters as we did our heroes in order to maintain visual continuity throughout the entire experience.

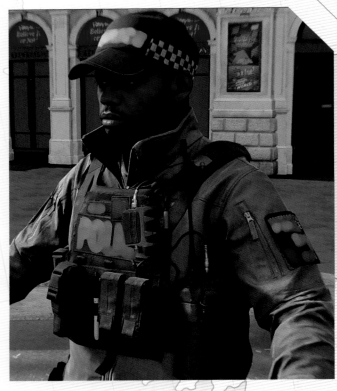

Not the everyday attire of the typical British bobby. The officers *below* and the one on the *right* look like they are dressed for trouble. And you can be sure there will be plenty of that.

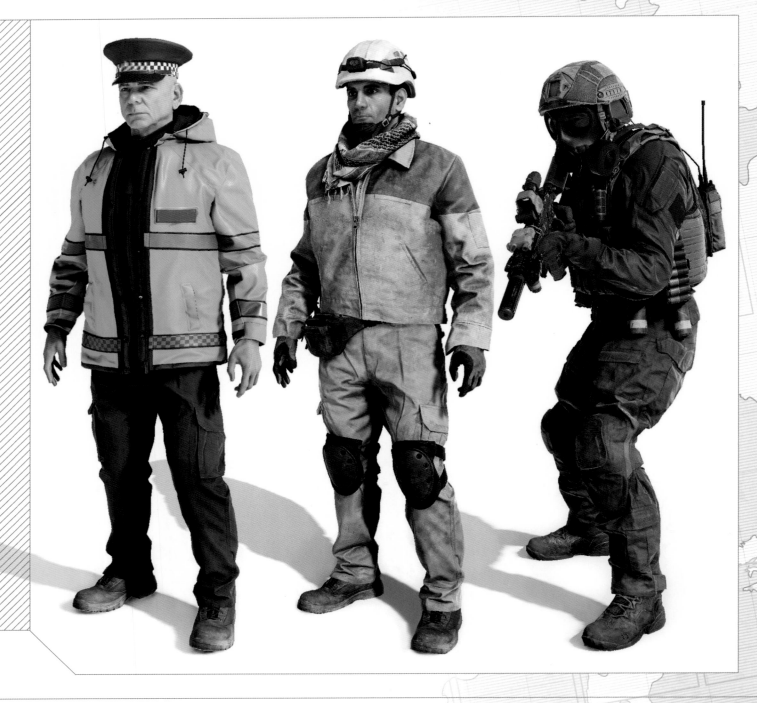

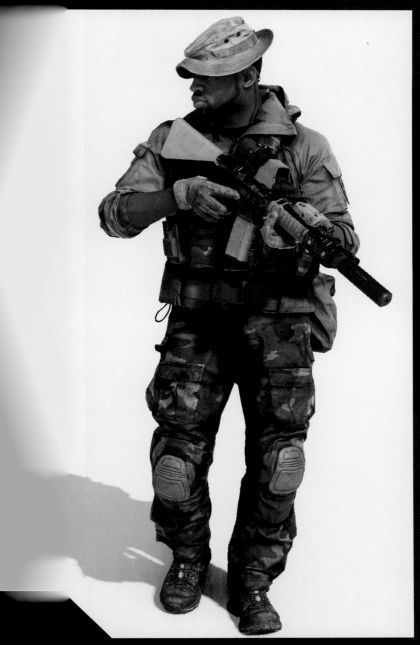

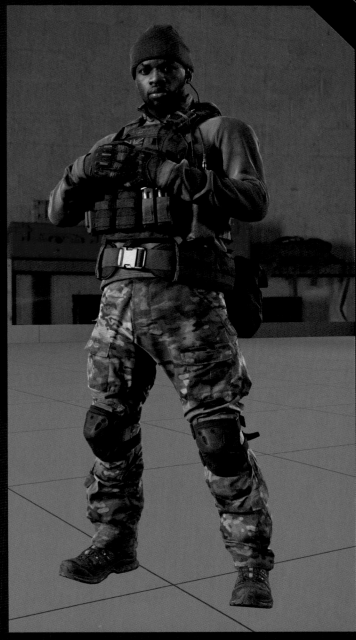

CHARACTERS // **THORNE**

Where every single non-playable character is rendered in incredible detail, it's great to learn that those you can choose in the multiplayer game–such as Thorne here–are just as photo-realistic too. *Modern Warfare*'s multiplayer experience required the creation of memorable high quality characters that players could choose to represent themselves as avatars. These are called Combat operators. These characters have to be distinctive and have different costumes and profiles for players to choose from.

With multiplayer characters having such lifelike features, combat is sure to be a vividly realistic experience.

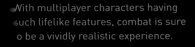

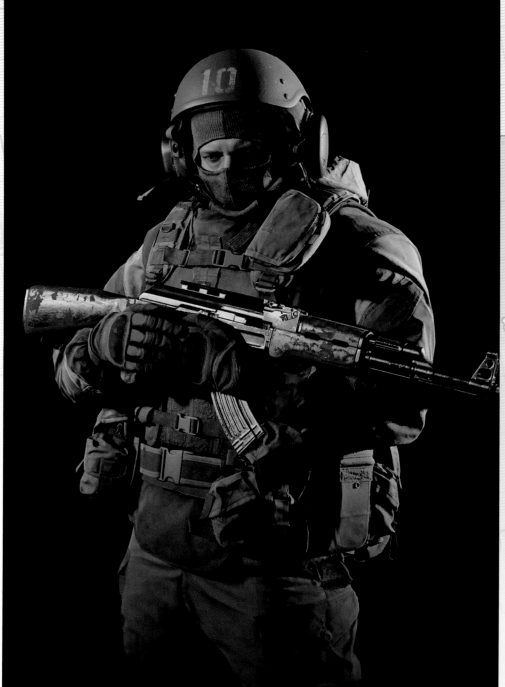

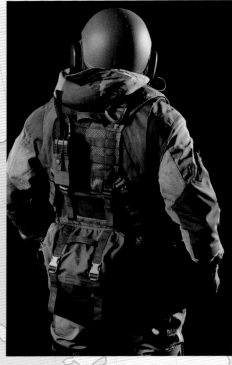

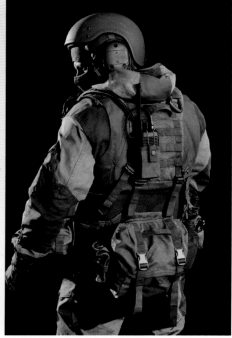

CHARACTERS // **BALE**

The multiplayer components of *Modern Warfare* are not straightforward matches of good versus evil. Rather, opposing forces are arranged along broad geographical lines. Combat Operators exist within two primary factions in the game's universe–West and East. This is Bale, who is a Tier One Spetsnaz character that embodies a true-to-military visual quality.

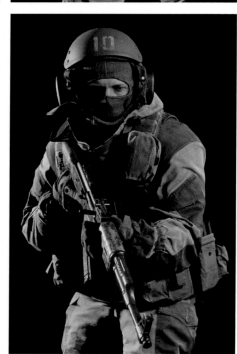

His face, hidden in a balaclava, reveals little of Bale's personality. Then again, his lethal armaments and substantial armor tell you everything you need to know.

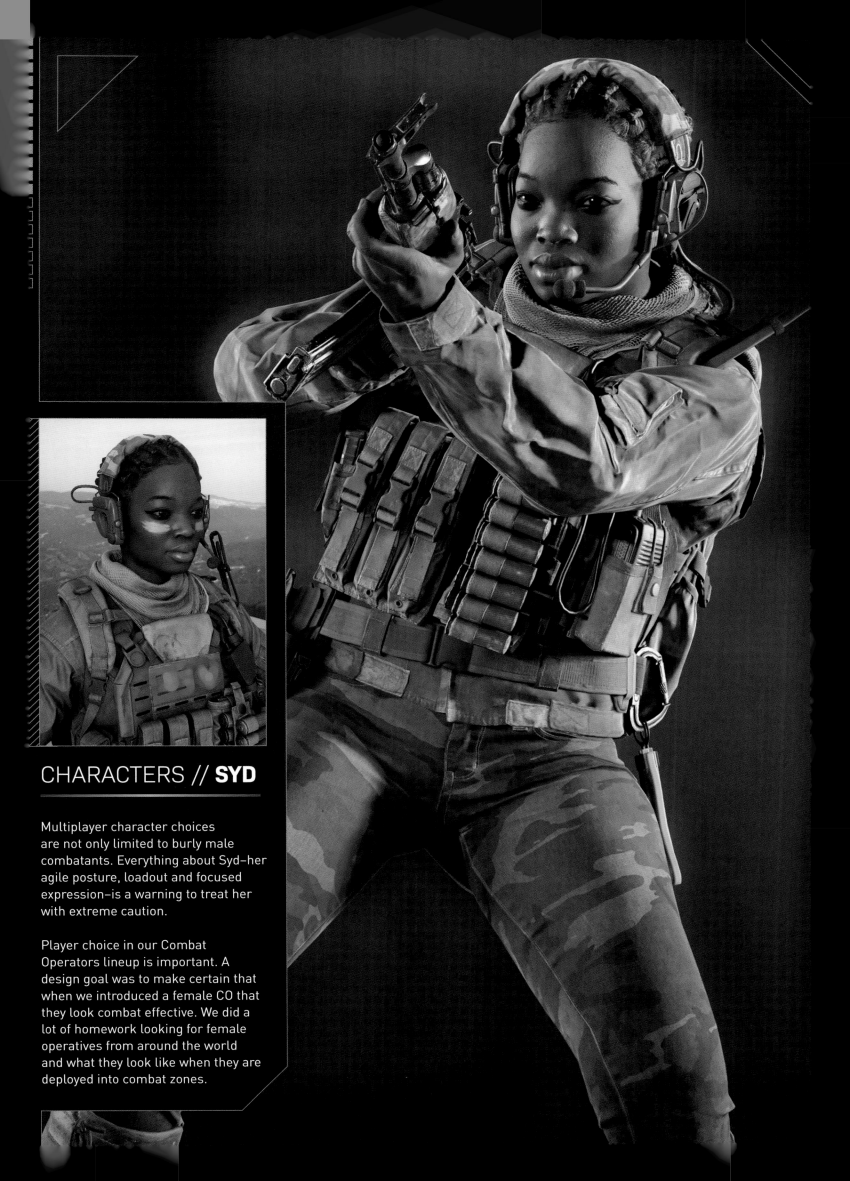

CHARACTERS // SYD

Multiplayer character choices
are not only limited to burly male
combatants. Everything about Syd–her
agile posture, loadout and focused
expression–is a warning to treat her
with extreme caution.

Player choice in our Combat
Operators lineup is important. A
design goal was to make certain that
when we introduced a female CO that
they look combat effective. We did a
lot of homework looking for female
operatives from around the world
and what they look like when they are
deployed into combat zones.

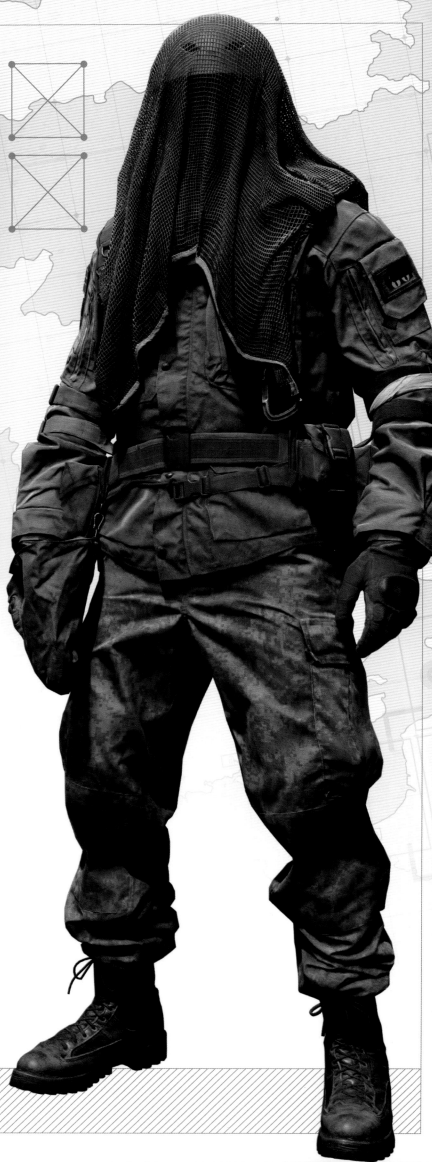

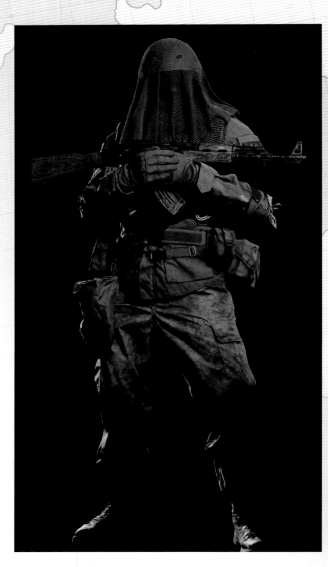

CHARACTERS // **KRUEGAR**

Camouflage is an important consideration in the field of battle. Kruegar's woven scrim headgear not only makes him harder to pinpoint in certain environments, but it also looks completely awesome. Its protective usefulness is otherwise minimal, but if you're heading into a fierce multiplayer firefight you might as well do so in style. Years ago we came across an image of a Special Forces soldier with a netted veil over his head. It was a really cool look, but at the time it wasn't possible to create the net mesh covering the head convincingly. It's amazing to see this character fully realized as the Combat Operator Kruegar.

In spite of his casual posture, it's fairly safe to assume that Kruegar is no slouch on the battlefield.

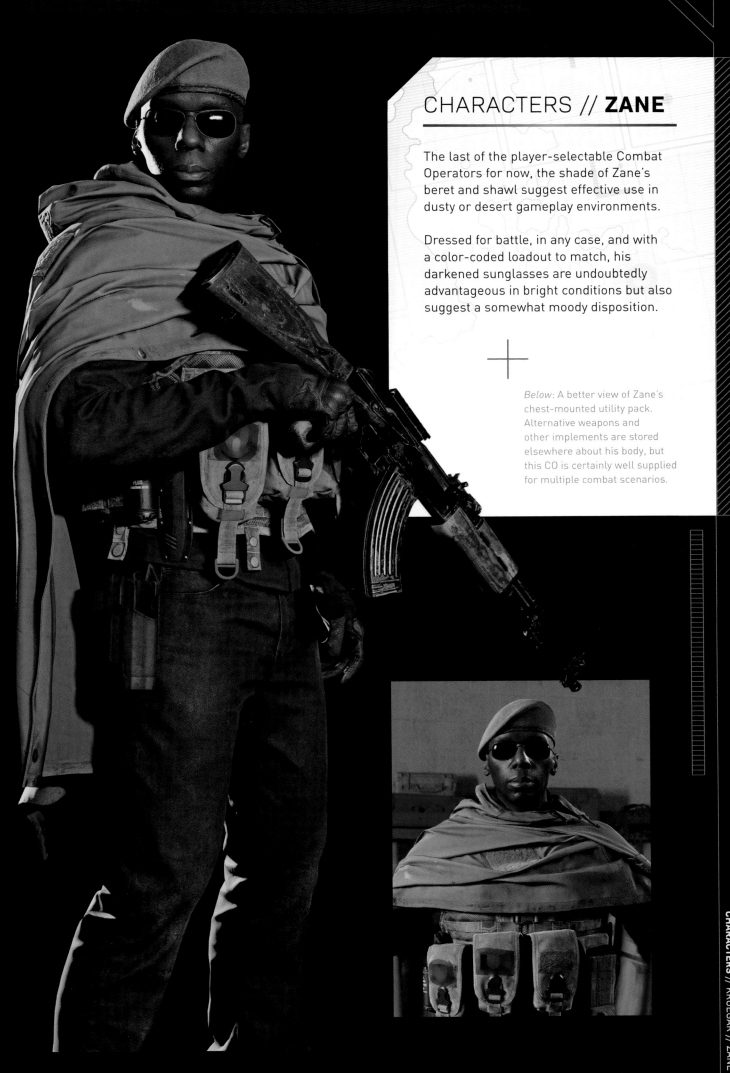

CHARACTERS // ZANE

The last of the player-selectable Combat Operators for now, the shade of Zane's beret and shawl suggest effective use in dusty or desert gameplay environments.

Dressed for battle, in any case, and with a color-coded loadout to match, his darkened sunglasses are undoubtedly advantageous in bright conditions but also suggest a somewhat moody disposition.

Below: A better view of Zane's chest-mounted utility pack. Alternative weapons and other implements are stored elsewhere about his body, but this CO is certainly well supplied for multiple combat scenarios.

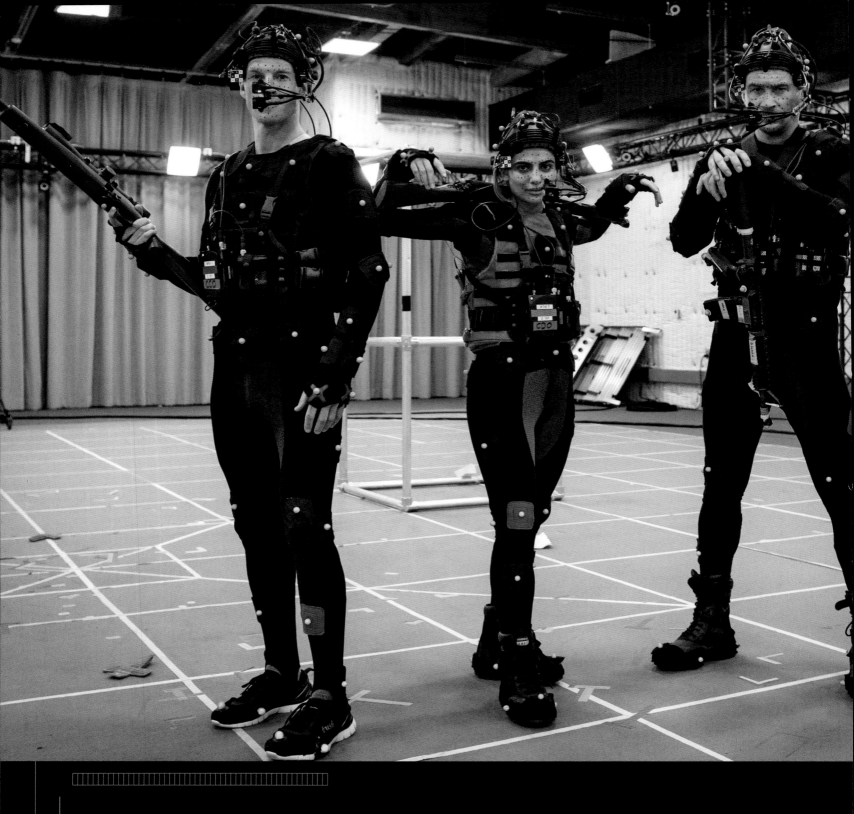

CHARACTERS // **PERFORMANCE CAPTURE**

Real actors have been used to portray many of the characters in *Modern Warfare*, their performances recorded and brought into the game using a process called 'performance capture'– or 'p-cap' for short. This complex procedure has been in development for many years. In summary, reference markers are placed about an actor's body and/or face–the dots and balls in these pictures. The scene is then filmed digitally, as directed, with smaller cameras and microphones worn about the head to monitor facial and character movements, and vocal performances at the same time. The position and motion of the markers are tracked as the actor moves, and this data is later matched to the digital model of the character. That's a dramatically short and basic overview, but fluid and unerringly natural animation is produced as a result. Combined with

photorealistic visuals, the characters in the game are brought to life like never before.

The following pages show various scenes from the performance capture studio, but we begin with a group shot to get the ball rolling. Left to right we have Chad Michael Collins (Alex), Claudia Doumit (Farah Karim), Barry Sloane (Captain John Price) and Elliot Knight (Kyle Garrick)–the main players in the game. While shooting performance capture scenes on stage, body motion, facial movements, and audio is simultaneously recorded. This helps create authentic performances with nuanced emotions, allowing the actors to be inspired by, and play off of each others' performances.

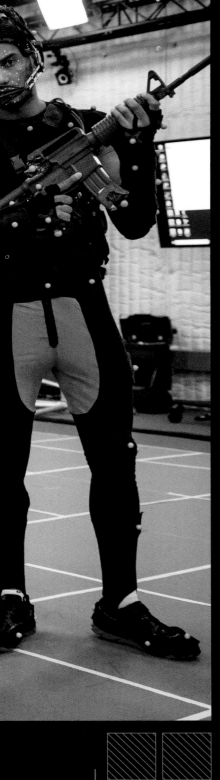

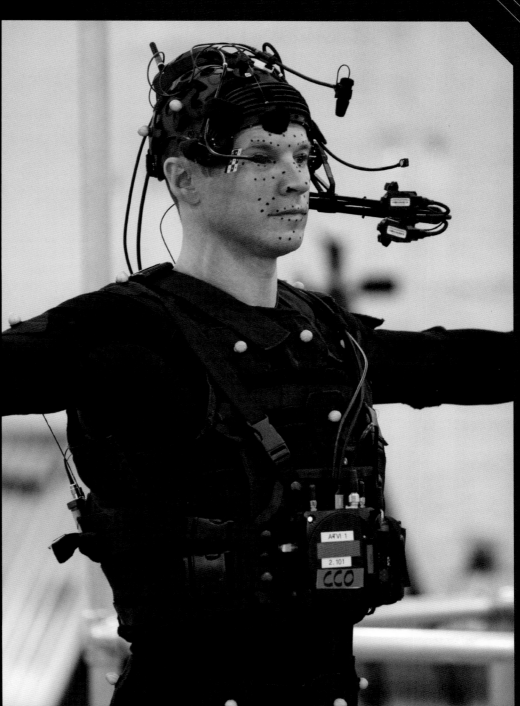

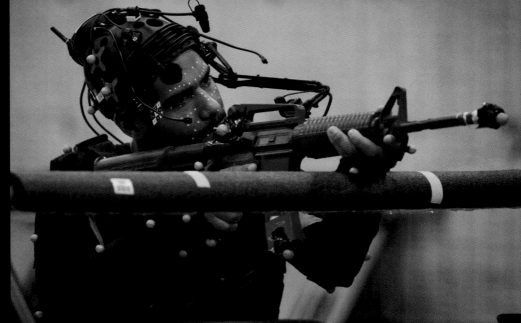

Top: Chad Michael Collins 'T-poses' to initialize the skeleton on his model before capturing a sequence. *Above:* Elliot Knight rehearses his blocking for a scene. When shooting scenes on the p-cap stage, rudimentary sets are built for actors to have 'touch points'. This creates a grounded performance with characters that organically interact with the CG environment.

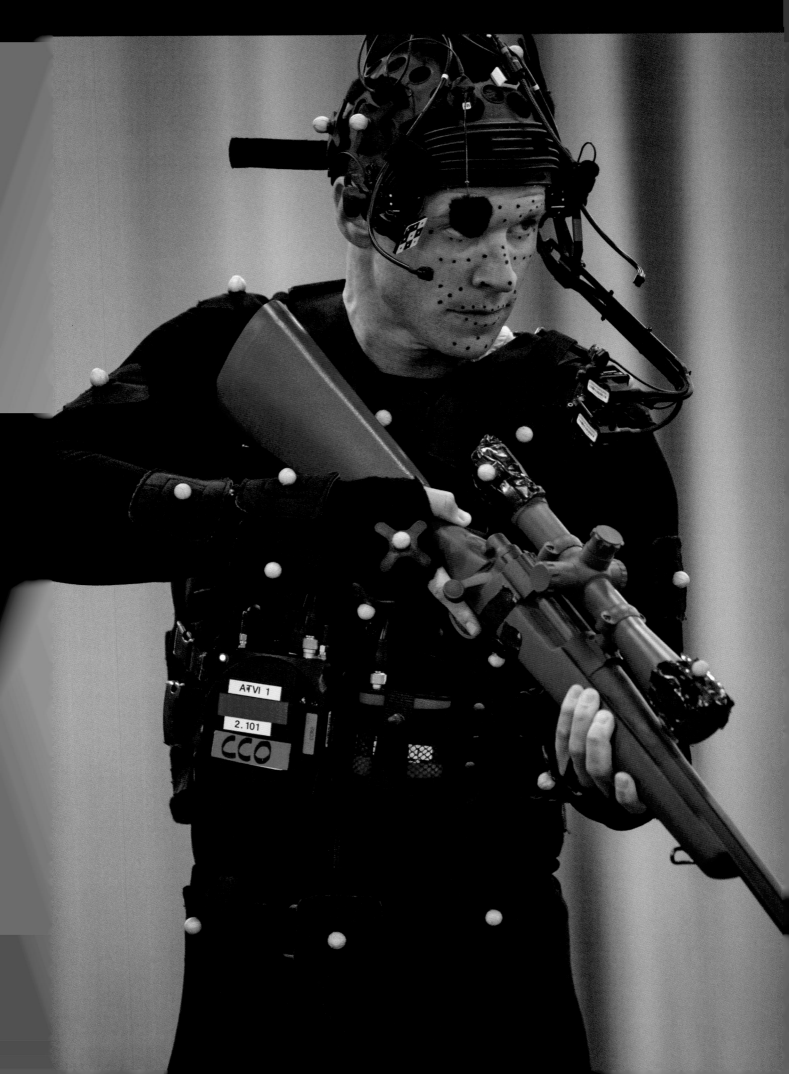

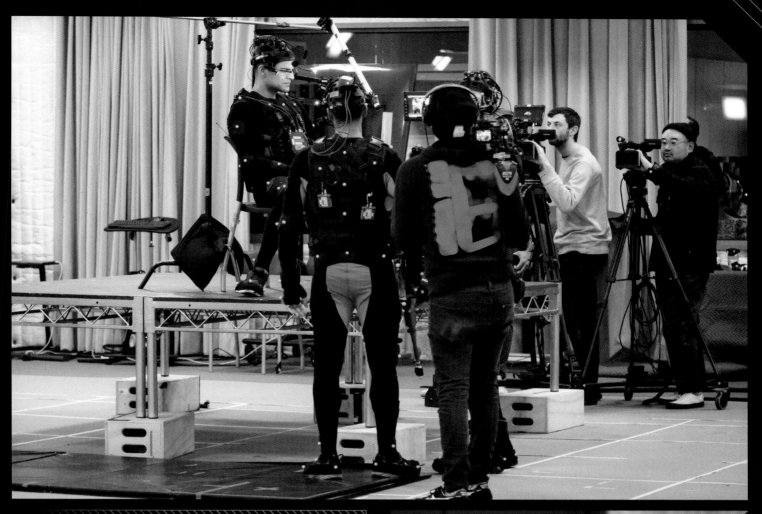

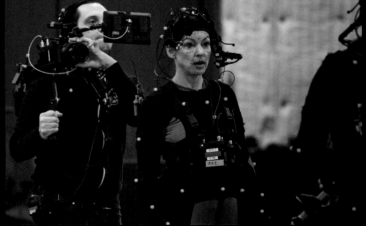

The process of performance capture begins in earnest, and we get a closer look at the markers that track an actor's movements. It is also interesting to note the amount of equipment that they need to wield—not least the ersatz rifle, but also the power packs and technical gadgetry that is worn about the body and head. All of which makes it even more impressive that the actors were able to turn in a performance at the same time. Clockwise from the left: The tiny dots track the actor's facial expressions and help the animation team to accurately capture his performance. This data is then applied to the CG character model, which is created from a 1:1 scan of the actor. This renders a naturalistic execution of the scene.

Top of the page: Reference cameras provide the narrative editorial department the raw performances from a scene. These reference angles are cut together to form a road map of the scene before it goes to animation. Middle: Shoulder-mounted cameras capture the cast performance in order to ground the scene and respond to the actors' movements in real-time. Right: Claudia Doumit stares intently as she performs a scene.

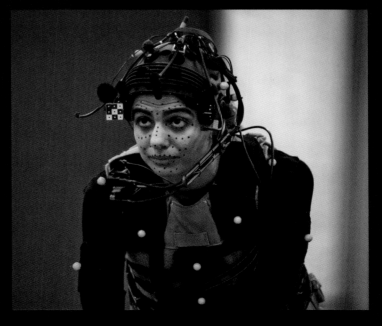

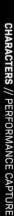

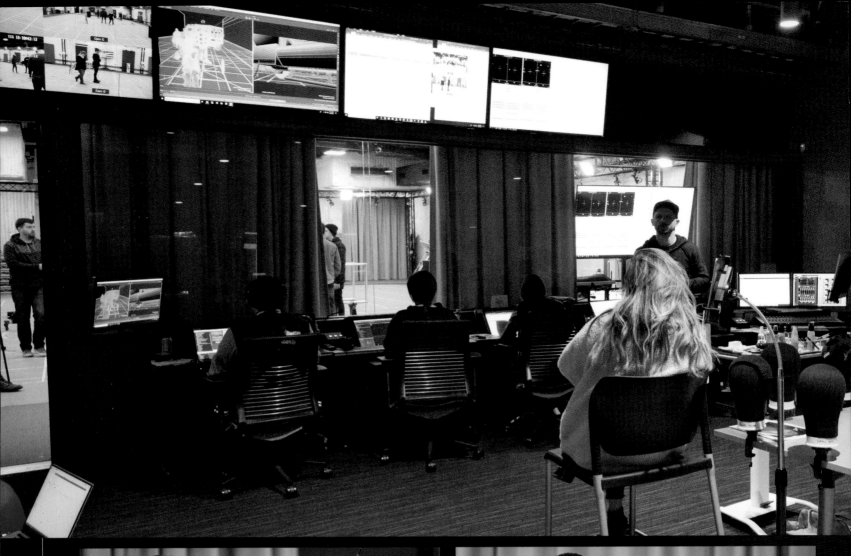

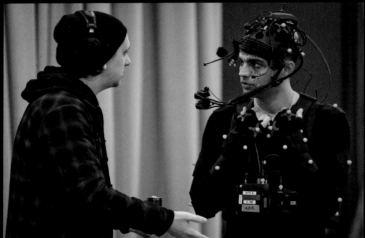

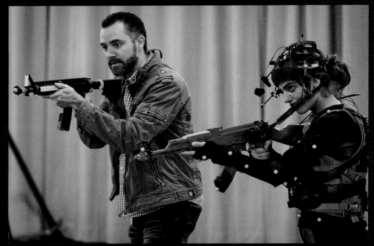

Finally, we have a selection of scenes from both sides of the cameras and we get a greater sense of the complexity involved in putting a performance capture scene together—also some of the unlikely shortcuts entailed.

Clockwise from top left: The p-cap crew at their stations, as the rest of the team prepares the shoot. It takes a group of 25 people to capture a scene. p-cap and facial technicians, sound engineers, camera operators, and makeup artists work together seamlessly to bring performances to life. *Above right:* A little down time in the Green Room. *Left to right*—Producer Graham Hagmaier and Studio Narrative Director Taylor Kurosaki prepare scripts, as several cast members wait for the next shot. *Middle left:* Taylor

Kurosaki gives the cast a little script insight before shooting commences. *Lower right:* The cast rehearses a scene while the crew watches through the virtual camera. This enables them to view the character models in real-time, and in turn allows them to react to discoveries the actors make as they rehearse. *Right:* A little of the magic is revealed, as Barry Sloane and Elliot Knight perform a scene in a haphazard vehicle assembled from speedrail and apple boxes. It will not appear in the game like that, of course!

Above right: Animator Zach Volker gets into the game as he helps Claudia to prepare for her sequence. *Above Left:* Cinematographer Jeff Negus and Aidan Bristow (Hadir Karim) discuss the main elements of a scene.

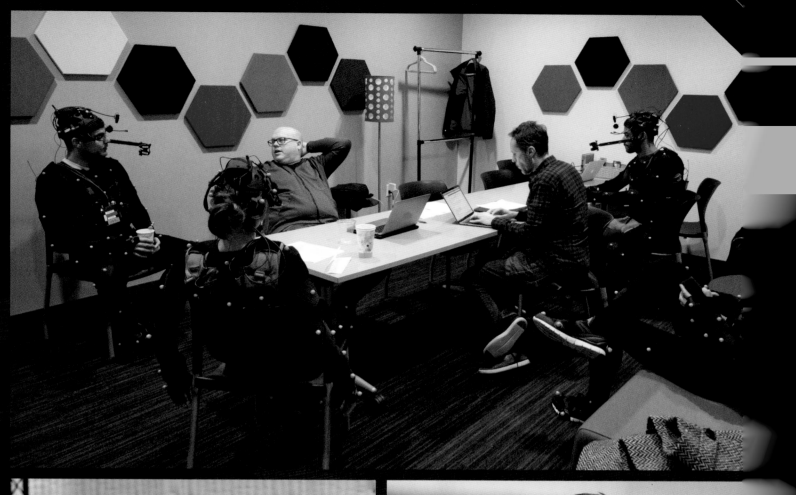
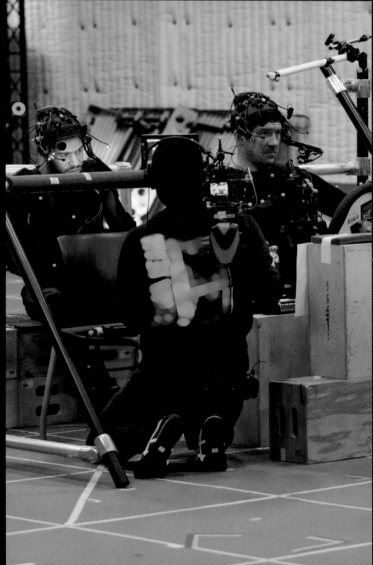

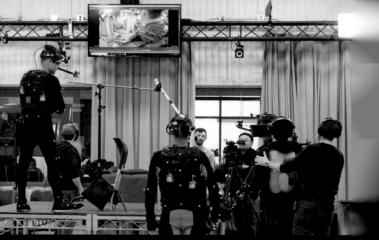

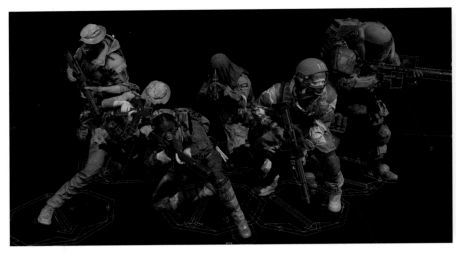

CHARACTERS // **TECHNICAL RIGGING**

Rigging is the placing of a digital skeleton within our character meshes. These skeletons have a built-in logic, along with nodes that are placed on the joints of the skeleton. Using these digital handles and points, the animators can drive and pose the character like a puppet. These skeleton 'rigs' require a tremendous amount of skill and patience to build.

Modern Warfare characters are very diverse, not only in the personalities but their gear and body types as well. The rigging team was challenged early on in the project to tackle some really difficult features. The first was to allow the character department to have characters with various long coats, ponchos, and hoods. This all required finding technical solutions that simulate dynamic cloth. The characters also wear a considerable amount of gear. 'Jiggle joints' were added so that the gear flops and bounces around when the characters are in motion. Another big improvement was to get the Juggernauts to move more believably. The Juggernaut not only needed extra rigging work, but also a specific type of motion capture that could only be done with a special padded suit that simulates the character's proportions.

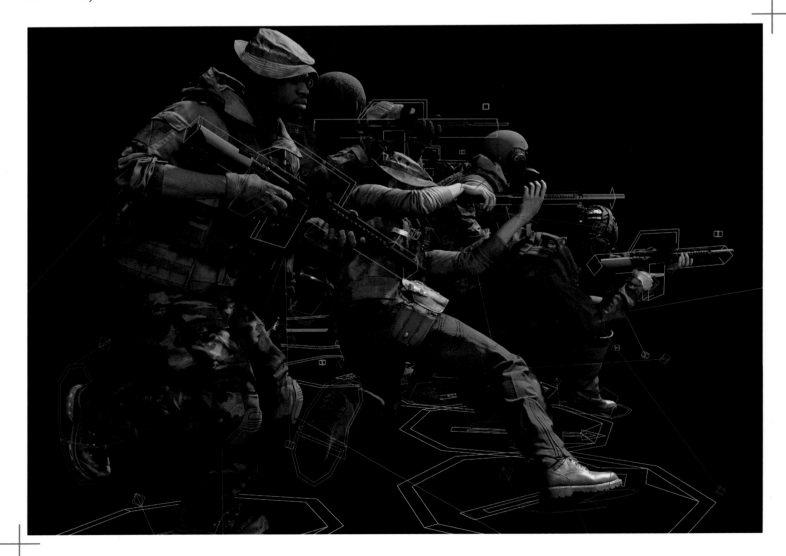

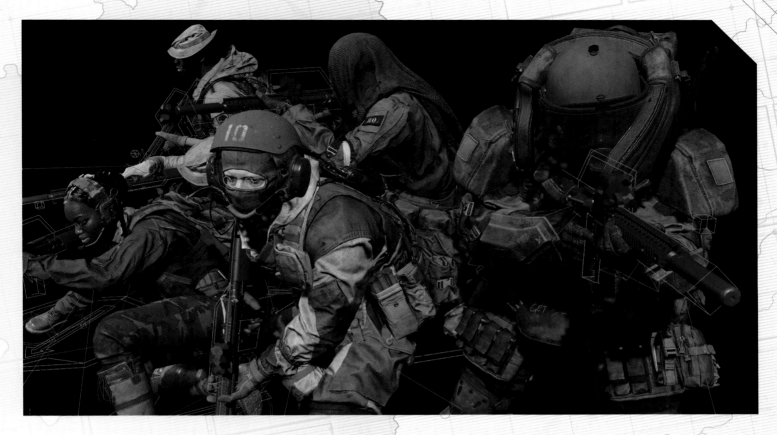

The skeletal 'rig' within each
character allows for realistic postures
and movements. The rig itself can be
seen *upper left*, and the other images
demonstrate the incredible potential
of using this system.

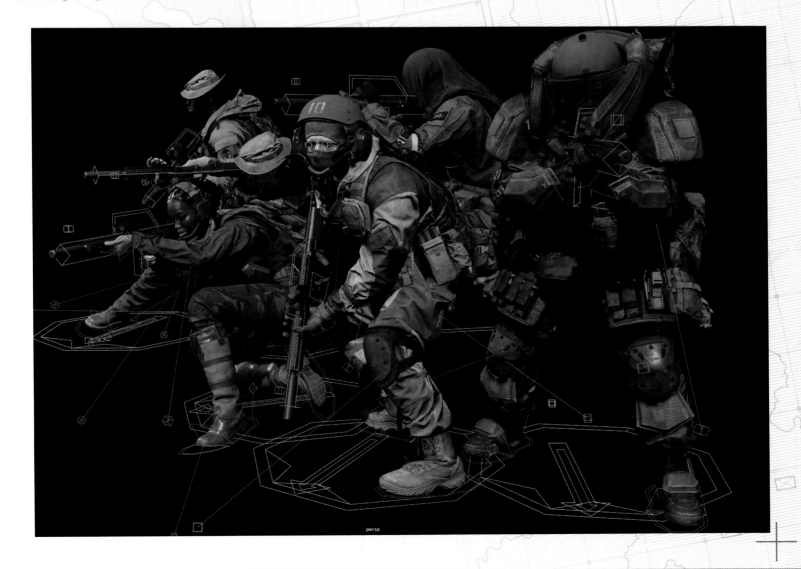

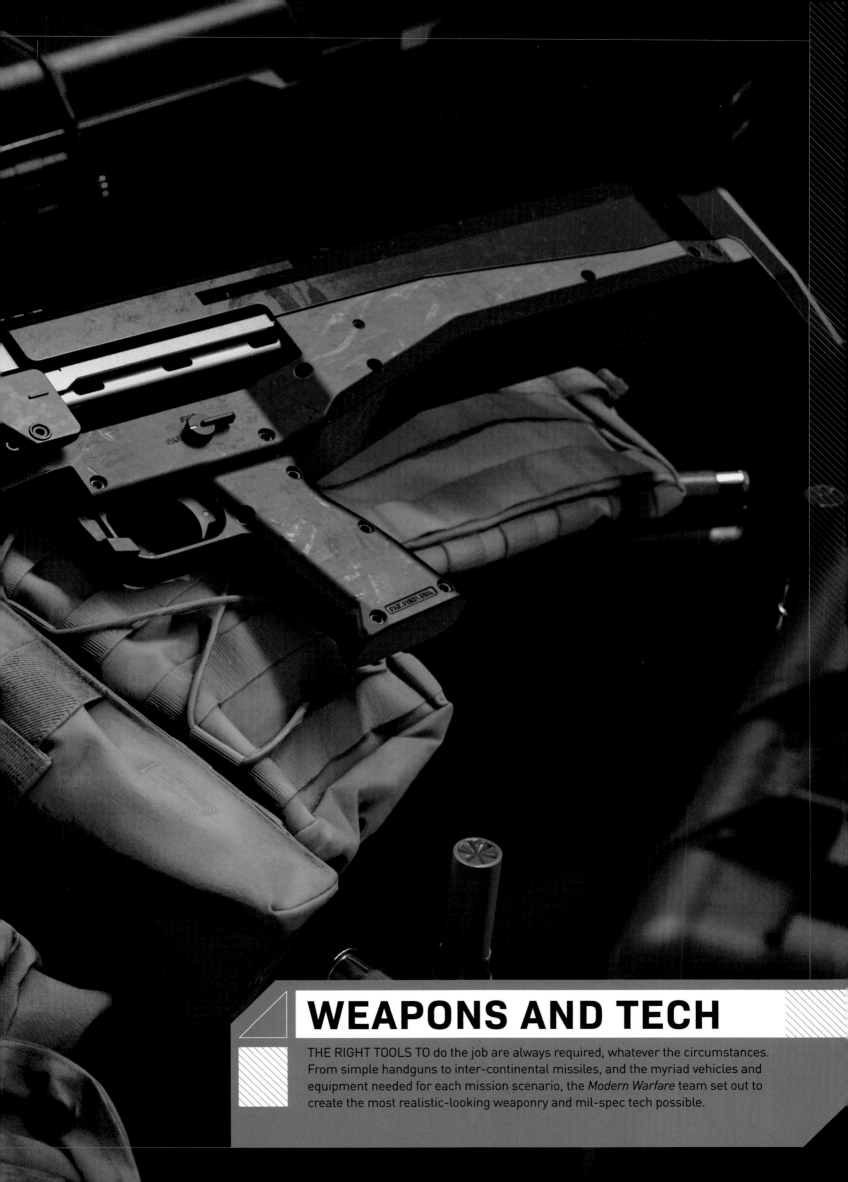

WEAPONS AND TECH

THE RIGHT TOOLS TO do the job are always required, whatever the circumstances. From simple handguns to inter-continental missiles, and the myriad vehicles and equipment needed for each mission scenario, the *Modern Warfare* team set out to create the most realistic-looking weaponry and mil-spec tech possible.

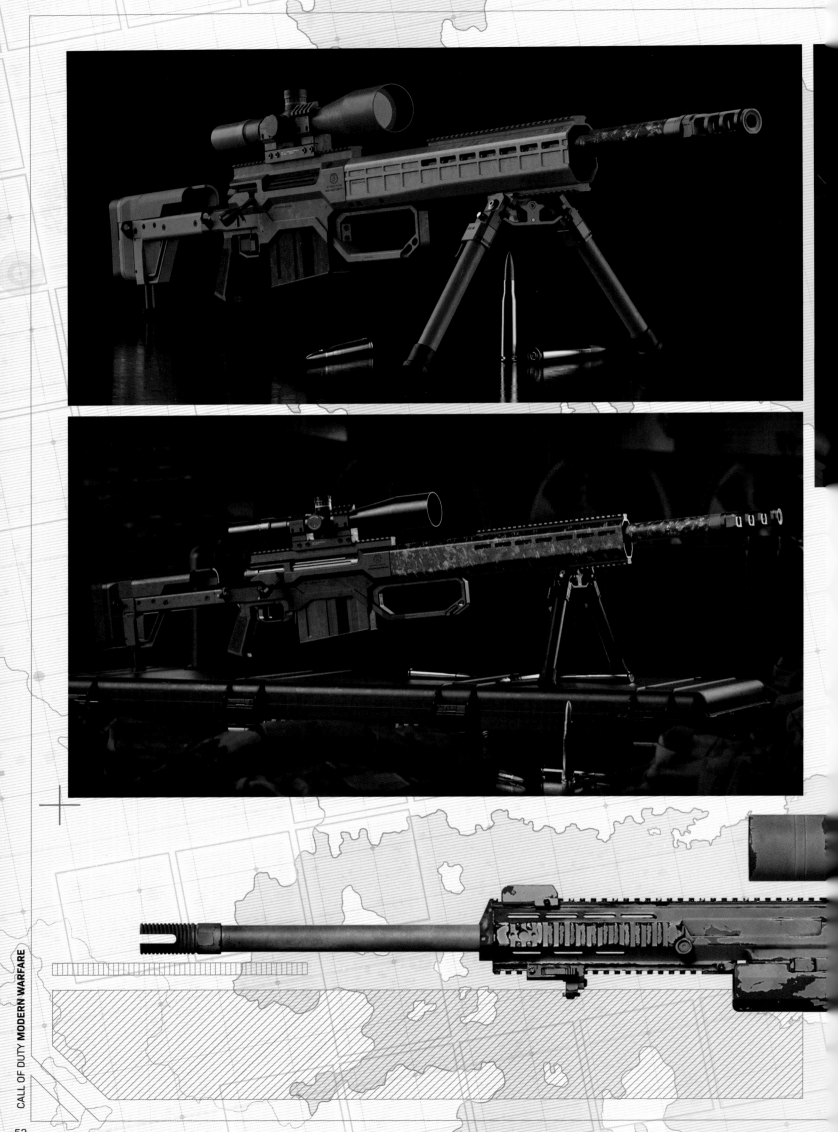

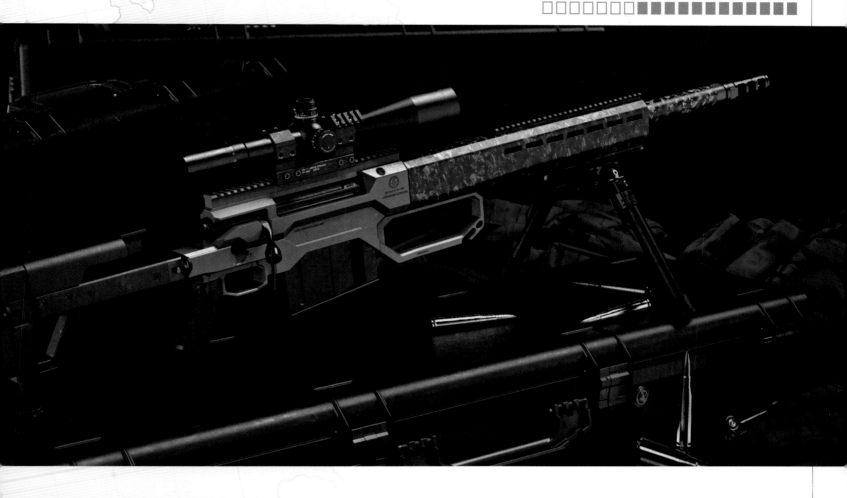

WEAPONS // **SNIPER RIFLES**

Accurate and devastating in the right hands, these long-range weapons are a sharpshooter's best friend. *Modern Warfare* players will find lots of occasions to make good use of them too. Marksmanship is more important than ever in the game. For rifles such as this, wind direction, physical bullet drop, and even the caliber of bullets was considered when designing the weapon.

These rifles are fired at long-range, so the scopes on them needed to look high-powered too. An important addition that isn't noticeable here is how realistic our magnified scopes are in the game. When a player aims through our scopes the scope actually magnifies what the player is aiming at—just like a real optic.

A weapon of many parts, effective use requires a steady hand and a sturdy and preferably covert platform. A realistic scope facilitates accuracy over long distances, although environmental factors must also be taken into consideration.

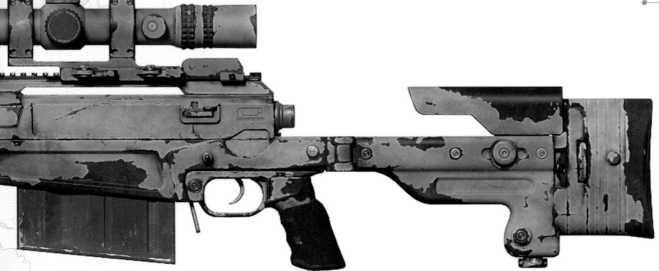

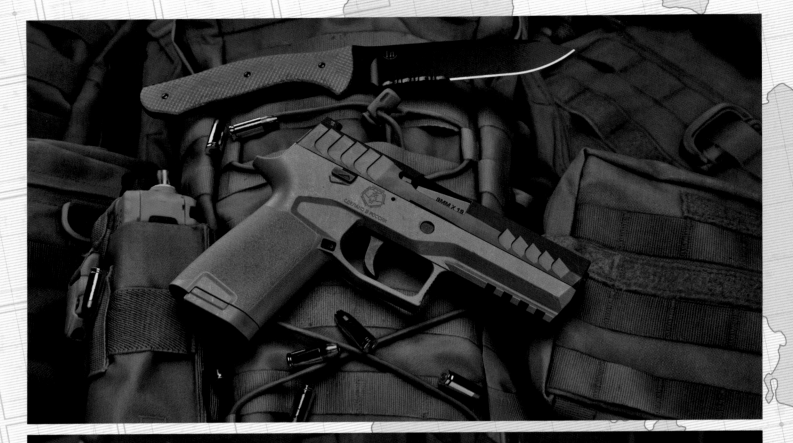

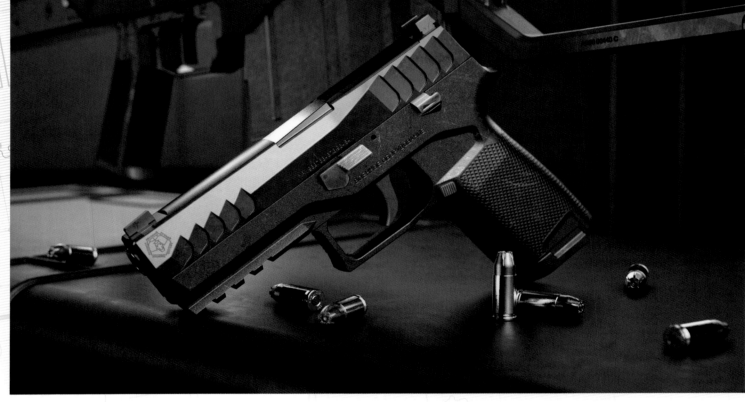

WEAPONS // **HANDGUNS**

In tight spots on the field of battle, when backed into a corner or when all other options are exhausted, a simple handgun is a very capable weapon to have at your disposal. Small and eminently portable, it copes best in close-quarters combat scenarios. For our handguns we explored different finishes, plastics and stippling to give them character. Every model we created was detailed down to the interior parts and components.

Among the many other benefits of these firearms, they also come in green or black colorways. The very thing for style-conscious combatants.

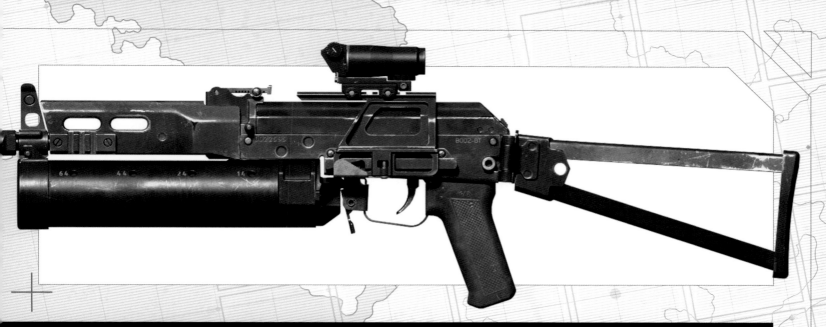

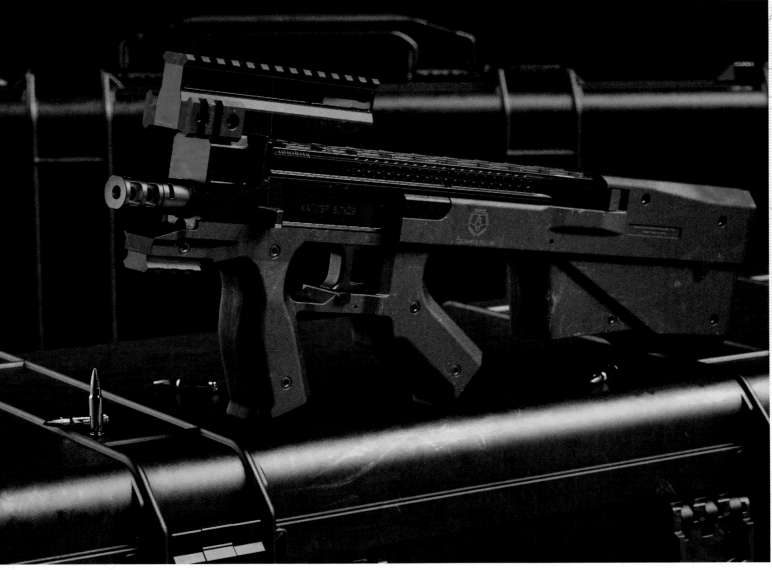

WEAPONS // **SUBMACHINE GUNS**

Realism and credibility are key components of the entire *Modern Warfare* experience, and this holds true for the weapons used in the game as much as the characters and locations visited. Seen here are concepts for variations of some submachine guns. It's always tricky to create weapons that look like custom designs, but without looking like they belong in a science fiction movie. We followed a very basic design rule—they need to look logically functional with realistic materials. A good example is that you would never make the barrel out of a plastic material.

A lightweight plastic body enhances portability, although the important parts of this SMG are made out of metal.

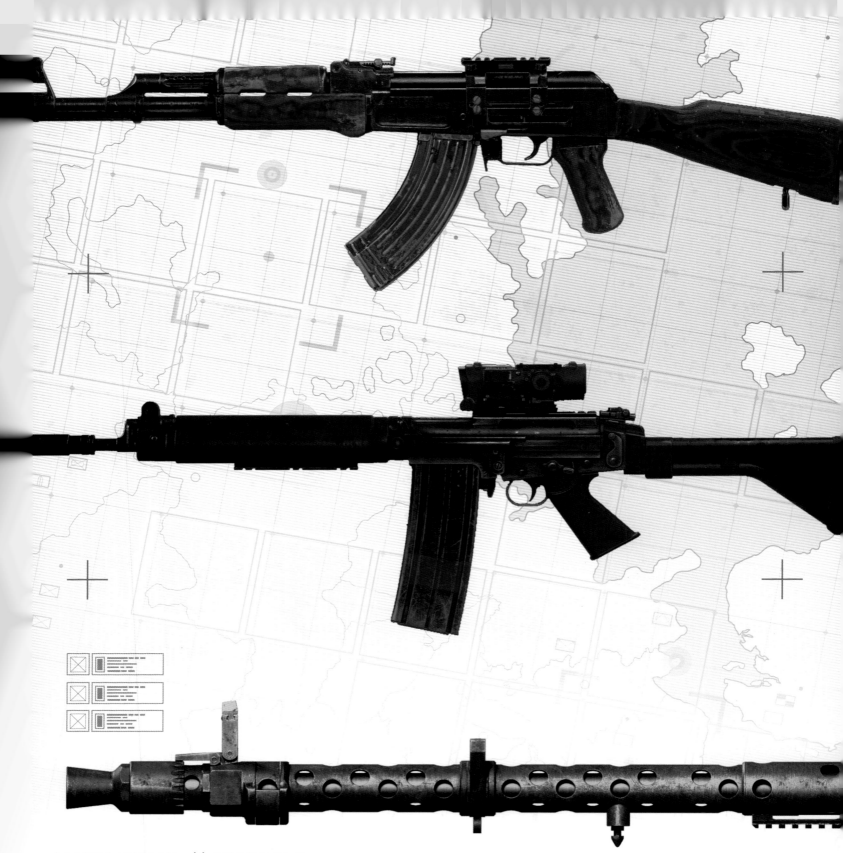

WEAPONS // **MODELS**

Certain combat scenarios are best suited to specific load-outs and gameplay strategies. In spite of that, and with specific reference to *Modern Warfare*'s multiplayer gameplay options, players can not only choose from a generous array of stock weaponry, but they are also able to select from a menu of components in order to build and craft their own.

The weapons shown here are modest examples of what can be achieved with this system, and they are quite credible at the same time. More outlandish creations are also possible, as we'll soon see, but it is a luxury to have such a wealth of options. *Modern Warfare* has a vast library of firearms. The game even supports a system which allows players to customize and smith their own weapons in game. With all these possibilities comes a great deal of personality.

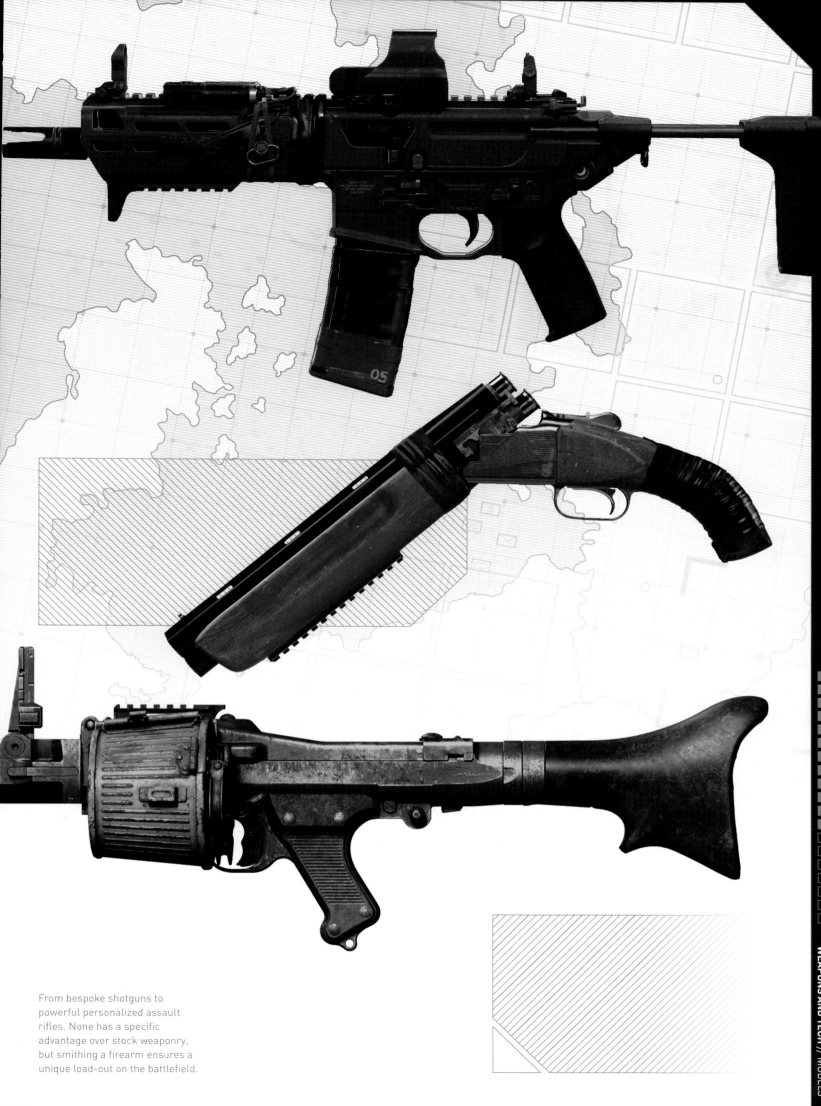

From bespoke shotguns to powerful personalized assault rifles. None has a specific advantage over stock weaponry, but smithing a firearm ensures a unique load-out on the battlefield.

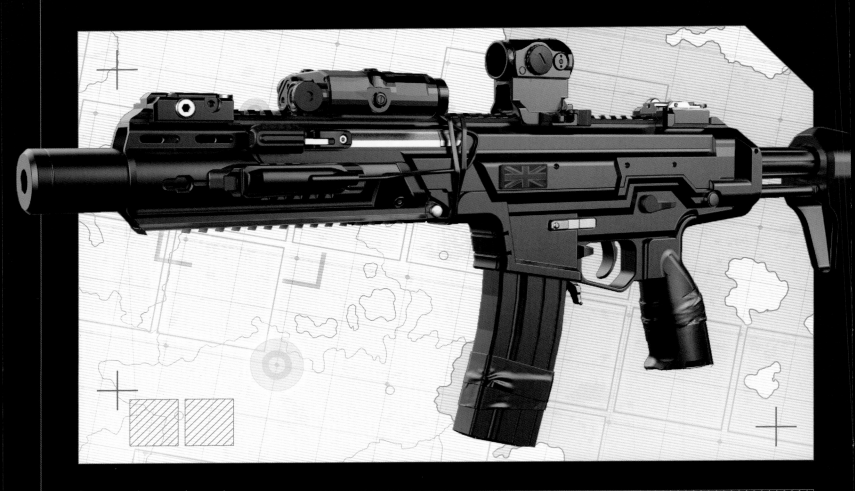

Some narrative scenarios require weapons to reflect a Special Forces unit, a faction or a particular country. Subtle details like rubber bands and gaffer tape are a great way to add a human touch to the hardware.

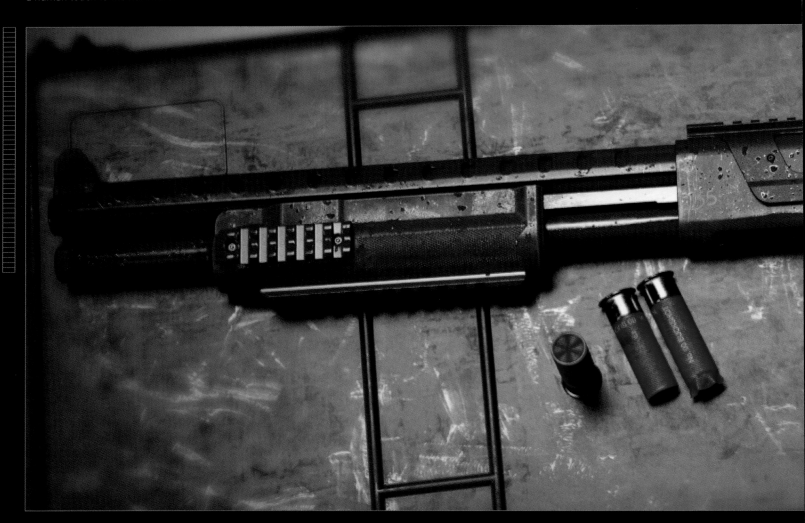

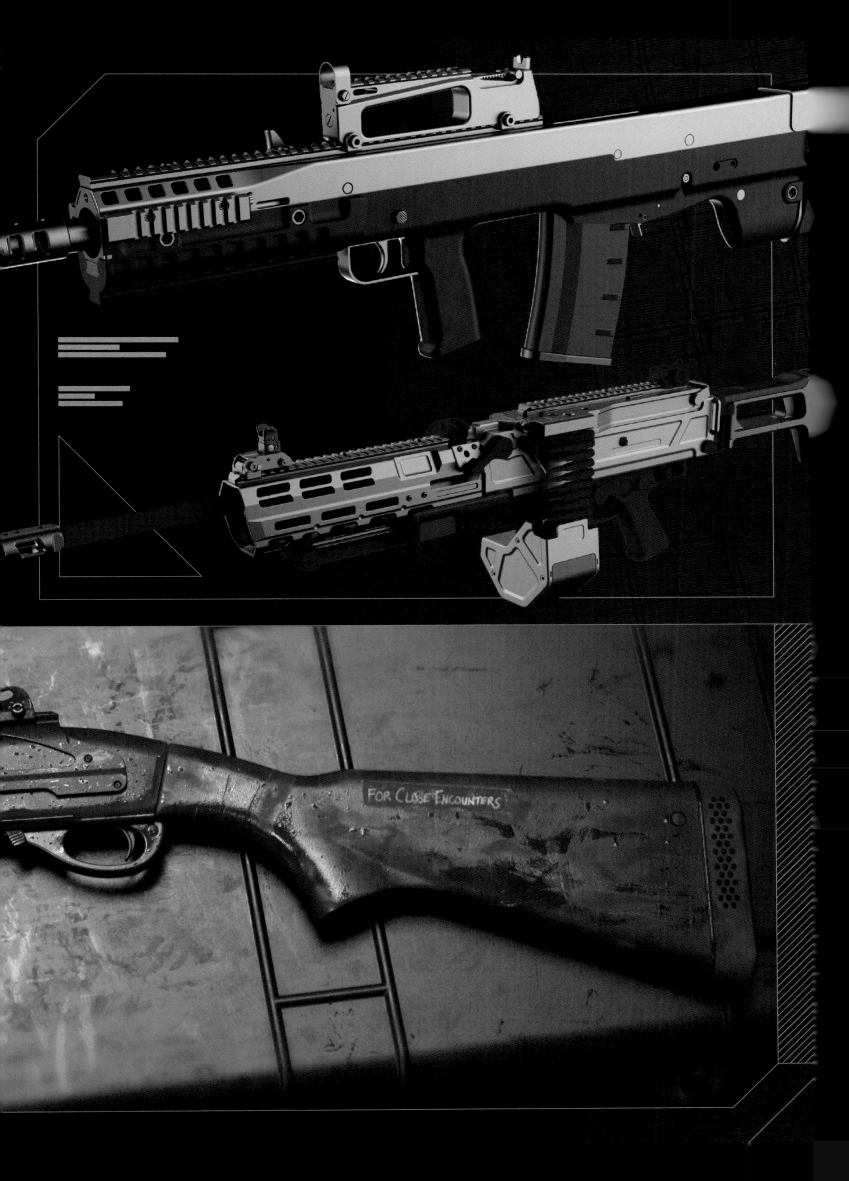

FOR CLOSE ENCOUNTERS

There is nothing wrong with any of the standard issue firearms, in that they will all perform their intended functions. If players are seeking to personalize their load-out, however, they can certainly withstand a few enhancements...

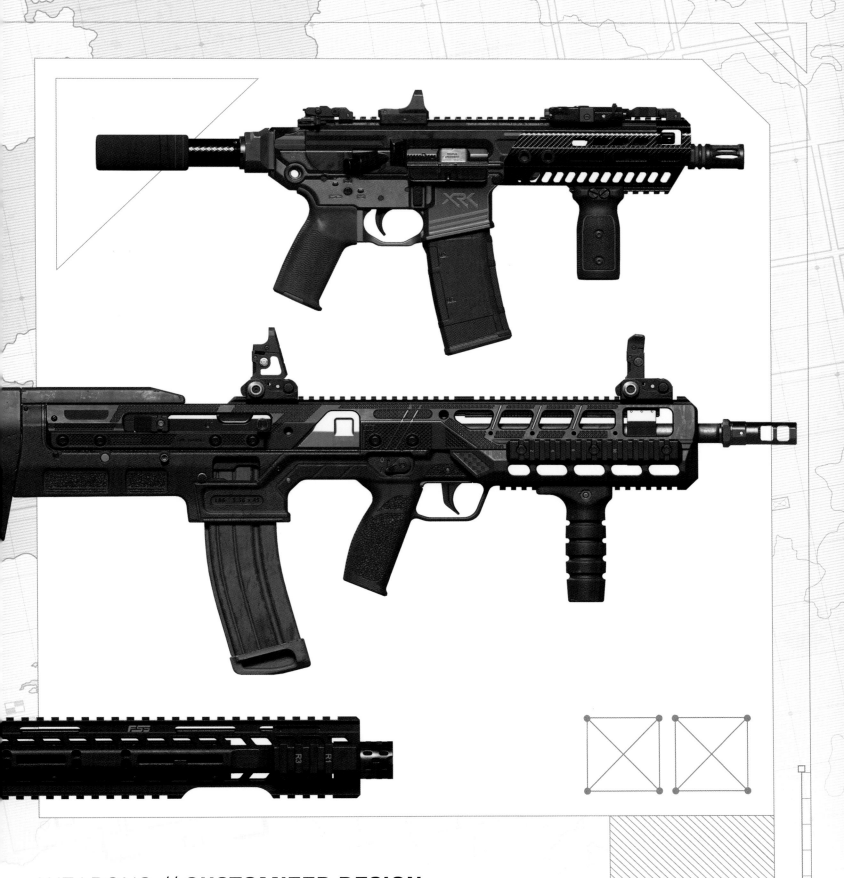

WEAPONS // **CUSTOMIZED DESIGN**

Modern Warfare boasts an entire arsenal of weapons, some better suited to particular conditions or combat situations than others—all of which is up to players to explore.

In the meantime, a range of customization options can make weapon selection a game in itself, and also allows players to tailor their experience to their own tastes. One of the first big tackles early in the project

was Weapon Customization. In advance of the Weapons Department's involvement, the Concept Department experimented with hundreds of designs by assembling components together in Photoshop. Grips, rails, magazines, muzzles, scopes, skins—just about anything we could think of were available as separate pieces and assembled like building blocks. It was fast and produced a lot of interesting results.

Above: The customization options allow for some lively liveries. However, more modest designs are less likely to attract the wrong sort of attention on the battlefield.

WEAPONS // **HERITAGE**

Over the course of three previous *Modern Warfare* games, and now with a fourth, the series has established a vibrant, compelling and credible mythology. Prior knowledge is not a barrier to enjoyment, of course, but long-time fans will find nods to earlier outings peppered throughout this latest one. *Modern Warfare* has a history and, even though this game is a reimagined story and universe, we still inserted references to the previous games. This handgun has the words 'War Pig' scratched into its slide. This is referencing a mission from the original mission with a tank named 'War Pig'.

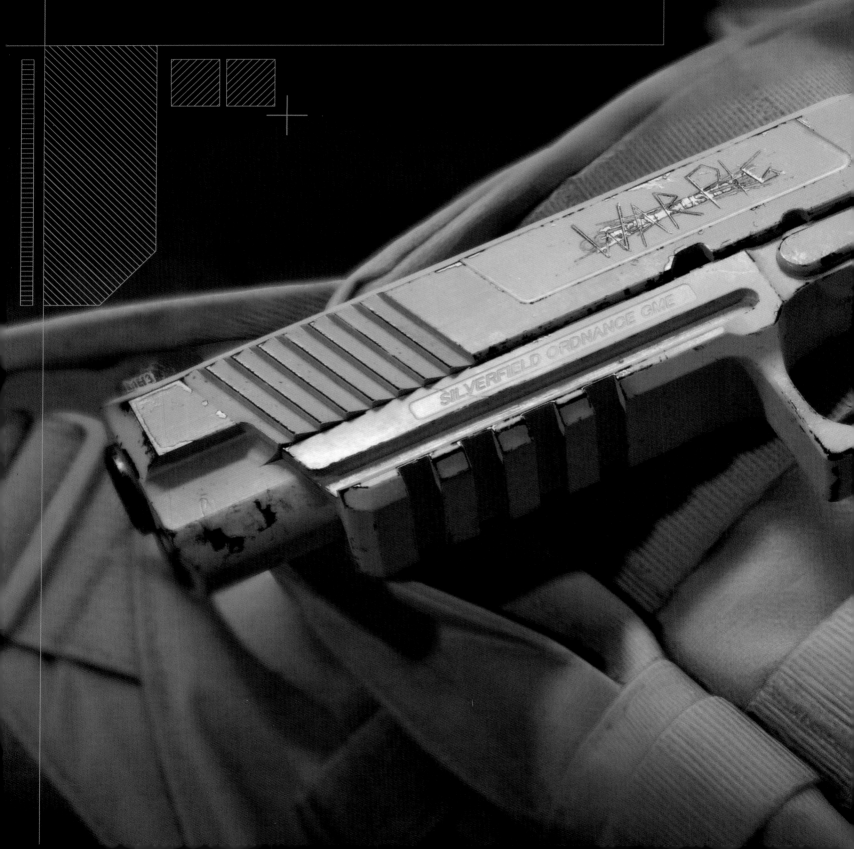

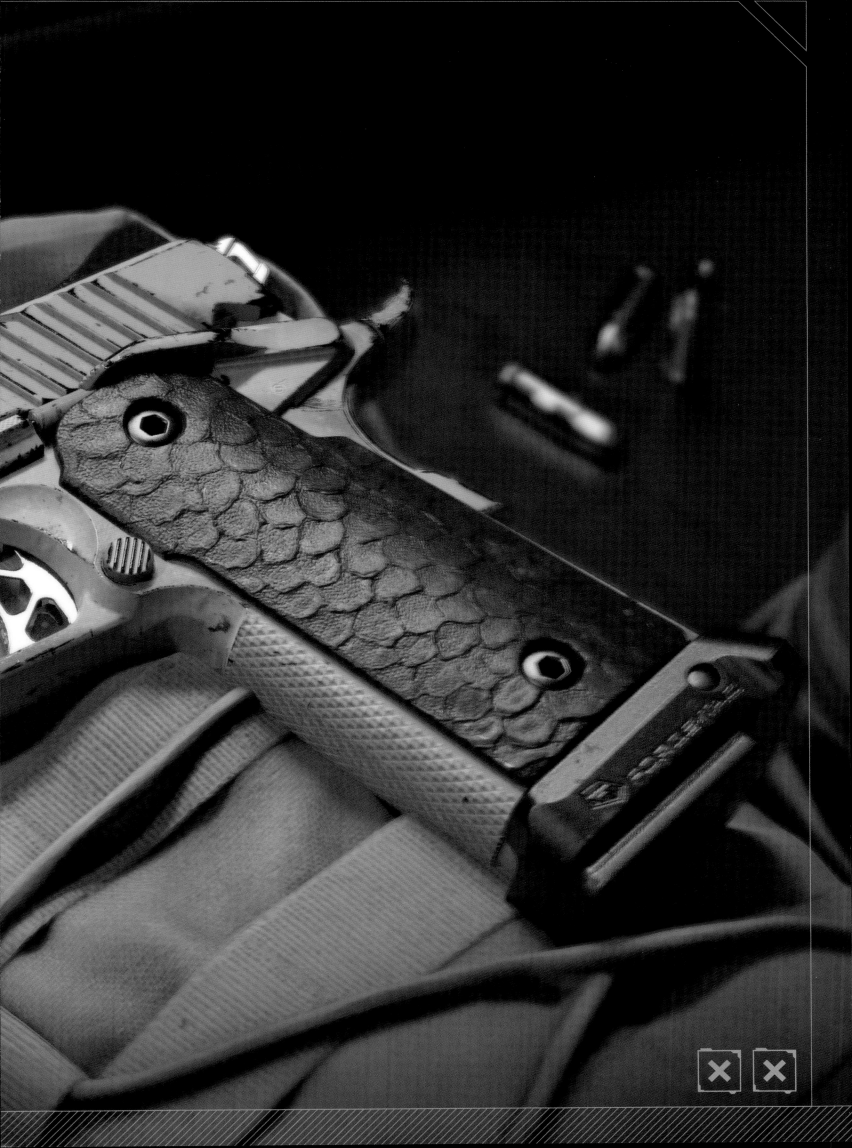

WEAPONS // **OPTIC SIGHTS**

Gaining a better view of the battlefield is not only crucial from a tactical perspective, but using the correct gun sight can make the difference between accurately targeting an adversary or missing a shot entirely.

Optics play a huge role in the game–they aren't just about looks. Different optics can have various reticles for aiming and different magnifications for better sight pictures. Every player has different likes and dislikes about optics depending on the weapon or the mission.

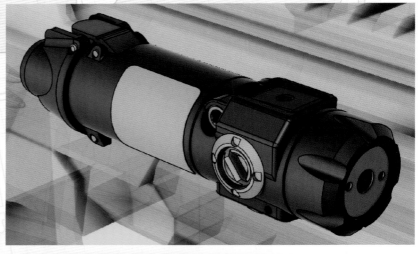

WEAPONS // **LASER SIGHTS**

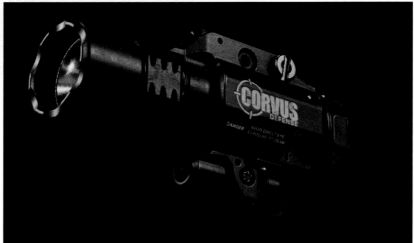

Modern Warfare employs a system called 'spectral rendering', which uses real wavelengths in order to display light beyond the visible spectrum–infrared, for instance. Using this technology is complicated, although the results are certainly more realistic to the eye–as seen throughout this book.

The laser sight *on the right* operates outside the range of normal eyesight, although an opponent wearing night vision goggles will immediately spot its beam. Careful use is certainly advised. Seen *below* is a tactical light that can be attached to a weapon and used to illuminated paths or targets.

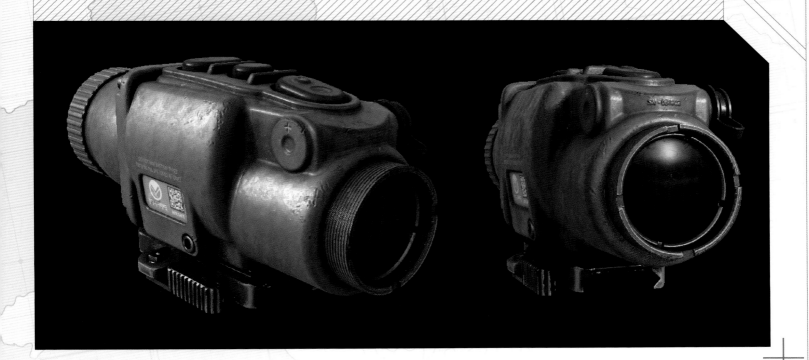

WEAPONS // **THERMAL SIGHTS**

Certain objects emit heat signatures, and thus reveal themselves to this useful thermal sight. Other game developers might seek to mimic this effect, although that wouldn't quite suffice for the *Modern Warfare* team.

Our graphics engineers developed realistically accurate rendering techniques. All of the thermal scopes in the game work realistically. All the surface materials in the game allow for temperature settings. Running car engines can be set to hot to show an active vehicle, while inanimate objects can be set to cold.

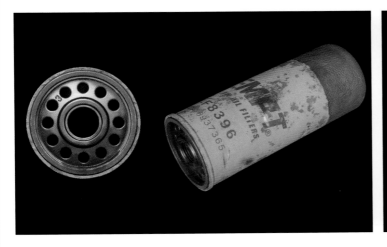 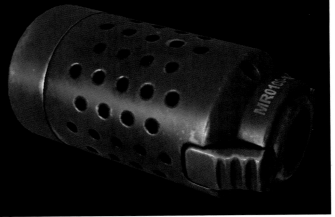

WEAPONS // **MUZZLE ATTACHMENTS**

An impressive attention to even the smallest details has resulted in an unprecedented level of authenticity in the game. This extends even to the choice of gun barrel, although careful selection can enhance functionality in certain instances.

Seen on the *left*, this orange cylinder is a makeshift suppressor made from an oil filter. We did some research on this, and it actually works if done properly. On the *right*, this muzzle brake is used to expel the gas from the weapon barrel as it fires. The gun is more stable and provides less recoil as a result.

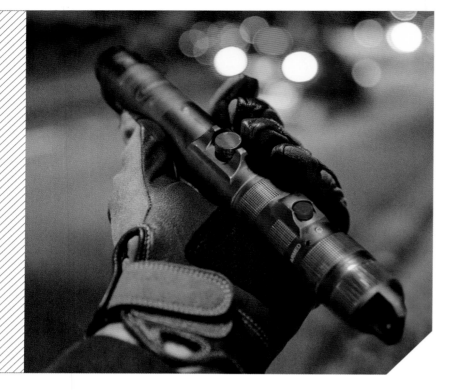

WEAPONS // **GREEN BEAM**

The Green Beam is a take on an infra-red targeting system that is commonly used by military and law-enforcement personnel. The in-game version required a few tweaks before it made the cut. Real military hardware is often designed merely to be functional, although the hardware in shooter games often has a tendency to be over-designed to point of being tacky. The trick is to aim for a design that balances *grounded* and *entertaining*. Real-world imagery was used to help sell this concept to the *Modern Warfare* team—in this case, a photo-realistic render composited in a real photo. The original photo was actually of a hand holding a flashlight.

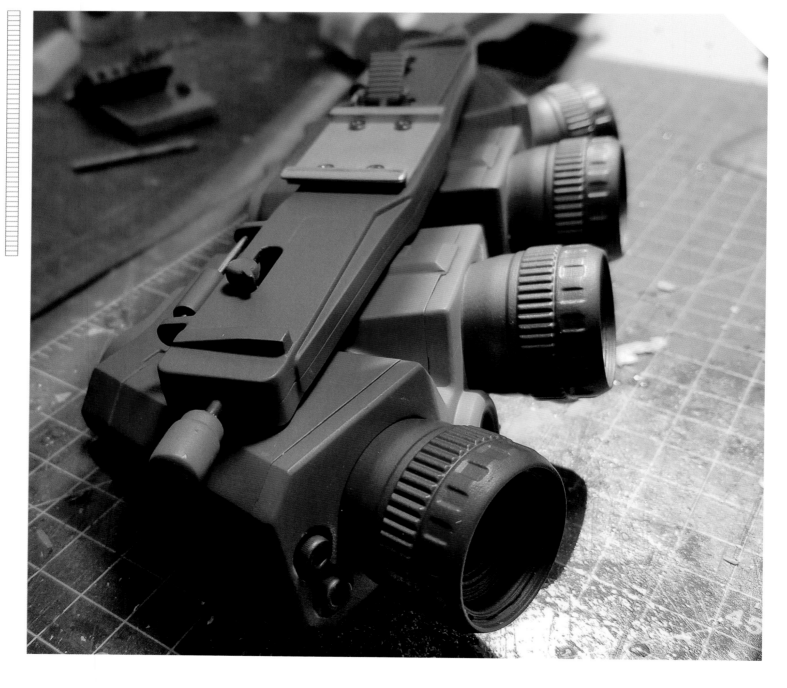

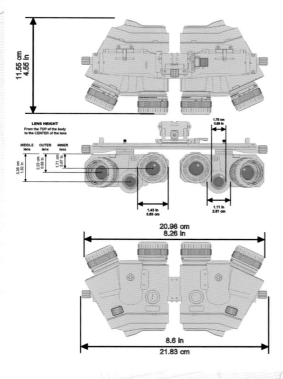

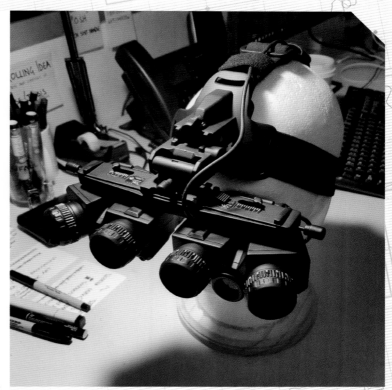

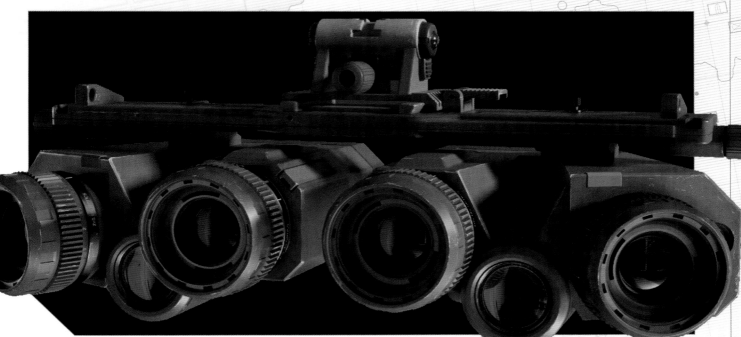

WEAPONS // **NIGHT VISION**

Night vision goggles are a vital tool in dark or stealth missions–and they are back with spectacular enhancements in *Modern Warfare*.

The goggles come into play in a number of challenging scenarios, but those used in previous games are much different in comparison to this magnificent multi-lens system. As with much of the game, no detail has been overlooked in the design–the

precise dimensions for which are provided *above*. The collector's edition of *Modern Warfare 2* was famous for its night vision goggles. They were pretty impressive for their time, but for this new collector's edition we were given the opportunity to design our NVGs from scratch. Once we were happy with the design, we not only sent them off to be built from the ground up, but also integrated them into the game to match.

The new night vision goggles have enhanced capabilities in-game, but look absolutely incredible in reality too.

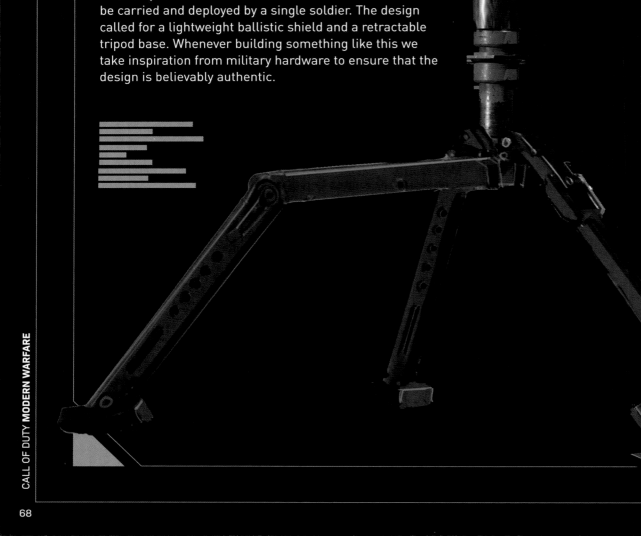

WEAPONS // **MOBILE TURRET**

Portable, stable and armored, the mobile turret is an accurate and effective addition to any arsenal. As with other weapons available in *Modern Warfare*, its design is based on a real-world item. Form follows function, as the saying goes, but in this case form follows design too. Our team requested a mobile turret that looked like it could be carried and deployed by a single soldier. The design called for a lightweight ballistic shield and a retractable tripod base. Whenever building something like this we take inspiration from military hardware to ensure that the design is believably authentic.

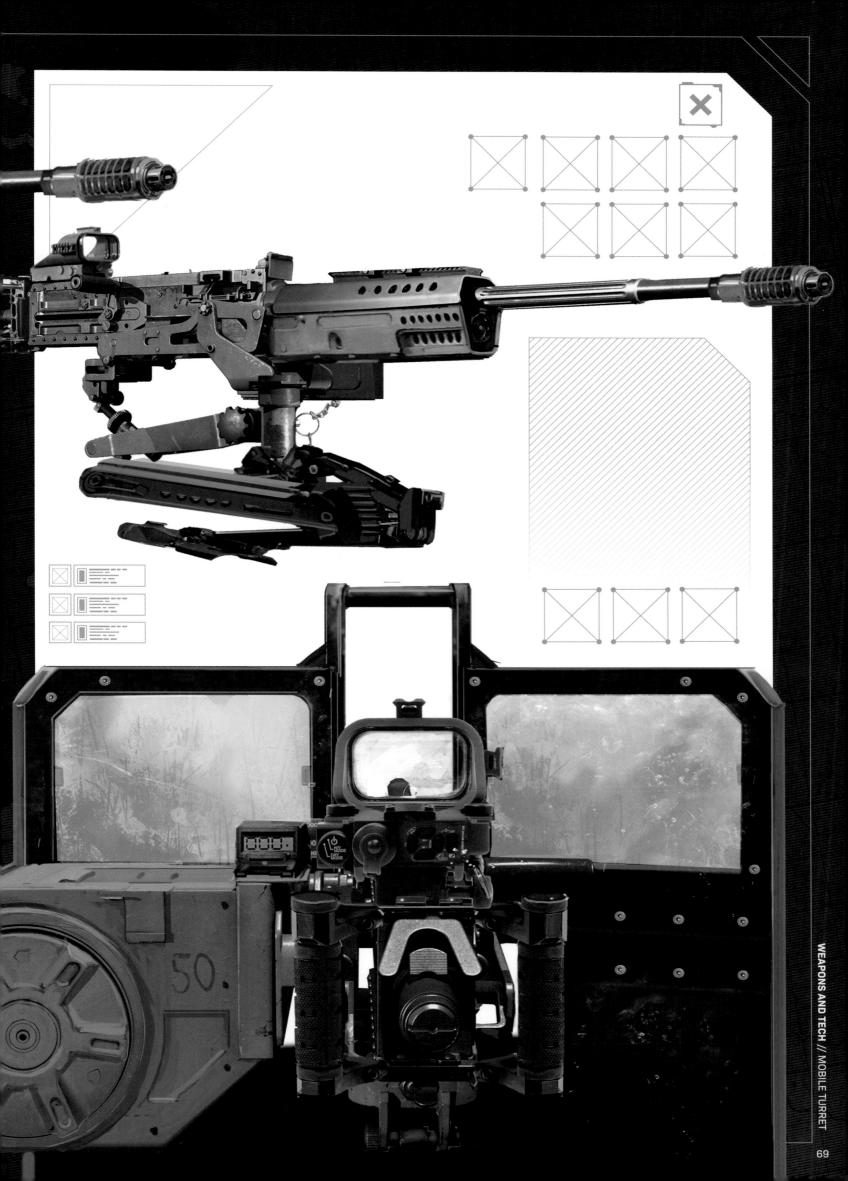

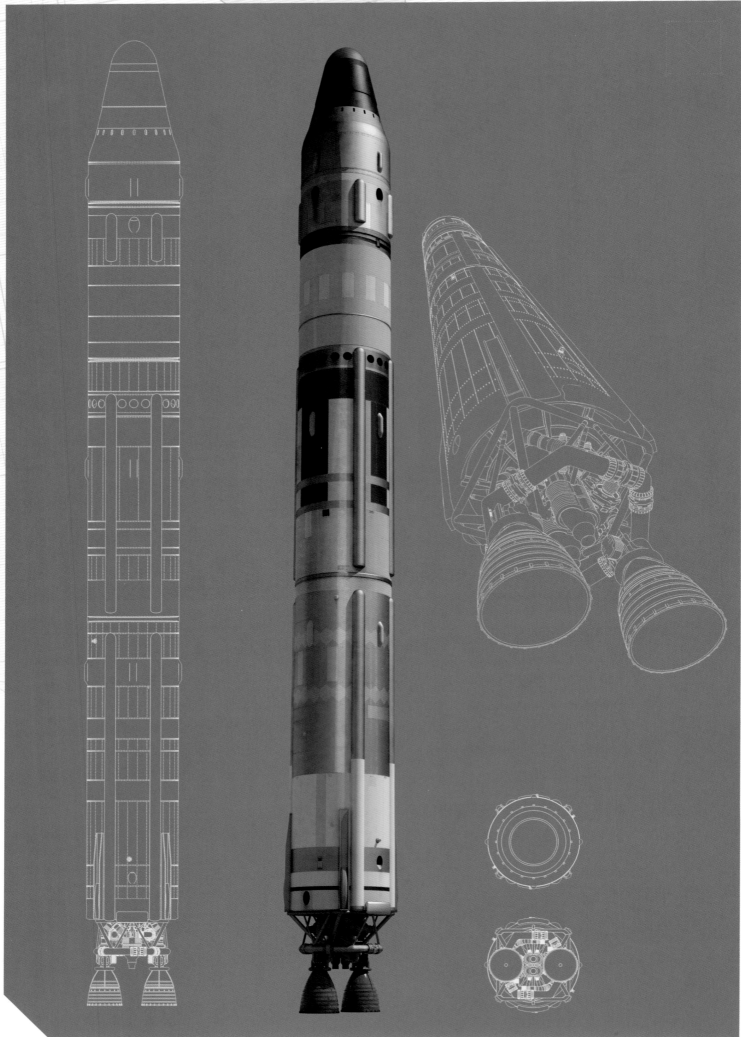

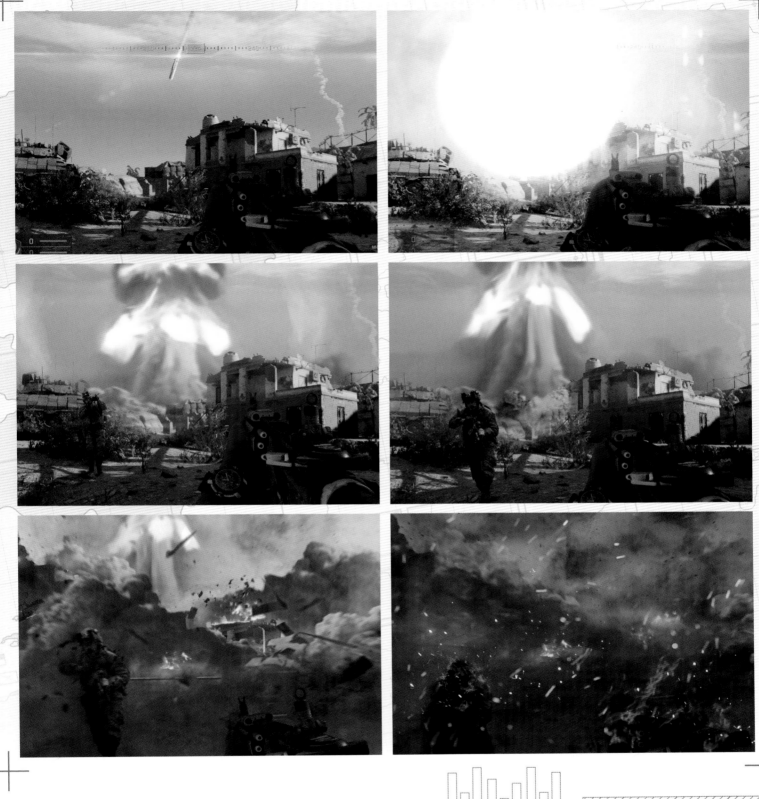

WEAPONS // **ICBM**

ICBMs are designed to reach long-distance targets, so in-game combatants are unlikely to see the source of their firing. It hardly matters, though, as the first thing to do at the sight of an incoming ICBM is to run and hide with extreme urgency!

Back in the realm of game development, the in-game ICBM is based on an actual missile. The model and a few rendered concepts were produced starting with a basic cylinder, then we built out some surface add-ons to complete its look.

Above: The nuke killstreak is a fan favorite from past *Modern Warfare* games and we knew we had to bring it back. These are designs and storyboards that the VFX team used to build the final effects passes for the moment the nuke detonates and obliterates the environment.

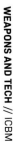

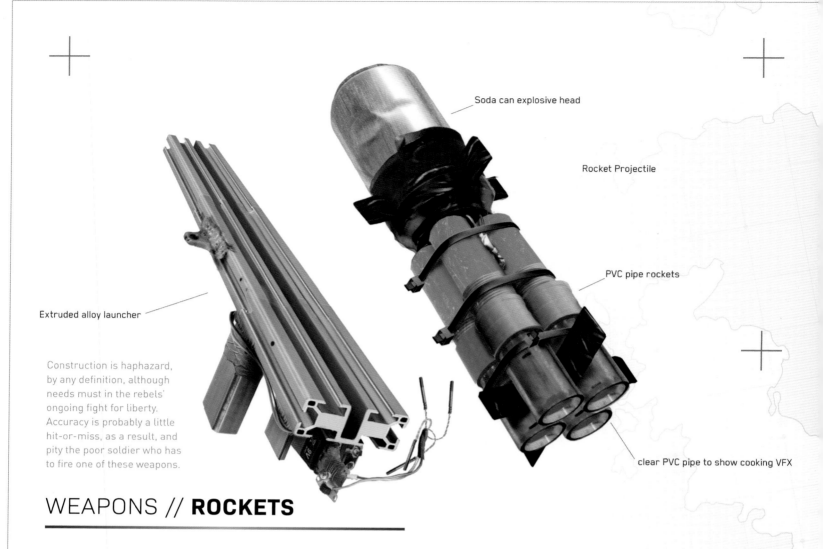

Soda can explosive head

Rocket Projectile

PVC pipe rockets

Extruded alloy launcher

clear PVC pipe to show cooking VFX

Construction is haphazard, by any definition, although needs must in the rebels' ongoing fight for liberty. Accuracy is probably a little hit-or-miss, as a result, and pity the poor soldier who has to fire one of these weapons.

WEAPONS // **ROCKETS**

Handguns and automatic weapons are useful in a great many circumstances, but sometimes more powerful munitions are required to get the job done–particularly for distant or more heavily armored targets. This is where rockets and rocket-propelled ordnance come into their own.

All sides make use of such weapons, although their construction can sometimes leave a little to be desired. Seen above, makeshift options employed by rebel forces, and a strip of extruded alloy stands in for a handheld rocket launcher. A rather more substantial offering below. With all the weapon choices in the multiplayer game and with mobile armor rolling around, players will need some heavy anti-armor support like this Anti-Tank platform.

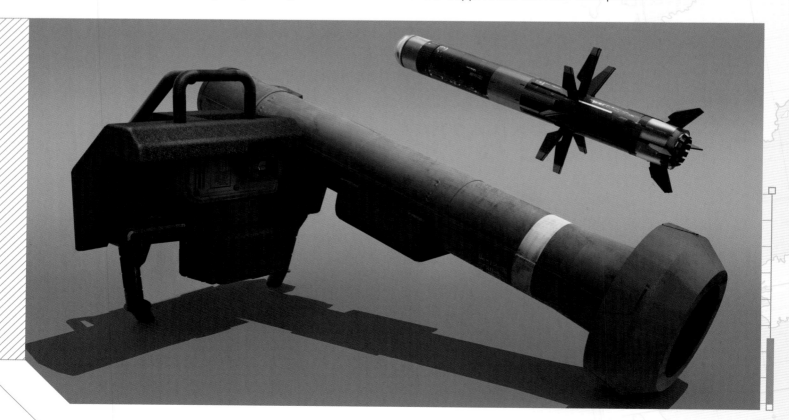

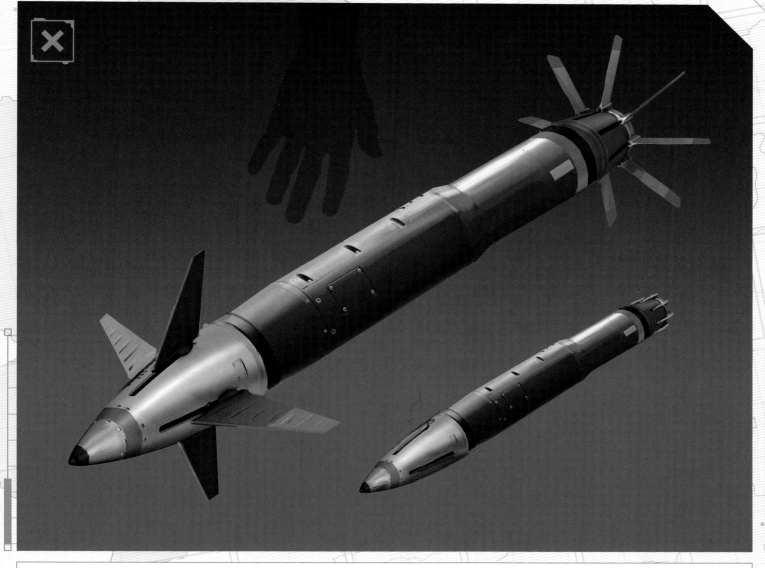

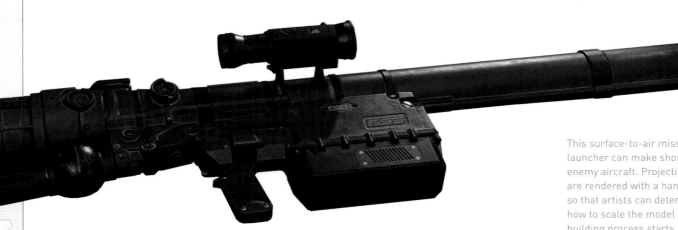

This surface-to-air missile launcher can make short work of enemy aircraft. Projectile concepts are rendered with a hand in shot, so that artists can determine how to scale the model once the building process starts.

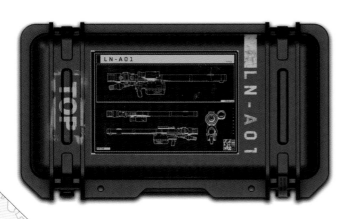

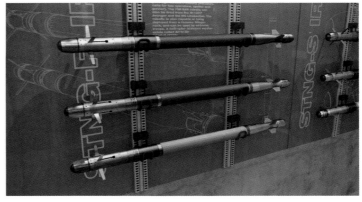

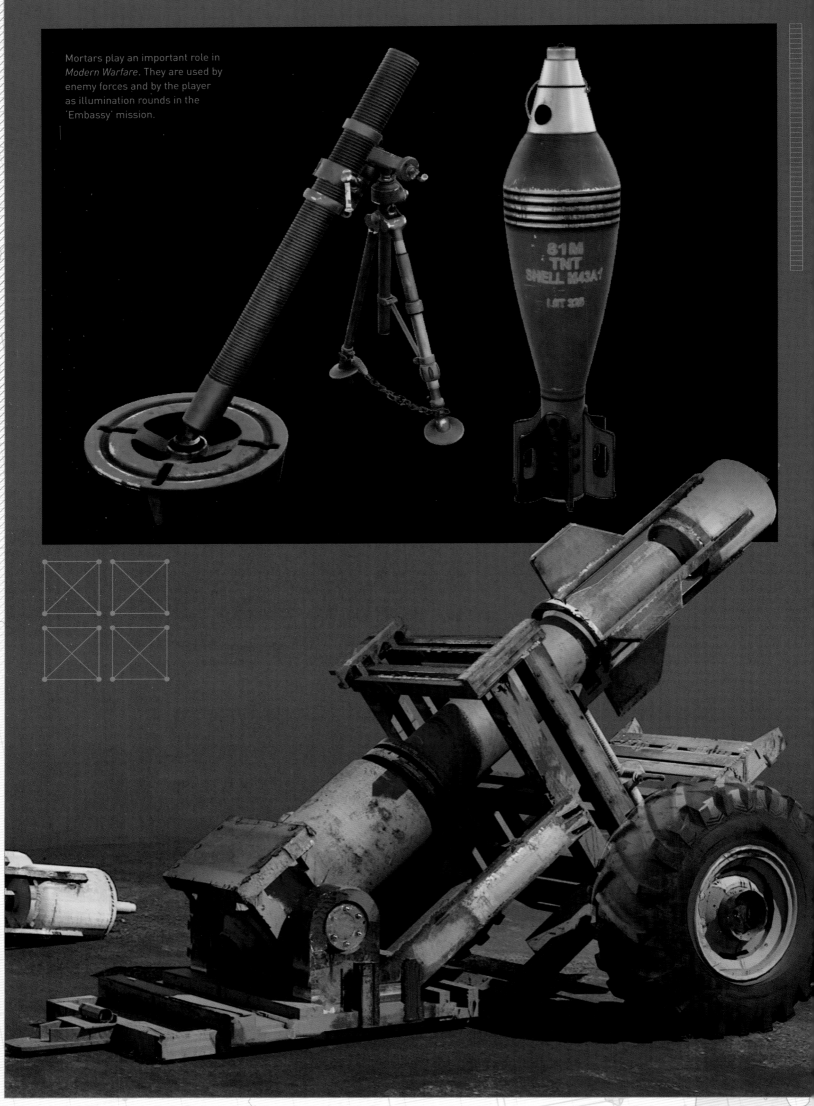

Mortars play an important role in *Modern Warfare*. They are used by enemy forces and by the player as illumination rounds in the 'Embassy' mission.

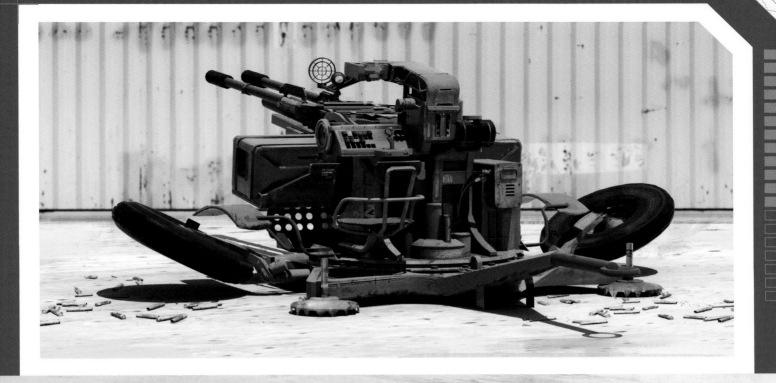

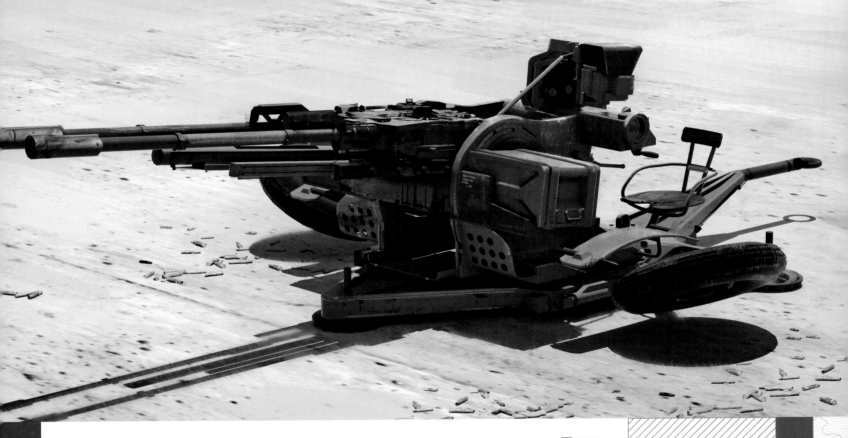

WEAPONS // **ZULU 23**

Necessity is the mother of invention, and Urzikistani freedom fighters create weapons with what they're able to scavenge or assemble from random parts. This begins with the re-purposed anti-aircraft gun *above*, which was left behind by retreating adversaries–it is now used in a defensive capacity.

The DIY Hell Cannon launcher on the *left* is another example of rebel ingenuity. We were surprised to find that launchers like this one exist in some parts of the world.

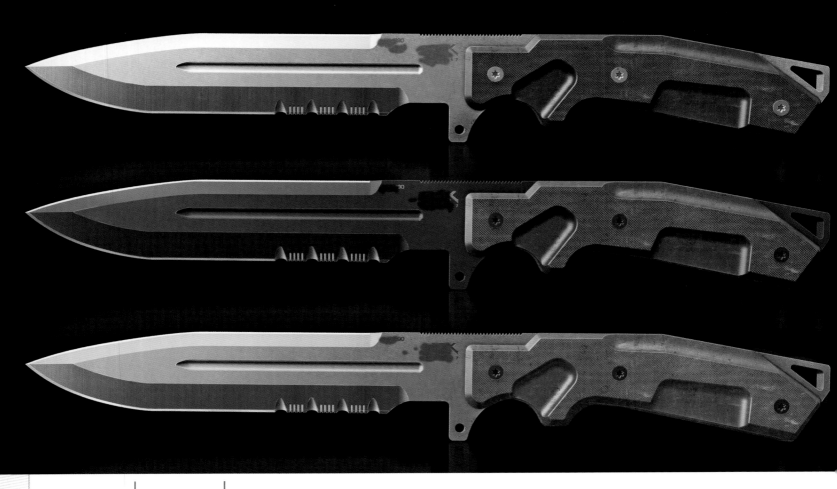

WEAPONS // **KNIVES**

As dependable as they are lethal, knives and bladed implements never run out of ammunition and they are silent in use—the perfect weapon in close-quarters encounters, then. As expected, many of the knives found in the game are based on or inspired by real-world and military-grade equipment.

Edge weapons can range from high-end tactical weapons to a simple kitchen knife—such as the one *below*, which appears in Farah's house in the 'Hometown' level. In that instance it's used by the player and the combat is viewed at close range. As such, *Modern Warfare* designers had to render the asset in two ways to support the storyline—tellingly, one view of the knife is much bloodier than the other.

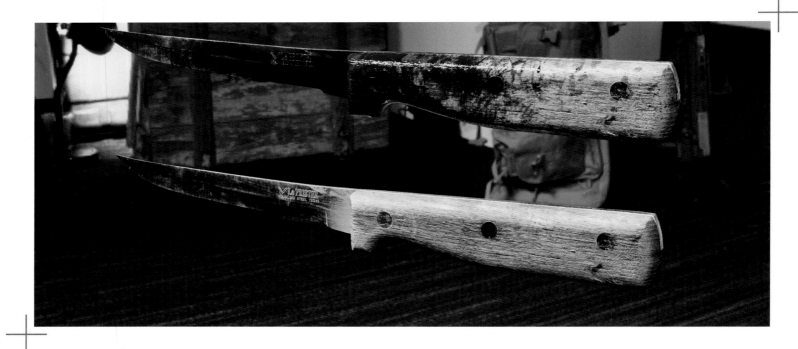

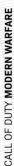

DEVICES // **WATCHES**

Military operations often require precise timing. *Modern Warfare* features a range of functional wrist-wear that the player can choose, and these rugged watches can offer a little more than their apparent functionality—which is up the player to discover.

We started with standard time pieces but things started getting imaginative and we began creating watches that did an array of cool things you can see in the final version of the game.

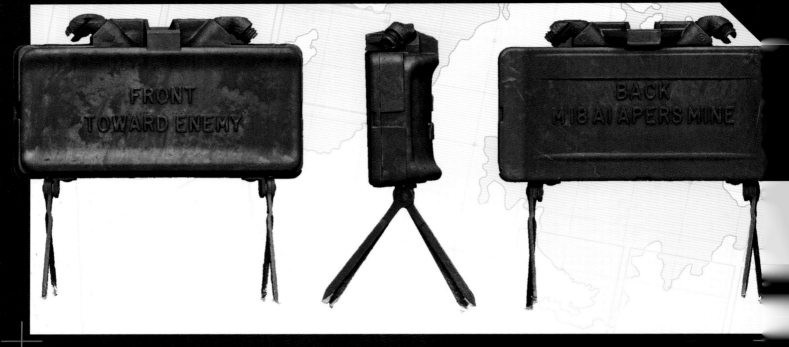

EQUIPMENT // **EXPLOSIVES**

A mine has the potential to incapacitate an adversary long after the combatant deploying it has departed the scene. Properly placed they are a threat in waiting; ripe for the moment that an unsuspecting foe walks by or steps on it. Mines come in a variety of shapes, sizes and explosive capacities, although more recent iterations also offer radio controls, anti-detection composite constructions and tripwire triggers that are barely visible to the naked eye. They offer a clear advantage if used correctly.

When it comes to equipment and devices such as these, there is always a gameplay purpose that drives them. What's important about assets like these is getting their visual language to look right. Visually these things need to tell the player how they can be used or how they are a threat.

Right: Tripwire devices are tricky to circumvent. Move slowly and cautiously to avoid triggering them—or perhaps there's a more creative solution to be found.

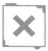

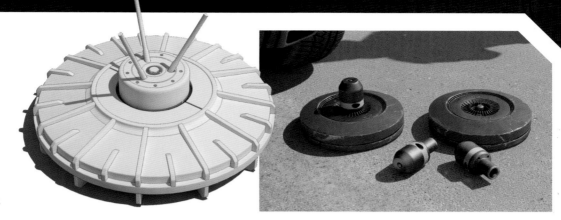

It pays to tread carefully at all times, although the prominent antennae on these landmines might give their positions away.

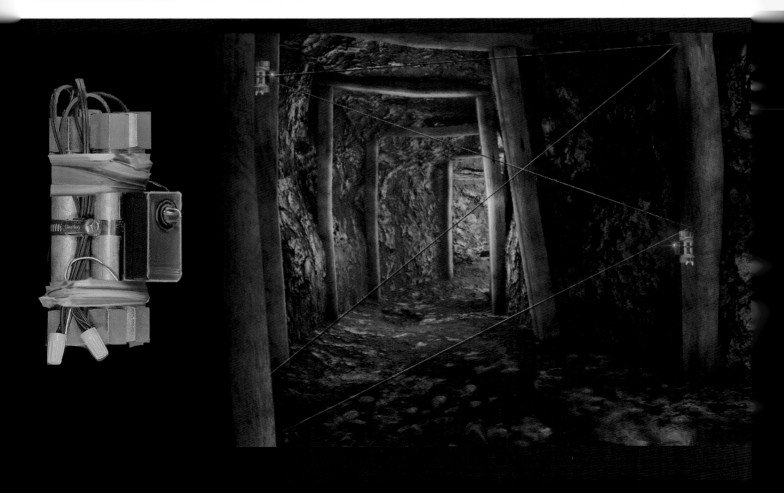

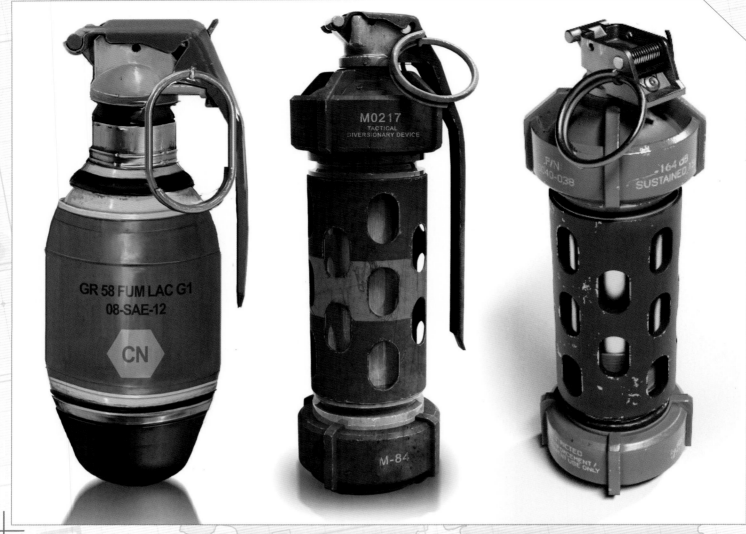

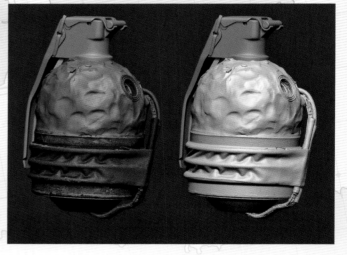

WEAPONS // **GRENADES**

Fraught combat scenarios can be brought to a swifter conclusion with a few well-aimed grenades. They are effective over close to medium ranges–as near or far as the player can throw them–and they offer a variety of useful and often quite devastating effects.

They have never been so diverse or looked so realistic either. Offhand devices like these play an important role in the game's tactical gameplay. *Modern Warfare* has several new elements in its environments that let players choose how they want to breach through doors. Different types of grenades like these give players tactical choice in *Modern Warfare's* new door-driven gameplay.

Above: A selection of thrown devices, but the flashbang grenade in the middle can temporarily stun several opponents at once. *Above right:* Frag grenades have never looked this good before. *Below right:* This 'snap shot' grenade produces a strobe effect to help detect hidden enemies. Admittedly it's a bit gamey, but sometimes you need to embrace the fun and not rationalize things too much.

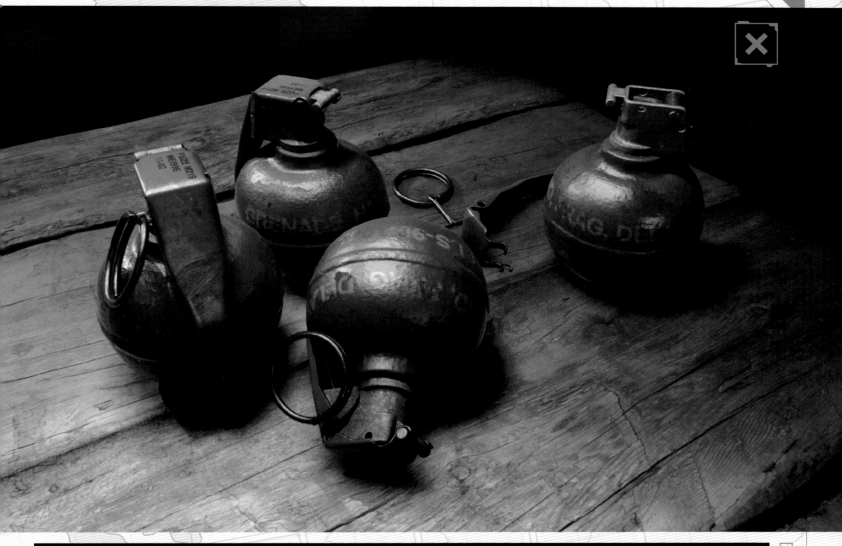

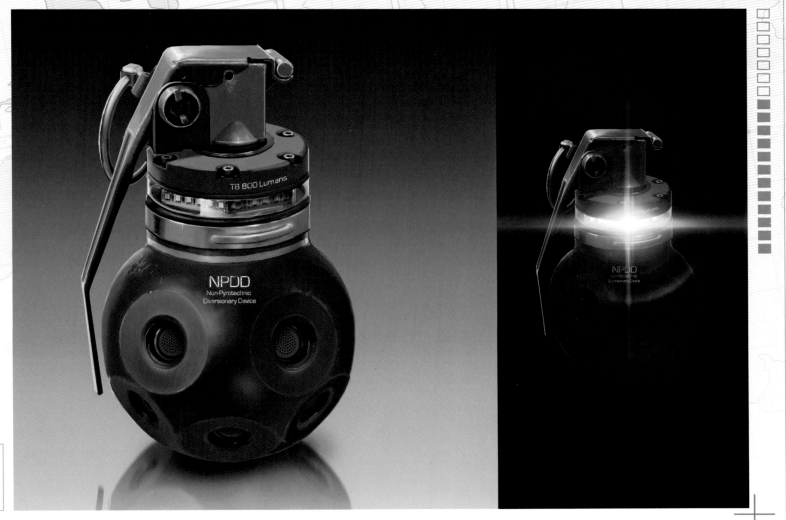

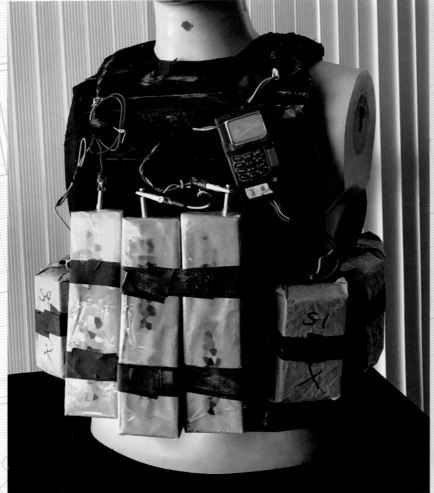

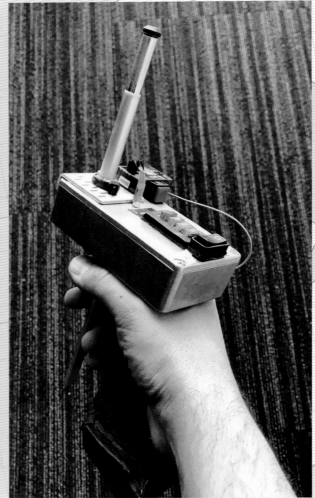

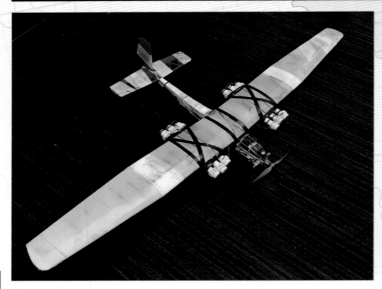

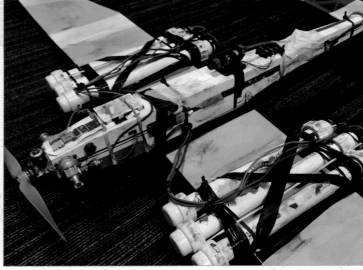

WEAPONS // **BOMBS**

Bombs have an important role to play in *Modern Warfare*, although it must be remembered that all sides have the capability to use them. More worrying, the volatile materials that cause explosions can be secreted into packages of all shapes and sizes, triggered remotely and even worn about the body.

An example of the latter can be seen at the *top* of the page. Artists also had a concept in mind for the detonator.

We let the physical materials determine the look of how it all fit together.

Immediately *above* is an improvised drone bomb. In one of the later levels we see Farah's squad using remote-controlled drones to launch a guerrilla attack on advanced enemy hardware. We were having so much success with creating physical props that we built the drones for real and scanned them.

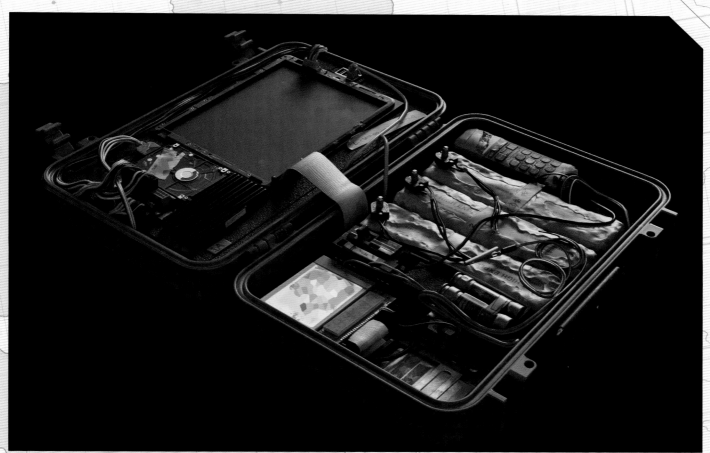

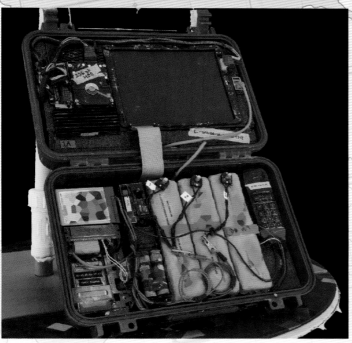

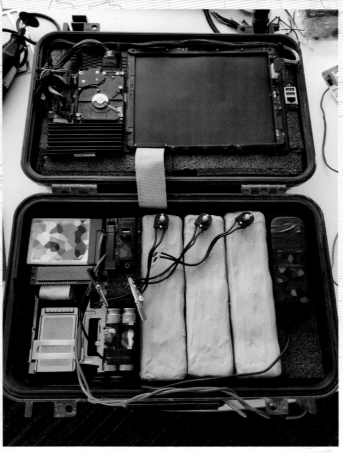

The images above illustrate an explosive device hidden inside a suitcase—a complicated project for somebody to defuse.

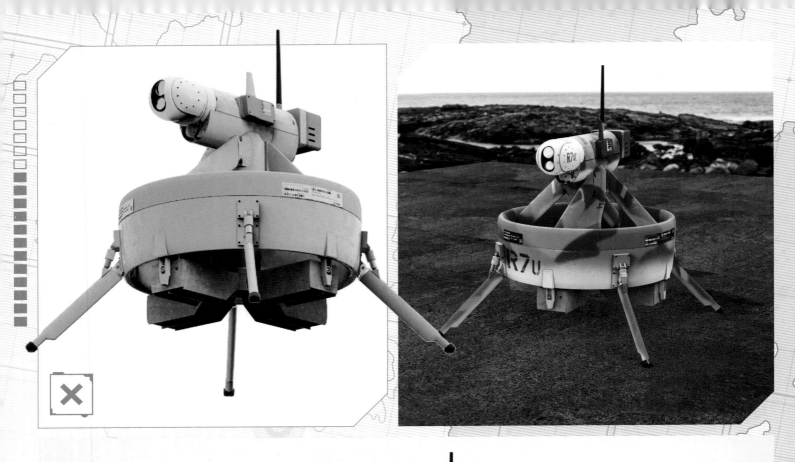

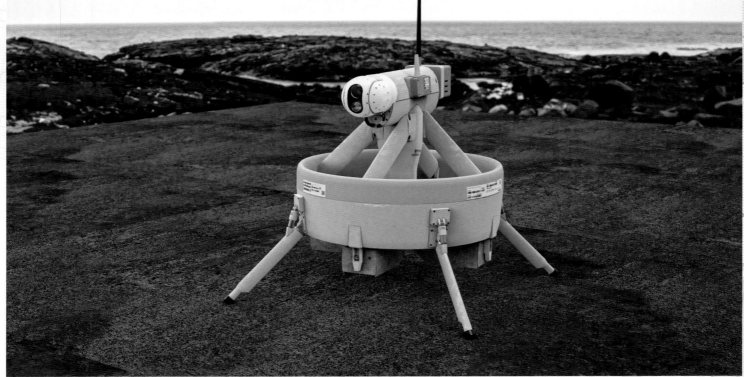

WEAPONS // **DRONES**

Controversial in their deployment in contemporary theaters of conflict, drones enable forces to reconnoiter or strike opponent targets remotely—and crucially without risking any of their own personnel during an operation.

They are the scourge of the battlefield in *Modern Warfare* too, with uses in many

scenarios, and they are thus many and varied in their design and construction. As such, it is vital that their functions are clearly understood from the outset.

Drones in the game have different uses and capabilities. Like much of our equipment and tech it's important that these things visually tell the player what they are and what they do.

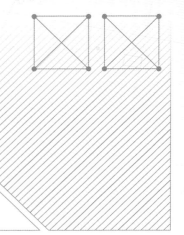

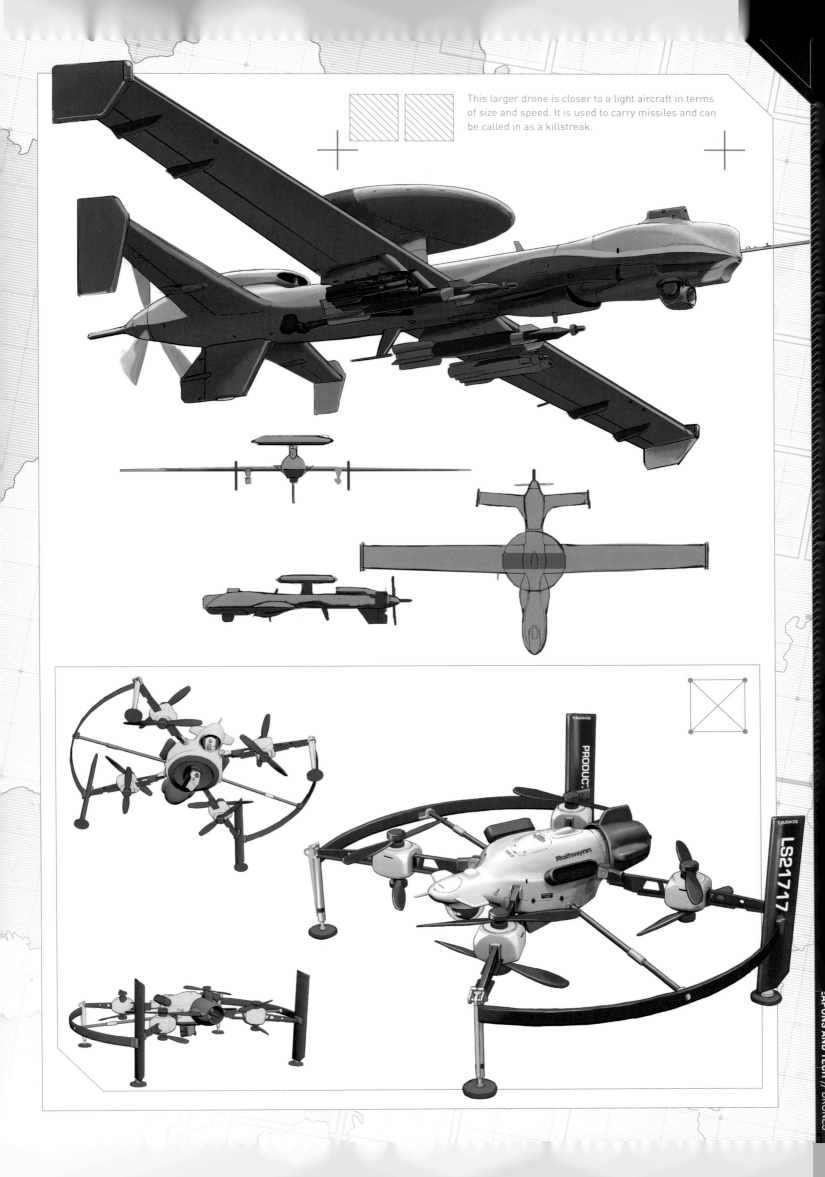

This larger drone is closer to a light aircraft in terms of size and speed. It is used to carry missiles and can be called in as a killstreak.

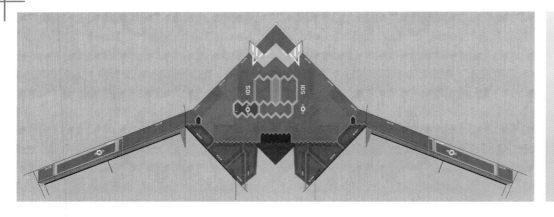

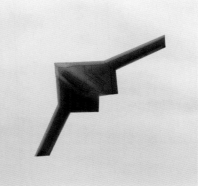

WEAPONS // **OVERSEER**

With a 'flying wing' morphology designed to defy detection, opposing factions are unlikely to spot the Overseer on radar before it arrives to deliver its devastating payload. its ominous profile makes it somewhat easier to spot by eye, however, so careful deployment is advised.

A larger and heavier drone like this one can be used for various mission profiles. One of its main uses is as an unmanned aerial vehicle (UAV) radar drone. Its silhouette is important because opposing players need to be able to see it and shoot it down if they are trying to knock out the enemy's radar.

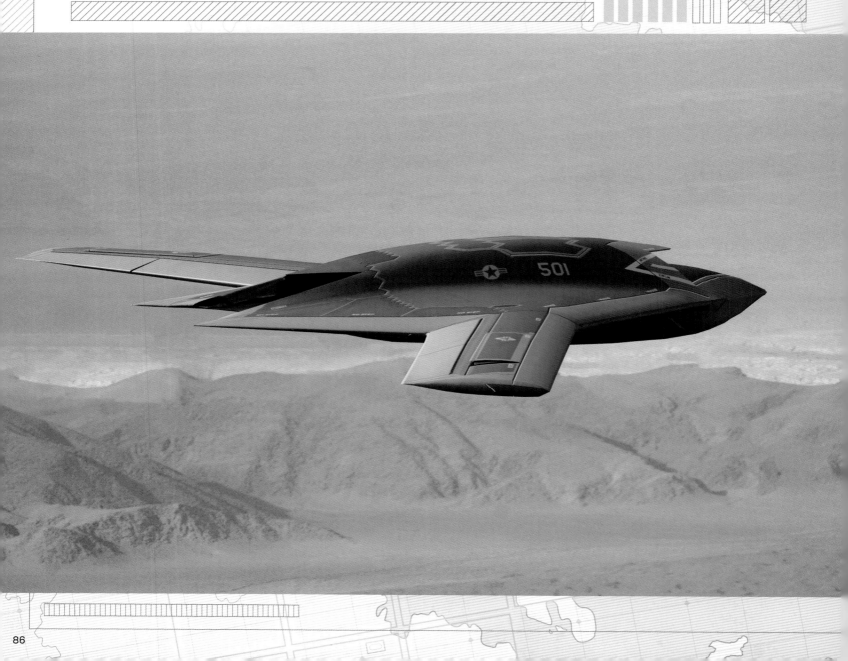

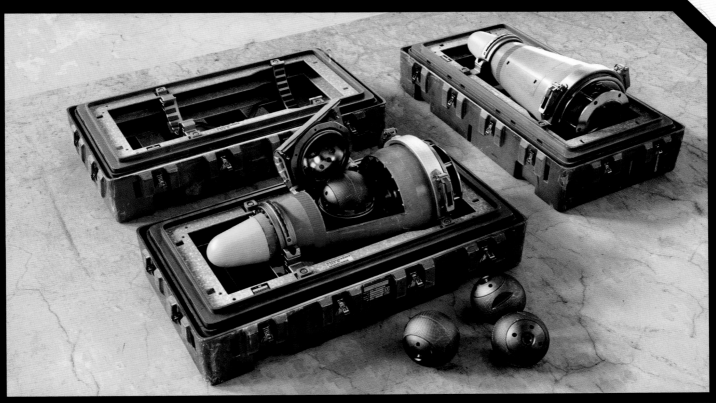

WEAPONS // **NUCLEAR WARHEAD**

Compact enough to be stored in sturdy carry-cases, the very portability of these nuclear devices poses the unappetizing prospect of them easily falling into the wrong hands. This was requested for a specific moment in the game where the player has to open the warhead and defuse the bomb. It was suggested that the player takes the plutonium cores out and carries them around for a mission goal.

These armaments are otherwise chillingly credible. The nuclear warhead concept is the result of a full collaboration between the concept artist and the team that requested this design. We started with a clear brief and clear goals as to what the design needed to accomplish. Once those guidelines were defined, the rest was simply execution. The design was the result of good team collaboration.

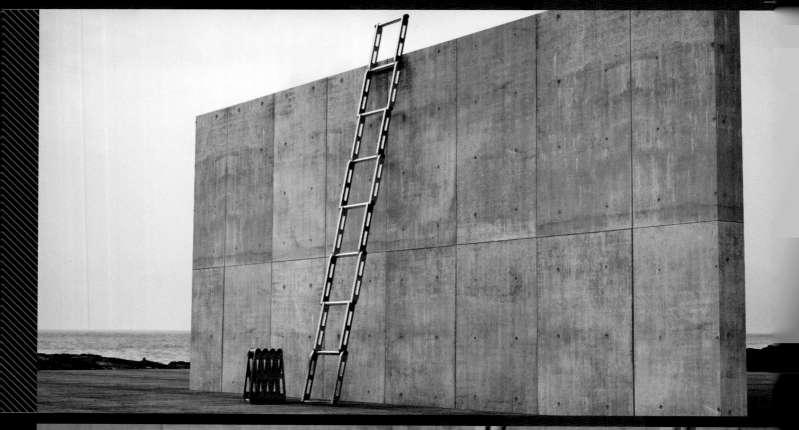

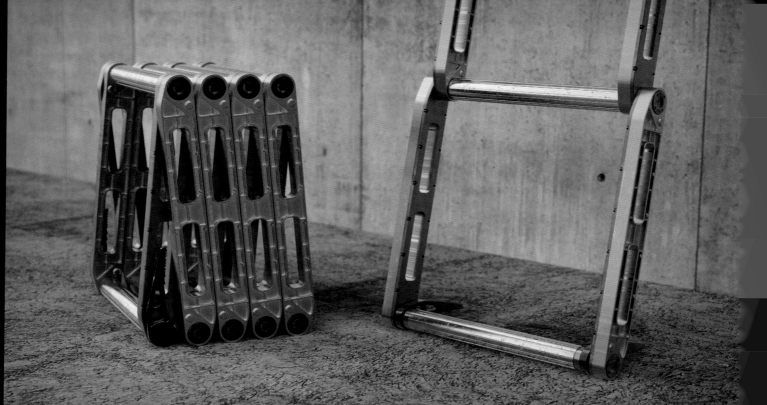

WEAPONS // **PORTABLES**

Combatants need to move across the battlefield with speed and efficiency. Simple barriers such as walls and fences should not be an impediment to progress, although a standard ladder would be an entirely impractical solution. In such instances, something smaller and more portable is required.

Our military consultants told us about scenarios where deployable ladders like this were used. The 'Townhouse' mission makes use of one and they are also available in other modes. We had to come up with a design that looked functional but could also be carried on a squad mate's back without looking ridiculous.

With a lightweight and foldable construction, the portable ladder easily surmounts obstacles of modest height.

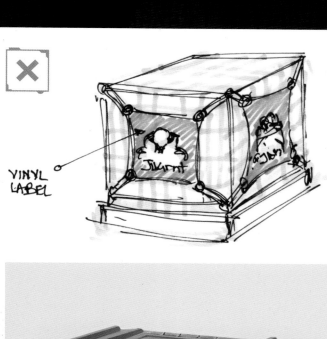

YINYL LABEL

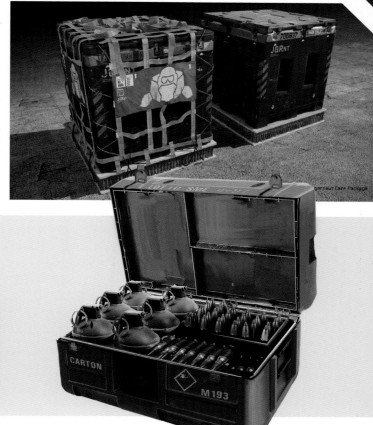

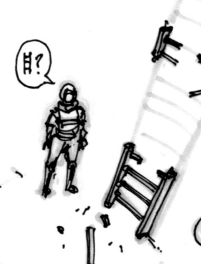

METAL VERSION

WOODEN VERSION

③

Above: Concepts for the 'Juggernaut crate'. When this is found on the battlefield players can crack it open, step into the suit and unleash hell.

H?

②

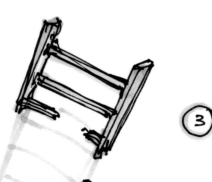

①

VARIABLE PARTS SO WE CAN HANDLE DIFFERENT SIZES.

D·BOTOM □TOP
D· MID 1 + VARIABLES.
D· MID 2

DEPLOYABLE LADDER FITS OVER.

WEAPONS // **SHIELDING**

Finding cover during a firefight is a highly recommended survival tactic, although safe havens are not always easy to locate. In such instances the solution is a portable barrier. In practical terms, such devices are no more advanced in nature than a medieval shield—the concept works, so why fix it! The modern day versions are obviously more advanced in their construction, though, and offer more protection from the bullets of high powered contemporary weapons.

Once again, *Modern Warfare* designers found inspiration the world of military hardware. Deployable cover is actually a real device that is used by tactical teams. In order to make this portable enough to carry around and deploy much of the device is made up of lightweight bullet-resistant material.

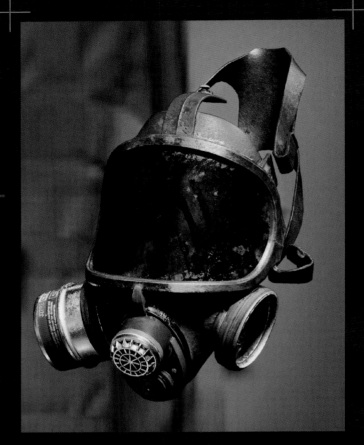

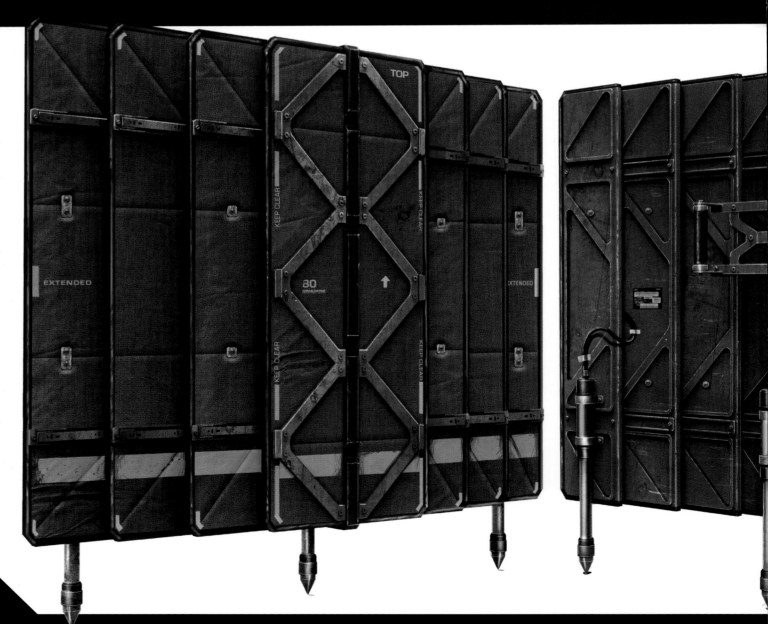

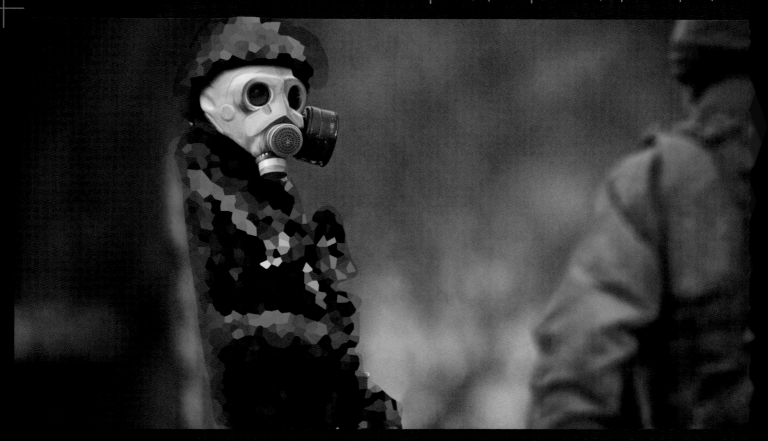

Personal shielding is also available in certain gameplay scenarios, and players of previous games might recognize the concept. The Riot Shield is back but we gave it a serious update to look more like some of today's models. *Above left and right:* A gas mask is no defense against bullets, but will provide protection during a poison gas attack.

TECH // **TACTICAL DEVICES**

We live in an age of digital communications and devices, and the players on *Modern Warfare* battlefields make good use of such technology. Sleek and lightweight they are not, in most instances, as these implements are required to survive the rigors of combat. In all other regards, the computer servers,

laptops, touchpads, routers and mobile phones used in *Modern Warfare* are every bit as sophisticated as those in the real world. Perhaps more so, since this equipment also needs to operate beyond the reach of the communication networks of civilian society.

Above: This touchpad is used for calling in killstreaks, and its display shows some of the details. Some pads are interactive and the player can pinpoint where strikes need to be deployed. A mil-spec laptop can be seen *below*.

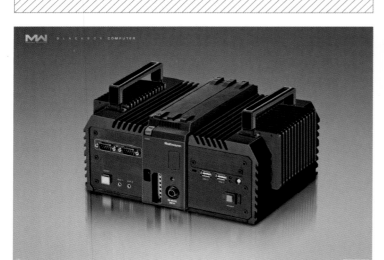

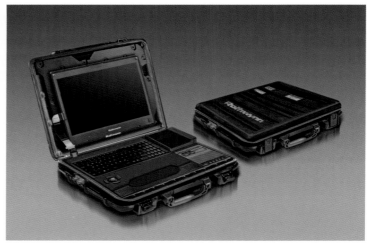

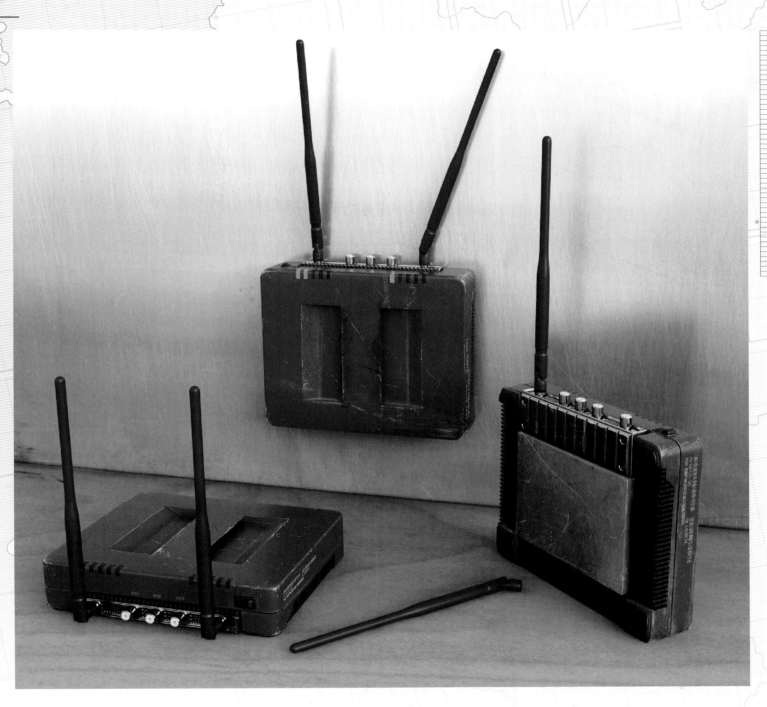

The wifi units *above* are robust enough for operation on the battlefield. The mainframe *below left* is used as an objective for various game modes. The mobile phone *below right* has certainly seen better days, but it too is built to withstand rough handling.

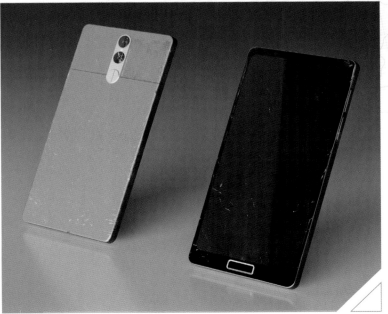

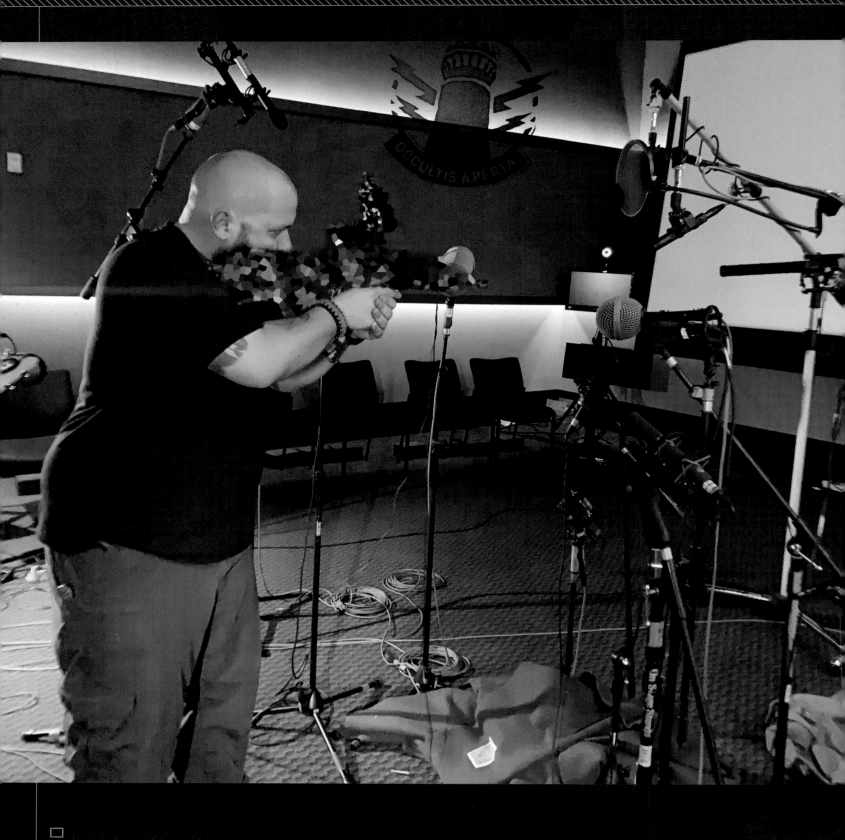

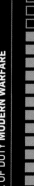

WEAPONS // **AUDIO**

The pursuit of a photo-realistic gaming experience has encouraged the *Modern Warfare* team to stretch the limits of gaming technology. Their monumental efforts have already yielded some stunning and utterly credible results—as seen throughout this book. The game not only establishes a new benchmark in terms of authenticity, but this same fastidious attention to detail also informs the sound design.

The audio soundscape is not always appreciated in the heat of a battle, yet it encompasses the entire game. From the unique atmospheres of locations flung far and wide, to the distinct sounds that different weapons and explosive devices make, right down to the noise of impact on various materials. In many instances, the only way to replicate a sound was to record its real-world equivalent.

In capturing the sound of weapons, there was no alternative but to actually fire them—the pictures on these pages demonstrate a few examples of the team doing just that. As with the rest of *Modern Warfare*, the entire audio system has been overhauled and improved. The process of capturing a sound accurately and with utmost fidelity is difficult and time-consuming, but it enabled some surprisingly sophisticated results.

To capture these components of the weapons several microphones were used. The upgraded audio system is so detailed that the player's spent brass that flies out of the ejection port on the side of the weapon can be heard hitting a wall if the player is firing next to one. Among the many other things the system drives is the sound of gunfire reflecting off of nearby buildings, if the player happens to be shooting in that type of an environment. This is all physically-based and working at that actual speed of sound.

Sound design is a complicated procedure requiring expensive equipment, multiple microphones and real weapons. In spite of that, it appears that these gents are enjoying their work.

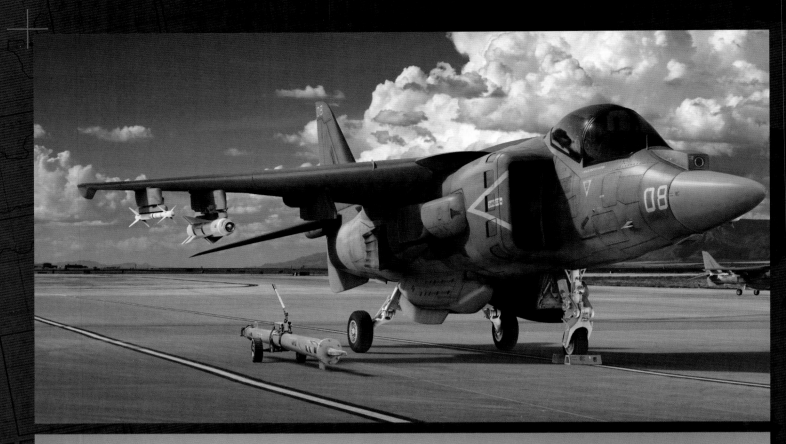

VEHICLES // **AIRCRAFT**

A selection of military and civilian aircraft, all brought convincingly to life through the process of photogrammetry. The two fighter

poised for imminent action. The jet liner to the left resembles mighty contemporary aircraft. The drone helicopter above can be called in as

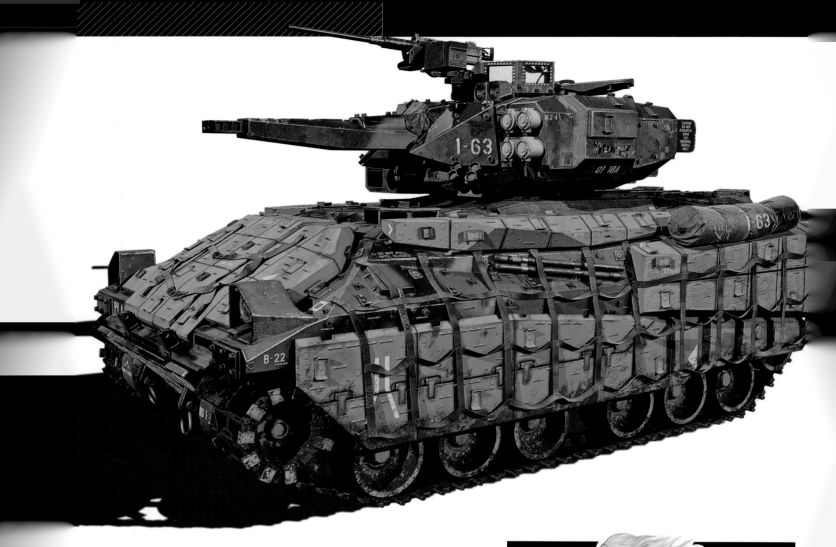

VEHICLES // **HEAVY ARTILLERY**

A new feature in the *Modern Warfare* multiplayer game allows players to radio in for a tank. The unit *on the left* is delivered by aircraft and parachuted down. Then players can jump aboard and create carnage in the battlefield. *On the right* is an original design for a Russian Armored Personnel Carrier. It has the name 'VIKTOR' and it can be fitted out for an assortment of mission profiles. All the assets on these pages were captured in-engine.

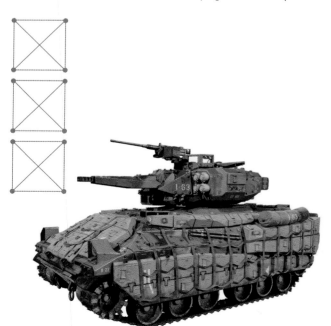

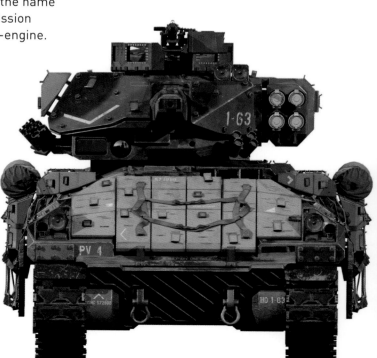

VEHICLES // **WHEELED GUN DRONES**

Remotely-piloted drones negate the requirement to meet an opponent face-to-face, the general idea being to strike further into enemy-held territories and reduce loss of troops in doing so. They have become an effective facet of contemporary conflicts, and now they play an increasingly prominent role in *Modern Warfare* too.

A dreaded sight on any battlefield, it is already bad enough that they can take the form of winged aircraft and helicopters. However, these images show that they can also trundle into battle like heavily-weaponised buggies. Not only that, these wheeled vehicles also come in two distinct varieties. This is one of our new killstreaks. For the Western version *on the left* we built the design around an electric engine powered by a battery pack.

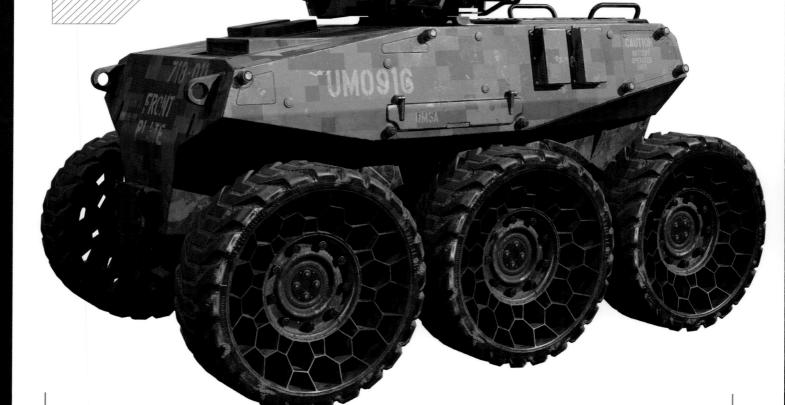

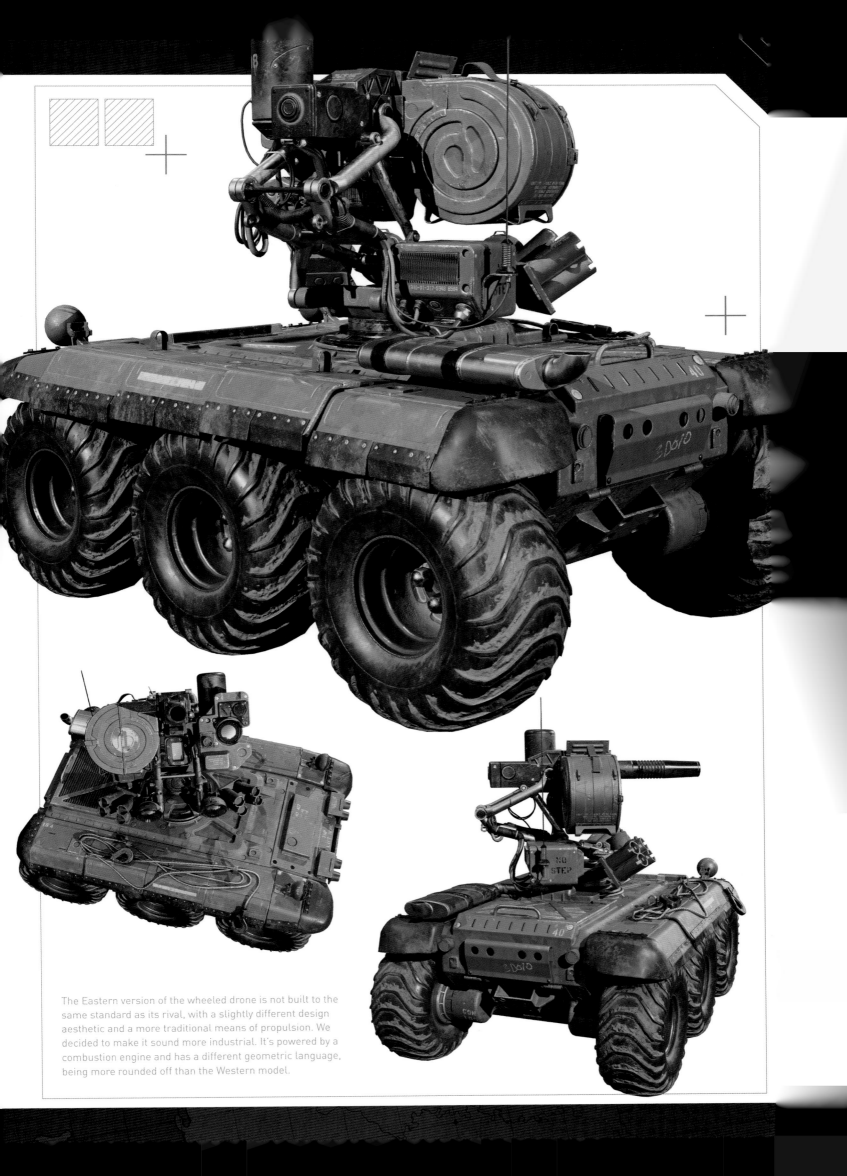

The Eastern version of the wheeled drone is not built to the same standard as its rival, with a slightly different design aesthetic and a more traditional means of propulsion. We decided to make it sound more industrial. It's powered by a combustion engine and has a different geometric language, being more rounded off than the Western model.

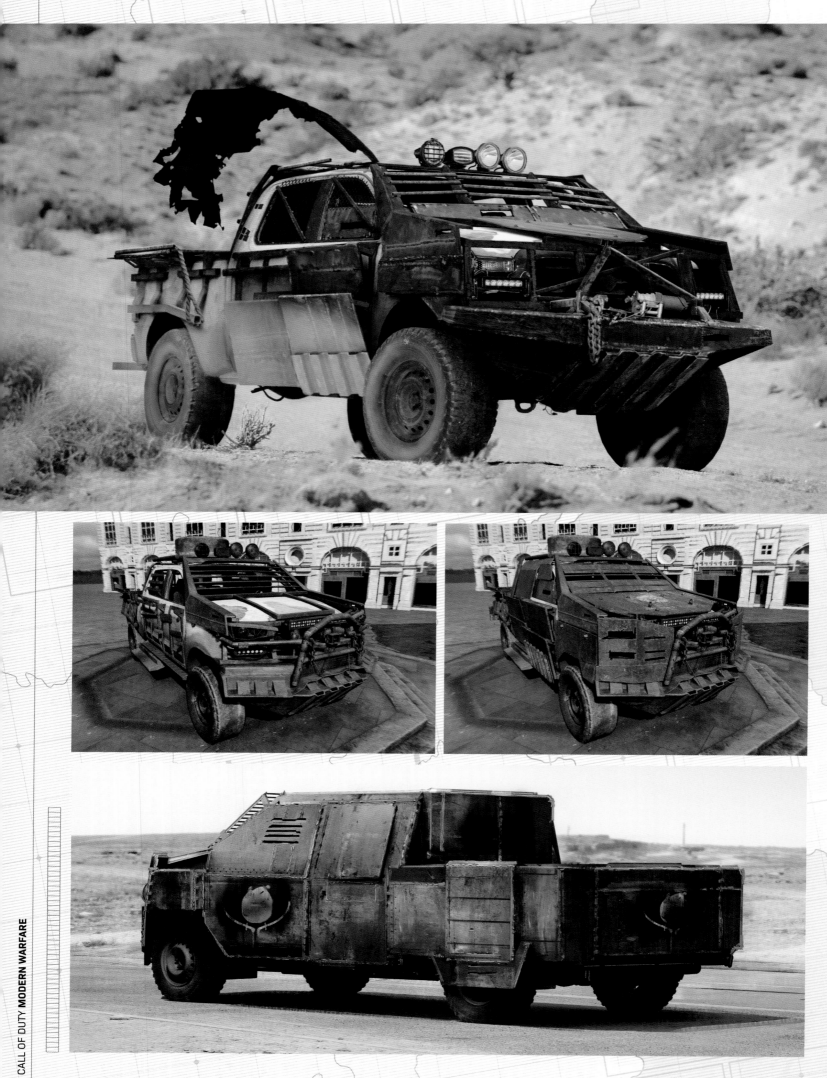

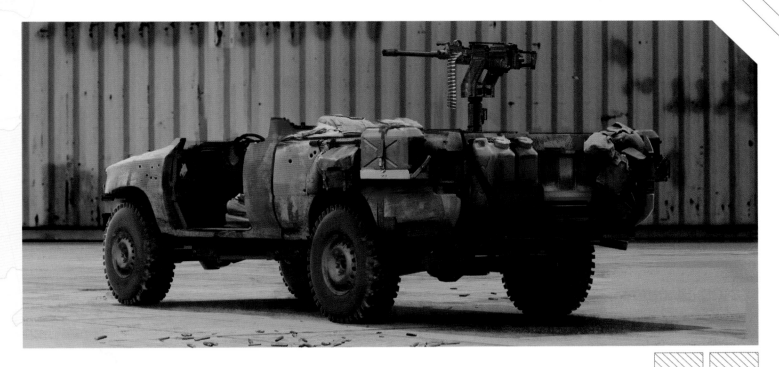

VEHICLES // **CUSTOM**

Fighting forces without the financial wherewithal to purchase heavyweight tanks and other military equipment are forced to rely on their ingenuity; employing civilian vehicles in the making of mobile battering rams, ad-hoc machine gun trucks and the like. The results are certainly eye-catching, in a post-apocalyptic manner, and yet they are entirely within the bounds of possibility.

Indeed, the *Modern Warfare* team didn't need to look much further than contemporary real world conflicts for inspiration.

It's very challenging to come up with designs for vehicles that have been slapped together in a junkyard and make them look cool. We worked hard to find a balance in our DIY armored vehicles.

The military might of organized forces may be overwhelming in many instances, although history repeatedly shows that guerilla wars are notoriously difficult to win. Otherwise, these impromptu assault vehicles are surely able to run rings around lumbering enemy tanks on the battlefield.

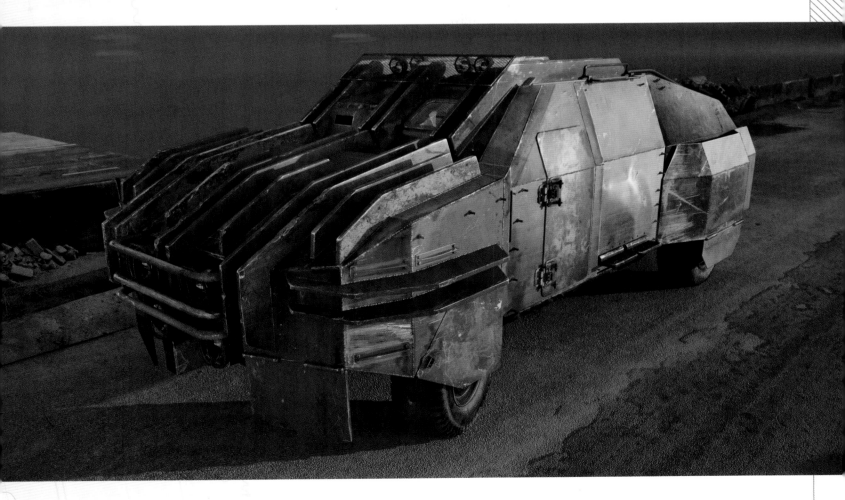

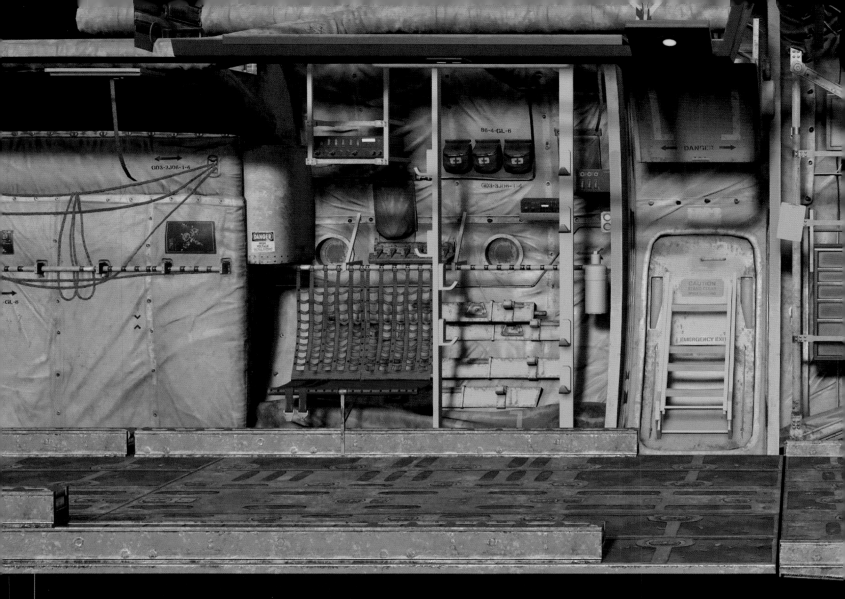

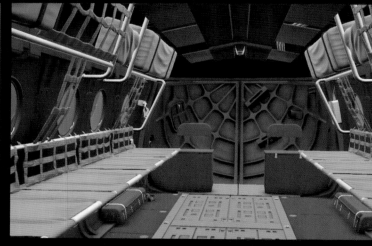

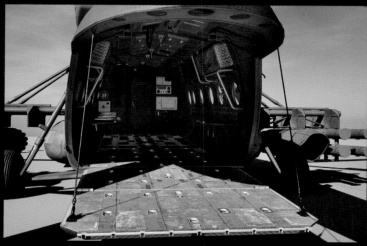

VEHICLES // **INTERIORS**

It is difficult not to over-emphasize the extent to which the *Modern Warfare* team has gone to in the quest for an authentic gameplay experience. Characters move and speak like never before, cities and towns both real and fictional are depicted in astounding detail, military equipment merges with the real-world via the process of photogrammetry and no detail was too small for due consideration.

As the ongoing conflict escalates worldwide, a variety of vehicles and aircraft is required to move troops from one battlefield to another. It might have been easier to bypass

such scenes entirely, although that is not the way of *Modern Warfare* artists and designers. Put simply, if a helicopter looks photo-realistically accurate on the exterior, the interior should be constructed to the same standards.

Troop carrying aircraft play a big role in *Modern Warfare*. The interiors need to be highly detailed to support players riding in them from a first person view. Building assets this large is always a challenge because of memory. They are often the size of a building. Our artists used various tricks to get the visual fidelity to where it needed to be while keeping the memory budget on track.

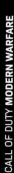

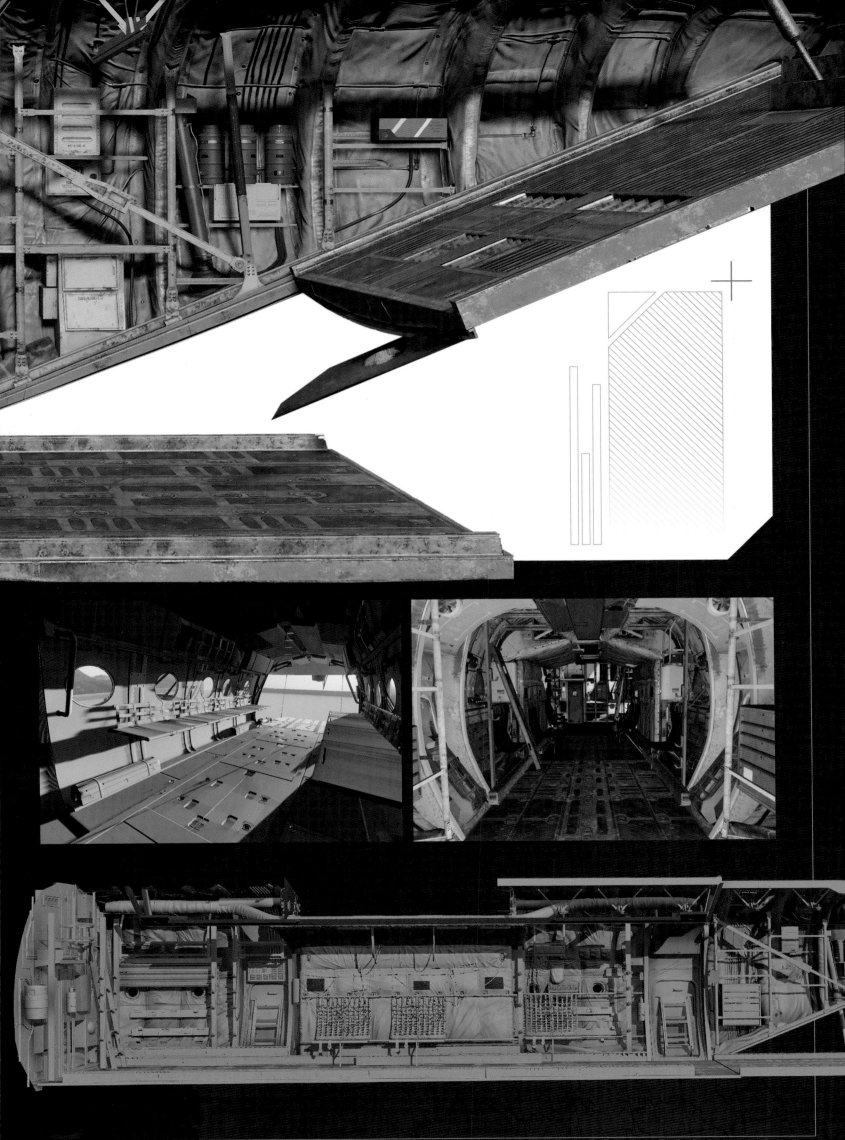

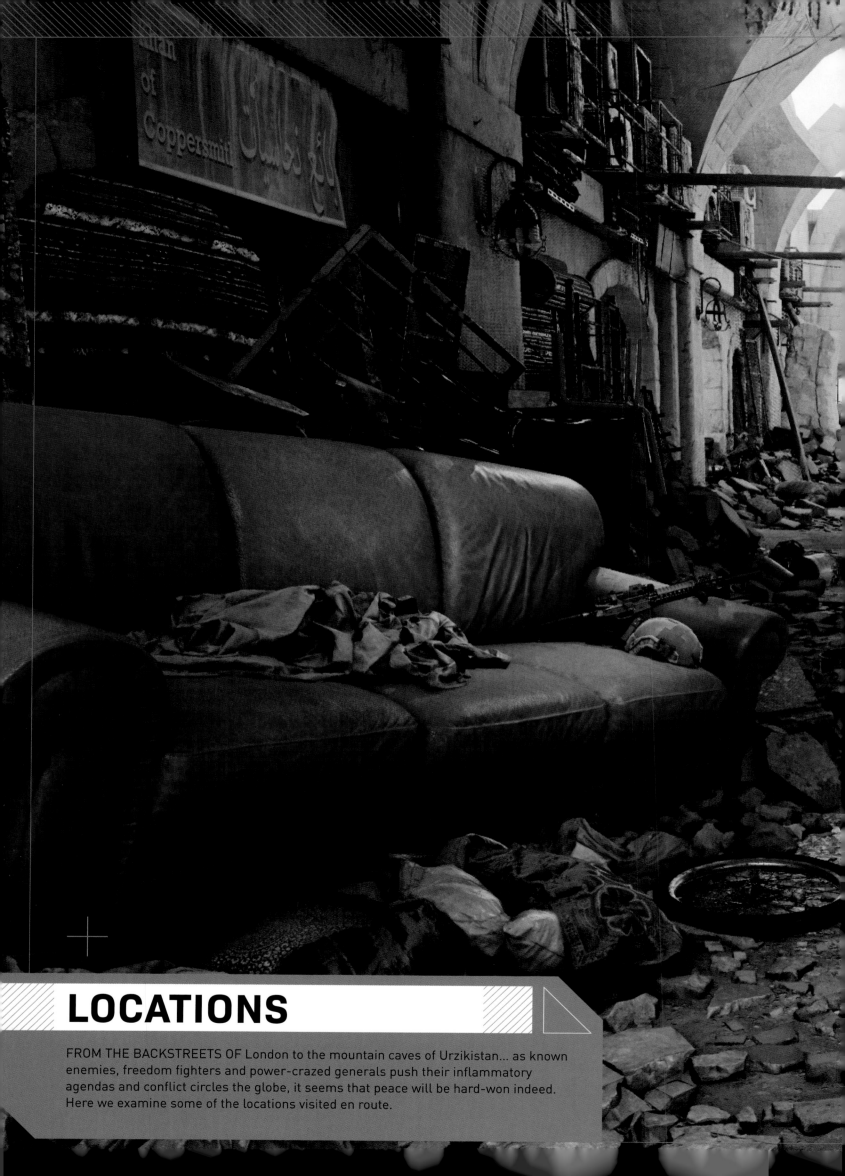

LOCATIONS

FROM THE BACKSTREETS OF London to the mountain caves of Urzikistan... as known enemies, freedom fighters and power-crazed generals push their inflammatory agendas and conflict circles the globe, it seems that peace will be hard-won indeed. Here we examine some of the locations visited en route.

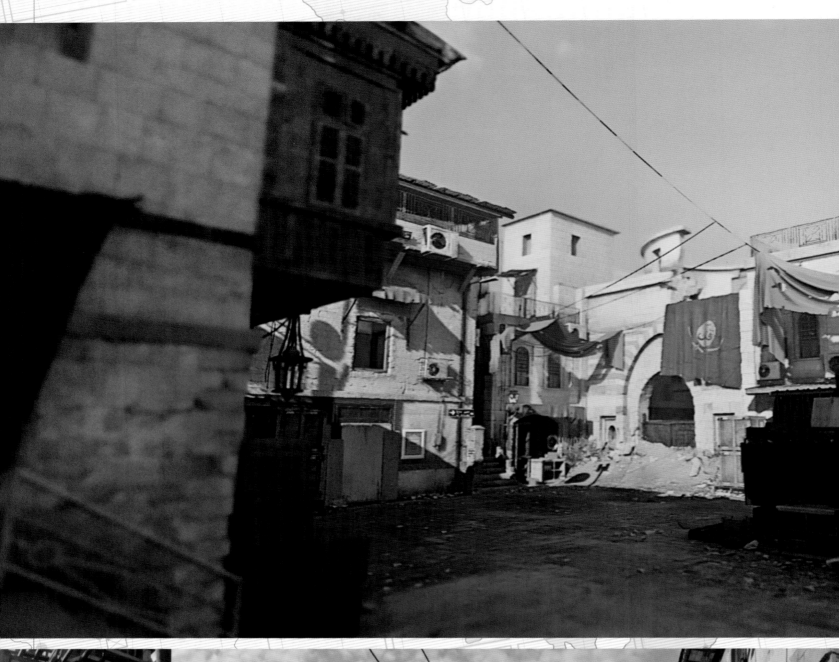

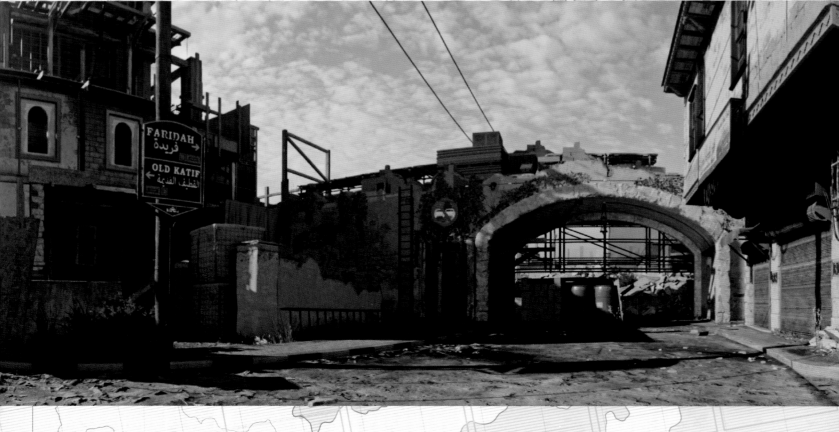

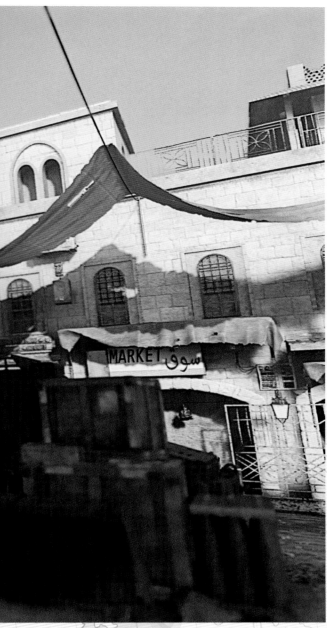

Left: Wooden market stalls are a common feature dating back to the Ottoman era. These detailed natural wooden materials provided a nice contrast to all the stone and plasterwork seen throughout the levels.

Below: Spear functions as both a multiplayer battleground and as part of the main singleplayer campaign.

LOCATIONS // **SPEAR**

This fictional Northern Urzikistan city is the site of an Al Qatala base and a thriving arms trade. Russian intelligence, in tracking stolen weapons, has launched a devastating strike. Allied forces now find themselves in a firefight that threatens to engulf the entire region.

Stucco walls bear the marks of the ensuing conflict; buildings crumble, debris spills into the city streets and few of its frightened residents dare to shop in the once thriving marketplaces. This is a palette of shattered concrete, exposed cinderblock, twisted metal and the dusty tones of the arid desert environment, although humanity still prevails among the rubble.

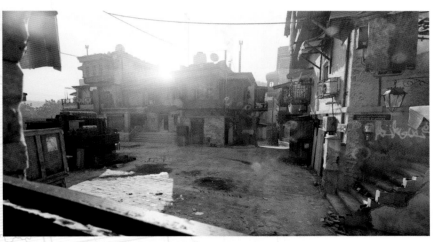

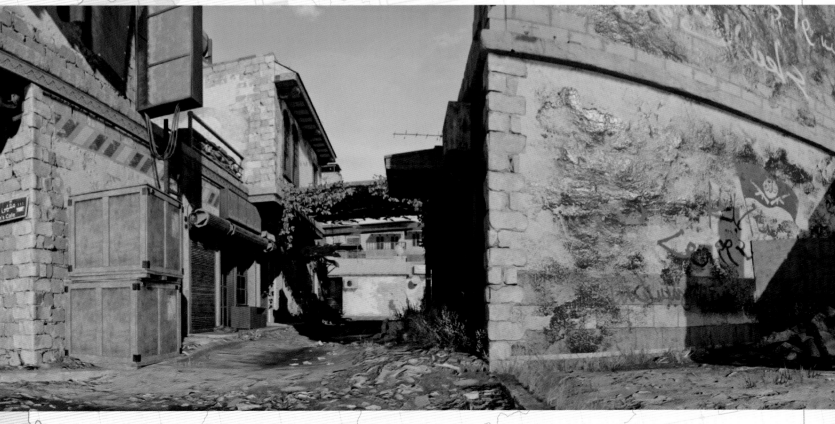

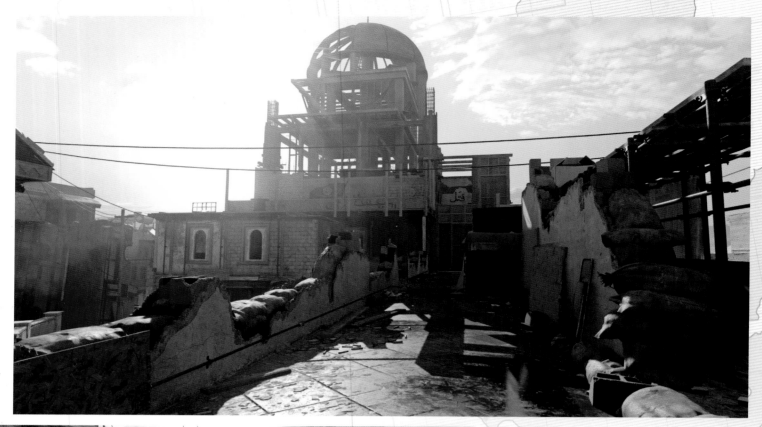

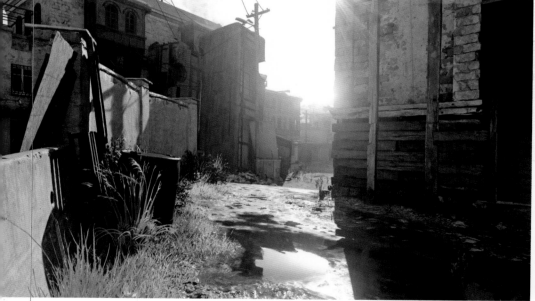

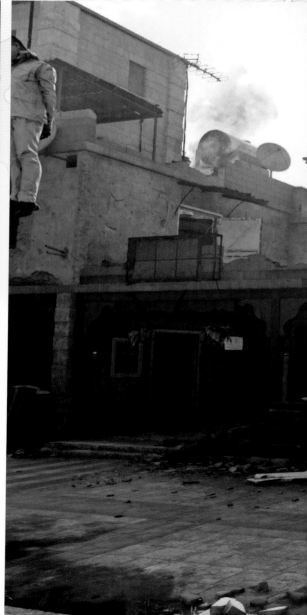

Scenes from a city under siege. Sandbags on a roof terrace can offer some protection in a gunfight, while other images depict the blasted detritus of the ongoing battle. Street signs, intact for now, point to other locations in the city and offer additional routing and orientation benefits.

As with other elements of the gameplay, much effort was employed in Spear's layout and design. It follows a three-lane construction, but incorporates verticality, route exploration and power positions for players to discover. In a standard team deathmatch this twist on the basic design gives players something to fight over.

Above: The rising dust of a late, lightly overcast afternoon gives a golden glow to this broken down backyard. A triumph of lighting design.

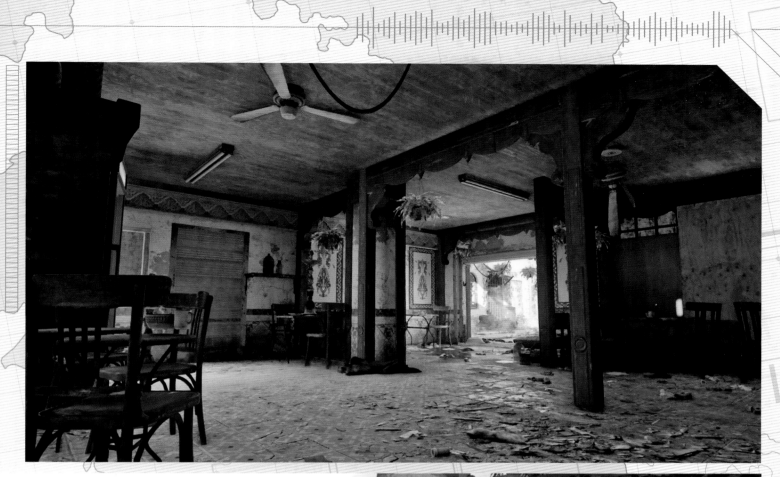

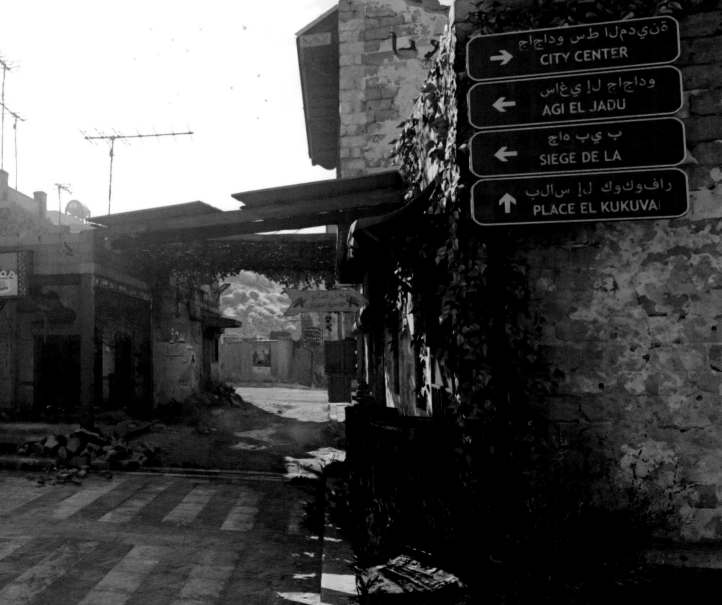

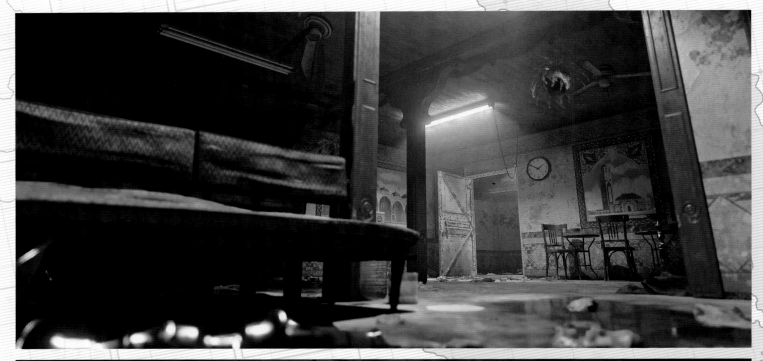

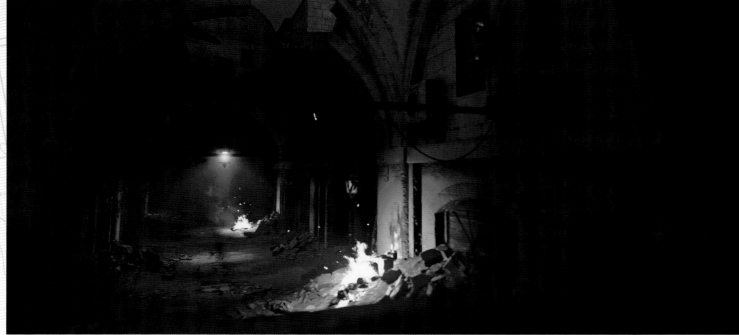

Although Spear is situated in the Urzikistani desert, some of the action sequences take place indoors, in artificially lit spaces, dim evening and dark nighttime environments. This posed several challenges for the *Modern Warfare* team, particularly in terms of the lighting design, but these were soon turned to gameplay advantages.

We wanted to make night time versions of some of our maps, but we wanted them to push gameplay in new ways. *Modern Warfare* has a robust night vision mechanic that we thought we should use for these maps. The design challenge was to make sure the maps had the right amount of pitch-black areas and lit sections as well. We didn't want players to be able to shoot out all the lights, so we needed to create a design language which tells players that specific lights are bulletproof. This is all part of balancing the quality of light and dark gameplay in the map.

Volumetric lighting does much to convey the dank atmosphere in these enclosed spaces. The two lit fires *above* barely illuminate the scene, so night-vision goggles may be required.

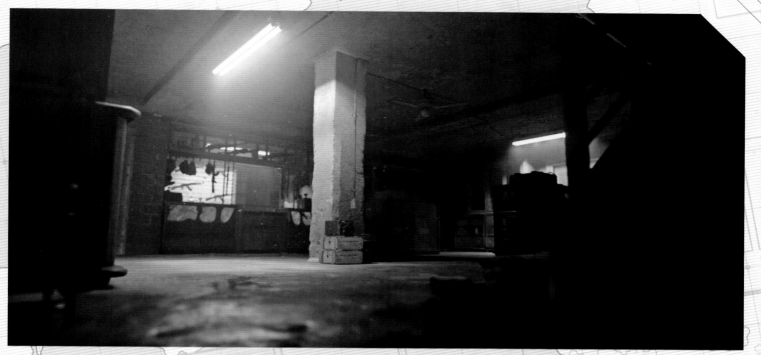

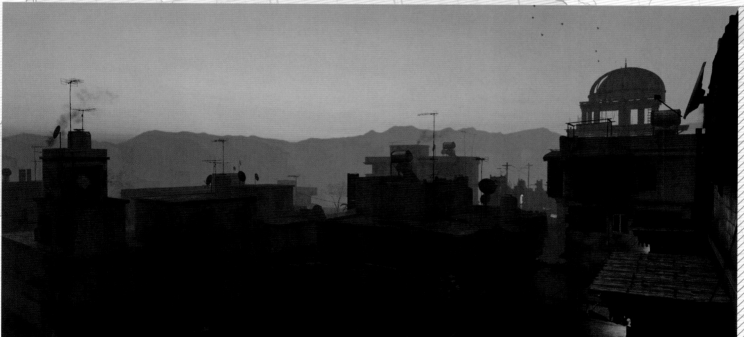

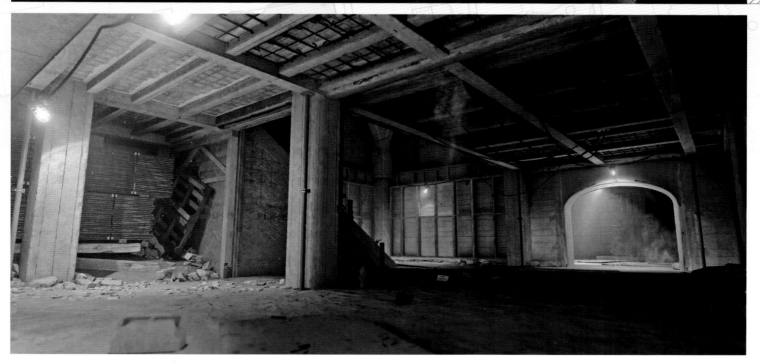

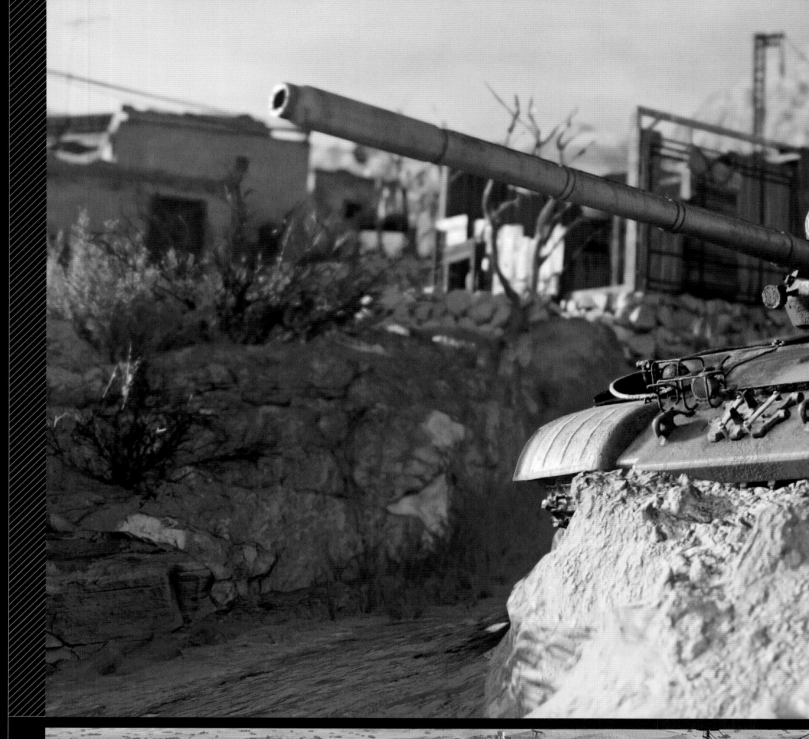

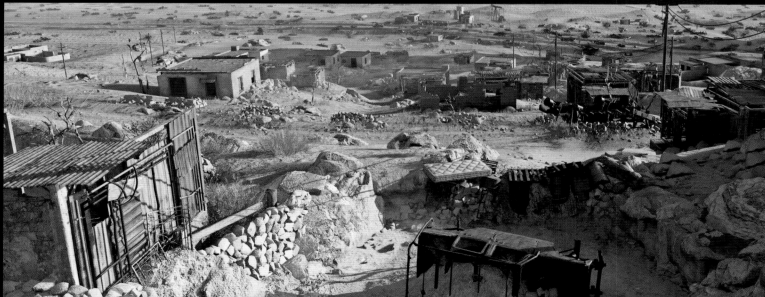

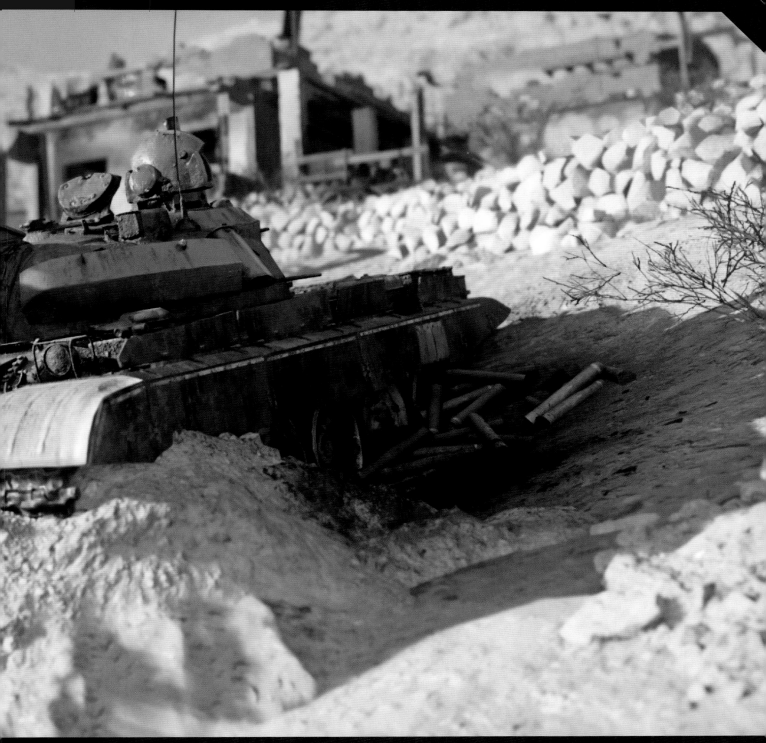

The first two years of *Modern Warfare* development required the art and engineering departments to integrate reality capture into these fraught environments. Highway was one of the first builds that integrated this technology successfully.

LOCATIONS // **HIGHWAY**

Farah fights for the freedom of her country, although her cause is not to be confused with the lethal ideology of Al Qatala. She is a key player in the Urzikistan missions, and the action takes a dramatic turn when players join her rebel force as they lie in wait for an Al Qatala convoy moving down the local highway.

Chaos follows as Russian forces give chase, their fighter jets strafing the road from above. Their attentions soon turn to the village, which is practically razed to the ground in the conflict. However, a plan is soon hatched to bring the fighting to an explosive conclusion.

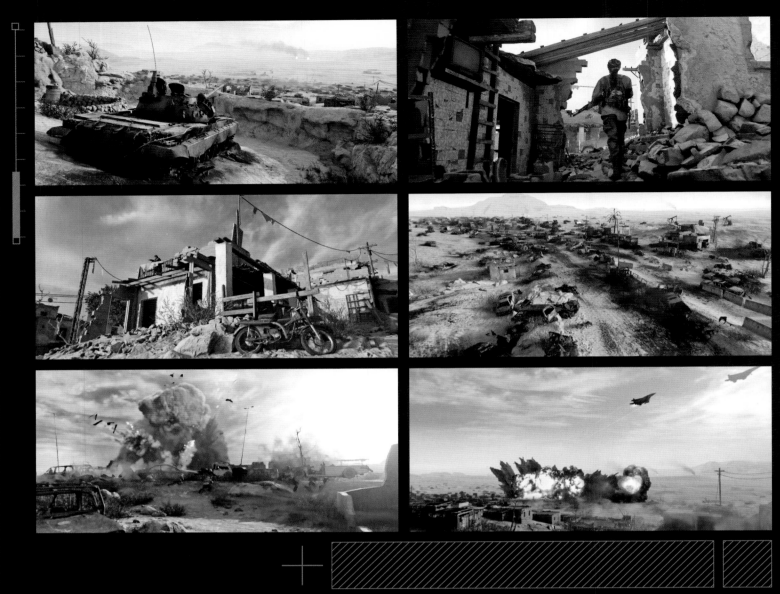
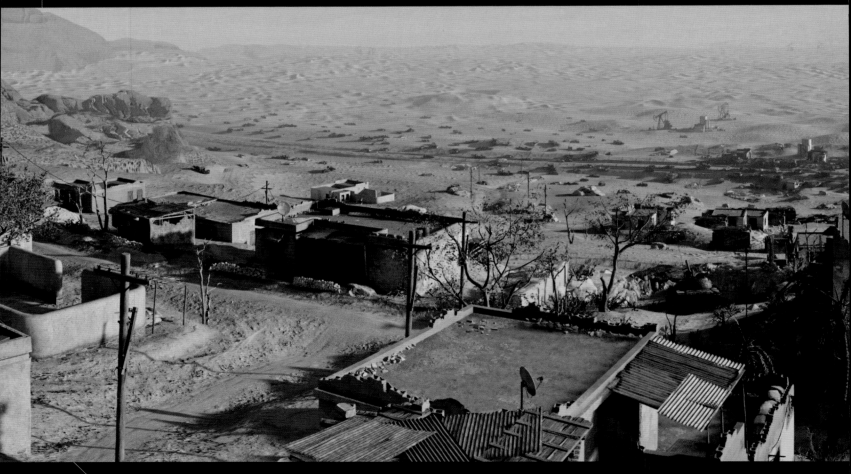

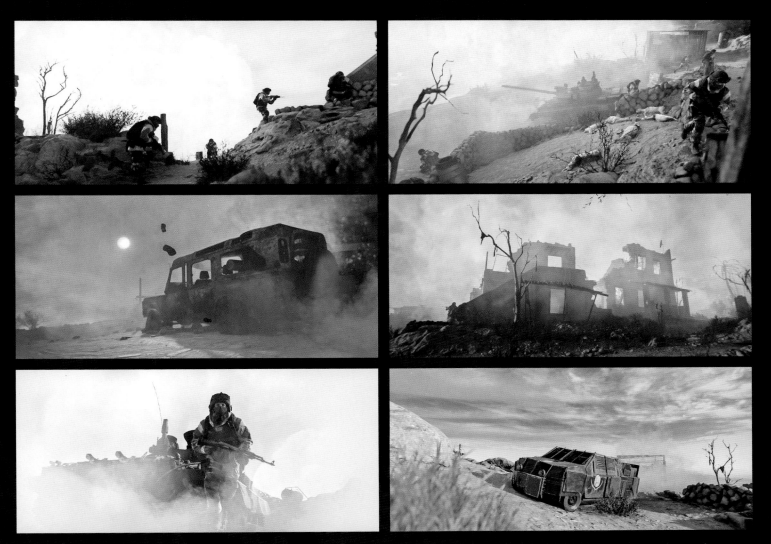

These scenes of carnage and devastation are so convincing that they could be taken from a real-world battlefield. The Highway sequence changes from one moment to the next, both in terms of gameplay, pace and the campaign narrative. A clear visual guide needed to be created to support these transitions. Color images, such as these, were an effective way to guide lighting and color that bests fit the action and tone of the level.

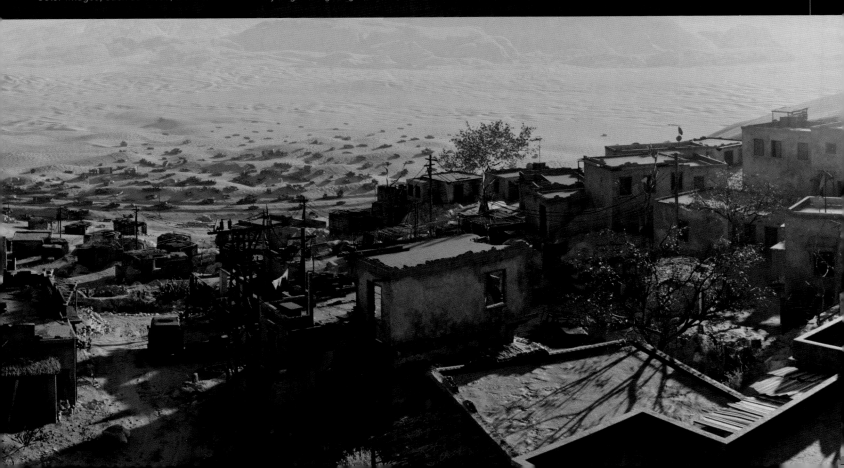

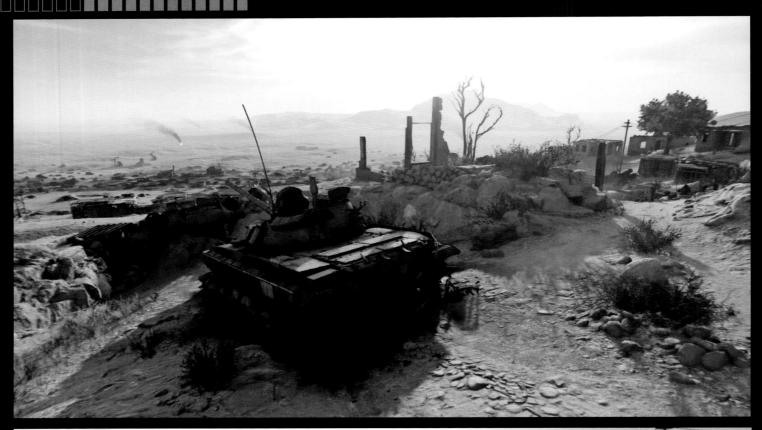

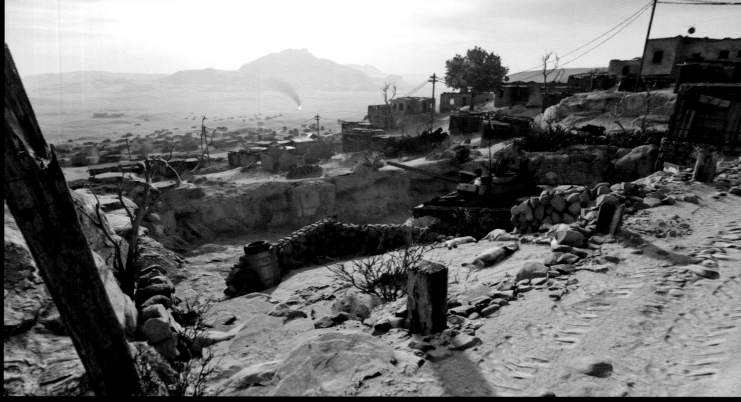

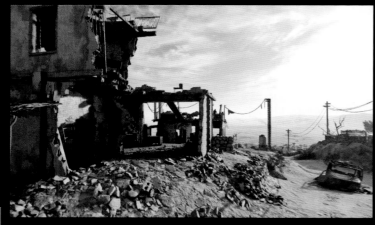

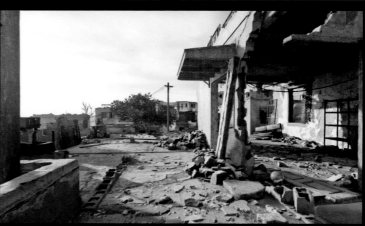

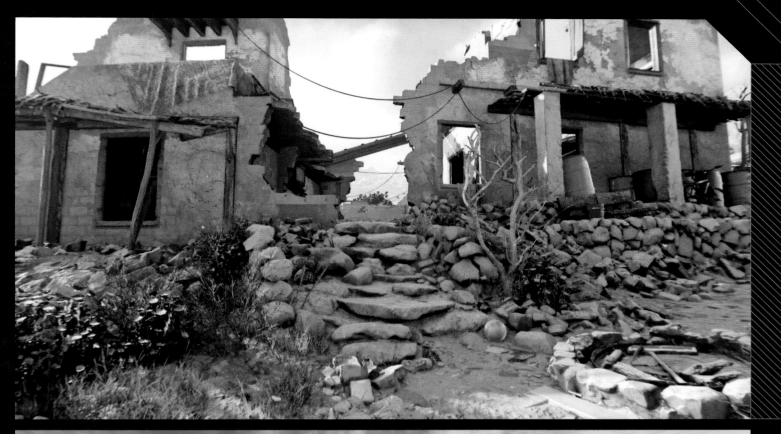

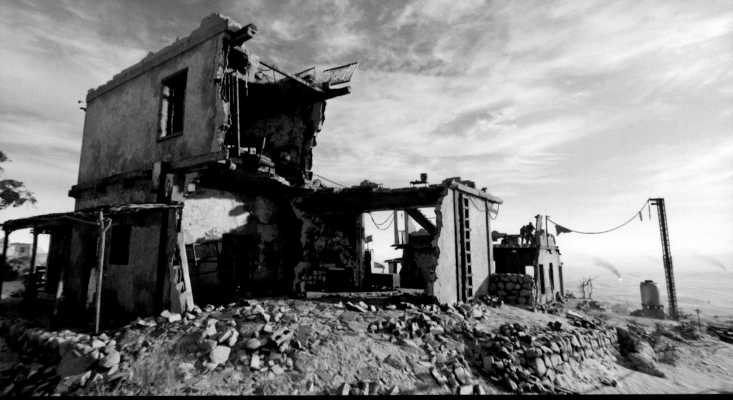

Designers studied how buildings explode and crumble, and the contents of a dwelling are exposed to the elements. *Left:* The rising heat haze gives a sense of true scale to targets and mountains in the far distance.

Farah's village, which borders the highway, does not survive the rogue Russian-led assault intact—if anything, it suffers an even worse fate than the nearby city. Tanks take up positions within the bounds of the desert settlement, and the resulting firefight decimates the homes of local residents.

Atmospheric conditions play an important role in bringing this level to life. Plants and grasses sway in the direction of the prevailing wind and remote targets

shimmer in the haze generated by the burning desert sun—both of which convey the visual language of the level and, of course, have a tangible impact on the accuracy of shots fired.

This is principally a defensive mission. The battle commences at a distance, but the pace changes considerably when the enemy forces break through the perimeter and the combat changes to close quarters.

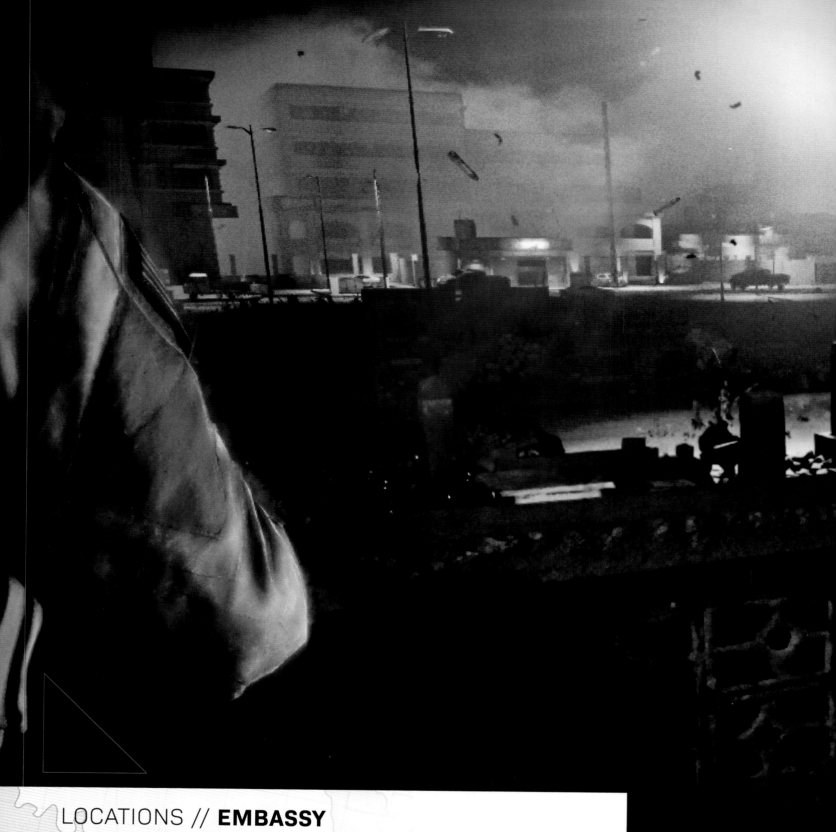

LOCATIONS // **EMBASSY**

Chaos reigns, as soldiers loyal to Al Qatala stage an attack on the US Embassy in Urzikistan.

Concrete and barbed wire are ineffective in preventing the mob from breaking through the Embassy barriers. Improvised missiles are lobbed over the compound walls, vehicles are set alight, and smoke fills the air.

Against this calamitous backdrop, the player takes part in the extraction of a prisoner. Farah and Price bring their expertise to bear, although it is perhaps wise to allow the attackers to enter the Embassy and engage them at close range rather than confronting them en masse.

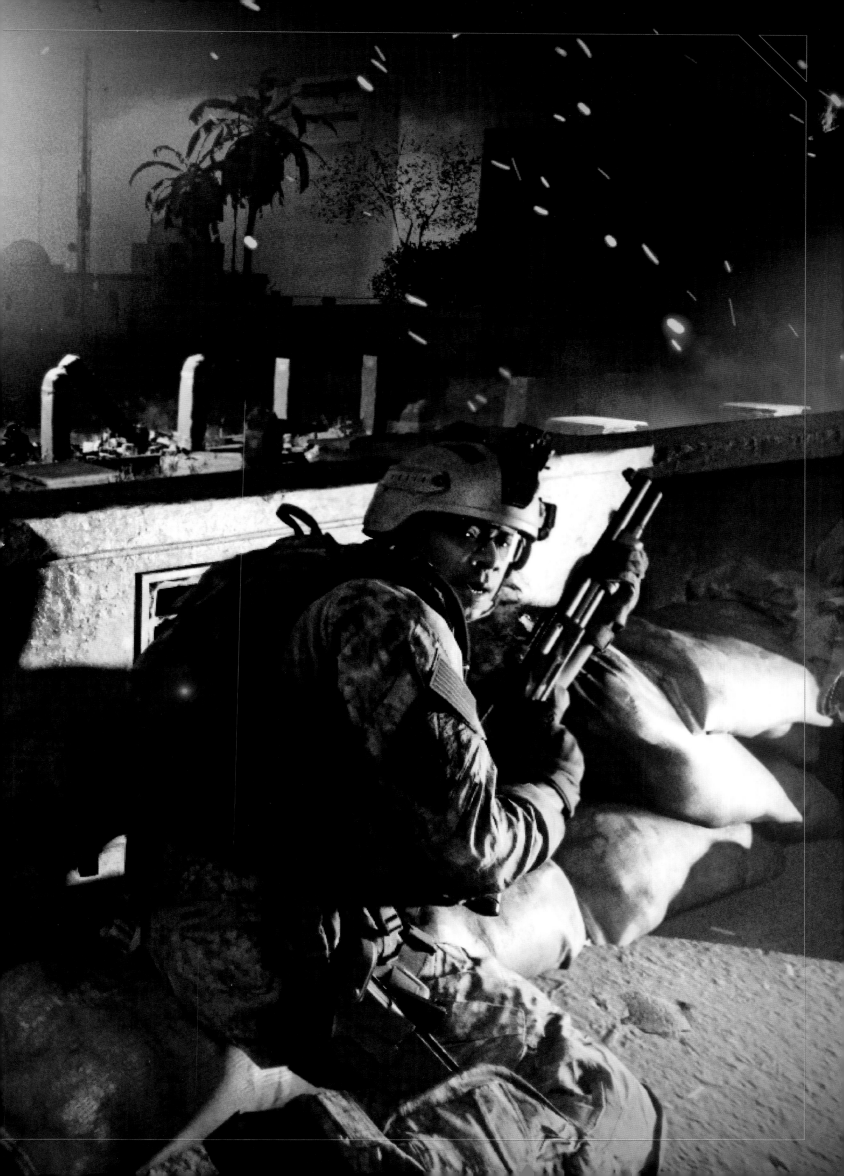

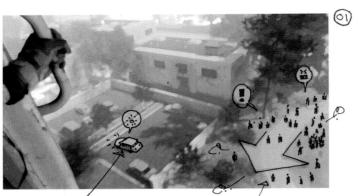

①

A CAR STARTING UP.
EMBASSY WORKER ATTEMPTING
TO FLEE.

PEOPLE WALKING TO JOIN
THE HORDE AT EMBASSY
ENTRANCE

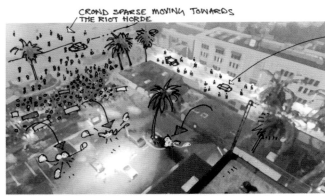

CROWD SPARSE MOVING TOWARDS
THE RIOT HORDE

CARS
MOVING
OUTSIDE
THE HORD

🔋 HORDE IS THROWING BOTLES AND OTHER THINGS OVER THE
⬤ WALL AT THE EMBASSY.

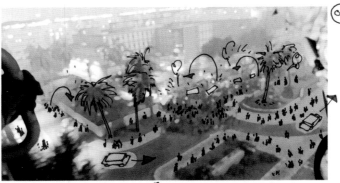

②

↪ CROWD THROWING
OBJECTS AT THE
EMBASSY

🔋 CARS LEAVING THE AREA

🔋 MORE PEOPLE WALKING IN TO
JOIN THE HORDE

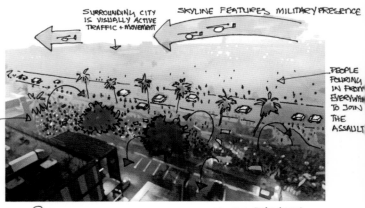

SURROUNDING CITY
IS VISUALLY ACTIVE
TRAFFIC + MOVEMENT

SKYLINE FEATURES MILITARY PRESENCE

ADD

PEOPLE
POURING
IN FROM
EVERYWH
TO JOIN
THE
ASSAULT

↪ HORDE IS THROWING OBJECTS AT THE EMBASSY

🔋 CAR TRAFFIC CAN BE SEEN DRIVING PAST THE
HORDE

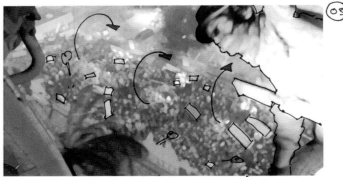

③

↪ CROWD THROWS ESCALATE TO MOLOTOVS.
STARTS OFF SMALL AND BEGINS TO
BUILD

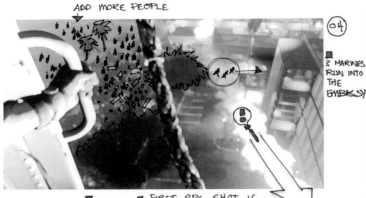

ADD MORE PEOPLE

④

🔋 2 MARINES
RUN INTO
THE
EMBASSY

⬤ CHANGE 🔋 FIRST RPG SHOT IS
NOW A BULLET BARRAGE.
SPARKS UP THE INTERIOR
CAUSING PRICE TO FLINCH.

🔲 · NEEDS STRAPS AND OTHER DANGLING PARTS ON CRASH

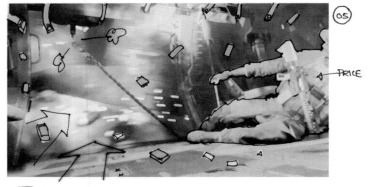

⑤

PRICE

🔲 · ADD DEBRIS FALLING OUT OF THE CHOPPER
+ MED KIT PARTS
+ MRE PACKS
+ PACKS

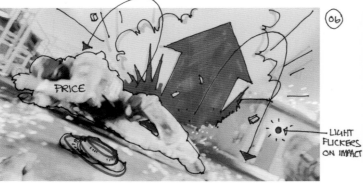

⑥

PRICE

LIGHT
FLICKERS
ON IMPACT

EXPLOSION NEEDS TO GET BIGGER + SPARKS.
MORE SPECTACULAR.

↪ ADD SOME HANG TIME DEBRIS THAT FOLLOWS THE
EXPLOSION. DEBRIS THUDS ON THE ROOF

Storyboards are a useful way to work out storylines and specific narrative events. Techniques vary, but they are often a little rough and ready to enable the speedy communication of ideas.

This infiltration sequence from the Embassy mission involved multiple departments. It's interesting to note the combination of screen-captured images with illustrated elements and handwritten stage directions. The gameplay is clearly and excitingly described, however.

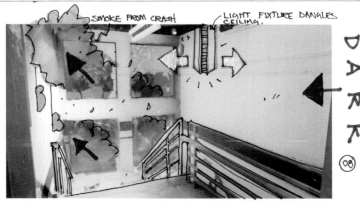

+SMOKE BILLOWING FROM CRASH DRIFTING IN THE WIND.

(07)

ANIM.
PRICE WAVES YOU OVER ●

□ THINGS ON THE ROOF BLOWING IN THE WIND.

□ LIGHT ABOVE PRICE IS FLICKERING.
■ PLAYER GETS UP AND DOES A WEAPON INSPECT !

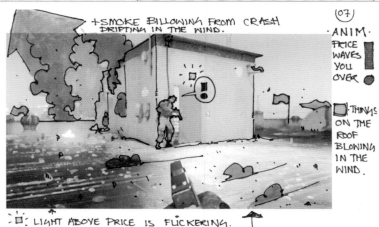

SMOKE FROM CRASH
LIGHT FIXTURE DANGLES CEILING.

DARK
(08)

■ STAIRWELL IS DARK. LIGHT FIXTURES AND SPARKS
● STROBE.
DUST AND ASH RAIN/TRICKLE FROM THE CEILING.
STAIRWELL IS DARK. □ FLOODLIGHTS "EMERGENCY SYSTEM"

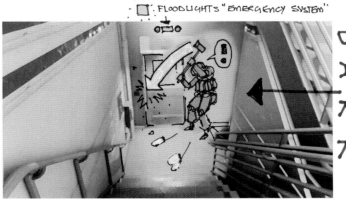

·□· FLOODLIGHTS "EMERGENCY SYSTEM"

DARK

PRICE CHECKS THE DOOR. ITS LOCKED. HE GRABS A FIRE AXE AND SMASHES THE LOCK.

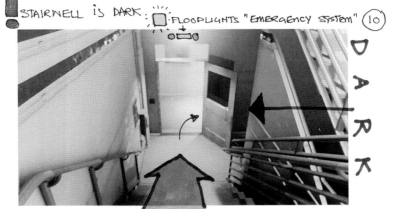

(10)

DARK

· DOOR OPENS AND PRICE GESTURES PLAYER TO FOLLOW.
· PRICE STOWS THE AXE ON HIS BACK FOR USE ELSEWHERE.

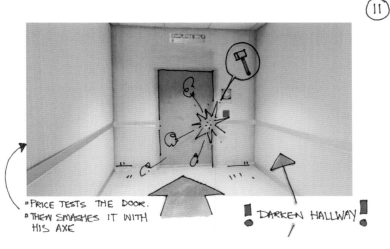

(11)

□ PRICE TESTS THE DOOR.
□ THEN SMASHES IT WITH HIS AXE

! DARKEN HALLWAY !

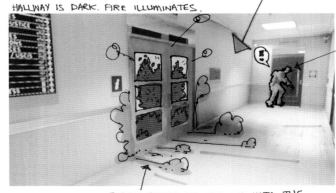

HALLWAY IS DARK. FIRE ILLUMINATES.

(12)

PRICE TALKS TO MARINE ON THE OTHER SIDE OF THE DOOR.

SMOKE STARTS TO STREAM INTO THE HALLWAY

■ A MOLOTOV IS THROWN A THE DOORS WHEN THE PLAYER ● ENTERS THE HALLWAY. "ON OTHER SIDE"

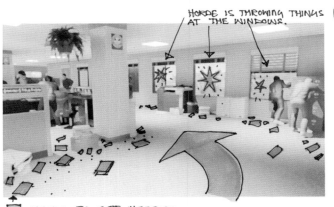

HORDE IS THROWING THINGS AT THE WINDOWS.

(13)

■ NEEDS TO GET MESSIER MORE FRANTIC.
□ SECTION IS WELL LIT.

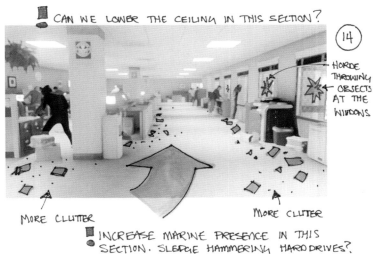

! CAN WE LOWER THE CEILING IN THIS SECTION?

(14)

HORDE THROWING OBJECTS AT THE WINDOWS

MORE CLUTTER
MORE CLUTTER

■ INCREASE MARINE PRESENCE IN THIS ● SECTION. SLEDGE HAMMERING HARD DRIVES?

Lighting design directions are provided as Captain Price prepares to enter the Embassy building and descend the stairwell. It is already dark when this event takes place, but players are able to increase their advantage by shooting out certain lights.

Such stage directions also explain how specific visual effects are integrated into the sequence. They are also helpful in detailing animated moments that give the scenes personality and context.

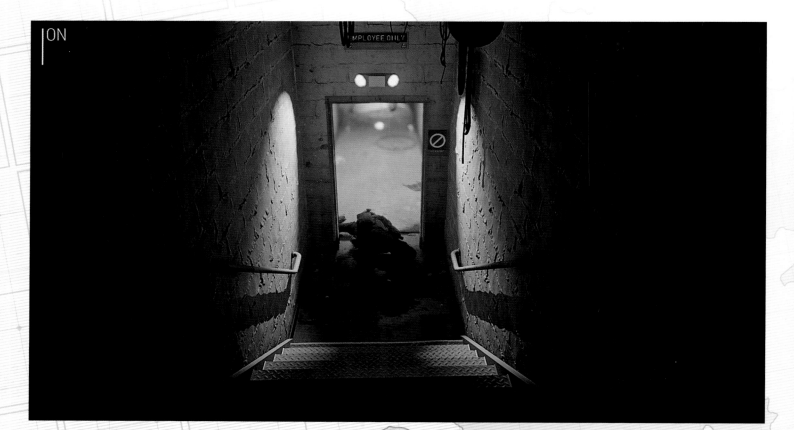

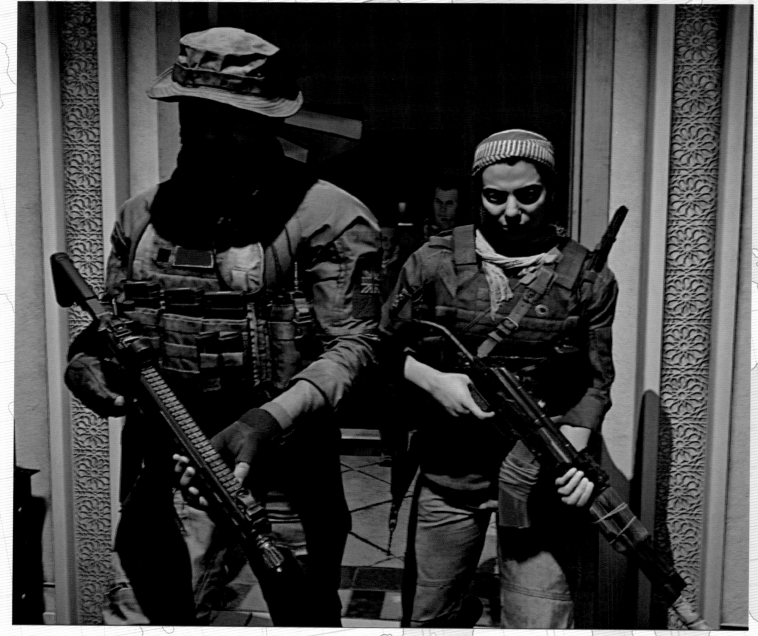

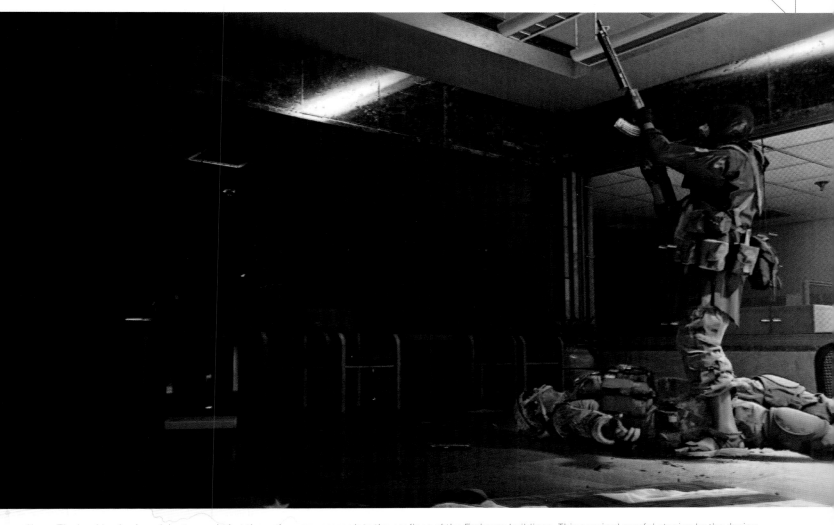

Above: The level begins in a violent assault, but the action soon moves into the confines of the Embassy buildings. This required careful staging by the design team, as the scale and severity of the attack is seen before the actual confrontation takes place. The answer was to fill some of the windows with military-grade bullet-proof glass. *Left:* Farah and Price escort the prisoner, and the firefight moves into the stairwell and basement of the Embassy.

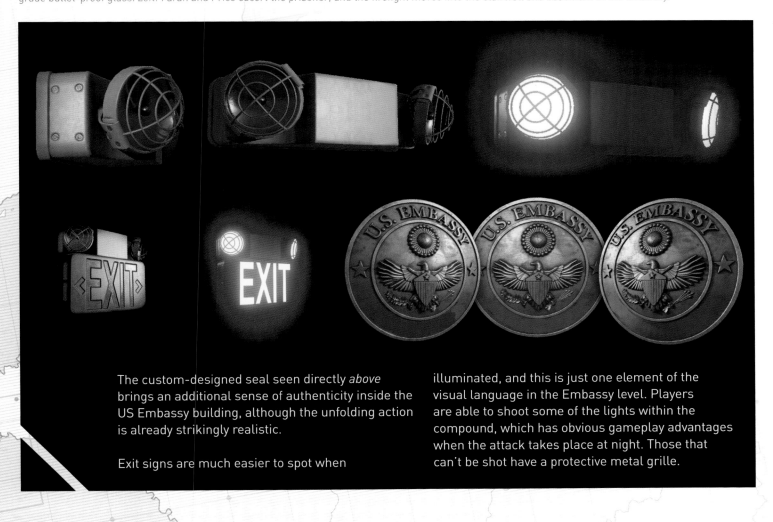

The custom-designed seal seen directly *above* brings an additional sense of authenticity inside the US Embassy building, although the unfolding action is already strikingly realistic.

Exit signs are much easier to spot when illuminated, and this is just one element of the visual language in the Embassy level. Players are able to shoot some of the lights within the compound, which has obvious gameplay advantages when the attack takes place at night. Those that can't be shot have a protective metal grille.

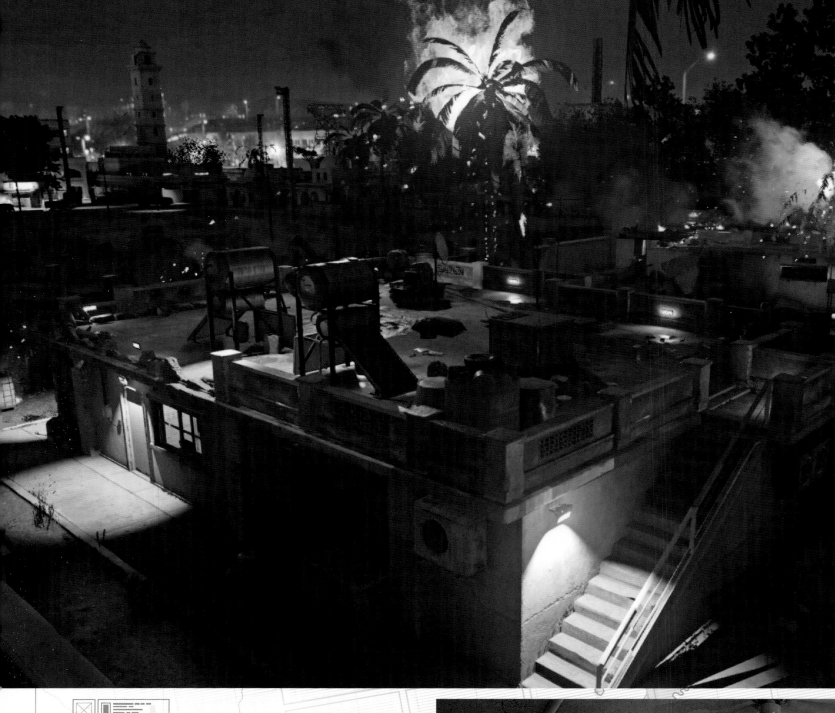

The Embassy compound comprises sizeable grounds and a number of smaller out-buildings. This is the final stand against the Al Qatala incursion and the firefight intensifies as the action moves from one location to another, and into smaller, tighter spaces. We had to map out the level from a drone view in order to stage the assault, and give the player the feeling of the world closing in on them.

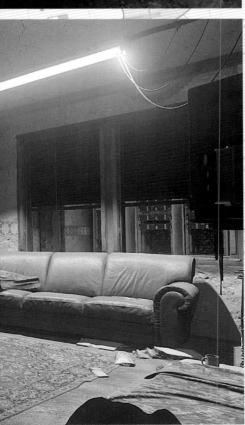

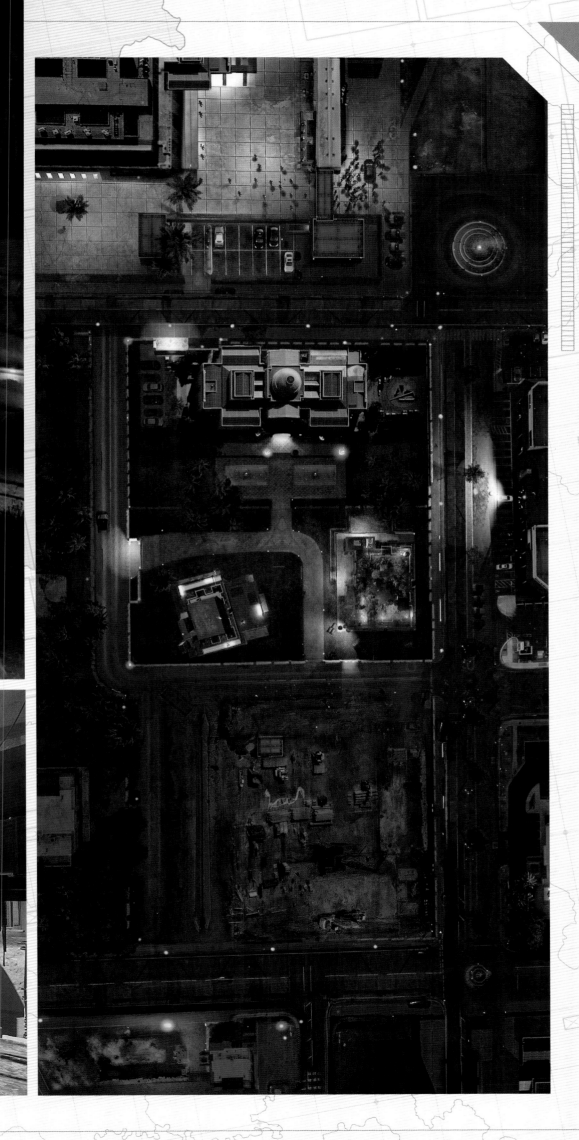

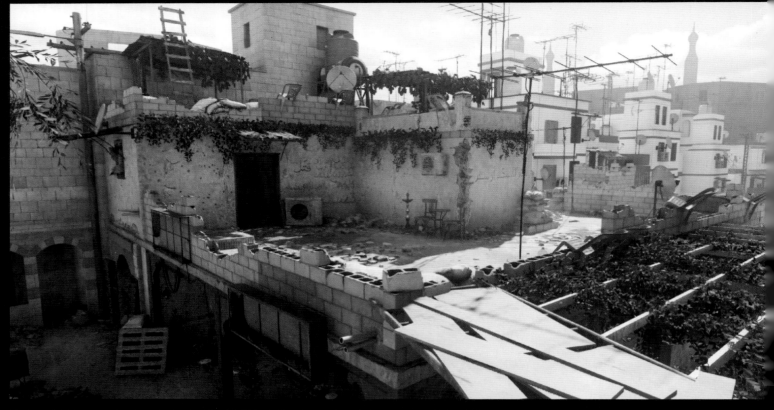

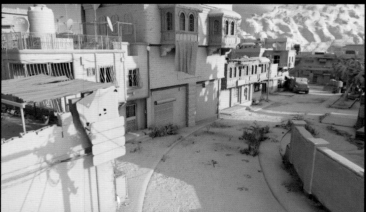
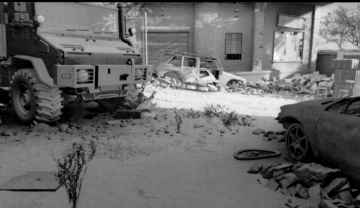

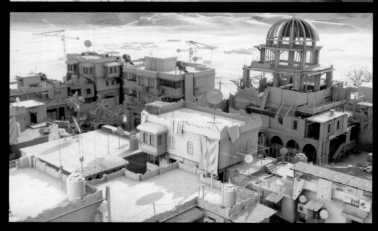
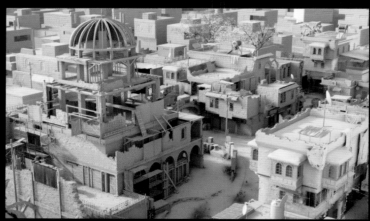

LOCATIONS // **SAFEHOUSE**

Differing views of the Safehouse level demonstrate the colors of this arid desert setting, the dust easily rising in the slightest breeze. The wrecks of military and civilian vehicles are a reminder that the streets are no longer safe for cars or drivers, and the skeleton of a local town hall has been laid bare in the fighting.

Signs of life remain in the chaos, as planks make an unsteady causeway above street level. It was decided that Safehouse would be a cat and mouse sabotage mission, with multiple sight lines, nooks and crannies to hide in and avenues to support the freedom of movement.

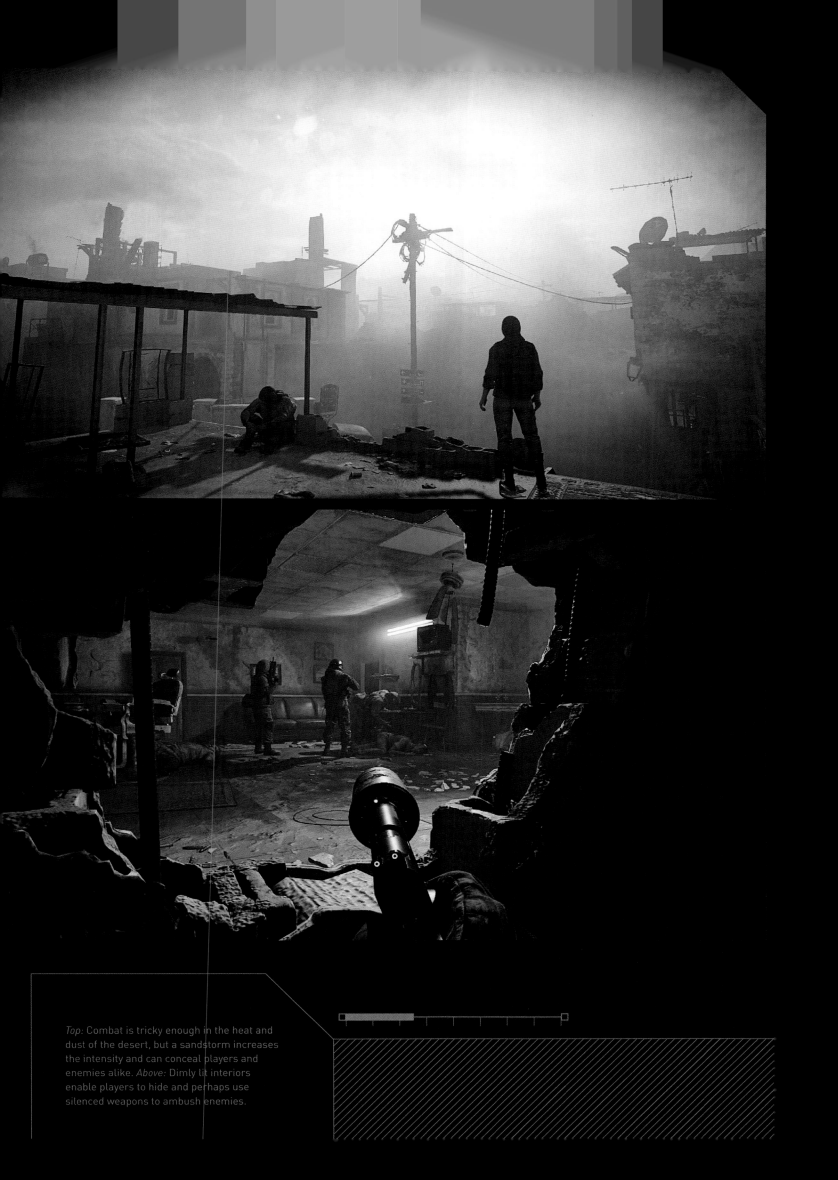

Top: Combat is tricky enough in the heat and dust of the desert, but a sandstorm increases the intensity and can conceal players and enemies alike. *Above:* Dimly lit interiors enable players to hide and perhaps use silenced weapons to ambush enemies.

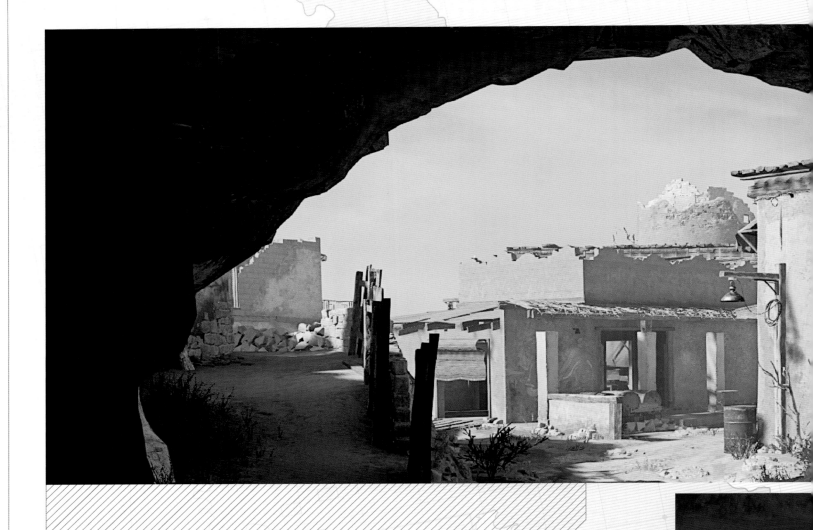

LOCATIONS // **CAVES**

Deep in the mountains of Urzikistan, and beneath the gaze of occupying Russian forces, Al Qatala is using an extensive series of underground caves to manufacture weapons and store the materials needed to make other ordnance. Airless and uncomfortable at any time of day, power and facilities are fed in from outside and basic quarters are constructed wherever possible. The caves level was inspired by a real location in Afghanistan, where local craftsmen had been creating and copying weapons of all varieties.

The combat takes place in both day and night settings, which offers two quite different gameplay experiences. Lighting conditions can vary dependant on time and location, although players will need to use night vision goggles to spot enemies after darkness falls or in pitch-black corners of the cave system.

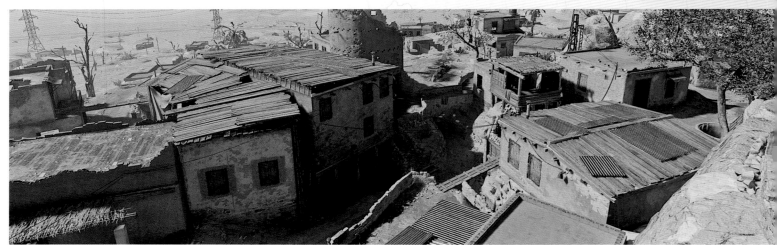

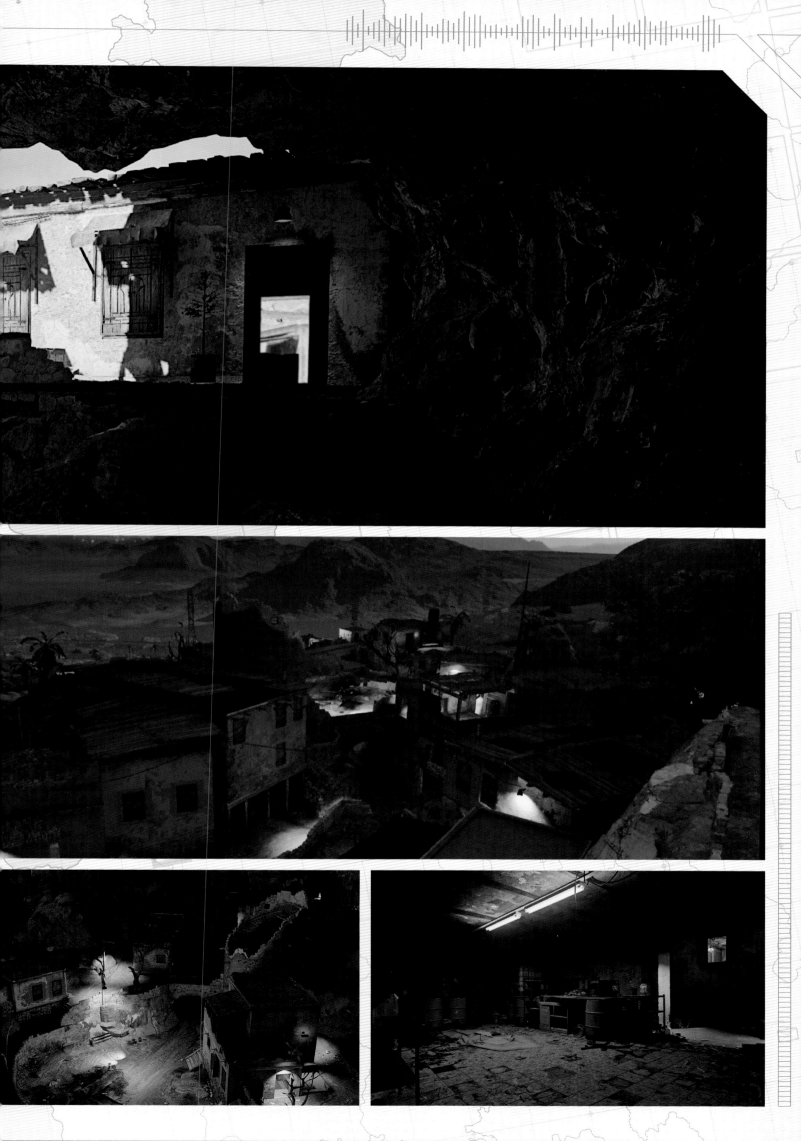

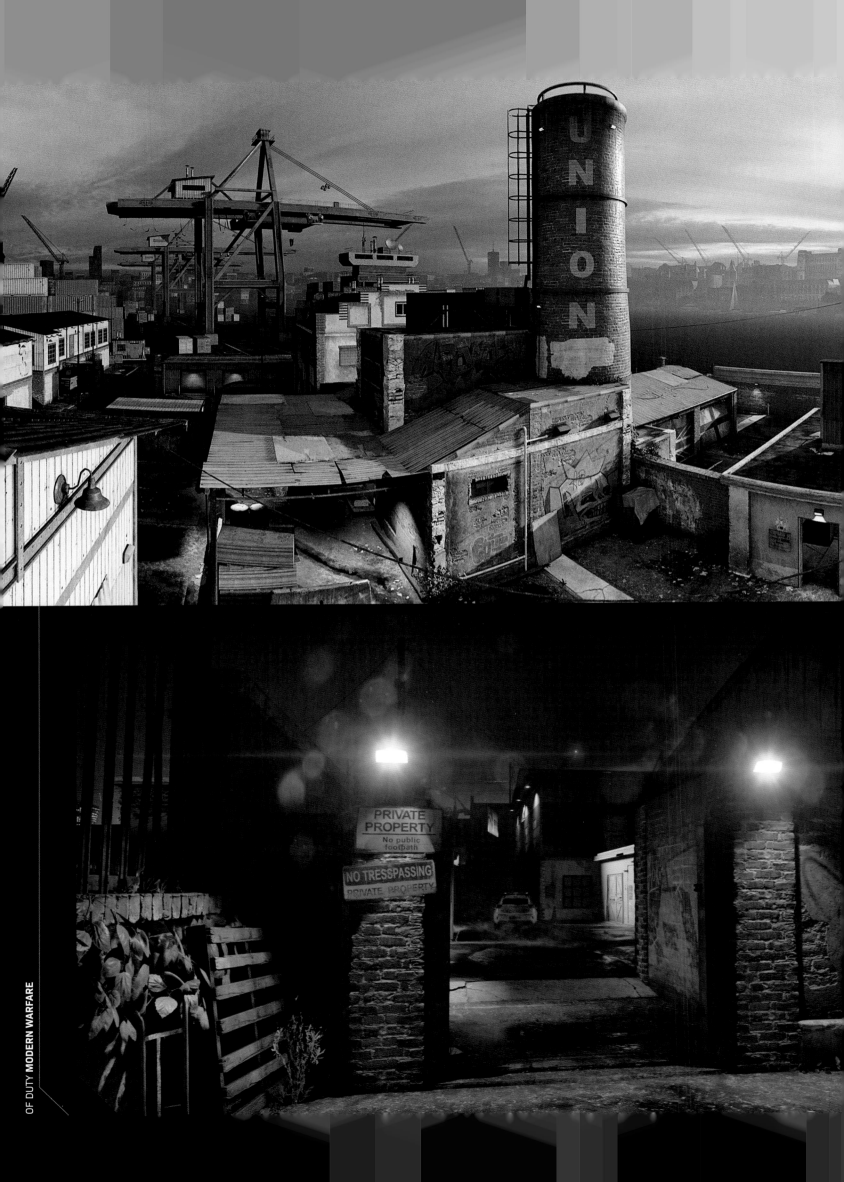

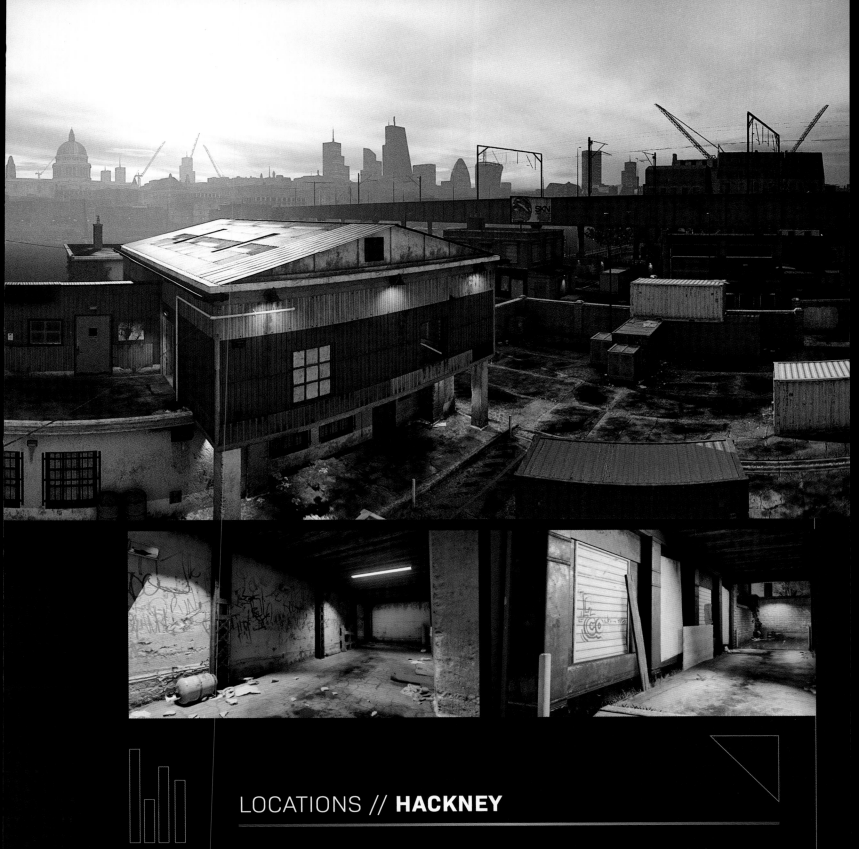

LOCATIONS // **HACKNEY**

British Intelligence has acquired information suggesting that Al Qatala's next attack is being planned from a derelict warehouse in this neglected corner of London. AQ operatives aim to bring the capital to its knees with a series of terrorist incidents, and have been using shipping containers to stockpile the materials needed to manufacture suicide vests and ad-hoc bomb devices. The final phase of its assault will employ an explosives-laden van in a highly populated area. The mission is thus set to thwart this lethal objective.

The East London borough of Hackney backdrops this urgent assignment, and this is another mission that offers day or night gameplay. Cleverly, light switches have been placed in some of the buildings so that players can blind unsuspecting enemies who enter while wearing their night vision goggles.

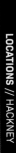

LOCATIONS // **PICCADILLY CIRCUS**

Few London landmarks are better known than the statue of Eros in the center of Piccadilly Circus, which is both a famous meeting point and the setting for a spectacular mission to foil a lethal Al Qatala plot.

Busy day and night, it is a prime target. Lighting and atmospheric effects bring much drama to the scene, with rain-soaked streets shining in the light of the famous advertising billboards.

This London location was selected early in the development process and represents a high point for *Modern Warfare* series. It takes advantage of every graphical advancement made to the game engine, and the entire environment is a visual ecosystem of city hustle and bustle. Also, the impact of the events that unfold at Piccadilly also sets Kyle Garrick's storyline in motion.

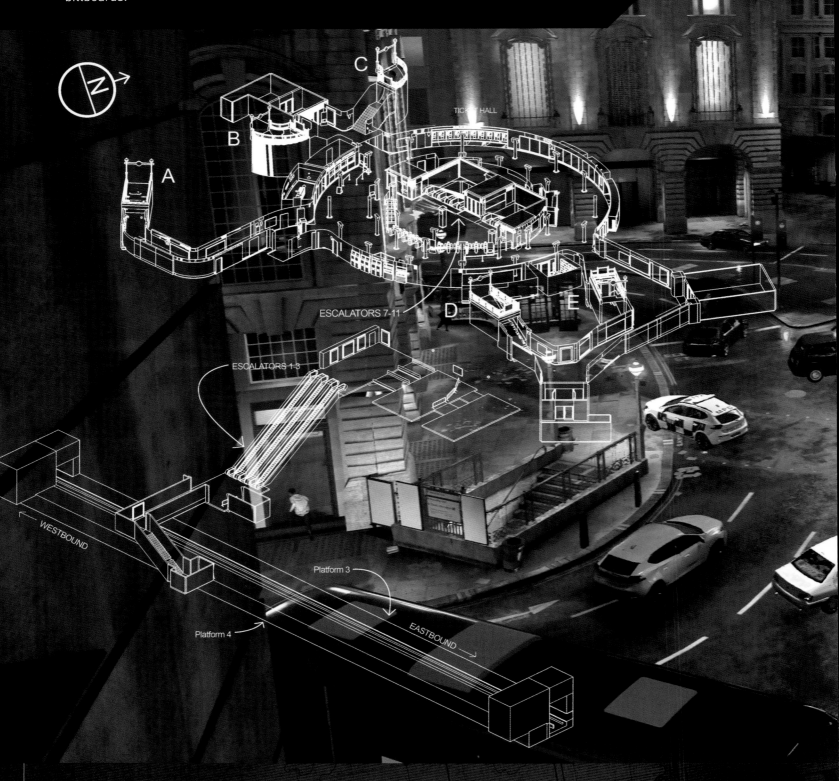

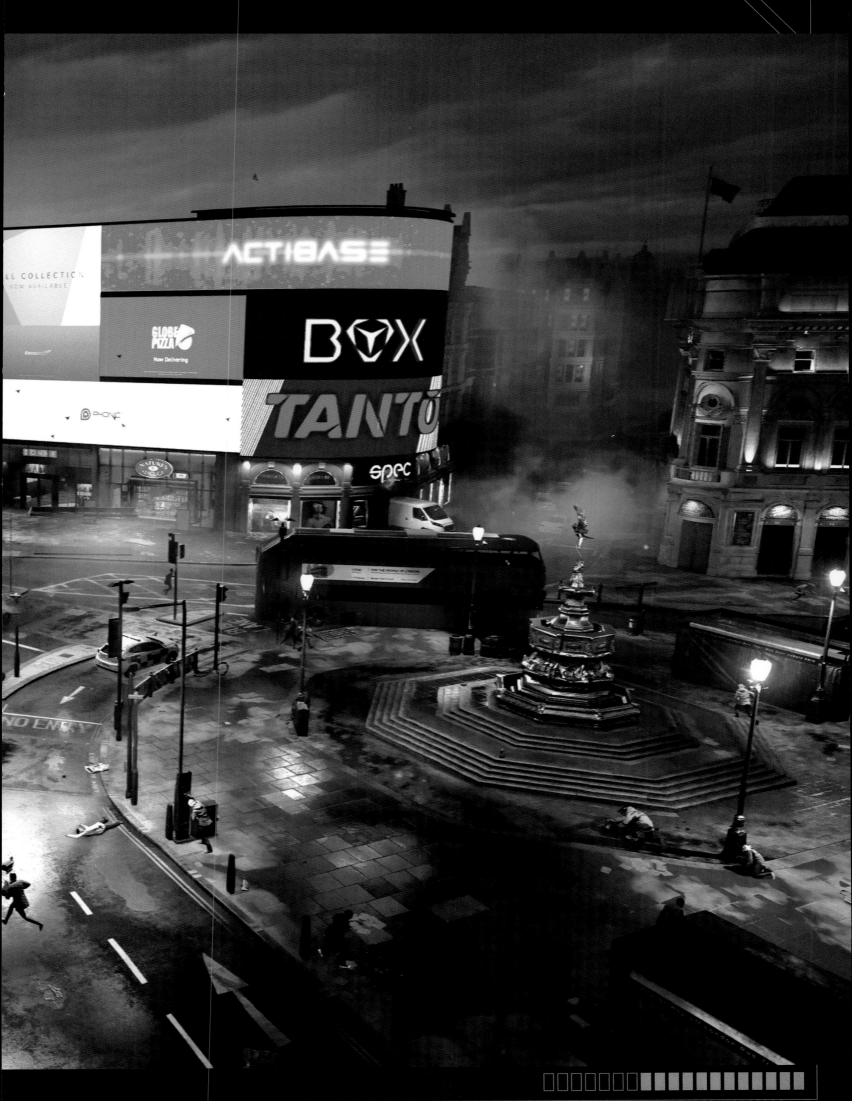

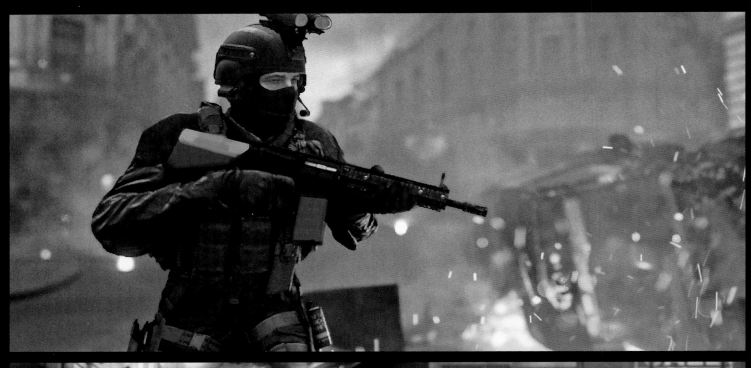

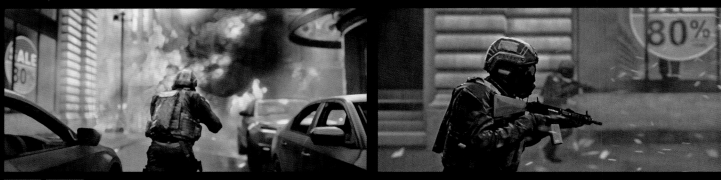

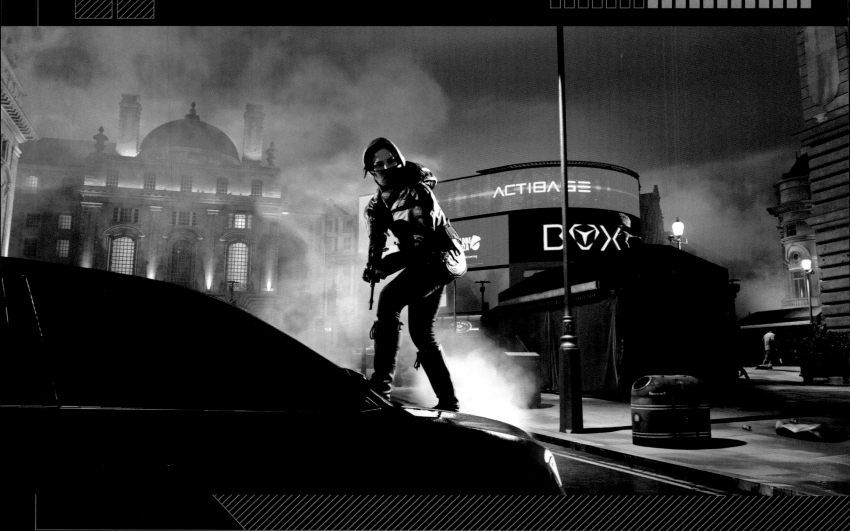

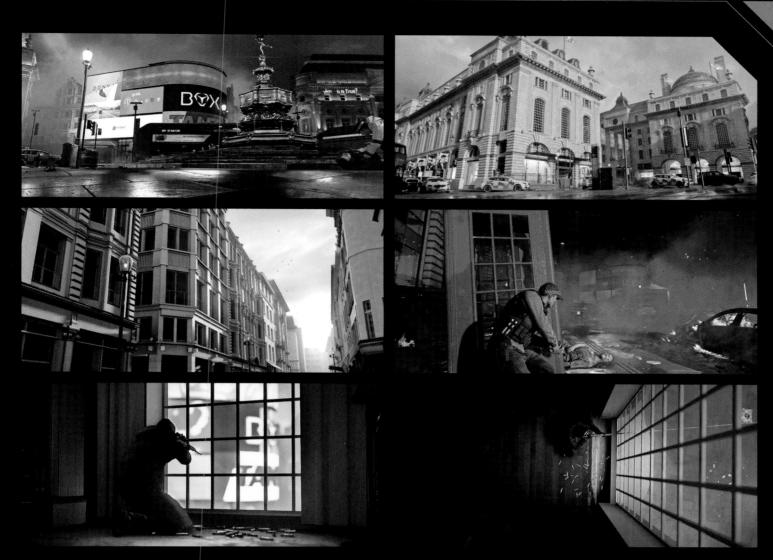

Various options were explored for the Piccadilly Circus sequence, including color schemes and hours of the day. We went through different lighting conditions for this level—day time, golden hour etc. Then we realized that night was the right time to bring this space to life.

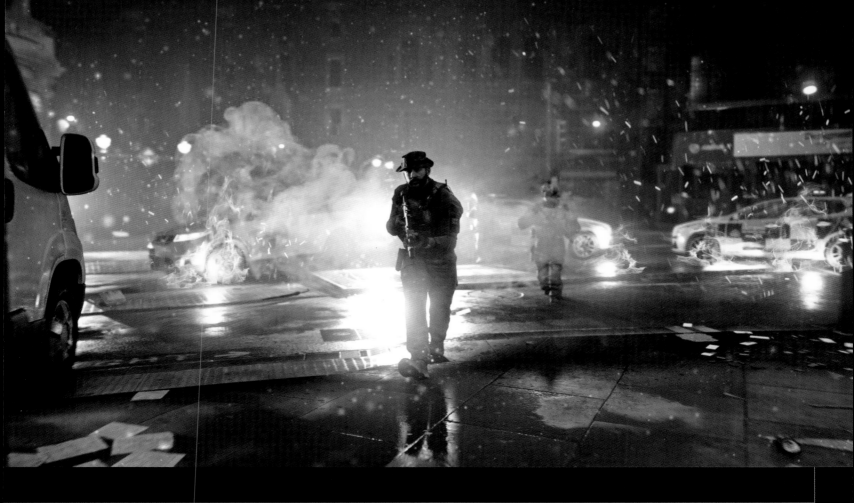

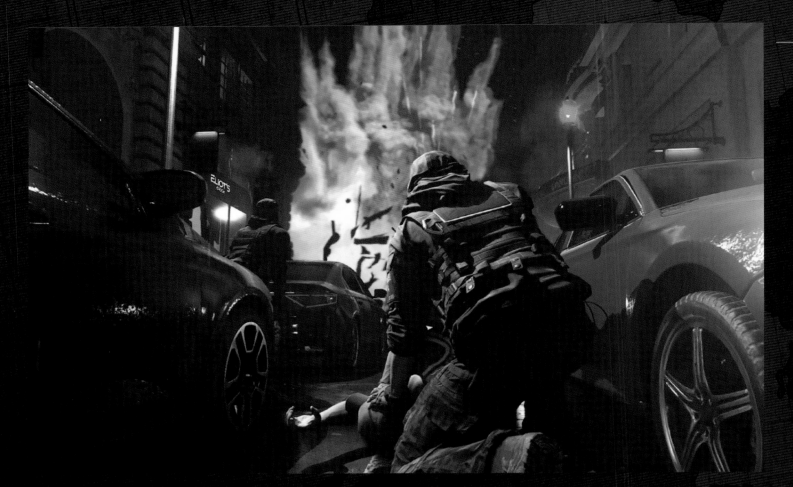

Citizens of London will recognize scenes in and around Piccadilly Circus too, all faithfully rendered. In our work towards getting environments like Piccadilly to look as photo-realistic as possible, we quickly realized that layers of atmosphere are crucial to getting the look right.

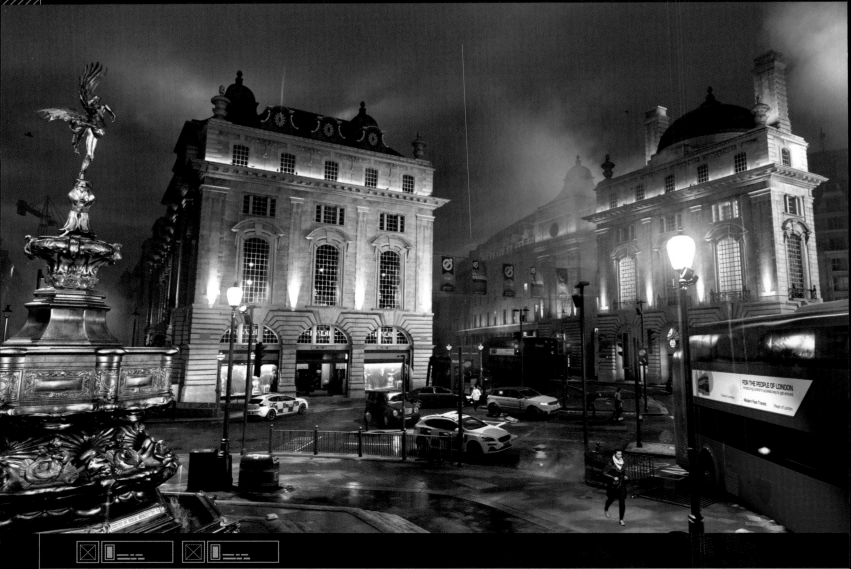

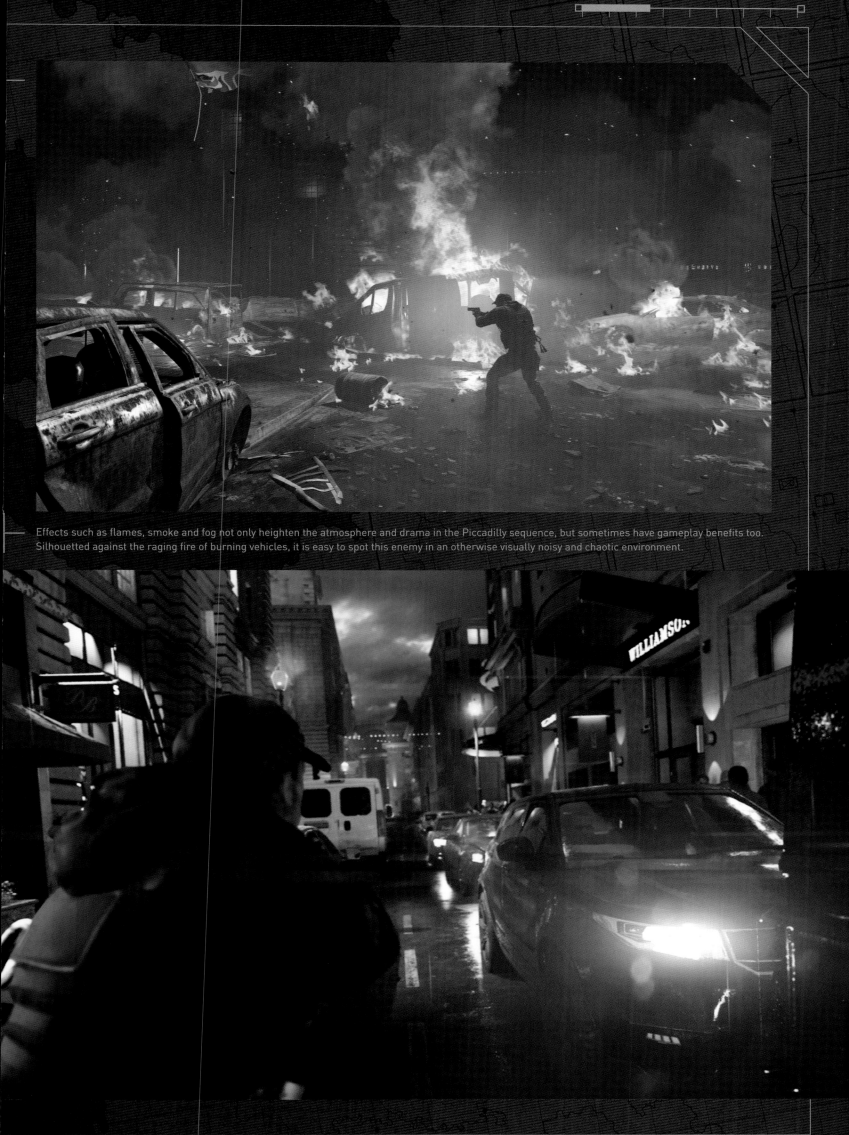

Effects such as flames, smoke and fog not only heighten the atmosphere and drama in the Piccadilly sequence, but sometimes have gameplay benefits too. Silhouetted against the raging fire of burning vehicles, it is easy to spot this enemy in an otherwise visually noisy and chaotic environment.

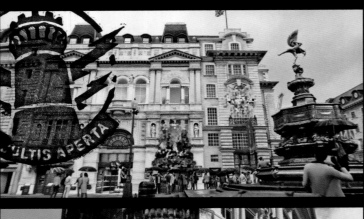
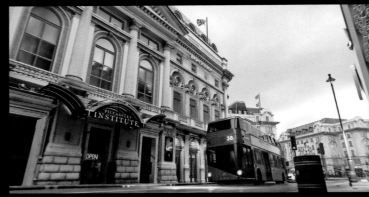

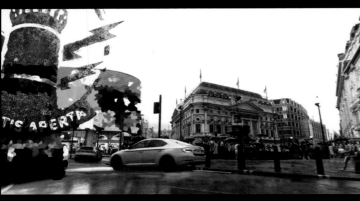
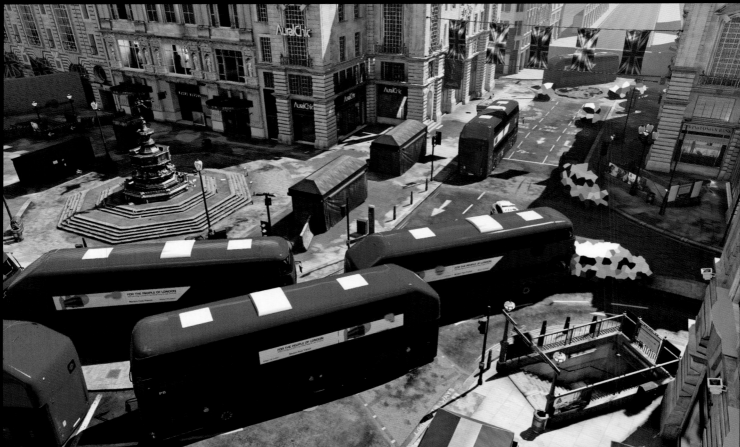

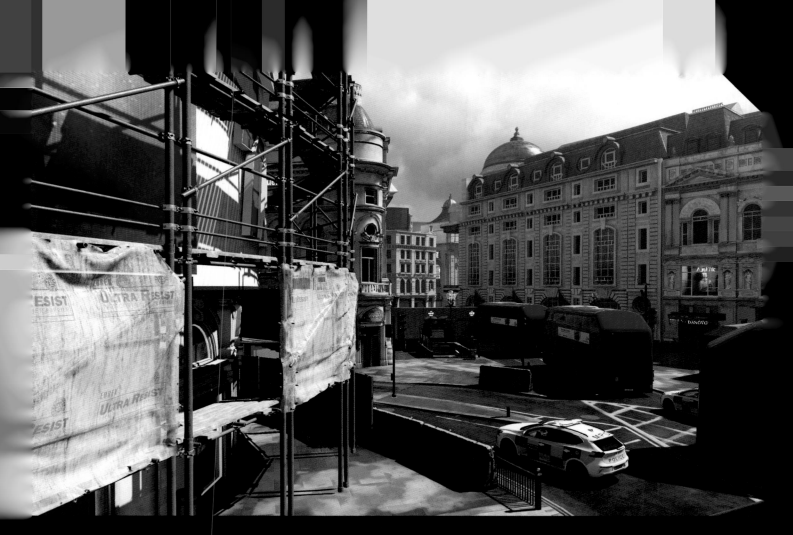

Piccadilly Circus looks quite different in the daylight hours, as it is seen in *Modern Warfare*'s multiplayer gameplay modes.

The sun is shining, strong shadows are cast over building facades and several other modifications were made to enhance the whole experience. Union Jack flags flutter and London buses enter the scene to support better gameplay geometry and give players sections to use for traversing the lengths of the large open streets.

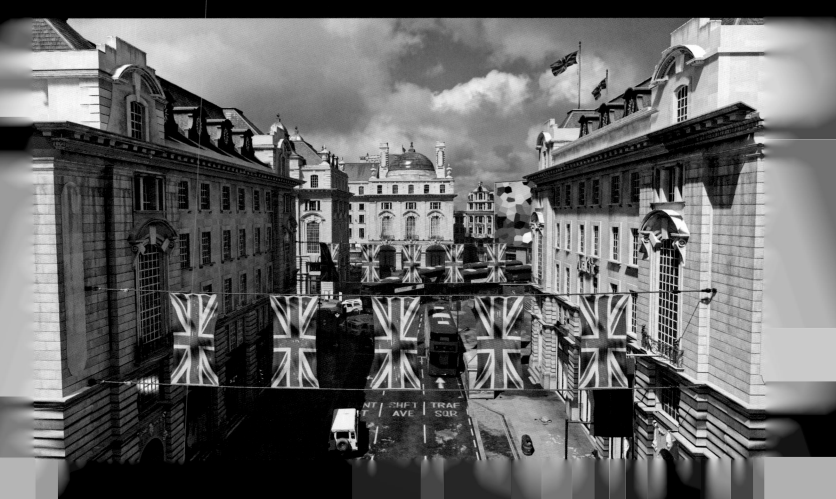

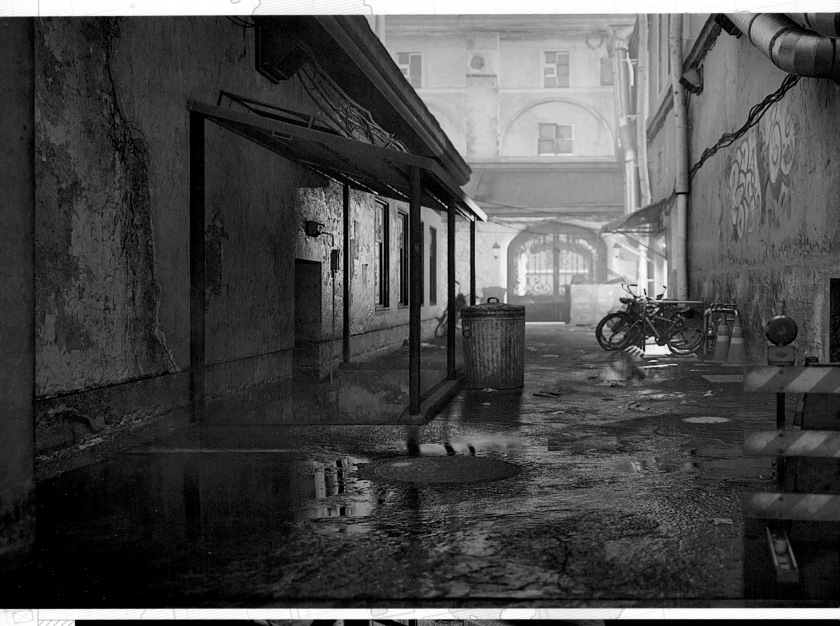

LOCATIONS // **SAINT PETERSBURG**

The Russian city of St. Petersburg is also a unique level in *Modern Warfare*. Captain Price and his crew go into the city undercover to follow an important lead—a dangerous endeavour, considering this is in the homeland of General Roman Barkov and his highly trained Spetsnaz fighters. Its location, in a corner of the Baltic, results in an often damp climate, and the Soviet architecture in its backstreets and alleyways looks especially austere after recent rainfall.

There's much grandeur elsewhere, although the entire location has been rendered in an astounding level of detail. While the same is true for every mission in the game, capturing St. Petersburg entailed sending team of artists and designers on an extended field trip to study and scan the city. Their efforts made it possible to create a highly convincing environment.

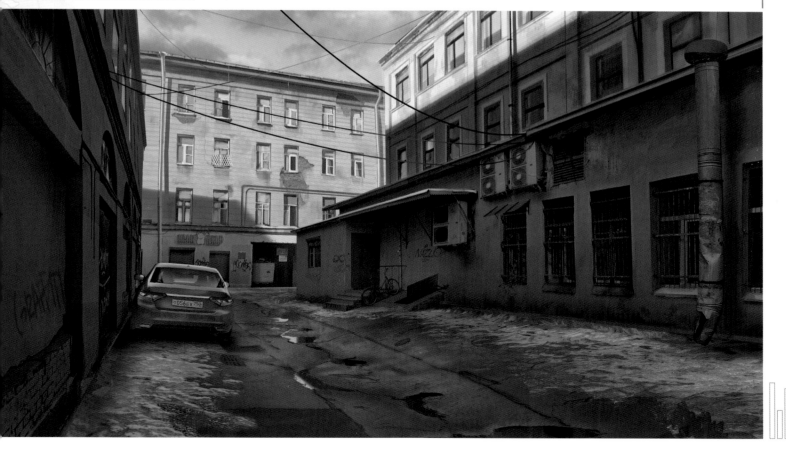

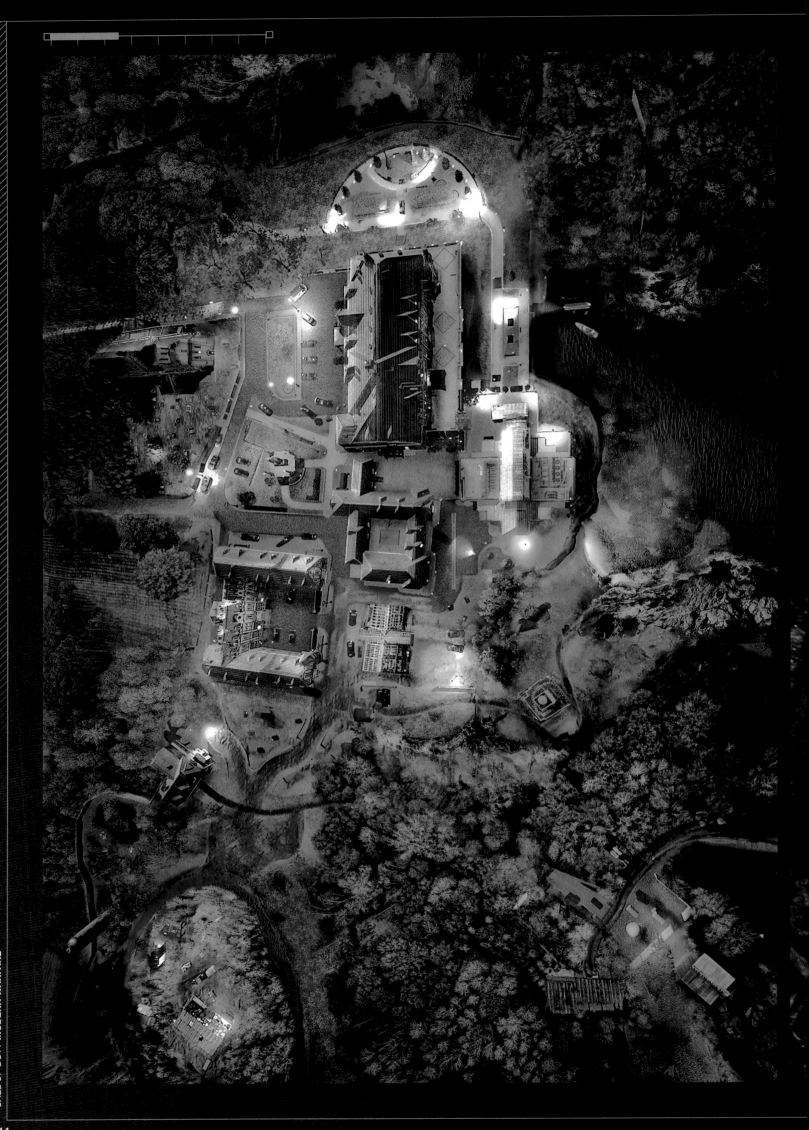

LOCATIONS // **ESTATE**

There is much variety in the Estate mission. Gameplay objectives can be approached in any order of the player's choice, there are light and dark action sequences to complete and enemies can be manipulated by shooting out certain lights within the compound.

The main image to the *left* demonstrates the size and variation of the Estate environment. The conflict unfolds throughout a number of buildings, both large and small, there are multiple floodlit pathways to negotiate, remote outposts to locate and the whole area is surrounded by deep woodland. This presented unique challenges in terms of the lighting models. Also, the night-vision goggles were modified to automatically detect when the player is indoors or outdoors; switching to a long range torch outside, so that the player can engage enemy soldiers over greater distances.

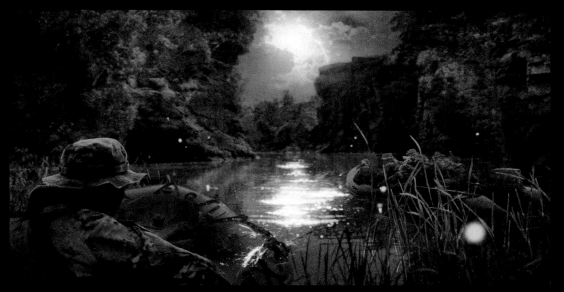

Night-vision goggles have become a staple of the *Modern Warfare* series, rendering scenes in an uncanny green light. The woodland scene *below* looks serene in the moonlight. It is likely to be anything but peaceful, of course...

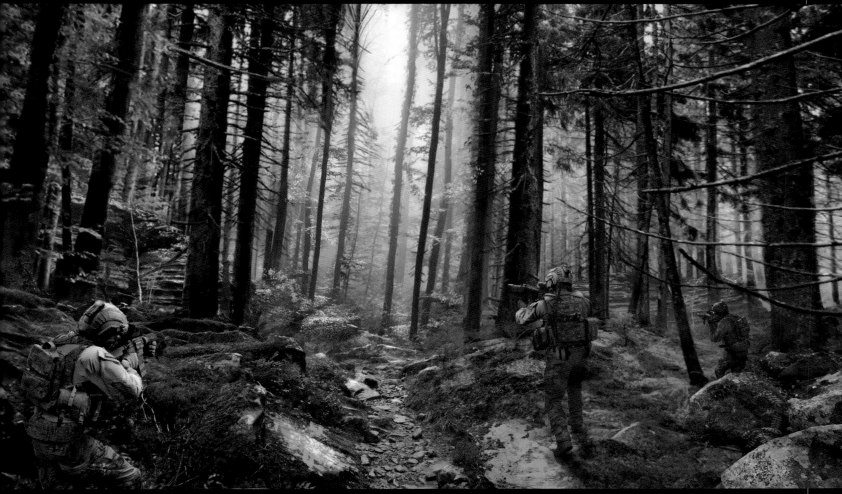

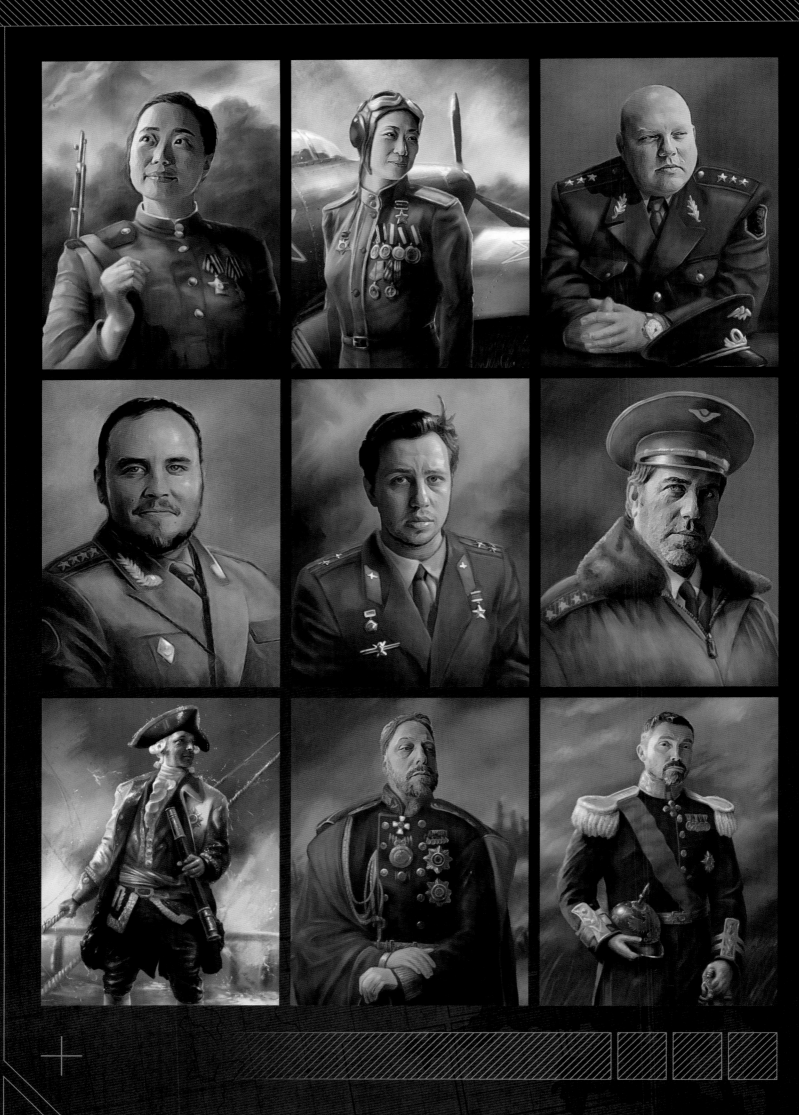

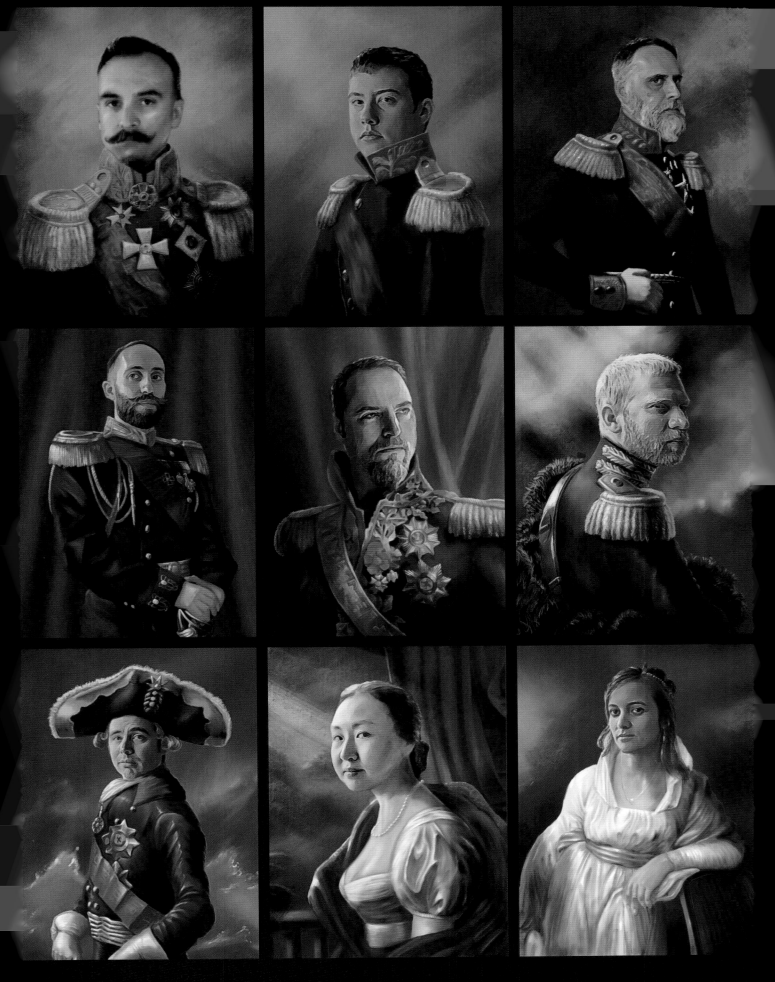

A rogues gallery by any definition, these are just a few of the paintings adorning the walls of the stately home and surrounding buildings of the Estate' mission.

The faces in these lavishly painted portraits will be unfamiliar to the majority of *Modern Warfare* players. However, they're actually members of the Infinity Ward team. It's always nice to add personal touches like this to the game that end up becoming cool Easter Eggs.

LOCATIONS // **CLEAN HOUSE**

Sometimes inspiration strikes and an idea can arrive fully formed. More often than not, however, it takes time and further consideration to refine a concept, and an original thought might lead to a completely different conclusion.

Such was the case for the 'Townhouse' level. In early development we had an entirely different beginning. Players would infil on the other side of railroad tracks and make their way through a garage. No matter what we did here, the garage part of the level got in the way of the assault. We then decided to get straight into the Townhouse, and the level finally came together with the right pacing that made the mission feel realistic.

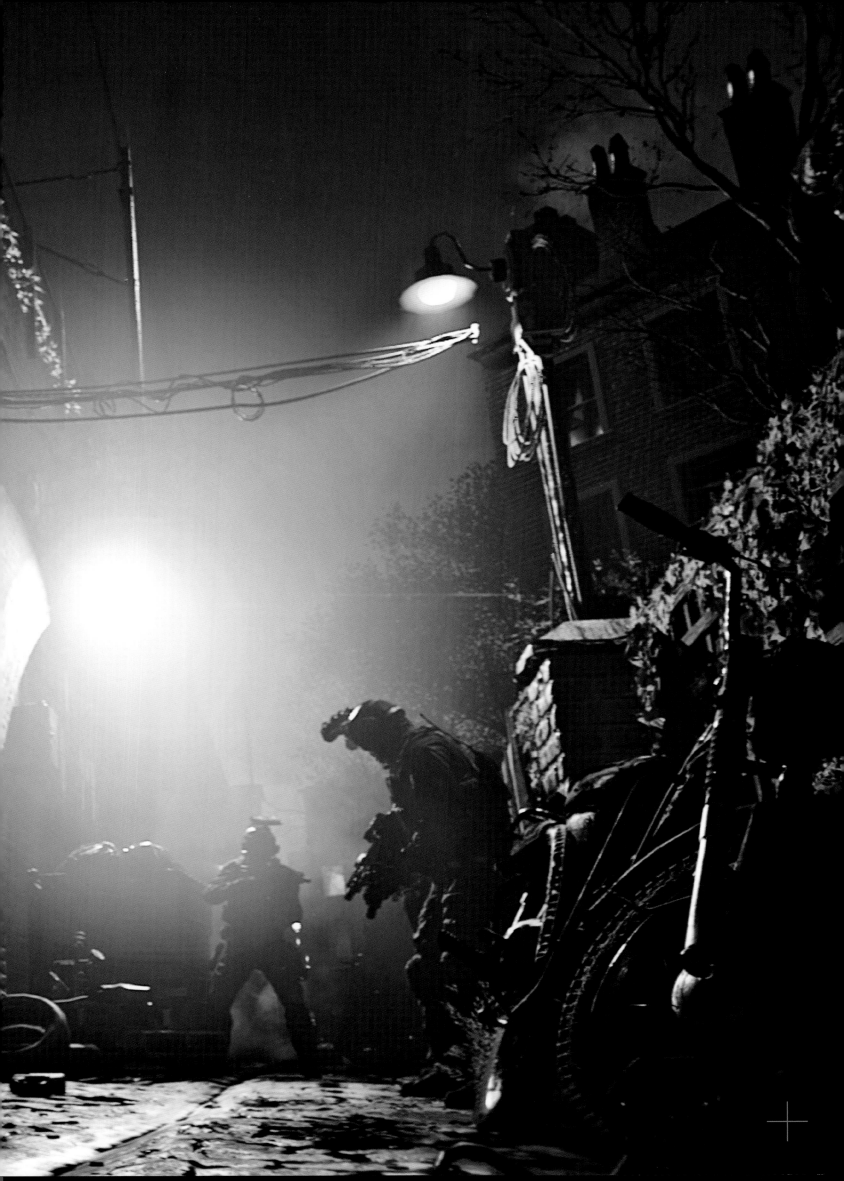

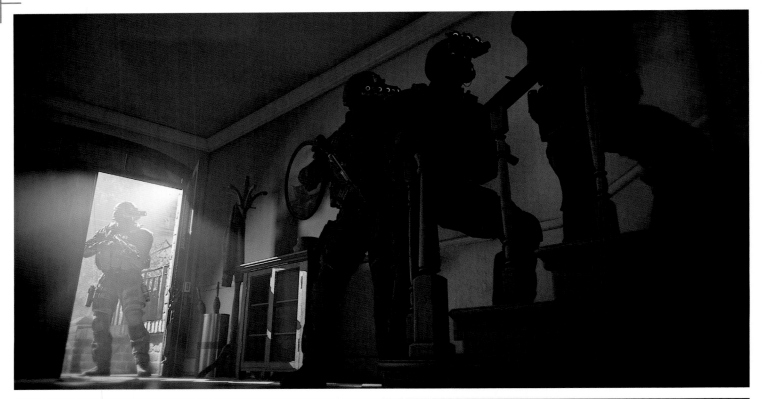

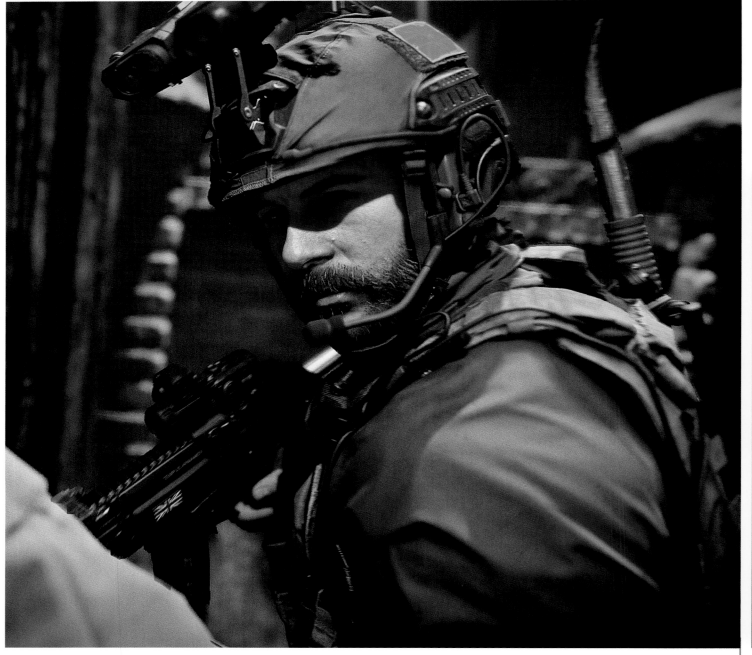

Townhouse encapsulates the accurate sense of scale felt throughout *Modern Warfare* – the building proportions in other games are sometimes exaggerated to aid player and AI character movements, and to avoid the potential for bugs to occur, but this environment is largely constructed at a ratio of 1:1. Highly immersive gameplay follows as a result.

Images to the *left*, *middle-left* and *below* illustrate the infiltration component of the mission. Dramatic backlighting heightens the tension as SAS operatives prepare to breach the Townhouse courtyard. All three of these pictures have been captured within the game engine.

Above: Night vision goggles will come in handy during certain sections. *Below:* Volumetric lighting adds much atmosphere to this tense sequence.

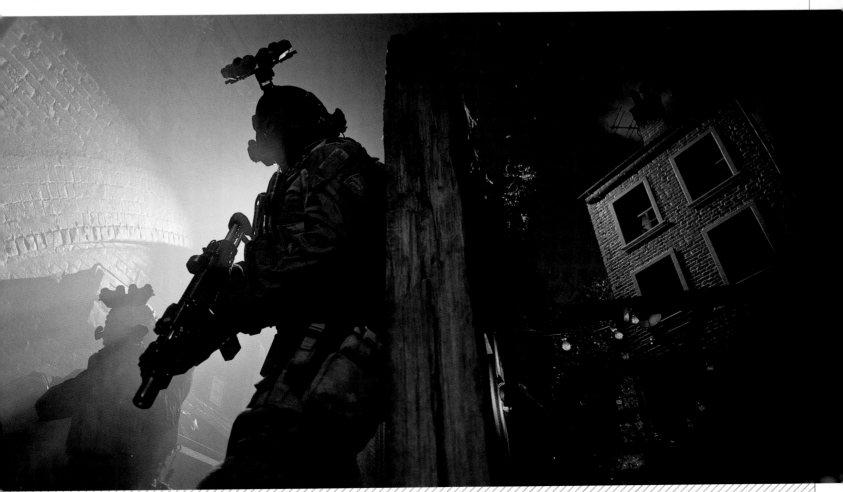

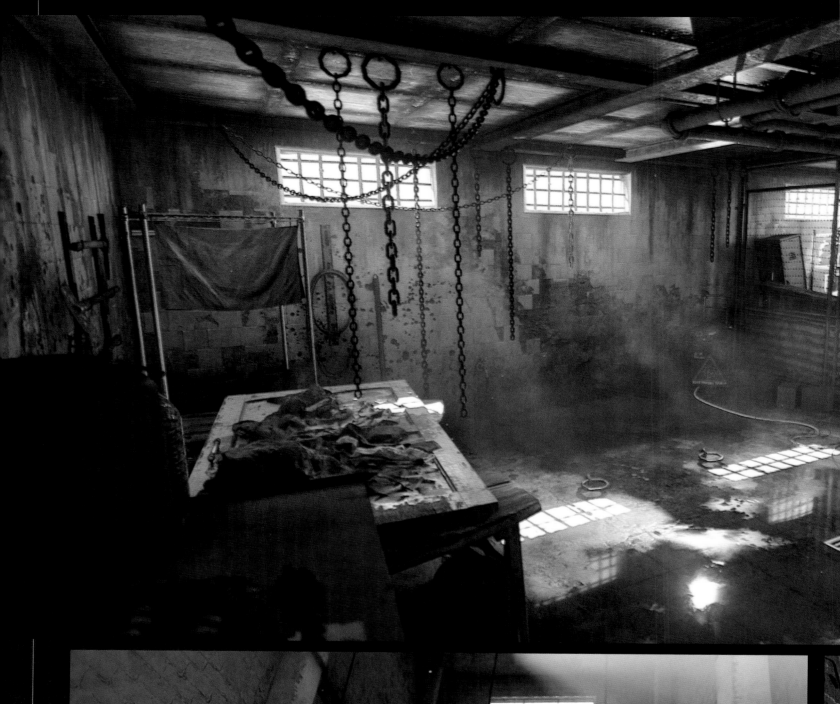

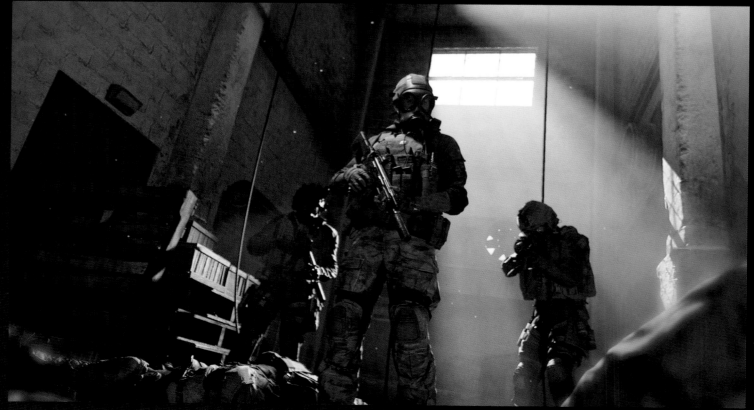

LOCATIONS // **CAPTIVE**

Some *Modern Warfare* locations are grim by nature, although these images might have come straight from a horror movie.

Chains hang from the ceiling; their purpose unknown but unlikely to be anything pleasant. Meanwhile, an old door makes for an ad-hoc bed or some kind of interrogation table, there are metal hoops in the concrete floor, there's a palpably dank atmosphere and the less said about the reason for the electrical wires strewn about the better.

It's no wonder that gasmasks are required in this nightmarishly dilapidated environment. This mission is crucial, however, as SAS operatives attempt to break in and free a prisoner. As elsewhere, all the images here are captured in-engine.

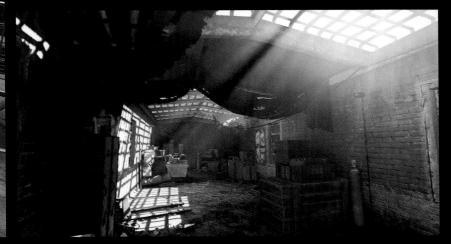

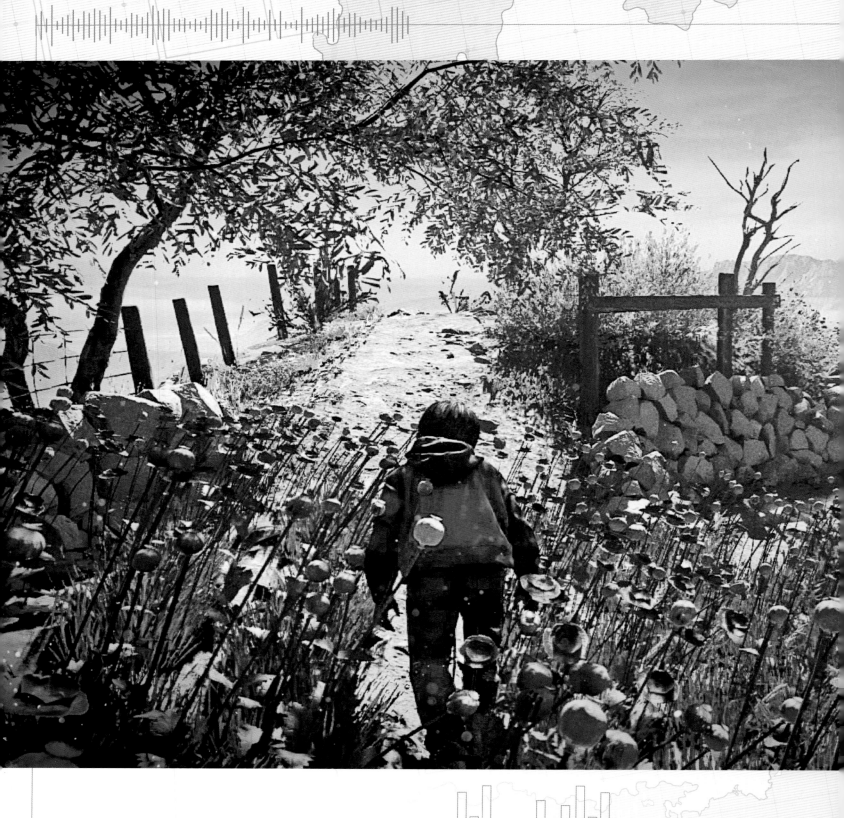

LOCATIONS // **HOMETOWN**

Among the chaos and raging firefights of other *Modern Warfare* missions, Hometown is unique in the emotional punch that it delivers.

Hometown is quite unlike other levels created for the *Call of Duty* series, in being viewed as a flashback to childhood. As youngsters, Farah and her brother Hadir are witnesses to harrowing events when

their homeland is attacked and occupied by invading foreign forces. The rural image *above* is part of their story, although those on the *right* illustrate scenes of the violent incursion itself.

No child should ever have to suffer such actions, of course, but what Farah and Hadir see as children informs their later development as ardent freedom fighters.

Above: An apparently tranquil scene in a rural poppy field hides the truth of a poison gas attack. Reactive foliage sways in the wind, indicating that the poison will soon blow away and the air will be safe to breathe again. This ingenious feature took several months to get right.

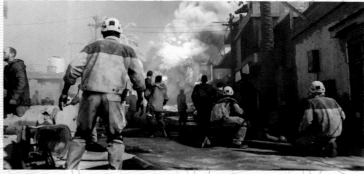

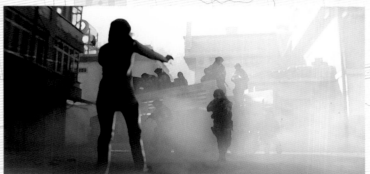

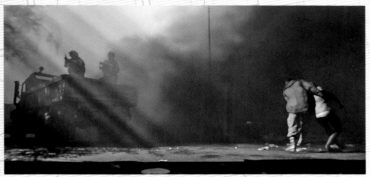

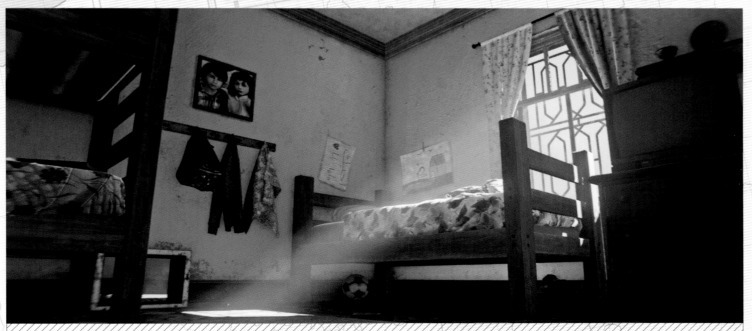

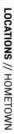

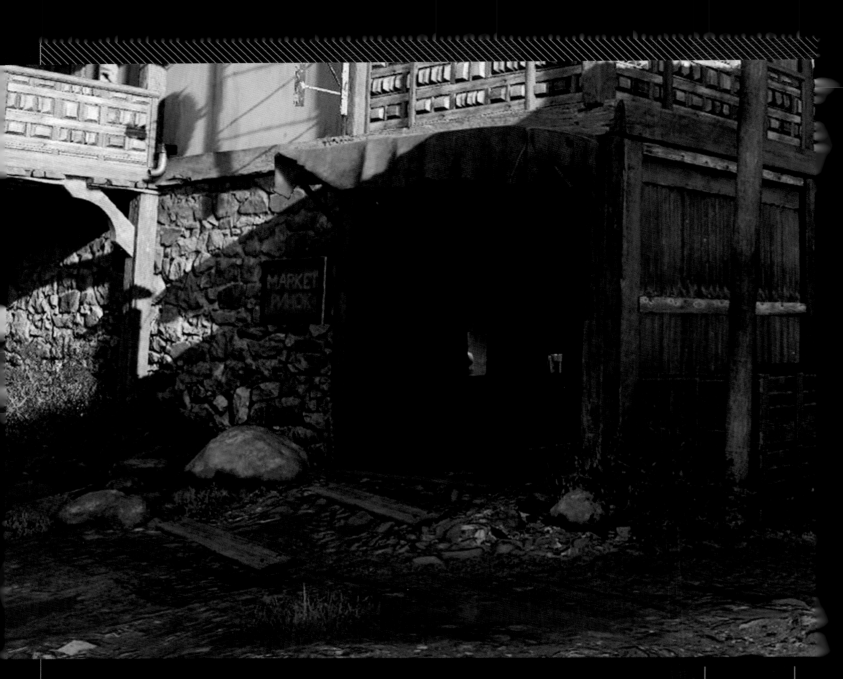

LOCATIONS // **DEADZONE**

Whether their cause is justified or not, the means employed by Al Qatala are certainly harsh and the organization is spreading across the globe.

An AQ cell has established a base in a Ukrainian village, from where they plan to store weapons and launch attacks in the region. Russian intel reports that the insurgents have taken prisoners and hijacked missile launchers. A mission is deployed to rescue the captives, destroy the cache and recover the missing equipment. One of the interesting aspects of this map is the idea of putting modern elements into an older looking environment. The contrast adds an element of personality.

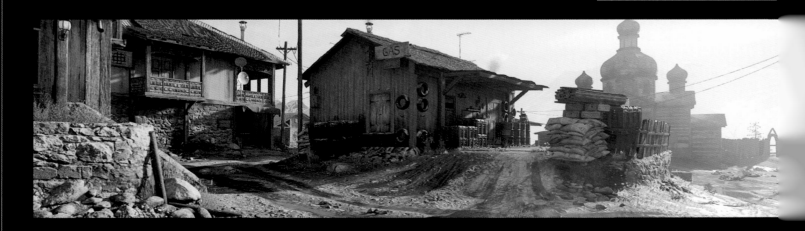

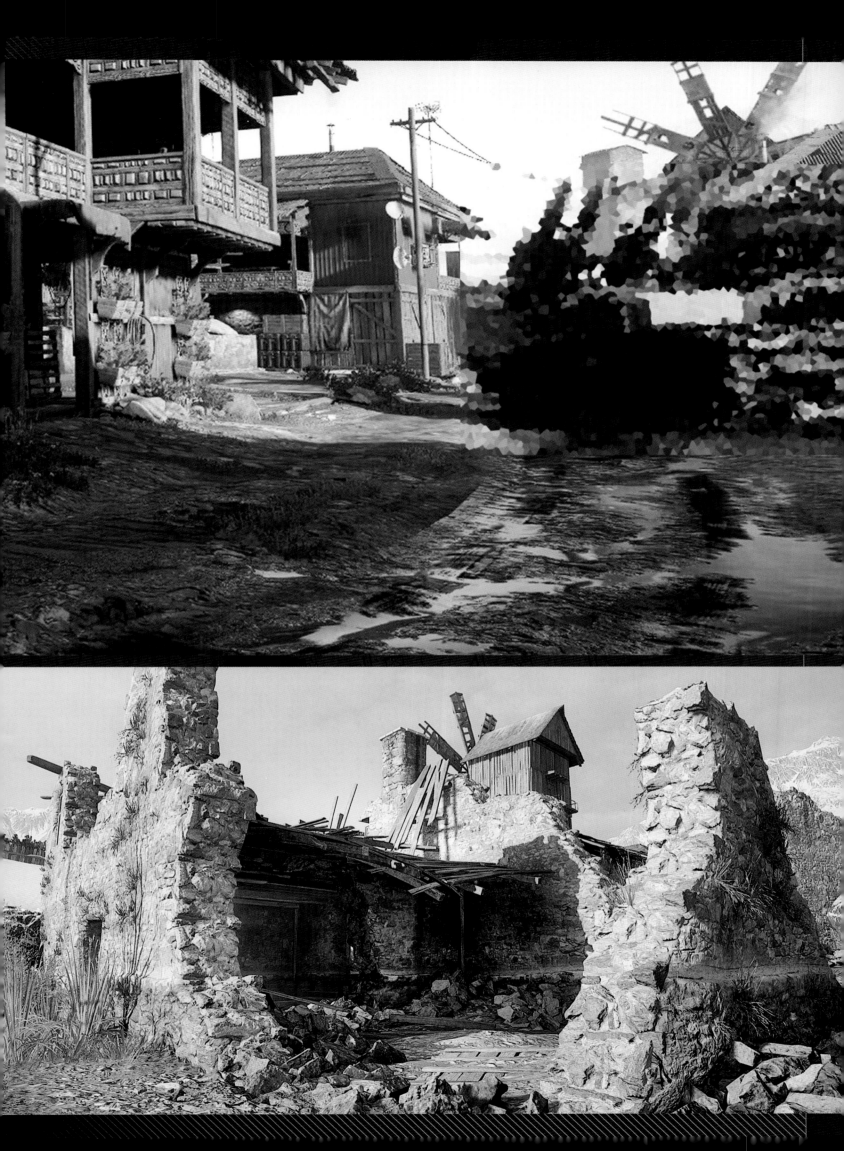

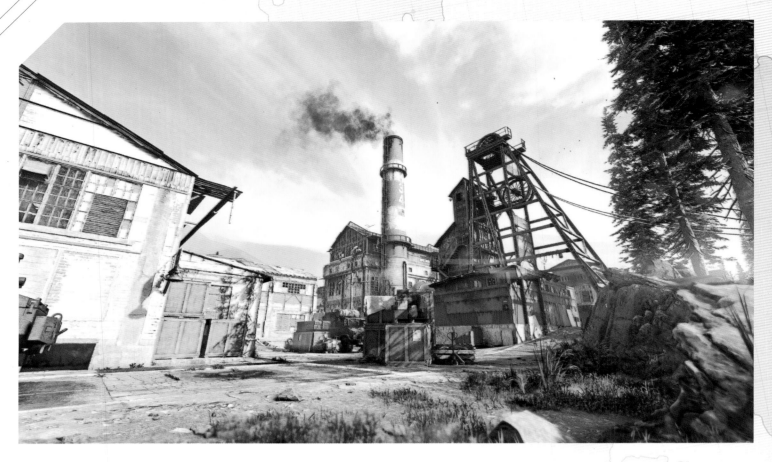

LOCATIONS // **RUNNER**

Trouble stirs among the pitheads and chimney stacks of this rural Russian coalmine. Rising smoke indicates that it is still semi-operational, although it also serves as a novel arena for raging multiplayer firefights.

Runner is surely ripe with gameplay potential, with stacked shipping containers, wooded areas and railway infrastructure. Also, with its lofty towers and building rooftops, there are lots of

opportunities to gain a height advantage over an opponent–or to become an easier target, of course. One can only hope that the mine cart comes into play at some point.

These images demonstrate scenes from Runner in an earlier iteration, major sections having been expanded as the game developed. The images *above* and *right* provide a taste of what players can look forward to.

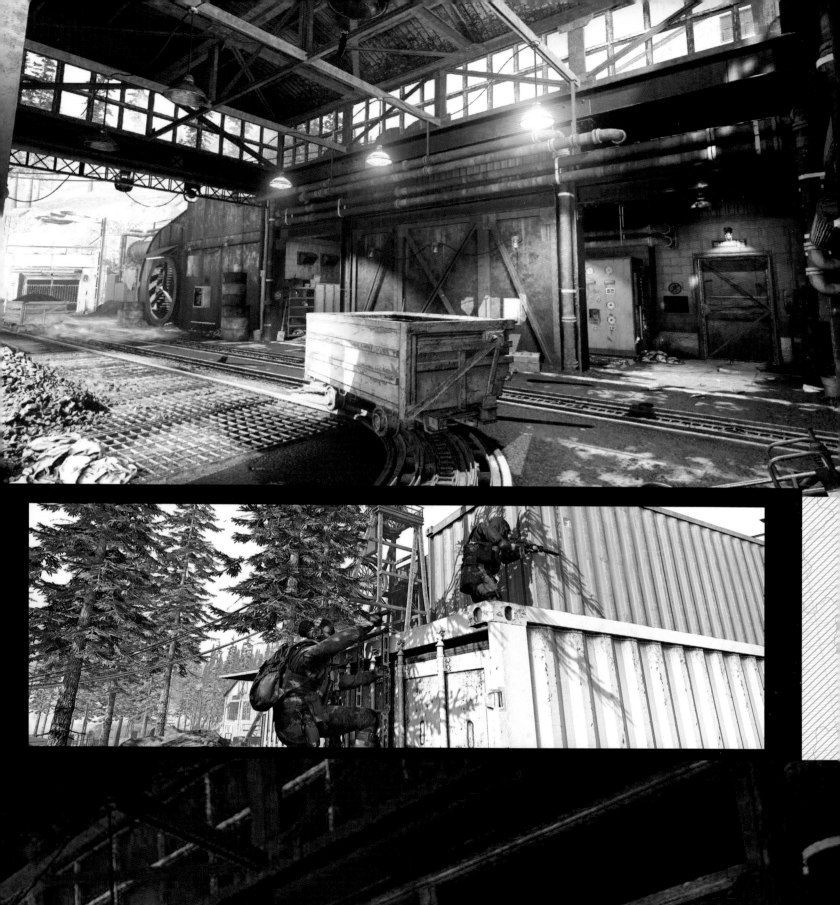

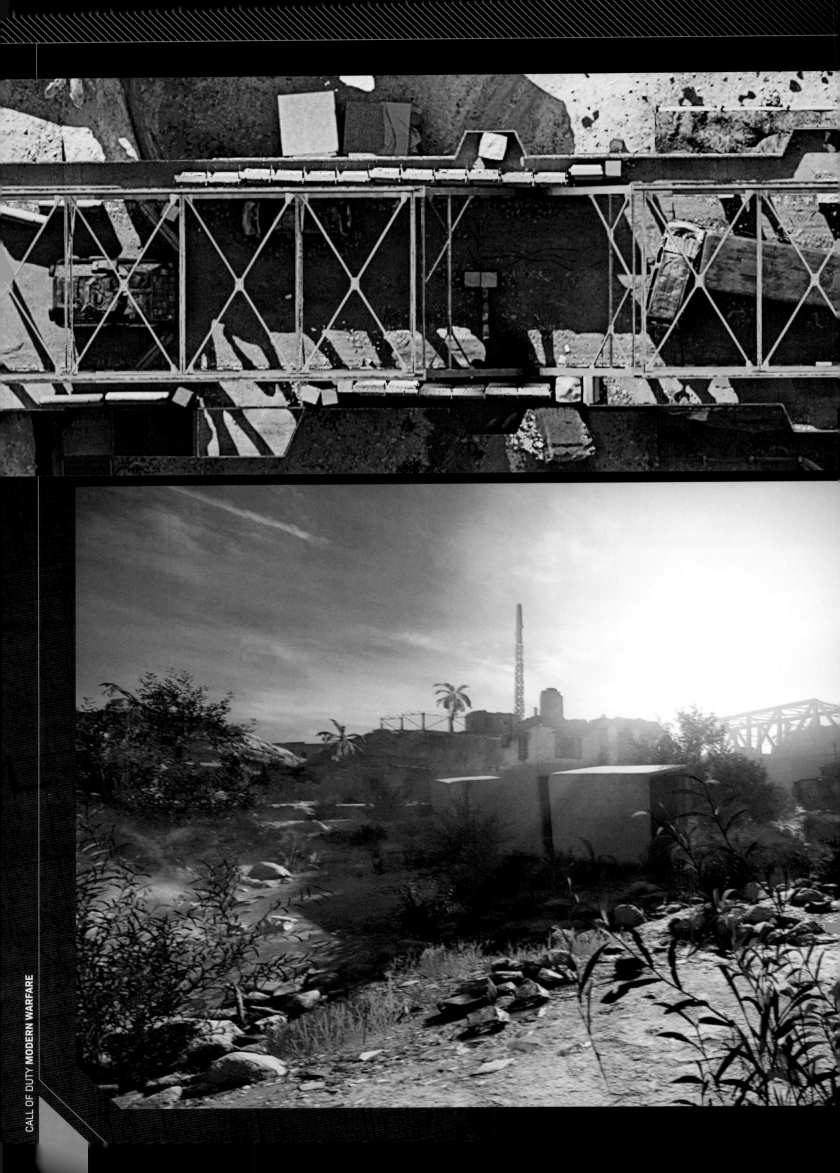

LOCATIONS // **EUPHRATES**

Like many places visited in the game, this fictional Urzikistani town is inspired by real world locations. It is otherwise a scene of great turmoil, as Allied and Al Qatala forces clash. A single bridge provides the sole access, but a stranded bus is rigged with explosives that could detonate at a moment's notice.

Euphrates is one of our favorite levels. The high ground of the bridge and the surrounding structures offer great vantage points that overlook the play space.

An overhead view of the girder bridge offers a preview of the dangers ahead. The abandoned bus is a potential hazard that's best avoided, although the image *below* suggests that the entire bridge is booby-trapped.

LOCATIONS // **BUILDING KIT**

Game development is a complicated and lengthy process, and certainly more so when the goal is photo-realistic perfection. However, with all the research and prototyping in the bank, *Modern Warfare* designers were able to develop 'Build Kits to help streamline production. These are basically collections of assets that fit together, both technically and thematically. Building vast environments is difficult and time consuming if you are to start from scratch each time you build a new area. Build kits make building environments, easier with creative freedom that doesn't slow the game down.

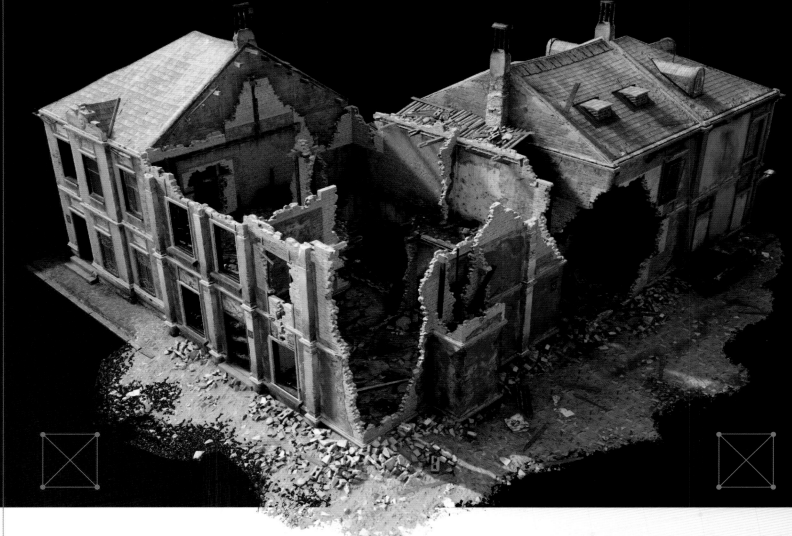

163

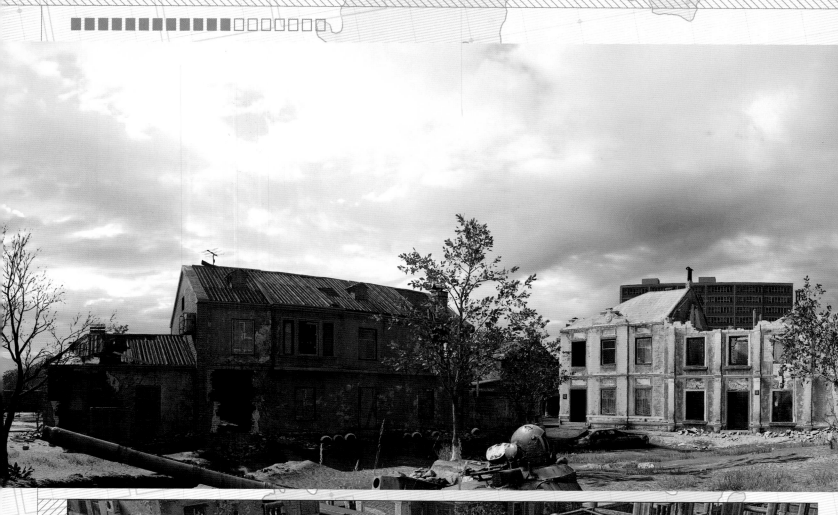

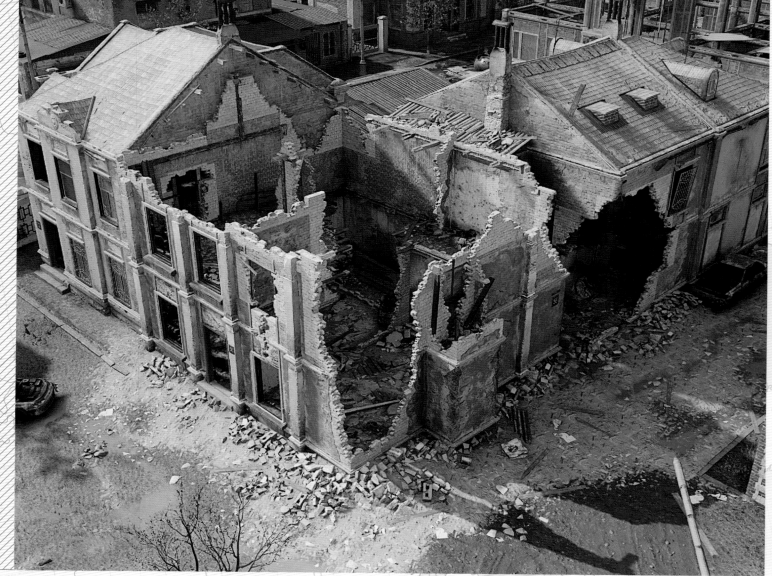

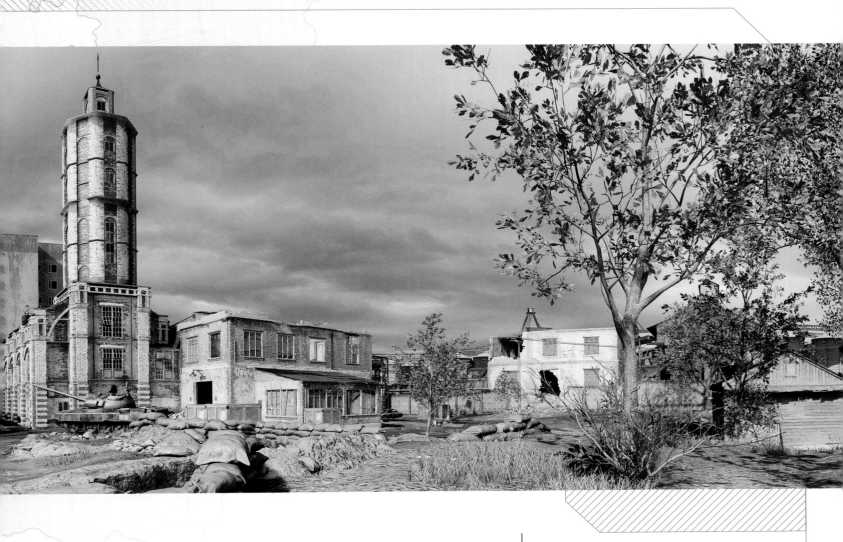

LOCATIONS // **RAID**

The blasted town of 'Raid' is set in an undisclosed Eastern European location. It is the present day, although the destroyed buildings, wrecked vehicles and empty streets make some sections look more like scenes from World War 2. In this respect, the Raid map could be seen as a return to the roots of the *Call of Duty* series.

Raid has plainly suffered as the result of a recent conflict. Happily, the vacant shells of its bombed-out buildings make perfect hiding places, or covert vantage points to give players the upper hand in multiplayer firefights. The possibilities are tantalizing, indeed. The buildings themselves are incredibly realistic, thanks to use of 'photogrammetry'–a technique that seamlessly blends real-world and digital images

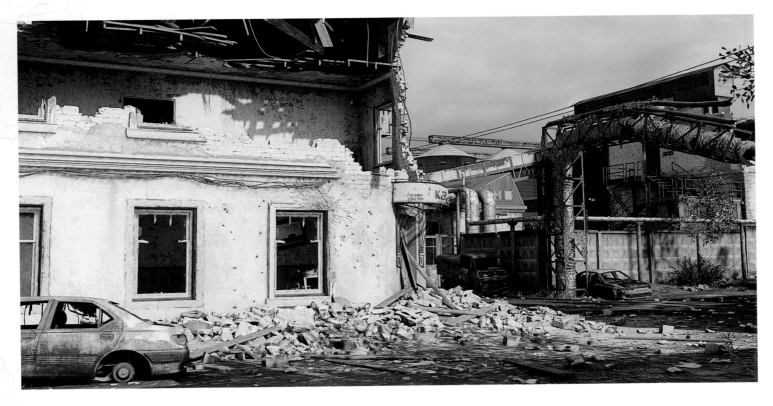

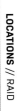

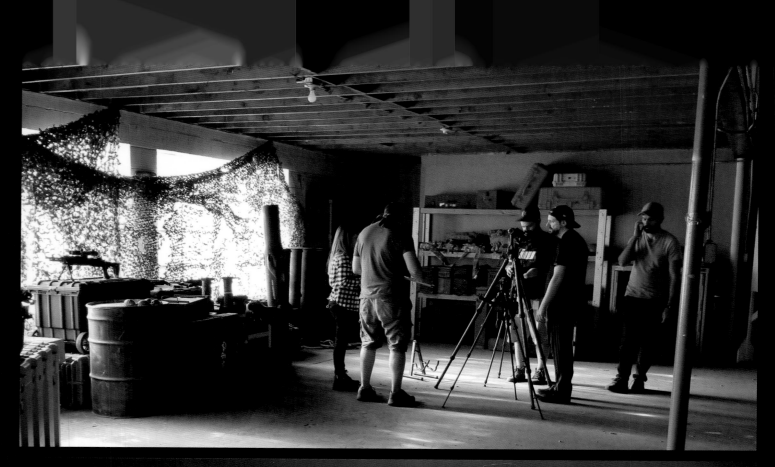

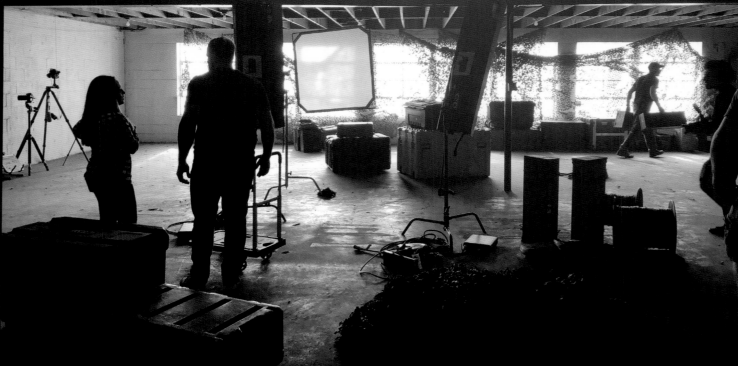

CHARACTER SELECTION

COMBAT OPERATOR
ANIMATES INTRO WHEN
SELECTED.

EAST ▷

BACK-
GROUND
OUT OF
FOCUS

5

SELECTABLE TILES
FOR CHARACTERS.

LOCATIONS // **CAPTURING REALITY**

Character selection is an enjoyable part of the *Modern Warfare*
multiplayer experience, although the process is considerably enhanced
in this game. Once again, real and digital images were combined
to incredible effect. We needed a photorealistic set to place these
characters in, but these sets had to be created quickly and be low on
memory so that we could fit them into our menu systems. We started
with concepts and decided to use a photo projection technique to
create the sets in-game. The challenge was that we needed to go
to real locations, and create and dress physical sets. Once we had
our shot we captured the scene with our cameras and took precise
measurements and readings.

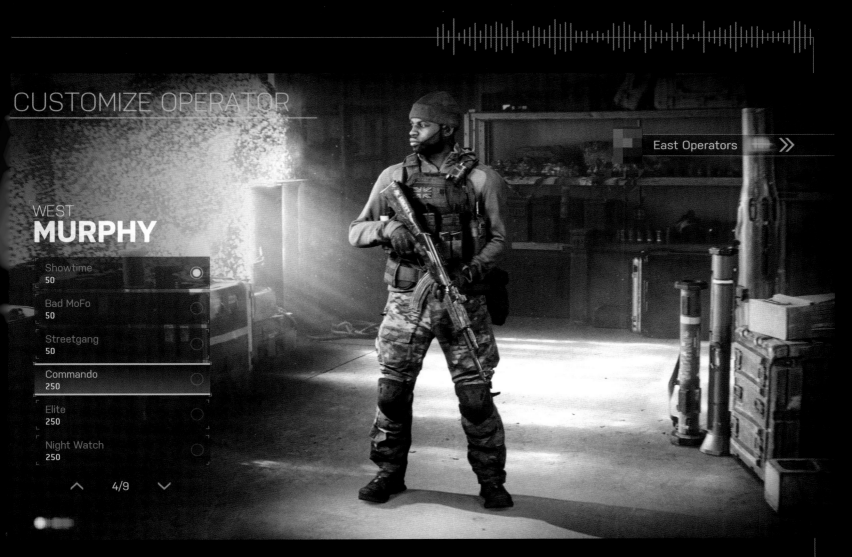

CUSTOMIZE OPERATOR

East Operators »

WEST
MURPHY

Showtime 50	●
Bad MoFo 50	○
Streetgang 50	○
Commando 250	○
Elite 250	○
Night Watch 250	○

∧ 4/9 ∨

Superimposing a digital character over an image of a real background might have been easier, but the *Modern Warfare* team took up the challenge of making the character appear to *inhabit* the environment. Integrating our real-world captures was tricky at first, but we soon discovered techniques to get our characters to seamlessly stand in our photo-projected sets. The final result is the character standing in a three- dimensional space that has depth and is photo-realistic.

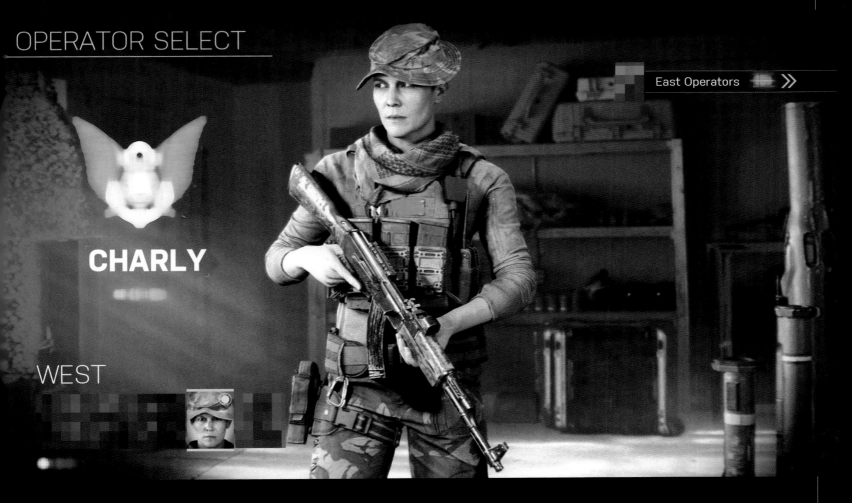

OPERATOR SELECT

East Operators »

CHARLY

WEST

When a physical set is created, the *Modern Warfare* team captures an image called an 'IBL'– an 'Image Base Light'. These are generally used as sky boxes for an environment, although this was slightly different. Firstly, the team needed to become proficient at capturing rooms and small spaces, but also in a way that supported High Dynamic Range. This entailed several different exposure layers for each of the photographs taken. These enhanced IBL images allow characters and objects to look like they were in the scene when it was photographed. If a character is wearing sunglasses the entire room is reflected in its lenses.

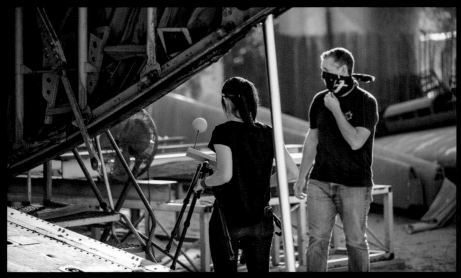

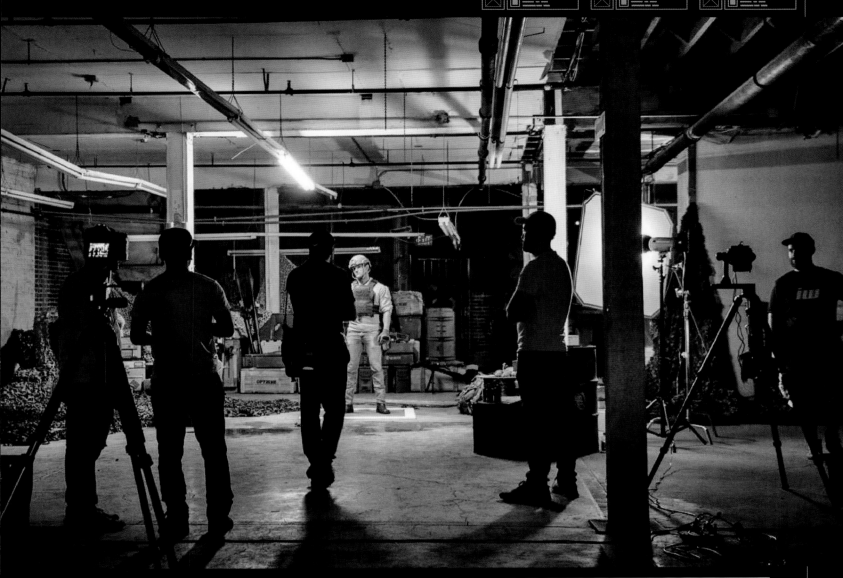

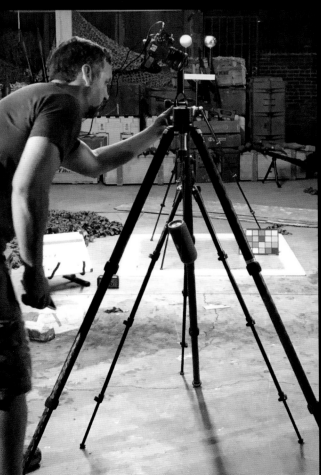

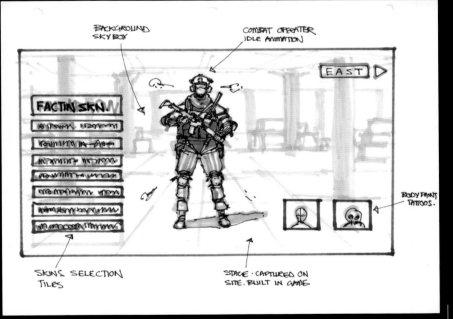

BACKGROUND
SKY BOX

COMBAT OPERATER
IDLE ANIMATION

EAST ▷

FACTIN SKN.

BODY PAINT
TATTOOS.

SKINS SELECTION
TILES

SPACE · CAPTURED ON
SITE. BUILT IN GAME

Perfect preparation prevents poor performance, as the saying goes.
For the *Modern Warfare* team, this not only entailed the effective
management of multiple resources and several departments, but also
the storyboarding of each image or sequence captured. These setups
required a tremendous amount of coordination. Everyone pitched in to
get the job done. It is very helpful to go into these types of setups with
a proper plan in mind. Storyboards go a long way, and are useful tools
for communicating the idea of what we are trying to achieve.

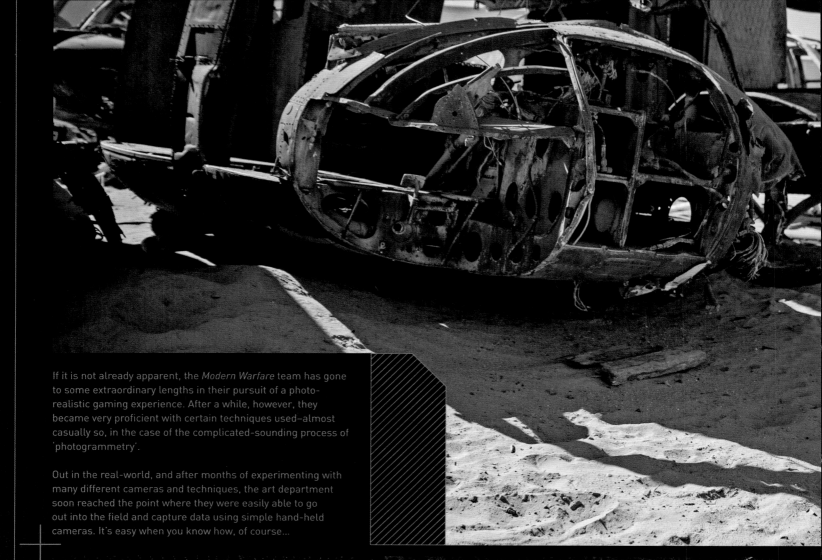

If it is not already apparent, the *Modern Warfare* team has gone to some extraordinary lengths in their pursuit of a photo-realistic gaming experience. After a while, however, they became very proficient with certain techniques used—almost casually so, in the case of the complicated-sounding process of 'photogrammetry'.

Out in the real-world, and after months of experimenting with many different cameras and techniques, the art department soon reached the point where they were easily able to go out into the field and capture data using simple hand-held cameras. It's easy when you know how, of course...

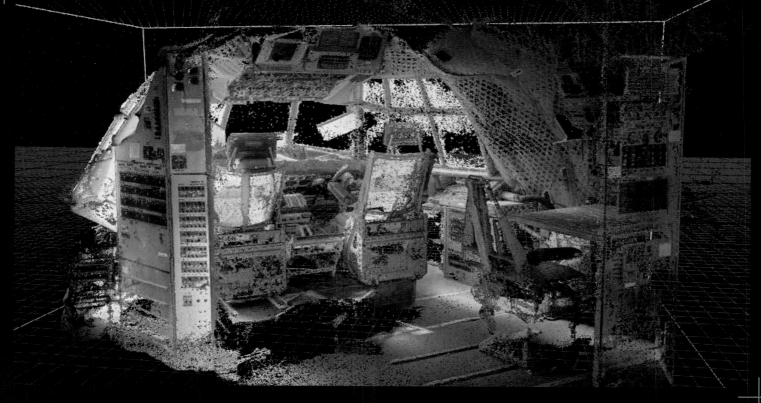

The process of photogrammetry is beginning to look like fun, although it is undoubtedly more complicated than it might appear. In the hands of skilled professionals, however, the photographs taken with relatively simple cameras can later be used to bring unprecedentedly photo-realistic images and environments into the game. Using these hand-held cameras also facilitates the capture of images and data that would otherwise be nearly impossible to get. The data can then be integrated on a one-to-one level or used by artists as handy three-dimensional guides for building convincingly lifelike models.

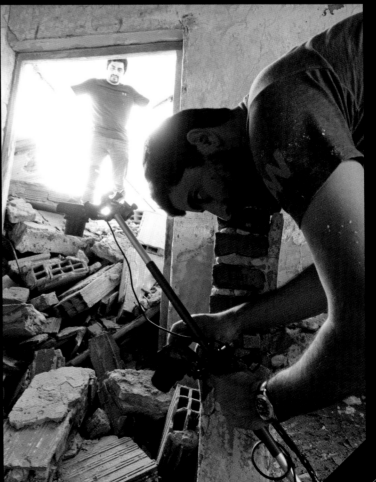

WIREFRAME	ALBEDO	GLOSS	NORMAL

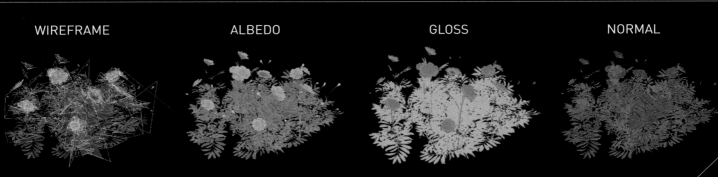

Adding flora to a level is no simple task of picking something green and vaguely plant-like, and then placing it wherever it might look convincing—not in the *Modern Warfare* universe, at least. Creating a new environment also entails researching and capturing even the smallest details. When we start the build process of a new environment style or a location, we research the types of biomes that would exist in that region. We use reality capture to collect the data and then integrate it into our libraries. All of this involves a tremendous amount of very specialized work.

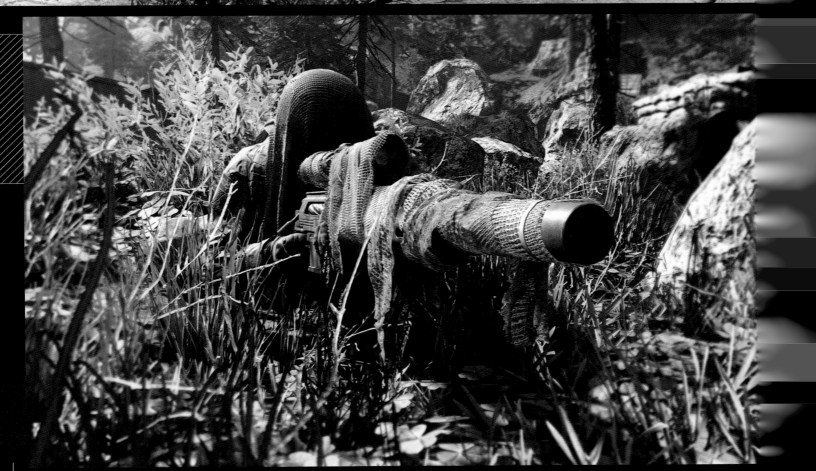

Flora and foliage are notoriously difficult to get right, and then environmental factors might also have an effect—a field of poppies bending convincingly in the wind, for instance, or the way that light makes leaves and grasses seem to glow when they are back-lit. Deep foliage

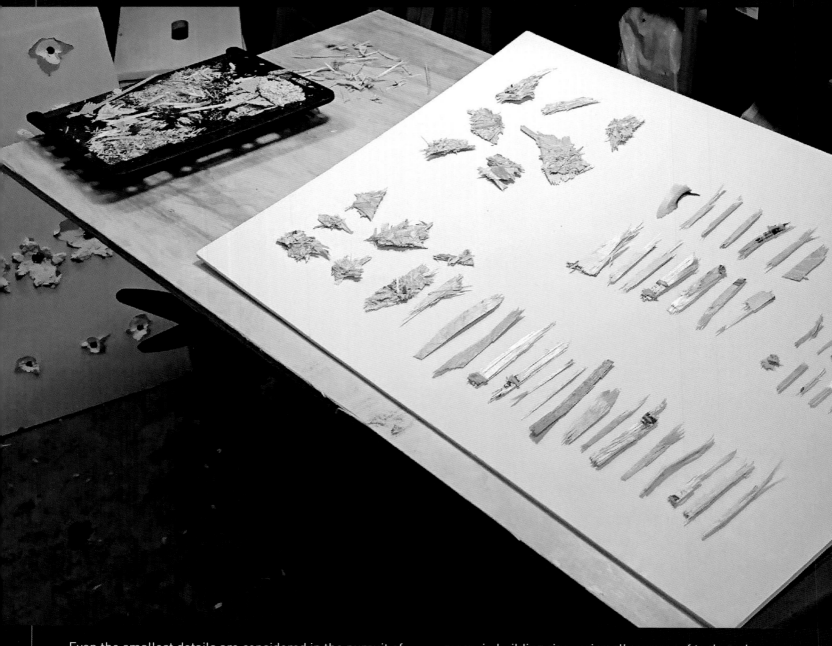

Even the smallest details are considered in the pursuit of photorealistic perfection. The *Call of Duty* series has always involved a range of destructive gameplay, but how often do players really think about the way that bullets leave holes in certain materials, how wood splinters when it is hit and how rock and concrete shatters?

It might be easy to overlook such minor details while playing, but when the rest of the game looks so utterly convincing the *Modern Warfare* team just had to get them right. What's

more, in building rigs, using all manner of tools and generally smashing things to pieces, it looks like they might have had fun at the same time!

To achieve realistic looking impacts for our weapons our VFX artists created a library of practical impacts that they could use for reality capture. Various materials are brought into the lab and pulverized using different techniques to achieve the desired effects. The VFX team even constructed their own custom scanners to capture the data.

■■■■■■■■■■■■□□□□□□□

It seems somehow fitting to conclude this chapter with a collection of cloudscapes and sunsets. These might be painted by a skilled digital artist, although that would not suffice since the *Modern Warfare* team is trying to make every element of the game look as convincingly lifelike as possible.

Intensive field study was once again the solution, although it does not appear to have been much of a chore for anyone involved. Even so, copious photographs of skies and sunsets were taken in many locations, and factors such as time and prevailing weather conditions were measured.

Put simply, if the skies in *Modern Warfare* look realistic, that's because they probably are.

The skies you see when you play the game are captured by our lighting team. Several trips were made to remote locations to photograph unique skies. It was crucial that the team not only photograph the skies overhead but also take precise measurements where the photos were taken. This requires a good deal of patience and even greater technical knowhow. The data they captured helps give the game its photographic look.

GRAPHICS

THE PURSUIT OF A credible experience has led the *Modern Warfare* team to consider even the smallest details—from product branding and the posters seen on walls, to faction insignia and body art. You might overlook the minutiae in the heat of battle, but the game would feel flat and lifeless without them. Here's a selection of the background visual items found throughout.

GRAPHICS // **BRANDING**

Modern Warfare combatants will come across many products and faux advertisements spread throughout the gameplay environments– all fictional, but each appropriate to the location and presented in an entirely authentic manner.

There is a sense here that the design team had fun in creating this selection of logos. If not for the fact that they're imaginary, it would be easy to believe they are the logos for real-world automotive items and suppliers.

KO

HI

АПТЕКА

HALSOP
INJECTION

MAIDENHEAD
DRIVE BELTS

ELIOT'S
LONDON

Road Couch
AUTO PARTS

Creed & Billy
auto parts
est.1967

Q

GRIP

REIFEN

Red-Red
LUBRICANTS

PISTOL GRIP

P

TOOLS

GB
otto

AZ1

crédit
mondialo

PHONIC
CELLULAR

Racing
CHAMPIONSHIP
'62

Frist Event
11 A.M.

RACING ORGANISED BY
LIVERPOOL RACING CO.

Admission
25/-

GRAPHICS // **AUTOMOTIVE POSTERS**

As with the branding seen previously, this selection of automotive posters has been given the same amount of consideration and is equally convincing. Given the use of the Union Jack flag in the background of the posters *left* and *above left*, it's a safe bet at least two of these images hail from the UK-based missions. The attention to detail is laudable regardless of their location, however.

Likewise the design and branding of the motor oil products *above* and *below*—none of which are available in stores right now, or at any time in the future. The game takes place all over the world, so we had to create ads and other branding that fit the local cultures for which they were supposedly created.

GRAPHICS // **DRINKS LABELS**

Counteracting the worst excesses of zealous terrorist factions and power-crazed Russian generals is thirsty work. Sadly, *Modern Warfare* players will not be able to avail themselves of the delicious looking sodas *below*, although they look so plausible they might easily exist in the real world.

Luna beer, *above*, might well be magic in a bottle–even though such a brew never

existed. However, this scuffed bottle is performing an entirely new trick as an impromptu incendiary device. Useful in a tight spot, no doubt, but the characters in the game would probably have preferred the original contents after a hard day on the battlefield. Even the finest details had to be considered. Beverage companies and even the Molotov Cocktail had to be an original creation.

CORVUS DEFENSE

GRAPHICS // LONDON

Below: This poster from Piccadilly Circus might be fake, but it still seems utterly plausible. The logo *above*, meanwhile, is suitably serious for the in-game arms manufacturer.

Players might not appreciate such symbols, as they engage in a fraught mission to prevent Al Qatala operatives from detonating an explosive-laden van at this iconic location. However, minor details like this, in combination with other signifiers– such as red London buses–makes for a more cohesive and believable depiction of the city.

The city is filled with ads for products, shows, events and such. This poster imagines a corny medieval-themed musical, but it might be fun to spot similar advertising in the London missions.

THE UNTOLD MUSICAL STORY

TRIUMPH

GRAPHICS // **INSIGNIAS**

The symbols indicating the allegiance of factions fighting in the game are yet more examples of the extraordinary lengths the *Modern Warfare* team has gone to in their pursuit of a credible game experience. Such details have no bearing on the action, of course, although they can bring a sense of authenticity to any environment, and their absence would have led to an ineffably lesser experience on the whole. A layer of detail that makes a world of difference in character and vehicle design is the markings passes. Having these details included in the artwork really makes them take on a level of realism. It is often the most fun part of building videogame models.

GRAPHICS // **GAME MODE ICONS**

Modern Warfare comprises a thrilling campaign for single players and a number of exciting modes designed to suit multiplayer gameplay. It remains for combatants to discover what each of these ominous looking icons represents, and the mission requirements within. The creation of these symbols was slightly problematic, however, and we had to go through hundreds of designs to get versions that we can use. The most challenging part is creating icons that can be seen at very small sizes.

These icons don't only represent a gameplay mode, but also the players and teams engaged in them. As such, each icon is designed so that it works in a variety of colorways.

GRAPHICS // **FACTION ICONS**

Things are starting to get personal, with this selection of player-selectable icons to use as faction insignias in the multiplayer battlegrounds. This is just a sample, although the preponderance of aggressive and dark imagery seems somehow relevant to the ferocious action in store. Less overtly hostile icons are also available–the Special Forces badge is positively sober in comparison to the others on this page–but the remaining choices at least bespeak intention on the part of the player.

Modern Warfare's multiplayer gameplay has gone back to its roots in factions. We had to find designs for both Western and Eastern sides and the sub-factions that fall under those two. Each sub-faction icon is meant to embody the personality origin of the squad it represents.

Faction icon design is a tricky business, with designs intended to represent aggression, a death-or-glory *esprit de corps* or to strike fear in the hearts of opponents.

GRAPHICS // **BODY ART**

Customization options are a crucial component of the multiplayer experience. Players may of course enter any combat arena kitted out with the default selections, although that is to miss out on some of the fun available beforehand. Seen here is just a small selection of tattoo concepts designed by the *Modern Warfare* team. Fierce imagery prevails, naturally, and it presumably falls to the player to make good on the promise of their ink choices thereafter.

Our Combat Operators have a considerable amount of variations and incarnations. For many of the alternates we like to include tattoos and other forms of body art. It's amazing to think that we went to this level of detail to render onto the characters' skin.

There is no requirement to get ink. In any case, once battle commences, opponents are probably more likely to get a better view of a player's choice. However, flourishes such as this add a layer of choice and ensure a distinctive appearance.

KILLCAM 0:03:02

Perks

GRAPHICS // **USER INTERFACE**

Our attention finally alights on a few of the ways in which the game presents itself–how it is viewed in certain gameplay scenarios and in some of the menu options.

Seen *above*, this 'killcam' view reduces the scene to near monochrome, presumably as a function of the lower-specification of the camera aboard the device–or perhaps

for clarity. A variety of weapon selection screens and interfaces *below*, all suitably military and utilitarian in their appearance. The User Interface has been in development since day one. These are just a few, but if we were to properly cover the work that goes into this part of the game we would probably need two books!

ROLL GUNSMITH AK47

MOD Level : 10
Weapon Level : 1

DATA_SEQUENCE/SEC

DEPLOYMENT

01:42 42

Stop

Weapon Unlocked

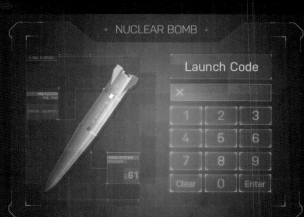

NUCLEAR BOMB

Launch Code

1	2	3
4	5	6
7	8	9
Clear	0	Enter

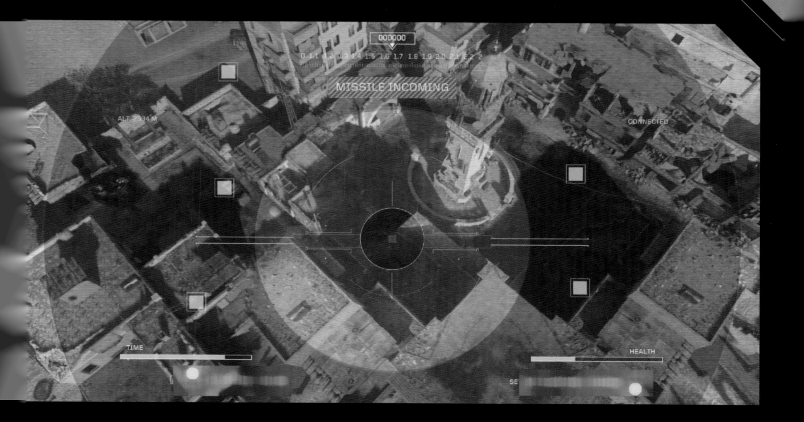

A similarly colorless view is adopted in this overhead perspective of the battlefield. Players of previous outings will recall many occasions when similar aspects were required for the sake of gameplay.

An authentic presentation was once again part of the experience, although the design of these interfaces entailed a standard approach. The targeting systems in the game have many layers to them to make them seem realistic. Aside from all the graphical features used to make it seem as though you are looking through a drone camera or an optic on a weapon, often times we will just simply sketch these elements.

The reticle seen in many gun sights depends on the weapon chosen. Simple crosshairs are generally useful for targeting distant enemies, although do not allow for finer adjustments. It is interesting to see these sketched concepts on the *left*—like scribblings in a school exercise book, but a delightfully analogue solution for what would eventually be a digital interface.

Written and Edited by: Andy McVittie
Designed by: Amazing 15 LTD

Activision
Activision/Blizzard Legal Team: Travis Stansbury, Amanda O'Keefe, Kap Kang,
Pharaba Hacker-Witt, Brian Monson
Special Thanks: Lindsay Murphy, Mike Gonzales, Ashley Maidy ,
The Consumer Products Team and Everyone at Activision

Blizzard Entertainment
Production: Alix Nicholaeff, Derek Rosenberg
Director, Consumer Products: Byron Parnell

INFINITY WARD
Concepts: Thomas Szakolczay, Nicolas Lebessis, Aaron Beck
Character Heads: Bernardo Antoniazzi
Characters: Chris George, Ricky Zhang, Donovan Keele, Jason Maynard, Chris Barnes, Dana De Lalla
Vehicles: Dan Savage, Jon Bailey, Jesse Moody, Thomas Shin, Konstantin Molchanov
Weapons: Peter Chen, Ben Garnell, Michael Velasquez, Ben Turner
Special Thanks: Ashton Williams, Madison Cromwell, Jeremy Thurman,
The Entire Art Team of Infinity Ward
Serious thanks to the entire Infinity Ward development team

They were my landscape

Phoebe Kiely

mackbooks.co.uk

Spring 2018

Front cover:
Sable Elyse Smith,
from the book *Landscapes*
& Playgrounds (San
Francisco: Sming Sming
Books, 2017)
© and courtesy the artist

Aperture, a not-for-profit foundation, connects the photo community and its audiences with the most inspiring work, the sharpest ideas, and with each other— in print, in person, and online.

Aperture (ISSN 0003-6420) is published quarterly, in spring, summer, fall, and winter, at 547 West 27th Street, 4th Floor, New York, N.Y. 10001. In the United States, a one-year subscription (four issues) is $75; a two-year subscription (eight issues) is $124. In Canada, a one-year subscription is $95. All other international subscriptions are $105 per year. Visit aperture.org to subscribe. Single copies may be purchased at $24.95 for most issues. Subscribe to the *Aperture Digital Archive* at aperture.org/archive. Periodicals postage paid at New York and additional offices. Postmaster: Send address changes to *Aperture*, P.O. Box 3000, Denville, N.J. 07834. Address queries regarding subscriptions, renewals, or gifts to: *Aperture* Subscription Service, 866-457-4603 (U.S. and Canada), or email custsvc_aperture@fulcoinc.com.

Newsstand distribution in the U.S. is handled by Curtis Circulation Company, 201-634-7400. For international distribution, contact Central Books, centralbooks.com. Other inquiries, email orders@aperture.org or call 212-505-5555.

Help maintain Aperture's publishing, education, and community activities by joining our general member program. Membership starts at $75 annually and includes invitations to special events, exclusive discounts on Aperture publications, and opportunities to meet artists and engage with leaders in the photography community. Aperture Foundation welcomes support at all levels of giving, and all gifts are tax-deductible to the fullest extent of the law. For more information about supporting Aperture, please visit aperture.org/join or contact the Development Department at membership@aperture.org.

Printed in Turkey by Ofset Yapimevi

Lead support for the "Prison Nation" issue of *Aperture* magazine is provided by the Reba Judith Sandler Foundation.

Further generous support for *Aperture* magazine is provided in part by the Anne Levy Fund, and public funds from the National Endowment for the Arts, the New York State Council on the Arts with the support of Governor Andrew M. Cuomo and the New York State Legislature, and the New York City Department of Cultural Affairs in partnership with the City Council.

OFSET
YAPIMEVİ

aperture

The Magazine of Photography and Ideas

Editor
Michael Famighetti

Contributing Editor
Nicole R. Fleetwood

Managing Editor
Brendan Wattenberg

Editorial Assistant
Annika Klein

Copy Editors
Clare Fentress, Donna Ghelerter

Senior Production Manager
True Sims

Production Managers
Nelson Chan, Bryan Krueger

Work Scholars
Izzy Leung, Lucas Vasilko, Chen Xiang

Art Direction, Design & Typefaces
A2/SW/HK, London

Publisher
Dana Triwush
magazine@aperture.org

Director of Brand Partnerships
Isabelle McTwigan
212-946-7118
imctwigan@aperture.org

Advertising
Elizabeth Morina
917-691-2608
emorina@aperture.org

**Executive Director,
Aperture Foundation**
Chris Boot

Minor White, Editor (1952–1974)

Michael E. Hoffman, Publisher and Executive Director (1964–2001)

aperture.org

Statement of Ownership, Management, and Circulation (Required by 39 U.S.C. 3685). 1. Publication Title: Aperture; 2. Publication no.: 0003-6420; 3. Filing Date: October 1, 2017 4. Issue Frequency: Quarterly; 5. No. of Issues Published Annually: 4; 6. Annual Subscription Price: $75.00; 7. Complete Mailing Address of Known Office of Publication: Aperture Foundation, 547 West 27th Street, 4th Floor, New York, NY 10001-5511; Contact Person: Dana Triwush; Telephone: 212-946-7116; 8. Complete Mailing Address of Headquarters or General Business Office of Publisher: Aperture Foundation, 547 West 27th Street, 4th Floor, New York, NY 10001-5511; 9. Full Names and Complete Mailing Addresses of Publisher, Editor, and Managing Editor: Publisher: Dana Triwush, Aperture Foundation, 547 West 27th Street, 4th Floor, New York, NY 10001-5511; Editor: Michael Famighetti, Aperture Foundation, 547 West 27th Street, 4th Floor, New York, NY 10001-5511; Managing Editor: Brendan Wattenberg, Aperture Foundation, 547 West 27th Street, 4th Floor, New York, NY 10001-5511; 10. Owner: Aperture Foundation, Inc., 547 West 27th Street, 4th Fl., New York, NY 10001; 11. Known Bondholders, Mortgagees, and Other Security Holders Owning or Holding 1 Percent or More of Total Amount of Bonds, Mortgages, or Other Securities: None; 12. Tax Status: The purpose, function, and nonprofit status of this organization and the exempt status for federal income tax purposes: Has Not Changed During Preceding 12 Months; 13. Publication Title: Aperture; 14. Issue Date for Circulation Data Below: Summer 2017 #227; 15. Extent and Nature of Circulation (Average No. Copies Each Issue During Preceding 12 Months; No. Copies of Single Issue Published Nearest to Filing Date): a. Total Number of Copies (Net press run): 14,863; 15,620; b. Paid Circulation: (1) Mailed Outside-County Paid Subscriptions Stated on PS Form 3541: 5,987; 5,859; (2) Mailed In-County Paid Subscriptions Stated on PS Form 3541: 5; 5; (3) Paid Distribution Outside the Mails Including Sales Through Dealers and Carriers, Street Vendors, Counter Sales, and Other Paid Distribution Outside USPS: 4,081; 3,995; (4) Paid Distribution by Other Classes of Mail Through the USPS: 35; 35; c. Total Paid Distribution: 10,108; 9,894; d. Free or Nominal Rate Distribution: (1) Free or Nominal Rate Outside-County Copies included on PS Form 3541: 312; 332; (2) Free or Nominal Rate In-County Copies Included on PS From 3541: 0; 0; (3) Free or Nominal Rate Copies Mailed at Other Classes Through the USPS: 105; 106; (4) Free or Nominal Rate Distribution Outside the Mail: 525; 600; e. Total Free or Nominal Rate Distribution: 942; 1,038; f. Total Distribution: 11,050; 10,932; g. Copies not Distributed: 3,813; 4,688; h. Total: 14,863; 15,620; i. Percent Paid 91.5%; 90.5%; 16. Electronic Copy Circulation, a. Paid Electronic Copies: 1,276; 1,216; b. Total Paid Print Copies + Paid Electronic Copies: 11,384; 11,110; c. Total Print Distribution + Paid Electronic Copies: 12,326; 12,148; d. Percent Paid (Both Print & Electronic Copies): 92.4%; 91.5%; I certify that 50% of all my distributed copies (Electronic & Print) are paid above a nominal price. 17. Publication of Statement of Ownership: Will be printed in the Spring 2018 issue of this publication.; 18. I certify that all information furnished on this form is true and complete. I understand that anyone who furnishes false or misleading information on this form or who omits material or information requested on the form may be subject to criminal sanctions (including fines and imprisonment) and/or civil sanctions (including civil penalties). Signature and Title of Editor, Publisher, Business Manager, or Owner: Dana Triwush, Publisher, October 1, 2017

Agenda
Exhibitions to See

Sally Mann

For more than four decades, Sally Mann has explored "the overarching themes of existence: memory, desire, death, the bonds of family, and nature's magisterial indifference to human endeavor," says Sarah Greenough, senior curator at the National Gallery of Art, where a major survey of Mann's elegiac black-and-white photographs arrives this spring. Featuring 125 works, the exhibition includes several images by the Virginia-born artist that have never been published or shown until now, and looks at Mann's relationship with her native land, "how it has shaped her work, and how the legacy of the South—as both homeland and graveyard, refuge and battleground—continues to inform American identity and experience."

Right: Sally Mann,
Jessie #25, 2004
© the artist and courtesy
Edwynn Houk Gallery,
New York

Sally Mann: A Thousand Crossings at the National Gallery of Art, Washington, D.C., March 4–May 28, 2018

Above: Sam Contis,
Denim Dress, 2014
© the artist; courtesy
the artist and Klaus von
Nichtssagend Gallery,
New York

Being: New Photography 2018

What does "being" look like in 2018? That is the question guiding this year's iteration of the Museum of Modern Art's biennial exhibition introducing new works by international photographers and artists working in photography and photo-based media. Whether utilizing facial recognition software, deliberately obscuring the face, or using surrogates or masks, the seventeen artists—among them Aïda Muluneh, Shilpa Gupta, Sam Contis, and Matthew Connors—take on provocative and "layered notions of personhood and subjectivity," says Lucy Gallun, assistant curator, Department of Photography. "At a time when representation is contested or troubled for many (for whom a photographic likeness can present a political or emotional threat), these artists operate within the parameters of standard photographic portraiture even as they disrupt them."

Being: New Photography 2018 at the Museum of Modern Art, New York, March 18–August 19, 2018

Sory Sanlé

The full title of the Art Institute of Chicago's exhibition *Volta Photo starring Sory Sanlé and the People of Bobo-Dioulasso in the Small but Musically Mighty Country of Upper Volta (now Burkina Faso)* speaks to the depths of the relationship between Ibrahima Sory Sanlé and the communities he photographs. Customers flocked to the portrait studio Sanlé opened in the style-conscious city of Bobo-Dioulasso around 1960, the year the West African Republic of Upper Volta gained independence from France. *Volta Photo* gathers approximately eighty, mostly vintage photographs of the 1960s and 1970s, together with photographic album covers from the era. The exhibition will also include Sanlé's signature painted backdrop, along with studio lamps and props that he still uses today. As Sanlé says, in his studio "religious people, artists, musicians, and everyone could become a hero."

Sory Sanlé,
Chez Inter Music, 1976
© the artist and courtesy
Yossi Milo Gallery, New York

Volta Photo at the Art Institute of Chicago,
April–August, 2018

Zineb Sedira,
Framing the View IV,
2008
© the artist/DACS, London,
and courtesy kamel
mennour, Paris/London

Zineb Sedira

In photographs and videos, the Paris-born Algerian artist Zineb Sedira has portrayed questions of migration and the intergenerational transmission of knowledge for almost two decades, often through a personal lens. A major survey at the Sharjah Art Foundation includes three new commissions: *Sunken Stories* focuses on wooden vessels, *dhows*, that have long facilitated trade to and from the Arabian Gulf. *Air A airs* retraces the historic British Imperial Airways route that connected London to Karachi via Sharjah's airport. *Laughter in Hell* examines the dark humor that emerged during Algeria's Black Decade of internal war, from 1991 to 2001, and considers how telling jokes can become a way for society to assimilate trauma.

Zineb Sedira at Sharjah Art Foundation,
March 16–June 16, 2018

Rediscovering Man Ray's *Unconcerned Photographs*
Simon Baker

show was bolstered by the international profile of Abstract Expressionism, particularly the posthumous celebrity of its fastest-burning star, Jackson Pollock. MoMA curator Grace Mayer brought together three hundred works by over seventy artists, with many names that one would expect at this time, such as Harry Callahan, Aaron Siskind, and Frederick Sommer, but also with a look back to the generation of László Moholy-Nagy, Alfred Stieglitz, and Edward Weston.

Recently, while researching in MoMA's collection, I was not surprised to find Man Ray on this list of artists, but the body of work appearing with his name, *Unconcerned Photographs* (1959), was unfamiliar to me. In response to Mayer's invitation to contribute to *The Sense of Abstraction*, Man Ray sent MoMA a group of Polaroids produced by swinging the camera around on its strap in his Paris studio. He indicated very minimal cropping instructions and suggested that they be reproduced as gelatin-silver prints. The museum then ordered seven Masonite-mounted enlargements for the exhibition, so that, as objects, they would sit happily alongside the works of Man Ray's contemporaries.

It's interesting, however, to reflect on the fact that both the process and title of Man Ray's contribution ran counter to the prevailing values of most of the photographers celebrated in *The Sense of Abstraction*, for whom painstaking composition and exceptional printing were de rigueur. Could it be that Man Ray's *Unconcerned Photographs* were offered to MoMA with more than a hint of an ex-Dadaist's wink? And that the relative lack of concern, since 1960, for this body of work suggests a deeper poetry in Man Ray's sense of abstraction than even he might have dreamed possible? With the inclusion, more than fifty years later, of *Unconcerned Photographs* in the 2018 Tate Modern exhibition *Into the Light: Photography and Abstract Art*, Man Ray finally finds himself in the company not just of photographers, but of the painters and sculptors who contributed to the invention of abstract art.

In 1960, the Museum of Modern Art (MoMA) held *The Sense of Abstraction*, its second show on the relationship between photography and abstract art in under ten years. Following *Abstraction in Photography*, in 1951, which mixed scientific and fine art photographs, *The Sense of Abstraction* shifted direction, redefining the topic at hand. The curatorial approach of the 1960

Simon Baker is Senior Curator, International Art (Photography), Tate. *Into the Light: Photography and Abstract Art* **is on view at Tate Modern, London, May 2–October 14, 2018.**

On Portraits
Garry Winogrand

A 1964 scene offers a narrative of color
Geoff Dyer

This is the first color picture by Garry Winogrand that I ever saw (on the cover of the 2002 book *Winogrand: 1964*), and the picture that made me want to visit White Sands in New Mexico. Is *visit* too mild a word for this extreme patch of otherworldly wilderness? Shade structure and barbecue lend the scene a hint of the suburbs. And how could they not, at a time when even Mars was conceived of as a potential extraterrestrial suburb? Everything urges us toward a point on the horizon—even though there is nothing there. In fact, the "everything" in that sentence is next to nothing: just the perspectival angling of car and shade structure. The sand is so featureless and white as to be a pure representation of nothingness. Usually doubling as signposts or pointers, the shadows have mainly crawled under the car, seeking the shade of which they are loyal, if lowly, representatives. So the four people are heading toward the sky with its cloudy suggestion of something building. This sense is strong enough to make us wonder, for a moment, if some of those clouds might not be mountains. The sky provides an atmospheric backdrop to the tension in the picture, the tension between narrative and its absence. The car's open door provides the lure of story: the scene is open-ended or ongoing. It implies movement. The people will have to come back to the car, get in, and close the door just as we, eventually, will have to close the book in which the picture is featured. But that other component of narrative, the road—or, more broadly, direction—is entirely absent. There is nowhere to go, or to have come from. The by now familiar question—What is happening?—becomes more specific: How did they get here? The people are both walking and absolutely still. The only thing happening is the sky, and it's happening in a still swirl of blue. And that's where the people are heading, what this futuristic picture is pointing to—the limitless promise of color.

Geoff Dyer's latest book is *The Street Philosophy of Garry Winogrand* (2018), from which this text is excerpted.

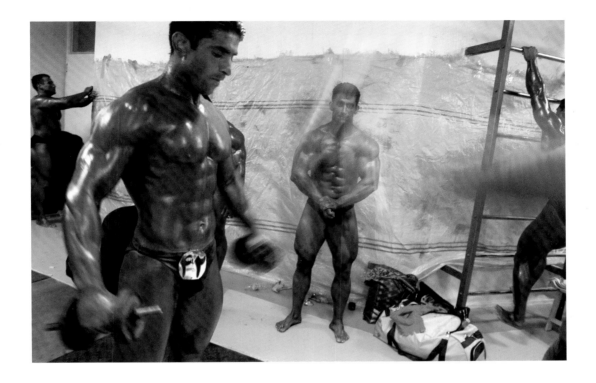

In a society with strict definitions of manhood, how are photographers portraying Iranian masculinity?

Haleh Anvari

Since the 1979 revolution, Iran's image abroad has been defined by its politics. In this newsroom universe, Iranian women have been front and center in the frame, the Western gaze seeking their exotic attire and problems. Iranian men, on the other hand, have been strangely absent from this picture, unless they are bearded politicians or directors of art-house movies. Young Iranian men, in particular— perennially present in their own cities in the countless murals of fallen heroes of the Iran-Iraq War—became invisible to the world, their issues lost in the daily economic and political maelstrom of the country.

Abbas Kowsari, one of Iran's prominent photojournalists, noticed the lack of representation of men in images about Iran while working as an assistant to the

late Sadegh Tirafkan, who addressed issues of masculinity in his internationally celebrated art photography. "Maybe it was because of the wars that Western powers were starting in the region," Kowsari says, referring to the consecutive wars in Afghanistan and Iraq. "There was more interest in women's issues and women photographers taking photographs of women."

In 2006, Kowsari began to focus on Iranian men in a series of photo-essays titled *Masculinity*. These images feature bodybuilders preparing for the stage (from oiling up to parading their pumped-up muscles) and wrestlers (who enjoy hero status in Iran because of the regular medals they bring home) captured in the moments before and after competition. "I really wanted to show that men can

also feel fatigued or defeated," Kowsari says. His photography addresses both the vanity and the vulnerability of men. His latest project, begun in 2015 and ongoing, documents male public bathhouses that operate in the poorer parts of Tehran.

While Kowsari's work records men in public spaces, Najaf Shokri's series *Bachelors* (2009) looks at the private spaces of a group of friends in the town of Karaj, some forty kilometers from the capital. Young men are seen whiling away their time at home, uninhibited and often half naked. Out of work and in retreat from the policed streets after the 2009 postelection turbulence in Iran, they depict a generation's lassitude. It is surprising how relaxed and open these men are in front of the camera. "They

fifteen years ago. These are the aspiring ayatollahs of the future—potentially the elite clerics who will lead the country's politics through religion. Jaez's series *Turbanites* (2014) was exhibited in Tehran last fall and published as a book by Nazar Art Publications in 2017. But this glimpse into the austere lives of these religious students has aroused the ire of his secular friends, condemning his choice to photograph the young clergy, who they feel should not be valorized. Jaez notes, however, that this community is not as monolithic as it may seem: "Ironically, not all of these guys decide to take the robe when they finish their studies," he explains.

Aspects of Iranian men's lives provide a wide scope for social documentary work about Iran as a whole. Men, especially the young, face overwhelming demands in a traditional society that defines manhood as a role of protecting and providing. In a country where the government is failing to create enough jobs, reduce rampant economic corruption, or prevent the current frightening increase in drug use, these men face challenges that are as complex as the issues that afflict the women and ultimately affect the whole population, regardless of gender. Photographers who choose to focus on the country's men accept that their images may not find a regular spot in international exhibitions on Iranian photography as easily as works by photographers who zoom in on Iran's women. And they know that these images of Iran's masculine population almost never make it to the front pages of major publications in the West. In the gaze of foreigners and Iranians themselves, Iran is no country for young men.

Men's lives provide a wide scope for social documentary work about Iran.

were happy that I was photographing them," Shokri says, "as if their lives became more meaningful by being photographed."

Although Shokri's photo-essay has been picked up for group exhibitions in the United States and Canada, he cannot show these photographs in Iran, as they reveal too much skin. Despite the fact that his series is reminiscent of the work of Larry Clark, in the intimate portrait it provides of friends, *Bachelors* is being both subjected to censorship inside the country and largely dismissed by the outside world, due to a tendency to favor stories from Iran that are told through images of its women.

In another cloistered environment, Behzad Jaez has recorded the lives of young men usually hidden from view: seminarians in religious schools across the country, whom he began photographing

Haleh Anvari is a writer based in Tehran and a regular contributor to the *Guardian*.

Ruth Bernhard (American, 1905-2006)
Angles, 1969
Gelatin silver
10-3/8 x 13-1/2 inches
Estimate: $4,000-6,000

Photographs
May 25
HA.com/5358

Inquiries
Nigel Russell
214.409.1231 | NigelR@HA.com

Curriculum
A List of Favorite Anythings
By Gregory Halpern

He was born in Buffalo, New York, but Gregory Halpern found the light in California. His award-winning photobook *ZZYZX* (2016), named for a village and former mineral springs spa near the Mojave Desert, presents images that move westward across Los Angeles in a five-year chronicle of vivid, seemingly unrelated scenes—a blue tarp punched with holes, a smoky mountainside, a staircase leading nowhere, a couple towing carts of their possessions. Whether in Los Angeles or Rochester, where he lives, Halpern pursues the American themes of isolation and manifest destiny with a sense of enigmatic, open-ended beauty.

Early British punk

I became fascinated by punk hilariously late in life, at age thirty. What I like is that it feels like art made from the body as much as from the head—and I like that one seems to *receive* it in the body as well. I can get swept up in the Sex Pistols or the Clash unlike almost anything else. I love the disregard for tradition, the working-class antagonism, and the idea of serving the middle finger to upper-middle-class values while simultaneously inventing a new form of art. Anger can be useful, if channeled creatively.

Anne Carson, *Autobiography of Red*, 1998

Part poem, part novel, this remarkable book is the autobiography of a winged red monster named Geryon who escapes an abusive older brother, falls in love with a drifter named Herakles, and, as an adolescent who has relinquished speech, takes up photography. Filled with metaphors for photography and the meaning of light, *Autobiography of Red* is a deeply beautiful story that brings me back to when I first discovered the magic of taking pictures, both as a way of understanding the adolescent pain of existence and as a way of expressing the seemingly inexpressible.

Buffalo Central Terminal

My brother and I grew up in Buffalo, New York, wandering through the cavernous rooms of this abandoned, seventeen-story train station. Back then, we could just walk in the front door, climb to the top, go out on the roof, and see the whole city. My regular pilgrimages to this building marked the beginning of a lifelong fascination with architecture and nurtured an early fascination with urban surrealism.

Judith Joy Ross

Judith Joy Ross's portraits move me every time I see them. In particular, her pictures of young people on the cusp of adulthood crush me. In *Why People Photograph* (1994), Robert Adams speaks of "the effort we all make, photographers and nonphotographers, to affirm life without lying about it." To me, no photographer does this better than Ross. She is shamefully underrated in the history of photography. I would rate her the greatest portrait photographer to have ever worked in the medium.

Medieval paintings

Medieval paintings are more amazing, weird, magical, and dark than almost anything else. For years, they made my eyes glaze over, but today they stir things inside me that contemporary art rarely seems to. As an artist, I like to see what's being shown in contemporary galleries, although it is increasingly dispiriting. To refill the cup, so to speak, the thing to do is go to the Met.

Augustin Lesage

Augustin Lesage was a French coal miner who, at the age of thirty-five, heard a voice in the mine predicting he would one day be a painter. A few months later, Lesage began making drawings dictated by spirits of the deceased, including his little sister, who died at the age of three. He then moved to making massive, meticulously detailed paintings of fantastical works of architecture—they are absolutely mesmerizing.

Jelly Roll Morton, "The Murder Ballad," 1938

"The Murder Ballad," recorded by Alan Lomax in 1938, is an epic, thirty-minute song originally performed by Jelly Roll Morton in the brothels of New Orleans. Containing sixty-one stanzas of raw, tragic, funny, and utterly filthy language, the ballad traces the rambling narrative of a betrayed woman and her vengeance. Dancer Jessica Emmanuel's interpretation of the song, in the theater collective Poor Dog Group's piece *Murder Ballad 1938* (2015), is one of the most memorable performances I have ever witnessed.

Ralph Ellison, *Invisible Man*, 1952

I first read *Invisible Man* twenty years ago in high school (thank you, Mr. LaChiusa!) but keep returning to it. With its strange blend of painful realism and dark fantasy, *Invisible Man* introduced me to Ellison's American style of magical realism—a chiefly Latin American genre that some suggest represents a postcolonial form of double consciousness, the result of simultaneously experiencing the realities of the conquerors, as well as those of the conquered. The painful "battle royal" scene—where wealthy white men in tuxedos force the narrator to fight viciously with another black boy—is particularly memorable, and sadly relevant to the next item on my list.

Colin Kaepernick

In one of the greatest political acts/sacrifices of a professional athlete since Muhammad Ali's stand against the Vietnam War, Colin Kaepernick (who was then quarterback for the San Francisco 49ers) kneeled during "The Star-Spangled Banner" in the 2016–17 season to protest the recent police shootings of black men. Many players throughout the league followed suit, although the NFL (egged on by Donald Trump) quashed the movement and Kaepernick was blackballed. His contract was not renewed, and he is still out of a job despite being universally accepted as one of the best quarterbacks of his time. Kaepernick's sacrifice will hopefully inspire an even bigger wave of solidarity among players, whose enormous collective political powers remain yet untapped.

William Faulkner, *The Sound and the Fury*, 1929

On its surface, *The Sound and the Fury* is the story of the dissolution of the Compson family, but it's really about narrative form. The book's four sections are each told by a distinctly unique character, the first three by different family members, each of whom is an unreliable narrator for their particular reasons. As you read, you circle the truth, never quite seeing it clearly. The book—particularly the genius of its structure—inspired me to think differently about the nature of narrative, photography, and the medium's slippery relationship to truth.

Opposite, clockwise from top left: Michael Pietrocarlo, *Curtiss Colonnade, Buffalo, New York*, 2016; Kaepernick's football jersey, 2017. Installation in *Items: Is Fashion Modern?*, the Museum of Modern Art, New York; Judith Joy Ross, *Untitled*, 1989, from the series *Easton, Pennsylvania*; David Montgomery, English punk group the Clash, ca. 1977; Jeff Brown, *Anne Carson*, 2013; Photographer unknown, Jelly Roll Morton, Chicago, ca. 1923; Gordon Parks, *The Invisible Man, Harlem, New York*, 1952

Prison Nation

Today's crisis of mass incarceration has deep historical roots. Understanding its connection to legacies of slavery, lynching, and segregation is at the heart of Bryan Stevenson's visionary work in the legal field. In a wide-ranging conversation with art historian Sarah Lewis, Stevenson—a lawyer who founded the Equal Justice Initiative in Montgomery, Alabama—discusses the role of culture in social justice. Counternarratives, they both argue, are essential to address underexamined historical truths. "I believe that truth and reconciliation are sequential," Stevenson says. "You have to tell the truth first. You have to create a consciousness around the truth before you can have any hopes of reconciliation."

Photography, since its early years, has been used to create and reenforce typologies of criminality, often singling out specific groups of people. The responsibility of photographers today is to provide counterpoints and move beyond simplistic descriptions of the criminal or the imprisoned. In Deborah Luster's exquisitely complex portraits of individuals participating in a passion play at Louisiana's Angola prison—a facility located on the site of a former slave plantation—the humanity and self-possession of her sitters are undeniable.

Luster is joined by a range of engaged image makers, activists, and scholars. Bruce Jackson brings us scenes from prisons in rural, 1960s- and '70s-era Arkansas and Texas that disturbingly resemble plantation life. An assertion of self-style and an effort to personalize institutional spaces define Jack Lueders-Booth's portraits from one of the country's first prisons for women, in Massachusetts. Jamel Shabazz and Lorenzo Steele, Jr., two photographers and former corrections officers at New York's Rikers Island prison complex, are deeply invested in ideas about black freedom and progress. "We hear about prisons," Shabazz says in his conversation with Steele. "But, what is the face of the inmate? What does the inmate look like?"

The voices of the incarcerated and the formerly incarcerated are essential here, such as Joseph Rodriguez's portraits from reentry centers in Los Angeles, as are images and artworks that address incarceration in conceptual, even abstract ways. Jesse Krimes served five years, during which time he produced an inventive body of work, often fashioned from prison-issued materials. "I try to create artwork that complicates oversimplified and harmful narratives," he remarks. Krimes believes that "art can be a way to spark empathy." Sable Elyse Smith deploys a layered visual approach—in her recent artist's book, personal letters and images of prisons and playgrounds offer a fragmented narrative of a relationship defined by incarceration.

Prison is relentless and brutal. As a mode of punishment, prison does not reduce crime, but instead begets warehouses of suffering that target the most vulnerable and marginalized in our society. Incarceration touches all of us. "Americans, even those who have never been to a prison or had a relative in prison, need to realize that we are all implicated in a form of governance that uses prison as a solution to many social, economic, and political problems," Fleetwood says. Empathy and political awareness are essential to creating systemic change—and images, we hope, may provoke us to see part of ourselves in the lives of those on the inside.

—**The Editors**

Most prisons and jails across the United States do not allow prisoners to have access to cameras. How, then, can images tell the story of mass incarceration when the imprisoned don't have control over their own representation? How can photographs visualize a reality that, for many, remains outside of view?

Nicole R. Fleetwood, this issue's contributing editor, is an expert on the intersections of art and incarceration. But for her, the story is personal. "My initial awareness of mass incarceration," she says, "came from growing up in a working-class black community in southwest Ohio that was highly policed, routinely harassed, and repeatedly brutalized by local police forces." This was also a time, in the 1980s and early '90s, when the so-called War on Drugs, the impact of deindustrialization (especially on cities and towns formerly reliant on manufacturing), the rise of a new conservative movement, and a 1994 crime bill under the Clinton administration resulted in the mass removal of people from society. Young black adults and teens, in particular, were taken from their communities, remaining absent for years or decades; some never returned at all. Fleetwood's moving essay in this issue chronicles her experience, over several years, of being photographed at prison-run studios while visiting two incarcerated cousins. In a range of poses, they mark time together against trompe l'oeil backdrops, fantasies of life beyond the walls.

Prisons operate as closed, often arbitrary systems. For photographers, working within prisons poses challenges: access is increasingly difficult to obtain, especially since 9/11, and can be revoked at any moment, and image makers must acknowledge prisoners' limited agency and inherent vulnerability. Yet today, 2.2 million people are incarcerated in the United States, a number all the more shocking when we account for the 3.8 million people on probation and the 870,000 former prisoners on parole.

Christoph Gielen,
Untitled XXXII Arizona,
2010
Courtesy the artist

Truth & Reconciliation

Bryan Stevenson in Conversation with Sarah Lewis

A visionary legal thinker, Bryan Stevenson has protected the rights of the vulnerable through his work as a death-row lawyer. With the Equal Justice Initiative (EJI), an organization he founded in 1994, Stevenson has made strides to end mass incarceration and challenge racial and economic injustice. He has argued cases before the Supreme Court, recently winning a watershed ruling that mandatory life-without-parole sentences for children seventeen and under are unconstitutional. Stevenson's 2014 memoir, *Just Mercy*, recounts his experiences navigating an unfair criminal justice system.

But his work extends beyond the legal realm—Stevenson is invested in shifting cultural narratives and making history visible. This is work to which Harvard professor and art historian Sarah Lewis, guest editor of *Aperture*'s 2016 "Vision & Justice" issue, is uniquely attuned. Lewis has written at length on the urgent role of art in social justice, on the corrective function of images and how they enable us to reimagine ourselves. Last October, Lewis visited Stevenson at his office in Montgomery, Alabama, for an extended conversation. Central to their discussion were Stevenson's next projects: on April 26, 2018, he will open the National Memorial for Peace and Justice in Montgomery, which will honor the lives of thousands of African Americans lynched in acts of racial terrorism in the United States, and the Legacy Museum: From Enslavement to Mass Incarceration, which will trace a historical line between slavery, lynching, segregation, and mass incarceration. Of his work, Stevenson remarks, acts of truth telling have a visual component. "If we just go to the public square and people say some words, it doesn't have the same power."

Page 20:
Bryan Stevenson at the
office of the Equal Justice
Initiative, Montgomery,
Alabama, October 2017
Photograph by John
Edmonds for *Aperture*

This page:
Soil from Alabama lynching
sites, collected as part
of EJI's Community
Remembrance Project,
Equal Justice Initiative,
Montgomery, Alabama,
October 2017
Photograph by John
Edmonds for *Aperture*

Sarah Lewis: **It's a rare privilege to be able to talk with someone doing work in the realm of justice who understands the role of culture for shifting our narratives regarding racial inequality. I want to have a conversation about how culture, specifically photography, has shifted national narratives on rights and race-based justice in the United States.**

Bryan Stevenson: Yes.

SL: **To begin, I would say that we must consider the journey from 1790 with the Naturalization Act, when citizenship was defined as being white, male, and able to hold property, to the present-day definition of citizenship. The question becomes: Is this journey a legal narrative or is it also a cultural one?**

BS: Absolutely.

SL: **You've spent a lot of time dealing with this history as it relates to emancipation and slavery, up until the current day. How did you arrive at a place of seeing the importance of culture for getting people to understand this work?**

BS: When I first started going to death row in the 1980s, I was constantly seeing things that communicated really important truths about the experience of the men and women I was meeting in these desperate places. You would see people interact with each other, constantly sharing gestures of compassion and love and support. You'd witness people acting in ways that were so human. And yet they were being condemned, in large part, because there was a judgment about their absence of humanity.

To counter the unforgiving judgment, I wanted other people to see what I saw. And, if anything, it was through the experience of

being in jails and prisons, year after year—seeing this rich humanity and the redemption and transformation of individuals, despite the harshness of the environments—that I became persuaded that if other people could see what I see, they would think differently about the issues presented in my work. So, in the 1990s, when we first started representing our work in a modest way, images became an important part. In our first report we used a picture of the Scottsboro Boys. And we also used a picture of a client with compelling features who had been on death row for twenty years. For me, it has always been clear that there is a way in which photography can illuminate what we believe and what we know and what we understand.

It led me to increasingly use imagery to try to help tell the story of our clients. After twenty years of doing that work—and we had a lot of success, but we also saw the limits—I became aware that the rights framework, the insistence on the rule of law was still going to be constrained by the metanarratives that push judges to stop at a certain point: the environment outside the court. That's what pushed me to think more critically about narrative, not just within a brief, within a case, within an action, but more broadly. And when it comes to narrative struggle, there is nothing that has been more confounding than racial inequality.

SL: **There's much work happening in the arts around the nexus of art, justice, and culture. But you're doing the work of having this become more understood in the wider realm. It's so crucial. Something that I asked myself as I began this work was: What is the connection between culture and justice? This piece about "narrative" is what unlocks that.**

BS: That's absolutely true for me. Because in many ways, our inattention to narrative is what has sustained the problems we've tried to overcome.

SL: **Yes. Inattention and also unconscious conditioning by it.**

BS: Absolutely. So if we think differently about what happened when white settlers came to this country with regard to native populations, if we actually identify what happened to millions of native people as a genocide, the word *genocide* introduces something into the narrative that is quite disruptive. We've been hesitant to use the word *genocide*, because the narrative would shift in really powerful ways if we understood the violence and exploitation of native people through that lens.

I think the same is true when you look at the African American experience in this country. I've gotten to the point where I believe that the North won the Civil War, but the South won the narrative war. They were able to hold on to the ideology of white supremacy and the narrative of racial difference that sustained slavery and shaped social, economic, and political conditions in America. And because the South won the narrative war, it didn't take very long for them to reassert the same racial hierarchy that stained the soul of this nation during slavery and replicate the violence and racial oppression that existed before the great insurrection.

It's the narrative of racial difference that condemns African Americans to one hundred years of segregation, exclusion, and terror, following emancipation. Had we paid more attention to the narrative, we would not have seen the U.S. Supreme Court strike down all of those acts by Congress in the 1870s that were designed to protect emancipated black people and create racial equality. But the Supreme Court embraced the narrative that basically maintained that black lives are not worth risking further alienation of the South. It wasn't about law for the court. The law said that we were all equal, but the narrative allowed the court to accommodate inequality and racial terror.

When it comes to narrative struggle, there is nothing that has been more confounding than racial inequality.

Narrative struggle is where we have to pay attention if we want to avoid replicating these dynamics as we continue to face the same problem of racial divide.

SL: **On this point about looking at the ways in which whiteness became conflated with nation through narrative, there are a number of things to mention. But just to get back to the Native American piece and the criminalization of rights-based action, it was, in large part, photography that legitimated acts of genocide. Edward Curtis's photographs, for example, naturalized and supported the genocide.**

BS: That's right. Because if you can create the idea that these native people are savages and you can create a visual record that supports that idea, then people don't view the abuse and victimization as they ought to.

What's interesting to me about some of that early art and visual work is that it's really about perpetuating the politics of fear and anger. And fear and anger are the essential ingredients of oppression. Art is complicit in creating these narratives that then allow our policymakers to perpetrate acts of injustice, decade after decade, generation after generation.

SL: **Absolutely. But before we get more to the current day, I think there is a framework here that we should acknowledge, and a thinker who did the courageous work at the time, during the Civil War, to put out this idea about narrative— and that is Frederick Douglass. He gave a speech during the Civil War that he called "Pictures and Progress." He confused his audience at the time by speaking about what seemed like a trifle during this nation-severing conflict. Something seemingly as small as a picture, he argued, could have as much force as a political action, as a law. It's a fascinating speech. He was interested in what he called "thought pictures." This was his gesture toward narrative; he used this term to describe the ways in which culture, what we consume daily through pictures, can shift our notion of the world. That is what he thought would effect the change. Douglass was the most photographed American man in the nineteenth century, for good reason. He believed in this idea.**

BS: It's a really powerful insight, that he could appreciate how getting people to see his humanness was critical for them to understand the inhumanity and degradation of slavery. In many ways, Dr. King had that same insight.

SL: **Yes.**

BS: He understood that the spectacle of nonviolent resistance to white, armed, military repression could create a consciousness about the African American struggle in the South that could not be created any other way.

As we've been working on our Legacy Museum, which explores slavery and the human suffering created by the domestic slave trade, it's been frustrating, because there is so little photography or imagery that exposes the inhumanity of enslavement. It's almost as if there was a real effort to avoid visual documentation that might have implicated us and revealed our complicity in facilitating such great suffering.

I have found in the published narratives of enslaved people this unbelievably rich source of content, not visual in the sense of photography or art, but visual in terms of language. They tell stories. They use the narrative form to create a very intimate picture of what it was like on the day when their children were taken away on the auction block, or when they lost their loved ones. In our museum,

we're using technology and video to give animation to these words through performance. I'm really excited about it because it creates a kind of intimacy, it paints the kind of picture that Douglass tried to achieve.

SL: **We're sitting here in a building in Montgomery that functions as a kind of narrative correction. Is that right?**

BS: Yes. We're a few blocks from Dr. King's church and from where Rosa Parks started the modern civil rights movement. However, what we didn't appreciate until we began our racial justice project is that we were also in the epicenter of the domestic slave trade. That part of the historical narrative of this community had largely been ignored. But it became clearer to us that this street, Commerce Street, was one of the most active slave-trading spaces in America. Tens of thousands of enslaved people were brought here.

SL: **Hence the name.**

BS: Yes, that's right, hence the name. Thousands of black people were trafficked here by rail and by boat. Montgomery had the only continuous rail line to the Upper South in the 1850s.

So this knowledge made me reimagine how this space could contribute to a more honest American identity. And the marker project was the first thing we did locally, to try to create awareness of this past. If you come to Montgomery, there are fifty-nine markers and monuments to the Confederacy in this city. They are everywhere. "The First White House of the Confederacy" is the sign you pass when you drive into town. Our two largest high schools are Robert E. Lee High and Jefferson Davis High. But not a word about slavery. So putting up these markers that introduced facts about the Montgomery slave trade and the domestic slave trade and the slave warehouses and the slave depots that shaped this city, which were avoided by local historians, was really important.

SL: **You talked about the need to shift our cultural infrastructure in the United States because of the deliberate silence about racial terror, and, of course, this connects to mass incarceration. But can you talk about the shifts that you're hoping will occur in the National Memorial for Peace and Justice and the museum in Montgomery?**

BS: I do think we have to make our history of racial inequality visible. We have been so inundated with these narratives of American greatness and how wonderful things have been in this country that it's going to take cultural work that disrupts the narrative in a visual way to force a more honest accounting of our past. People take great pride in the Confederacy because they actually don't associate it with the abuse and victimization of millions of enslaved black people. So that has to be disrupted.

What appeals to me about the markers is that they are public; everyone encounters them. We can create a museum. We can create indoor spaces that try to express and deal with these issues. But a lot of the people who need this education are never going to step inside those places. Public markers, however, can't be ignored, and we have continued that effort with our work on lynching. Our goal is to mark as many of the lynching sites in America as possible. We use the words *racial terrorism* on each one of the markers. We name the victims. We give a narrative that contextualizes the brutality and torture black people endured. I do think that's important, to challenge the public landscape, which has been complicit in sustaining these narratives of white supremacy and racial inequality. That's another way in which acts of truth telling have a visual component. If we just go to the public square and people say some words, it doesn't have the same power as permanent symbols of collective memory.

We are opening the National Memorial for Peace and Justice in Montgomery, which will acknowledge over four thousand victims of lynchings and identify over eight hundred counties in America where racial terrorism took place. Hundreds of six-foot monuments will be on the site, including sculptures created by artists who contextualize lynching within an understanding of slavery, segregation, and contemporary police violence. Deeper exploration of these issues is then possible in the museum, and all of this, for me, is really exciting. Particularly in these political times where you've seen the retreat and obfuscation of historical truth. It was a shock to me in 2008 how quick people were to assert that we now live in a postracial society; that was obviously incredibly naive.

SL: It occurs to me, and I wonder if this is correct, that you focused on your own experience of needing narrative to communicate what you were seeing with your clients — how racial terror and lynching have structured the criminal justice system and the landscape of racial inequality.

BS: Yes, absolutely. It's not a surprise that after emancipation, people went from being called "slaves" to being called "criminals." Convict leasing and lynching were about criminalizing black people. Rosa Parks makes her stand, and she's immediately criminalized. Those women who fought for equality on buses here in Montgomery, what they were being threatened with was a formal designation as criminals: Claudette Colvin, Mary Louise Smith, all of these women.

The notion that resistance to racial inequality makes you a dangerous criminal has always been there. So, then, it's not a surprise that after the success of the Voting Rights Act and the Civil Rights Act, prosecutors begin focusing on "voter fraud" in the black community, followed by this new War on Drugs, which then leads

to the United States having the largest incarcerated population in the world. The rate of incarceration is just unprecedented.

I think that the criminalization of black people, and now brown people who are deemed illegal because of their state of national origin, is very much a part of the American story, and it's been present with us in ways that we just haven't acknowledged. We criminalized Japanese Americans during World War II and put them in concentration camps, but were unconcerned about Italian Americans and German Americans.

SL: One of the interventions of the civil rights movement, it seems, is to reframe criminality and rights-based behavior as actually a positive, an act of citizenship.

BS: Right.

SL: Or as an indicator of such. The 1958 image that Charles Moore took of Dr. King is probably iconic in that regard.

BS: Right. We used that for one of our calendars. I think the images we often see of Dr. King are with him poised, speaking in front of thousands of people in these esteemed spaces, where his leadership is what's being highlighted. What's powerful to me about this image is that here he is being criminalized. He's being brutalized by law enforcement. And there is some fear in his eyes, because there is the uncertainty of what will happen. Because the long history of black struggle is that once you are put in this criminal status your survival is not guaranteed, your safety is certainly not guaranteed. And yet, he persists, and he continues. I love the way Coretta Scott King is witnessing his abuse with such dignity and confidence. It just says a lot about the kind of courage that is needed to fight a fight like this.

You have to create a consciousness around the truth before you can have any hopes of reconciliation.

Rosa Parks is also so powerful in that regard. One of the first people we want to honor in our memorial garden is Thomas Edward Brooks, a black World War II veteran who shaped Rosa Parks's activism on the buses.

In 1950, Mr. Brooks returned home to Montgomery, in his uniform. The segregation protocol on the bus was, of course, that you get on at the front of the bus, you put your dime in, then you get off the bus, and you walk to the back door, and get back on, and head to the back. Mr. Brooks gets on, puts his dime in, but he doesn't get off the bus. He walks down the center aisle to the back. The bus driver is screaming at him and calls the police. The police officer comes on the bus, and Mr. Brooks is in his military uniform in a defiant posture, according to witnesses. The police officer just goes up and hits him in the head with the club, knocks him down, rattles him, and he starts dragging him toward the front of the bus, and when he gets to the front of the bus, the black soldier gathers himself and jumps up and shoves the police officer and starts running, and the officer takes out his gun and shoots him in the back, and kills him.

Two years later, the same thing happens to another black soldier. Rosa Parks was the person who was documenting these tragedies, as a secretary to the NAACP. And that sense of violent repression and menace—the understanding that police officers could kill a black soldier, shoot him in the back—took her commitment to change conditions to a whole other level. It was no longer just insult and subordination. It was lethal, which makes her protest all the more inspiring.

SL: **Your work allows us to understand the narrative of black veterans and the way they were targeted and subjugated to racial terror. It's a feature of the landscape that we need to understand.**

BS: Well, it's an important part of the story, because, you know, W. E. B. Du Bois and others said, We go fight for this country; let's save this country, and then they will save us. And it didn't happen after World War I. In fact, it was the opposite. They were targeted and victimized for their military service. It complicated the idea of black inferiority to have black soldiers go to Paris, France, and be triumphant and successful. That's why, in some ways, the lynchings increase during this time, in 1919, 1920, 1921, when black soldiers are returning home and creating a new identity. The same thing happens after World War II; you see this increased racial violence in the 1940s targeting black veterans.

My dad just passed away. He was born in 1929, and he fought in the Korean War. He was very active in the church, and he talked about his faith all the time, but he never talked about his military service. For economic reasons he wanted to be buried at the veterans cemetery, and there you see all of these U.S. flags, and there's all of that symbolism of nationalism and American pride. When I got to his grave site, they put on the little plate, "Howard C. Stevenson, Corporal, U.S. Army, Korean War," and a flag. But it wasn't completely true. He served in a racially segregated unit and was denied most of the rewards white veterans received for their military service; his rank and service were diminished by racial bigotry. And there is no acknowledgment of that. I believe his willingness to serve despite racism should be recognized. For me, this highlights how much work we still need to do in this country around truth telling. I believe

that truth and reconciliation are sequential. You have to tell the truth first. You have to create a consciousness around the truth before you can have any hopes of reconciliation. And reconciliation may not come, but truth *must* come. That's the condition.

SL: If someone were to say that we're having a conversation about culture and mass incarceration or racial inequality, they might think that it's about the portrayal of that specific group that has been terrorized or dehumanized by these actions. But, in fact, it's also about the opposite, the way in which the presence of racial terror has also conditioned the entire population.

BS: Absolutely. That point is so critical. Terrorism, the violence of lynching, is critical for understanding how you could have decades of Jim Crow. No one would have accepted drinking out of the inferior water fountain or going into the less desirable "colored" bathroom unless violence could be exercised against you for noncompliance with segregation with impunity.

Racial-terror lynching propelled the massive displacement of black people in the twentieth century. The idea that black people went to Cleveland and Chicago and Detroit and LA and Oakland as immigrants, looking for economic opportunities, is really misguided. You have to understand that they went there as refugees and exiles from terror and lynching.

Today we have generational poverty and distress in urban communities in the North and West, and black people are criticized for not solving these problems, and most people don't understand how the legacy of racial terror shaped the structural problems we continue to face. That's what provokes me when people come up to me and they talk about problems in the black family. I'm thinking about the fact that fifty percent of enslaved black people during the domestic slave trade were separated from their wives and their children and their husbands and their parents by white slave owners, and the commerce of slavery. During the lynching era, black women had to send away spouses and children who were threatened with mob violence for something trivial. We haven't addressed the devastation and trauma to black family life created by this history.

SL: **I'm looking at the EJI report "Lynching in America: Confronting the Legacy of Racial Terror." The photographs demonstrate that watching a lynching was a family activity for some white Americans.**

BS: That's exactly right. And this effort to acculturate white people to accept and embrace the torture, brutalization, and violence they see black people around them experience ... it's a tragic infection that afflicts our society. Nelson Mandela says, in effect, "No one is born hating someone else; you have to be taught." The way in which we have taught racial violence and white supremacy is intricate, and devastating. It won't go away without treatment.

SL: **Chandra McCormick and Keith Calhoun's work *Slavery: The Prison Industrial Complex*, begun in the early 1980s and ongoing to this day, shows the continuation of this violence through photographs of life at Angola, the Louisiana State Penitentiary.**

BS: We represent lots of people who are at Angola now. Angola has one of the largest populations of children sentenced to life imprisonment without parole in the country. We have clients who received write-ups for not picking cotton fast enough in the 1980s when prisoners were forced to toil in the fields. Now these men are parole-eligible, and we have to explain to the parole board why refusing to pick cotton thirty years ago is not something they should hold against this person when they were sentenced to die in prison. You still have officers on horseback down there, riding around. You still see men going out into the fields. It is a former plantation.

So I think images are really important. The narrative of putting imprisoned, largely black people out in the fields to hoe and pick cotton, which you would think would be just unconscionable to a society trying to recover from slavery, is actually exciting to a lot of people. It's like the chain gangs they brought back to Alabama twenty years ago. Some people loved the visual of mostly black men in striped uniforms chained together along the roadside and being forced to work. The optics are so important, and it sort of reminds me of those images around lynching. It's the same thing: Let's use this imagery to excite the masses so that we can recover something that has been lost, restore something that has been taken from us, and allow us to reclaim an identity that replicates the good old days of racial hierarchy in precisely the same ways. It's why the phrase "Make America Great Again" is provocative to many of us, and why our indifference to mass incarceration is so unacceptable. I'm persuaded we are still in a struggle for basic equality and there is much work still to be done.

Sarah Lewis is Assistant Professor of History of Art and Architecture and African and African American Studies at Harvard University and the author of *The Rise: Creativity, the Gift of Failure, and the Search for Mastery* (2015).

Chandra McCormick, *Line Boss, Angola Prison*, 2004
Courtesy the artist

Photographer unknown,
John Regan (Irishman),
steamboat thief, ca.
1851–59. Ambrotype
from the Rogues Gallery
Collection
Courtesy the Missouri
Historical Society, St. Louis

The Mug Shot
A Brief History

Shawn Michelle Smith

Photography has a long-standing relation to policing. Not long after its invention, in 1839, the technology began to be used for the twinned purposes of identification and surveillance. In Paris, the police deployed photography in efforts to pinpoint serial offenders, and also to instruct a broader population in methods of scrutiny. Police departments in the United States started photographing arrested men and women as early as the 1850s, and displayed their portraits for public viewing in rogues' galleries. Early ambrotypes and tintypes captured suspects in a range of gray hues, encircled by ornamental brass frames; occasionally, their cheeks have been tinted pink. Later in the nineteenth century, as photographs became easy and inexpensive to reproduce as paper prints, the mug shot was used widely in police departments throughout Europe and the United States.

But the mug shot as we know it today did not simply emerge as a ready-made form with the advent of photography. It had to be distinguished from everyday portraits and shaped to conform to the priorities of policing. In the 1880s, Alphonse Bertillon, an anthropologist and chief of the Judicial Identification Service of France, invented the mug shot, a doubled photographic portrait focused tightly on the head, with one view facing the camera and the other in profile. Bertillon celebrated the photograph as an essential visual record, but he also saw it as inadequate to the task of identification. Therefore he devised an elaborate biometric system to supplement the mug shot—what he called the *portrait parlé*, or speaking image. The *portrait parlé* involved nine physical measurements, including the breadth of the arm span, the diameter of the head, the length of the foot, and even the size of the ear. Bertillon's system demonstrated that the photograph did not provide a transparent record, but required textual, discursive, and institutional support to make it legible. Called *Bertillonage*, this approach paradoxically heralded the mug shot while underscoring the insufficiency of photographic identification.

In the *portrait parlé*, text frames the photographic images. The detailed record of physical measurements is further augmented with textual descriptions of the face, including the colors of the subject's eyes and hair. The text on the front of the card occupies as much space as the photographs, and the back of the card is devoted entirely to written narrative, with room to note any scars or salient marks on the body, as well as name, address, relatives, and profession. Bertillon designed the *portrait parlé* in an effort to catch masters of disguise who committed crimes under different aliases. He proposed that although a repeat offender might conceal his identity, one would be able to discover him if his physical measurements matched those of "another" offender already recorded.

The Bertillon system of identification was widely adopted in the United States, and a series of photographs made by the New York City Police Department around 1908 testifies to its popularity.

Across the series, two white men, expertly framed and illuminated by flash, perform Bertillonage for the camera, demonstrating the technique and showing how each of the physical measurements should be made. One man, with a bushy mustache and short, slicked-back hair, plays the recording officer. He wears a bow tie and has carefully rolled up his shirtsleeves for the task at hand. His younger, slighter colleague plays the person under arrest.

In one striking image in the series, the man who plays the arrested subject looks directly at the camera as his counterpart presses close against him, stretching out his arms horizontally, to measure the man's arm span. It is a notably intimate pose; the measurement requires the officer to extend his own body against the man under investigation. Such performative views show how an arrested individual is to be surveyed by the police, but they also imply a marked degree of compliance necessary on the part of the offender. Other images simulate people who refuse to sit for their mug shots and are wrestled into submission before the camera by multiple men, suggesting that not all subjects would be amenable to these extensive measurements.

Bertillonage is the epitome of an instrumentalized way of seeing, measuring, and recording the body. As such practices flourished, police stations in the United States also provided a parallel form of viewing for a broader public, the rogues' gallery. Mug shots were displayed for popular entertainment with the hope that public viewing would increase the number of investigative eyes on the ground. Another kind of popular rogues' gallery was circulated in printed form: in 1886, Thomas Byrnes, chief detective of the New York City Police Department, published 204 photographs of legal offenders in his book *Professional Criminals of America*.

Byrnes departed from the strict form of Bertillonage in his published rogues' gallery, presenting a single, numbered photograph of each subject, a notation of his or her multiple aliases, a physical description, and a detailed record of past crimes. For example, number 115, Ellen Clegg, alias Ellen Lee, also known as Mary Wilson, Mary Gray, and Mary Lane, is identified as a shoplifter, pickpocket, and handbag opener. Her photograph is described as "a pretty good one, taken in 1876," and shows her turned slightly away from the camera, dressed in street clothes, including a coat and an elaborate hat. According to Byrnes, she weighs 145 pounds; stands five feet, five inches tall; and has brown hair, brown eyes, a light complexion, and large ears. The detective describes her as a clever woman, and an expert thief whose photograph graces several rogues' galleries across the country. In his general discussion of pickpockets, Byrnes notes that they are not unusual in manner and dress and would not draw attention in a public place; Clegg's photograph corroborates that statement. *Professional Criminals of America* subtly instructs readers to study the faces of the people it records, as well as those they encounter in daily life, encouraging viewers to be on the lookout for infamous repeat offenders.

One of the most notable aspects of Byrnes's *Professional Criminals of America* is the apparent whiteness of its subjects. None of the written descriptions paired with photographs identify men and women as "colored," although at least one arresting officer is described as such. Instead, the text delineates different white ethnicities, including Irish, English, Scottish, German, and Jewish. Complexions are described as "florid," "sallow," "ruddy," and "sandy," and there are almost as many deemed "dark" as "light." But these are all considered different shades of white. Given the grossly disproportionate numbers of men and women of color incarcerated in the United States today, how might one understand the whiteness of the subjects represented in Byrnes's 1886 text?

As Simone Browne has argued in *Dark Matters: On the Surveillance of Blackness* (2015), beginning with slavery, the black body has been an object of surveillance in the United States, marked, literally and metaphorically, as property. Blackness is

115

116

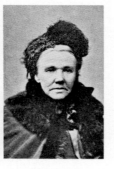

117

ELLEN CLEGG,
ALIAS ELLEN LEE,
SHOP LIFTER AND PICKPOCKET.

MARY HOEY,
ALIAS MOLLY HOLLBROOK,
PICKPOCKET.

MARGRET BROWN,
ALIAS OLD MOTHER HUBBARD,
PICKPOCKET AND SATCHEL WORKER.

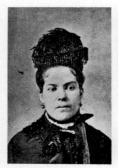

118

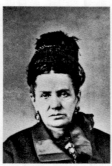

119

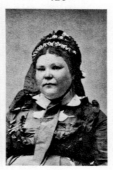

120

CHRISTENE MAYER,
ALIAS KID GLOVE ROSEY,
SHOP LIFTER.

LENA KLEINSCHMIDT,
ALIAS RICE and BLACK LENA,
SHOP LIFTER.

MARY CONNELLY,
ALIAS IRVING,
PICKPOCKET AND SHOP LIFTER.

Opposite, top:
**Bain News Service,
New York City Police
Department taking
Bertillon measurements—
cranium, ca. 1908**
Courtesy the Library
of Congress, Prints and
Photographs Division

Opposite, bottom:
**Page from Thomas
Byrnes, *Professional
Criminals of America*
(New York: Chelsea House,
1969)**

This page:
**Alphonse Bertillon,
Self-portrait, 1912**
Courtesy Wikimedia
Commons

Blackness is always already under scrutiny, while whiteness is defined by not being put on display; surveillance is a racialized optic.

always already under scrutiny, while whiteness is defined by not being put on display; surveillance is a racialized optic. In this cultural context, the absence of men and women of color from Byrnes's printed rogues' gallery suggests that viewers did not need to learn to read the body of color since men and women of color were already under a racialized surveillance. The delineation of white subjects in Byrnes's text suggests that viewers had to be trained and instructed to see white men and women as criminal and also to parse whiteness itself. *Professional Criminals of America* makes visible the notion of "variegated whiteness" that proliferated in the United States in the late nineteenth and early twentieth centuries. Historian Matthew Frye Jacobson has discussed how, in response to increased European immigration, so-called Anglo-Saxon nativists sought to restrict the definition of "free white persons" eligible for naturalized citizenship according to the 1790 naturalization law. They did so by delineating a new hierarchy of "white races." In part, Byrnes's text instructs viewers to distinguish Anglo-Saxons from "other" white races increasingly deemed suspect.

Today the mug shot remains a prevalent (paired) image, an instrumental photograph that continues to encourage popular practices of observation, inviting the public to police itself. What the history of the mug shot demonstrates is that such disciplinary ways of looking had to be learned; they were crafted, standardized, practiced, and taught. There is nothing transparent about these images or the way they present individuals, and despite their long legacy, their point of view can be challenged in order to generate alternative ways of seeing and representing incarcerated people.

Shawn Michelle Smith is Professor of Visual and Critical Studies at the School of the Art Institute of Chicago and the author of *At the Edge of Sight: Photography and the Unseen* (2013).

Bruce Jackson On the Inside

When a folklorist set out to document life in American prisons, he found the enduring segregation of the Old South

Brian Wallis

Among other things, the American prison system is designed to keep a purportedly disagreeable or disposable portion of the population out of sight and out of mind. The same walls that keep prisoners in are intended to keep prying eyes out. The secret lives of prisoners—their living conditions, their social systems, their codes—are, in the free world, virtually invisible, and, therefore, unknowable. Breaking through these barriers, folklorist and photographer Bruce Jackson has, for over fifty years, tried to get inside the penitentiary walls to tape-record, film, and photograph inmates, not only to document their unique cultural forms and social microcosms, but also to make a clamorous case for prison reform and prisoners' rights.

Like many documentary photographers of the 1960s and 1970s, Jackson developed a unique approach to infiltrating and re-presenting otherwise unknown aspects of seemingly impenetrable and forbidding subcultures. Between 1964 and 1979, he compiled extensive studies of the social behavior of prisoners in Texas and Arkansas state prisons, and his research was presented in dozens of scholarly books, essays, films, and audio recordings. In 1964, while a visiting fellow at Harvard University, he first traveled to Ramsey prison farm, near Rosharon, south of Houston; it was Freedom Summer, a period of especially high racial tension in the South. Jackson's goal—as noted in his 1965 text "Prison Folklore"— was to record "the ways of prison life, the factors that make for an independent world: the language and code, the stories and sayings, and, sometimes, the songs." Following in the footsteps of early folk song collectors like Alan Lomax and Paul Oliver, Jackson was gathering the remnants of a rapidly disappearing African cultural tradition lingering in the diaspora in the forms of oral histories, toasts, spirituals, gospel music, blues, and work songs.

The archipelago of southern prison farms that Jackson encountered in East Texas from 1964 to 1967 consisted of vast tracts of forests and farmlands, often located on the sites of former slave plantations. Under the watchful eyes of mounted prison guards, segregated work details of inmates, in matching white uniforms, labored from dawn to darkness building roads and levees, picking cotton and tobacco, planting bottomlands and felling trees, swinging axes in unison to the chants of traditional work songs. Cadenced work songs were a survival technique, intended to synchronize the prisoners' labor, pace them under the scalding sun, and keep slower workers from falling behind. In the free world such music had been forced away or co-opted by commercial interest, but in the isolated prison work crews and chain gangs this anachronistic music survived. "I was interested in the black convict work songs," Jackson recalled, "because they go back to a slavery-time musical tradition which in turn goes back to an African musical tradition. It's a pure, unbroken line of musical performance and style, and the way music and physical labor integrated with one another."

In March 1966, Jackson joined with folk singer Pete Seeger and his family to film the last vestiges of African American work songs at Ellis prison farm, near Huntsville, Texas. The mesmerizing thirty-minute, black-and-white documentary film they produced, *Afro-American Work Songs in a Texas Prison*, records the chants and the rhythmic chopping, with very little narration. It's the only known film record of a tradition that, by the following year, had literally vanished.

In this context, Jackson began taking photographs, initially as notes or aides-mémoire, and later to illustrate his many publications. Jackson was interested in capturing whatever elements of prison folklife could be recorded, using whatever documentary instruments were necessary to gather this information as thoroughly as possible. According to Jackson, "Documentary work entails a responsibility to an external reality. For me, that external reality is broad and complex. Human experience is not one thing, it is everything:

**Texas and Arkansas prison
photographs, 1965–78**
All photographs courtesy
the artist

With a certain detachment, Jackson's photographs examine the cruel labor and relentless mundanity of prison life.

it is what you have for breakfast, what you wear, what you make, and the stories you tell. So, what I was trying to do was to use as many instruments as I could to look at and to preserve as many aspects of that world as I could, to let other people see what I saw. Photography was equivalent to my tape recorder." Jackson's photographs formed a crucial part of the research for his several classic books on prison life, including *In the Life: Versions of the Criminal Experience* (1972), *Wake Up Dead Man: Afro-American Worksongs from Texas Prisons* (1972), and *"Get Your Ass in the Water and Swim Like Me": Narrative Poetry from Black Oral Tradition* (1974).

True to his training as a folklorist, Jackson tended to be more practical than poetic about his photography, saying, "What I wanted in my photographs was the sense of what it was like if you were standing where I was standing." Jackson's photographs from the antiquated East Texas prisons meticulously catalog the various components of the bureaucratic penal system: the entry, or sally port; the chain-link and razor-wire perimeter; the warden's office, with its boar's head decor; the uniformed guards, mounted on horseback with rifles; the prison yard, where inmates are forced to strip down; and the endless parched fields, where the prisoners work. A retrospective volume of Jackson's photographs, *Inside the Wire: Photographs from Texas and Arkansas* (2013), reproduces these brutal pictures with merciless fidelity. And they are astonishing, in part, because they seem so alien and anachronistic.

These stark black-and-white photographs capture the primitive social conditions and enforced slavery-like labor of a not-so-distant version of criminal justice. They show legions of prisoners with raised shovels and hoes marching to work in the fields; they show uniformed guards with rifles monitoring the workers from high on horseback; they show inmates in striped prison costumes performing at a local rodeo; and they show inmates at ease in anonymous and poorly lit prison lunchrooms, confronting boredom. Pictures of

paunchy white prison guards sipping iced tea while a field of hunched-over, white-suited African American prisoners pick cotton are not only images of a bizarre cultural remnant of the Old South, but also are records of the deliberately dehumanizing, almost medieval, caste system that survived in American prisons as late as the 1970s.

If Jackson's vivid prison scenes bring to mind the photographs of Danny Lyon, especially those from his classic 1971 book, *Conversations with the Dead*, the association is not coincidental. In 1967, Jackson helped to facilitate Lyon's access to the Texas prison system, and over the next fourteen months Lyon photographed at many of the same units where Jackson had worked. At times, the two men photographed alongside one another. But there is a striking difference between their photographs, which reflects their differing approaches to documentary photography. Lyon was a full-time photographer who had covered the civil rights movement in Mississippi and filmed a notorious motorcycle club in Chicago. His photographs of Texas prisoners are stunningly composed images that emphasize the physical beauty of the prisoners and the dignity of their labor. Lyon's fascination with confinement is perhaps clearest in the many photographs in *Conversations with the Dead* that feature the naked bodies of prisoners. Whether in the shower, getting hosed down in the prison yard, or experiencing a shakedown, they are totally vulnerable—fully exposed to us, the viewer—yet their faces, in most cases, are hidden, turned away from the camera.

Jackson's photographs, on the other hand, are more overtly descriptive, even ethnographic; with a certain detachment, they examine the cruel labor and relentless mundanity of prison life, the unique homosocial culture of the segregated lockups, and the furtive glances between the prisoners and the photographer. Jackson refers to his picture taking as a "collaborative performance" between him and his subjects, and has stated that as a researcher,

"the experience isn't passive; it's collaborative, even symbiotic." A careful and deliberate listener, Jackson is also a meticulous watcher and a political advocate; his photographs show him to be keen-eyed to the subtle meanings of pose, clothes, possessions, and environment. "Documentary is an engagement," Jackson says, "an engagement with a community, a process, a social issue, and an audience; you are engaging that thing and you are part of it." Rather than composing his experiences with a purely aesthetic eye, Jackson lets the information come to him. Jackson's friend, lawyer William Kunstler, once said of his approach that "the politics and theory seem to *derive* from what [Jackson] saw; with most observers, the politics and theory seem to *control* what they saw." Ironically, when Jackson's blistering essay "Our Prisons Are Criminal" was published in the *New York Times* in 1968, it was illustrated not with one of Jackson's own photographs, but with one by Lyon.

In 1971, Jackson traveled to the Cummins prison farm, near Grady, Arkansas, to experience the first prison system in the United States deemed unconstitutional, what *Time* magazine had called "hell in Arkansas." In the 1969 case *Holt v. Sarver*, inmates sued the commissioner of corrections of the state of Arkansas, and a federal judge ruled in their favor, finding that the Arkansas prison system as a whole had practiced racial discrimination and cruel punishment in ways that clearly violated the U.S. Constitution. To help remedy conditions there, the state appointed as commissioner of the Arkansas Department of Correction T. Don Hutto, a former Texas prison official whom Jackson knew. When he visited, Jackson was afforded the same total access he had enjoyed in Texas. From 1971 to 1979, Jackson made eight visits to Cummins and concentrated more thoroughly on his photography than he had in Texas, even making innovative panoramic views using a Widelux camera. Many of these photographs were published in Jackson's book *Killing Time: Life in the Arkansas Penitentiary* (1977).

With the modernization efforts taking place in Arkansas, the structure of prison life was very different from what Jackson had seen earlier in Texas. He focused more on individual portraits of prisoners, on their social interactions, and even on their creative works, often a kind of outsider art made with available materials. "I wanted to show what it was like to be in that world and what were the cultural products of that world," Jackson recalls. "A lot of the photographs from prison are portraits of the guys with things they've made out of cigarette wrappers, or stones, or toothpicks." In one photograph, from 1975, a prisoner stands in his prison cell, casually holding a coffee cup and smiling mischievously. He proudly displays two of his artworks made for sale to other prisoners: a painting of a young African American boy copied from a photograph and a wildly inventive painting of the biblical flood. While the portrait signals the prisoner's desire for home and family, the imagery of the flood proposes a unique and highly personal iconography, depicting, instead of the typical view of Noah's ark, with its pairs of animal refugees, the experience of the doomed individuals excluded from the safety of the ship. With the storm raging and floodwaters dashing against them, doomed and disheveled folks cling hopelessly to rocks as a tiny ark sails away without them. The metaphor is clear.

In an environment in which all outdoor views are occluded by bars, crafted and reproduced images take on a special importance. Jackson was always attentive to the ways prisoners surrounded themselves with visual icons, not only family photographs, but also fanciful tattoos, miniature houses, and scribbled graffiti. His photographs frequently document these images and objects that prisoners made and collected and displayed: a bare-chested and tattooed prisoner standing before a wall of *Playboy* centerfolds carefully taped together and cleverly mounted under electrical switch plates; a prisoner with a collage of personal photographs covering every surface inside his personal trunk. Jackson notes that every prisoner had such image collections, and that when he showed some of his shots to Walker Evans, Evans chided him for not photographing every single one of them.

Like Evans, Jackson is a documentarian of the vernacular. His work involves various research techniques for gathering cultural materials, often the endangered detritus of everyday life, which only later will be organized into recognizable patterns, or analyzed for meanings. As with many progressive documentary projects, the goals of Jackson's photographs were to point to creative elements of everyday human behavior that were overlooked, to preserve aspects of culture that were in danger of disappearing, and to agitate for change in instances of social and moral injustice. "Documentary is always answerable to something in the real world exterior to itself," Jackson says, as he reflects on his early experiences collecting folk songs and photographs in Southern prisons. "I could relate to these guys and their world. I liked the music and thought it was important. What was going on in their lives was important. And it was important to tell their story. I didn't know how I was going to tell the story, but I knew it was important to accumulate the elements, like collecting pebbles."

Brian Wallis is a writer and curator based in New York.

Jack Lueders-Booth

Christie Thompson

A photograph means more in prison. Tacked on a cell wall, it can be one of the few connections to life outside—to the Christmases, birthdays, and graduations passing, or the children and grandchildren growing older. And, in the rare moments when the incarcerated themselves are the subject, it can be validation within a dehumanizing system: You are still here. You exist.

That's what Jack Lueders-Booth found at the Massachusetts Correctional Institution-Framingham when he became what a friend called "the school photographer of Framingham prison," one of the oldest women's prisons in the country. For seven years, in the late 1970s and mid-1980s, Lueders-Booth photographed the prisoners of Framingham for a series of intimate and challenging portraits. The photographs have almost none of the visual shortcuts that we associate with prison. There are no barbed-wire fences, rusting metal bars, or khaki uniforms (at the time, the prisoners were allowed to wear their own clothes). Instead, we see the women on their own terms, intertwined with friends or putting on makeup. They stare directly at us.

The project began when Lueders-Booth was teaching a photography class to the women of Framingham while completing his master's degree in education. Prison administrators allowed him to build a darkroom in an abandoned wing. He taught the women how to make photograms, and how to take landscape photographs of the prison and portraits of each other. In his own work, Lueders-Booth had been trying to move past documentary photography and toward pictorialism, but something about his students at the prison drew him in. "I wanted to get as close as I could and reveal more of who was there. I felt very privileged and honored by their trust," he said in an interview.

Recording oral histories of the women's lives drew Lueders-Booth even closer. He set up a microphone and gave them no prompt. What emerged were the wounds that had brought each woman to that moment in Framingham. One woman talked about an adolescence spent under the watch of "ass-kicking" nuns in juvenile detention. One spoke defiantly about the instant when she stopped being pushed around by a man. A pregnant woman thought ahead to when prison officials would separate her from her days-old baby. "I had known these women for years before I did this, and when they started talking a whole different side of them was revealed," Lueders-Booth said. "How did I think I knew these women when I really knew nothing?"

As Lueders-Booth made this series, the country was ramping up a decades-long War on Drugs that would drive women's incarceration to unprecedented rates. Now, politicians are in a moment of reckoning for what that war has wrought. The Massachusetts House and Senate passed comprehensive bills in fall 2017, aimed at undoing the damage and reducing prison populations. Yet for all the movement in state legislatures and public opinion since Lueders-Booth photographed at Framingham, these women's stories force us to question how much has really changed. Women and girls are the fastest growing population in U.S. prisons and jails. They are still separated from their children and often driven to crime by abusive partners and deep poverty. As one woman told Lueders-Booth, echoing what might be heard today, "I want security for my children, my brother, and a home to go to. I even thought that I had all that, and they took it all away."

Christie Thompson is a staff writer for The Marshall Project, a nonprofit newsroom covering criminal justice.

All photographs from the
series *Women Prisoners,
MCI Framingham
(Massachusetts
Correctional Institution
at Framingham)*, **1978-85**
Courtesy the artist and
Gallery Kayafas, Boston

Jamel Shabazz, A detainee
from Brooklyn poses in
the corridor of his housing
area, Rikers Island, 1986

Behind These Prison Walls

Jamel Shabazz and Lorenzo Steele, Jr., two photographers who worked as corrections officers, speak with Zarinah Shabazz about photographing life at New York's Rikers Island

Zarinah Shabazz: **You were both introduced to photography by members of your family at an early age. As young men, you both became corrections officers. How did you each decide to work in corrections?**

Lorenzo Steele, Jr.: I grew up in Queens. My father was a disciplinarian, and my mother was a disciplinarian. We were the generation that your father and mother were like, "Listen, take those city tests, those civil service tests." I took the test. One day, my mother said, "You've got mail." I opened it up, and it was from the Department of Correction. I had passed the test. This was 1987, and I was twenty-two years old.

Jamel Shabazz: I had just come home from the army in the summer of 1980. At that time, I had aspirations to go to college, but my father stressed to me the importance of taking a city job, because of the good benefits that it afforded. I applied for a variety of jobs—Transit, Post Office, and Correction. In 1982, both Correction and Post Office called me at the same time. I realized that I had to make a choice, and felt that Correction was the best place for me to be, because a lot of young brothers were being locked up and I had a desire to make a difference.

Prior to working in Correction, I worked at the Wards Island men's shelter as a security officer. Wards Island is almost like a prison, and a lot of men of color were housed there. Oftentimes you would have men who were going through difficult times; those who were trying to find shelter, and then some who had just been released from prison. I happened to meet a city corrections officer who was homeless, and he saw the way I was handling the clients. He told me, "You'll make a really good corrections officer. They need people like you." That pretty much put the icing on the cake, and I made the decision that this was where I needed to be. I have to say, it was one of the best decisions I ever made in my life. I was twenty-three at the time.

ZS: **How was the environment when you came to the job?**

JS: We went through seven weeks at the corrections academy and had really excellent and professional instructors, but nothing they taught us could prepare us for what I would see when I went inside.

When I first started, I worked among the adolescents. The first thing that surprised me was the fact that there were so many people of color locked up. It was very troubling for me to see so many young men, many of whom came from my community, a lot of them who got trapped in the system. Just seeing these confined black and brown young men reminded me of slave ships and the slave ports. I'll never forget going by this large bull pen that held maybe one hundred inmates going to court. That troubled me.

It was a very hostile environment. Oftentimes, we worked between eight to sixteen hours a day under difficult conditions, and during this particular period, the crack epidemic was just beginning to spread. You were seeing a large influx of people coming into the system who had fallen victim to crack, by either using it or selling it. It was a major influx like never before.

ZS: **Lorenzo, how would you describe the environment?**

LS: My first contact with the facility was very hurtful, because all I saw was black and brown faces; blacks and Hispanic, all over. It was scary just to see that. Rikers Island to this day is still called the most violent adolescent prison in the nation. We used to average close to forty to fifty razor slashings a month, and I saw so much blood. I saw so many people cut. I could actually stitch somebody up, if I really had to, myself. Just knowing how to do that without even being a doctor tells you how violent that place was and is. People don't realize that corrections officers didn't carry weapons. The only weapon you had was your mind.

JS: That's right.

LS: Imagine going into a hostile environment, and every day, *every day* that you walked behind those prison bars, your life could be taken—just like that. It was a very troubling, courageous time. But we saved a lot of people's lives. I'm so glad that we have the opportunity to actually give an officer's perspective about what it's like, because we save more than we hurt. I was a very good officer. Jamel was a very good officer. Everyone was treated like a human being. Everybody got to use the telephone. Everybody got a visit at a certain time.

ZS: **Lorenzo, how did you go about making photographs at Rikers, and was it permitted?**

LS: At that time, it was very, you could say, staff-friendly. The officers were good with the captains and the supervisors. We played softball together. We played basketball together. Some even drank together. I just happened to be the photographer. What year did you leave, Bazz?

JS: I think it was 1987 that I got transferred to the work release and drug rehabilitation program.

LS: When you left, I came into the Adolescent Reception and Detention Center and I was the jail photographer. If there was a retirement party, they would say, "Steele, bring in your camera and take the pictures." It was normal for me to walk around the jail with my camera. At no time did I know that what I was doing would be later on used to help save individuals from actually going through the jail system.

ZS: **How so?**

LS: I wanted to capture what the average person didn't even know about unless they were actually coming through the system. But after twelve years, I just couldn't take it anymore. I just left. I knew it was time for me to go, spiritually, because the job really took a toll on me. "A toll on me" meaning I actually transformed from that twenty-two-year-old to someone coming into consciousness. After leaving the Department of Correction, it took me a good eight to nine months to detox. It was like I had just come home from a war, a twelve-year war, and I had to gather my thoughts and think, Okay, that chapter is over; what's your next chapter?

I always loved working with children, so I volunteered and went into the public school system—the Department of Education. I was actually using the same images that I took inside the jail to now show these young children: "Listen, if your habits and behavior don't change, there's a large possibility that you're going to go through the criminal justice system." So now, with those images, they're seeing it firsthand. Because the influence that the rap music has, and those guys who are coming home from jail, they're glorifying it. But nobody is telling you, "For the first two years I had to wash people's underwear"; "For the first year I got sexually abused." You're not going to hear those stories.

ZS: **Jamel, how did you go about taking photographs, and was it permitted?**

JS: My father, who was a professional photographer, instructed me early on to carry my camera everywhere I go. From the moment I was called to be a corrections officer, I had my camera. At the academy, I had my camera. At the range, I had my camera. I wanted a visual diary of my journey.

I felt it was necessary to show the human side of officers, because oftentimes the image of a corrections officer is negative.

Jamel Shabazz, Pretrial detainees all part of the "House Gang" (sanitation workforce) pose in the day room of their housing area, Rikers Island, 1986
All photographs courtesy the artists

I started by photographing officers in the locker room. Then I decided that it was important for me to bring my camera and my portfolios into the inmate housing area. I would often share my photographs with the young men, and it started conversations. It strengthened the relationship between me and them. I recognized that photography could serve as a form of visual medicine, and it could also help to heal them. I eventually became known as "the photographer." I think it's very important to show this work to help people see the human side of those incarcerated. We hear about prisons. But, what is the face of the inmate? What does the inmate look like?

ZS: **Why was it important for you to photograph inside the prison? What did you both hope to achieve? And did you wish for the public to see life on the inside and offer a point of view that isn't often seen?**

JS: I wanted the public to see what officers looked like. I felt it was necessary to show the human side of officers, because oftentimes the image of a corrections officer is negative. So what we documented is the family side—the mother, the father, the hard worker, and the person just trying to live the American dream.

LS: I captured those images because I wanted young people to see what it's really like behind bars. Those images, I know, are saving lives. I made a documentary called *Scarface 4 Life* (2005), where we shot video footage inside. One day, I was in Queens at a basketball tournament and a guy said, "Yo, that documentary that you did,

Scarface 4 Life, showing what goes on in jail, I actually sat down with my son, and now I have something to reference what jail is really like."

Think about people that are coming out of major institutions, educators who have never been to jail, but they read about it. That led me into my first book, *Behind These Prison Walls: Life Inside Rikers Island* (2017). I put it in an educational form, so now that book is actually being used in the Department of Education.

ZS: **How did your experience working as a corrections officer inside Rikers shape or influence the photography you made outside of prison?**

JS: A lot of the images in my books *Back in the Days* (2001) and *A Time Before Crack* (2005) reflect my travels going to and from work. On so many occasions, I would leave Rikers Island and go right to downtown Brooklyn—which was the heartbeat of Brooklyn, where many teenagers congregated—to decompress. The camera became an instrument that allowed me to connect and build relationships with them. One of the main points was to speak about the crack epidemic and the early stages of the War on Drugs. Another key point I stressed was that the only way to go to jail is as an officer. I actually encouraged some of the young brothers to become officers, because I felt we needed more balance, individuals who understood the street, who understood the language to get on that job. And it was good money with great benefits.

ZS: **How about you, Lorenzo?**

LS: In 1999, I went from officer to advocate. Some of the images that I took back in the days, I had them framed, and I put those images on easels in front of housing developments in Brownsville, Bed-Stuy, East New York, Far Rockaway, in my spare time. Why would I do something like that? Because the average person is not going to go to a museum and they're not going to go to an art gallery. So I bring the art gallery to them. But my art gallery is information that could help keep them out of the criminal justice system.

After leaving the Department of Correction, I went to Ghana to the slave dungeons. Spiritually, I had to go to Ghana. And I was standing inside the Elmina slave dungeons and comparing them to the receiving room. It's the same system. Nothing has changed. They have a place in the Elmina slave dungeon called "the door of no return." In one of my favorite pictures I'm in the receiving room, and I'm behind the black gate, and I'm shooting through the gate, and on the other side of the gate is a state officer escorting newly sentenced inmates onto a bus that's getting ready to go to one of those seventy-two prisons in upstate New York. That is my *Door of No Return*.

A lot of those individuals go through that door in the receiving room—and it's the same as that slave going on the ship to the plantation—never to return, and have their minds altered, conditioned, reconditioned to think. You come into the criminal justice system one way, and you leave another way. It's a place that breeds violence.

ZS: **What role does photography play in helping the public understand the current condition of mass incarceration in the United States?**

JS: Photography, in collaboration with words, is very, very important. I go back to that question: What does the inmate look like? You go in there; it shocks you, because you have people of all the various races—but mostly poor, disenfranchised people, and many individuals battling not only mental illness, but drug addiction as well. In addition, the violence factor that individuals inflict upon each

other—it turns them against humanity. So the work that Lorenzo is doing is so important, because it shows that aspect of violence.

I spent ten years working in the mental health area. A lot of times you had staff that were unsympathetic to this struggle. I worked in an area in which I took great care in treating them with dignity. It could be something as simple as bringing in old cologne that I was no longer wearing, and allowing them to put some on their hands and have a sense of pride. I always made it a point to bring literature in to help inspire people and try to educate them, to help empower them.

ZS: **Lorenzo, do you believe that photographs can influence or shape the conversation and debate around mass incarceration?**

LS: Yes, because without the photographs, it's just talk. When you can put up a picture, and you got a guy that just freshly got his face ripped wide-open, and you actually can see the tissue, sometimes the white meat, that's a different story. That affects all your emotions.

JS: During the 1980s, a lot of mental institutions were closed around the country. Jails became a holding ground for people who were mentally ill—who needed treatment, not incarceration; the same with drug addiction. In today's society, with the opioid epidemic and the fact that you have a lot of whites who are addicted to both opiates and heroin, now there's this whole talk about how we have to change the system. But when crack hit, the thinking was, "Lock them up and throw away the key." The politicians wanted to get elected, and the War on Drugs was actually a war on black and brown people.

LS: Yes, it was.

JS: And it was a failed effort. It's done more harm than good because people's lives have been compromised, and now you come home to nothing. You have a felony. You can't vote. You can't live in public housing. So your struggles continue. People who come home from prison are never the same. The trauma is and will always be there.

LS: Yes.

ZS: **The prison environment is dehumanizing. How can photography honor the humanity of the incarcerated?**

JS: When I think back on my days coming home from Rikers Island, I tried to empower a lot of young men on the street corner. I would practically plead with them and say, "We have to avoid jail; at the same time, we have to be proactive." We need more help. We need saviors on the street to talk to these young people and guide them, because we are losing a generation that is being set up. It's a trap. We need voices out there to speak about this, in hopes that young people will listen.

LS: These stories are the stories that must be told.

Zarinah Shabazz is a twenty-year veteran captain of the New York City Department of Correction.

Vanessa and Lauren
watering, GreenHouse
Program

Lucas Foglia

Rikers Garden

Jordan Kisner

Rikers Island has often been in the news lately. The island jail complex in New York, located across a narrow channel from LaGuardia Airport's runway paths, houses roughly ten thousand offenders at any given time, most of whom are waiting to be tried and sentenced. It has a reputation for brutal treatment of those detainees and its convicted prisoners. In 2013, after a number of reports of abuse and deaths surfaced, the complex was declared one of the country's ten worst correctional facilities, and, in 2017, New York's mayor, Bill de Blasio, announced plans to close Rikers altogether.

Somewhat incongruously, given its current reputation, Rikers is also home to tomatoes that rival the ones found at Manhattan's greenmarkets. Amid—and, occasionally, inside—the many detention centers on the island, there are five organic gardens, which are planned, raised, and tended by detainees and prisoners. These gardens constitute what is called the Rikers GreenHouse program. Created in 1996 by the Horticultural

Society of New York, in collaboration with the Department of Correction and the Department of Education, it is America's first program devoted to prison horticultural therapy. The Horticultural Society of New York claims that participation reduces recidivism by 40 percent.

In 2014, Lucas Foglia, a photographer known for his portraits of the American West and off-the-grid communities in the rural South, photographed inmates at two of the gardens on Rikers Island. One is the island's primary garden, a nine-acre plot in the Rose M. Singer Center tended by incarcerated people. This garden has rows of raised beds that were planted with peppers, tomatoes, corn, greens, squash, and berries the summer Foglia's photographs were taken. Nearby, there is a classroom, a greenhouse, an herb garden, and a pumpkin patch. Throughout the garden, which looks more like a miniature farm, are touches added by inmates over the years: a pergola wreathed with climbing grape vines, a chicken coop housing a flock of guinea fowl, a pond.

There is also a garden in the George Motchan Detention Center, which is tended by male detainees awaiting trial. Security in this center is stringent—its detainees are never allowed outside the building, and are only allowed in the garden because it is completely surrounded by the jail. The theory behind constructing gardens in such a space is that for those imprisoned, gardening, as the program's curriculum states, "allows them to control their environment through shared responsibilities— an unspoken contract between person and plant."

Altogether, the gardens on Rikers Island produce more than four hundred pounds of fruits and vegetables every year. While some is donated to homeless shelters and soup kitchens, a good amount is shared and eaten by the detainees and prisoners who participate in the program. Near the end of a day's shift, a few people are tasked with making the group a salad with whatever they've harvested that day, which is relished for being the best (and sometimes only) fresh produce they have the opportunity to eat. Tastes emerge: one young man developed a fondness for cucumbers and always seemed to have one in the pocket of his jumpsuit. (The iconic striped jumpsuits shown in Foglia's photographs aren't daily attire for inmates—they are only required to wear them when on the prison's outdoor grounds.)

Five days a week, the inmate-students learn about seasons, soil, growth cycles, and pruning. They decide as a group what to plant each season, and tend each crop from seedling to maturity. Many dread the weekends, when they're confined to their dorms and can't work in the garden. One inmate named Peter, who owns a bodega in Queens, made much of the fact that he knows exactly when to pick a melon. On weekends he worries about whether his plants are getting enough water. "If we could stay here all day that would be wonderful," he said. "It's the only place where we feel like human beings."

Jordan Kisner is a contributor to *n+1*, the *Guardian*, and *The New York Times Magazine*.

DEBORAH LUSTER

Zachary Lazar

ANGOLA PASSION PLAY

In 2013, two weeks before Easter, Deborah Luster and I went to document *The Life of Jesus Christ*, a passion play being performed for the general public at Louisiana State Penitentiary at Angola, a maximum-security prison. Cathy Fontenot, now a former assistant warden at the prison, who initiated these performances in 2012, saw it as an opportunity to humanize incarcerated people for an audience of free people.

An implausible coincidence led Luster and me to this project. We both had a parent who was murdered. Both murders happened in the same city, Phoenix, Arizona. They were both contract killings. Many years later, after establishing our separate lives, we met when I moved to New Orleans, where it turned out our houses were two blocks away from each other. Luster had photographed inmates at Angola many times, most notably for a book-length collaboration with the poet C. D. Wright called *One Big Self: Prisoners of Louisiana* (2007). As I wrote in my letter to Fontenot asking permission to visit, it seemed possible that by collaborating on this project Luster and I might force the coincidence between us to become more than just an unlikely wound that we shared.

The vast prison in central Louisiana, which houses about six thousand men, consists of several former slave plantations. I thought we would have a day there, but Fontenot provided a place for us to sleep at night, allowing us to stay for a full week. During this time, I interviewed over forty prisoners at great length—men from Angola and women from the nearby women's penitentiary in St. Gabriel—while Luster took photographs. Most of the men, and some of the women, are serving life sentences, or sentences so long that they amount to life. Because parole is extremely rare in Louisiana, 90 percent of the inmates at Angola are expected to die on its grounds. You can be sent to prison for life in Louisiana for just being present during a crime, even if you did not actually commit the crime yourself. You can be sent away for life for doing something stupid when you're sixteen. You can be sent away for doing nothing at all, an innocent person, or an exemplary one, like the protagonist of *The Life of Jesus Christ*. The state has the highest rate of incarceration of any place in the world.

Bobby Wallace, Donald Cousan, Earl Davis, Levelle Tolliver, Michael Porché, Vernon Washington—these are some of the men seen in Luster's photographs, who all revealed more to me about their lives than I can recount here. Wallace, who played Jesus, was the only one not serving life (he is now free). Cousan is an expert cook who uses the microwave in his dorm-style sleeping quarters to prepare red beans and rice, greens, corn, and his specialty, steak and gravy—"not gravy out of a can but from scratch." Washington is a superheavyweight boxing champion in the prison league. Luster's portraits capture something complex and indescribable about these men. Luster has said that she distrusts color because it's too seductive, preventing us from seeing what's really there. Shooting photographs in black and white is not an analogy for "seeing the world in black and white." The interest is in the infinite range of grays.

Upon our arrival at Angola, the crew was still building the stage sets. Three wooden crosses, bedecked with ropes, had been raised on a mound of dirt. A crowd of prisoners was standing around, chatting amid a few ranks of potted shrubs and a fake Roman temple made of plywood. It dawned on me that the men working with tape measures, levels, hammers, and saws on the emerging sets were not hired carpenters, but prisoners. The man standing next to me shooting with a Nikon turned out to be a prisoner who was a reporter for the prison magazine, the *Angolite*, covering the same story Luster and I were: A man who happens to be the son of God is betrayed, convicted, and sentenced to death. On the third day, he rises from the grave to save the world with a message not of retribution, but of mercy.

Zachary Lazar is the author of five books, including *Vengeance* (2018), a novel inspired by his experience of the passion play at Louisiana State Penitentiary.

Previous page:
Layla "Roach" Roberts (Inquisitor)
Opposite:
Bobby Wallace (Jesus Christ)
Page 70:
Jamal Johnson (Roman Soldier)
Page 71:
Mary Bell (Anna)
Page 72:
James Blackburn (Roman Horse Soldier)
Page 73:
Earl "Trinidad" Davis (John the Baptist)
Page 74:
Levelle "Black" Tolliver (Judas)
Page 75:
Vernon "Vicious" Washington (Pharisee)
All photographs from the series *Passion Play*, 2012–13
Courtesy the artist and Jack Shainman Gallery, New York

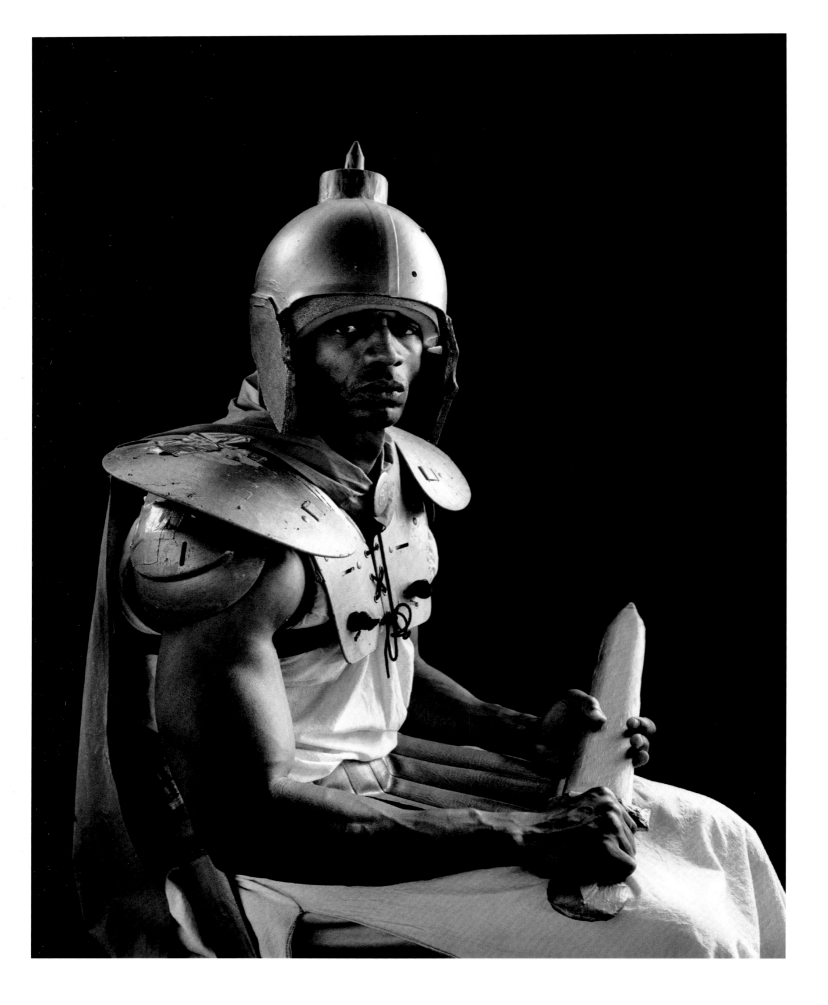

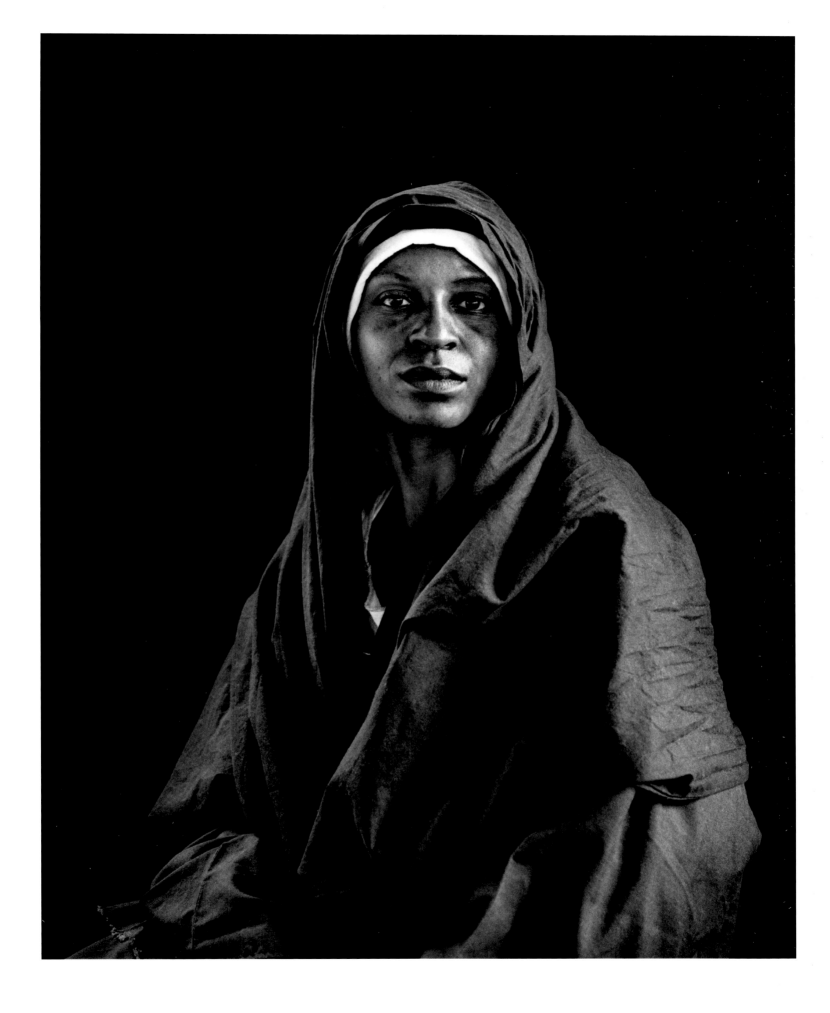

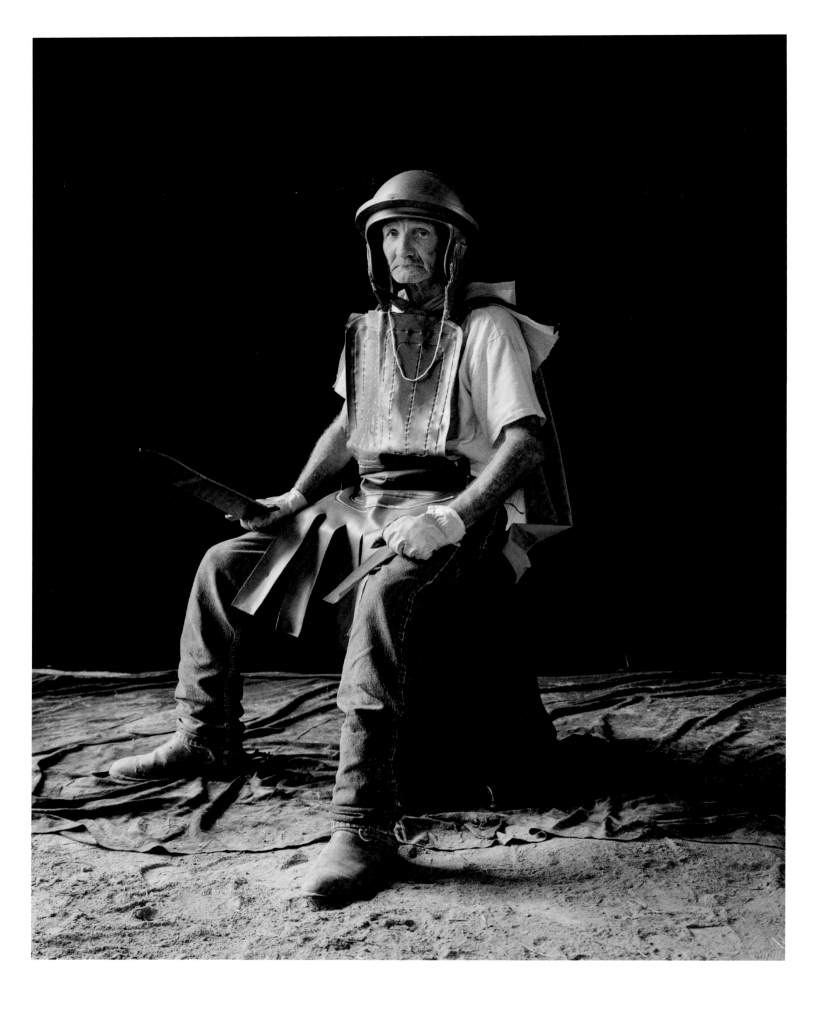

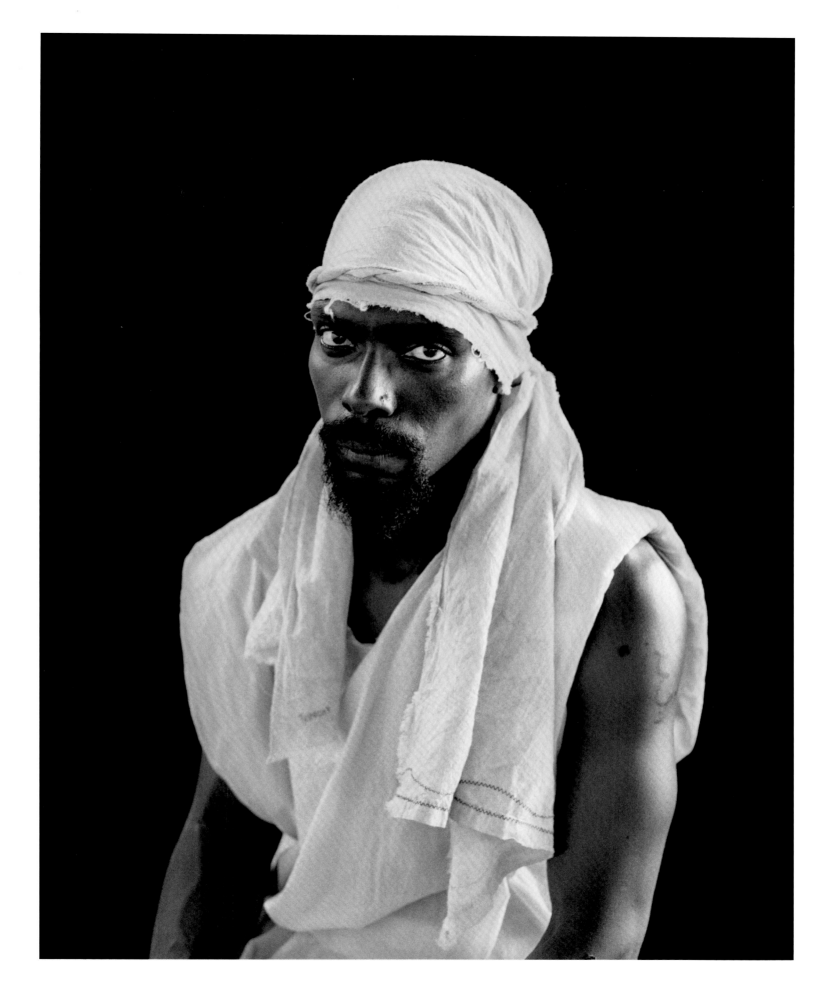

Marking Time

Nicole R. Fleetwood

Opposite:
Allen, Valentine's Day
portrait, ca. 2010

This page:
Nicole (the author),
Allen, and Sharon
(Allen's mother),
August 2012

Since 1994, I have had an exchange of words and images with my cousin Allen, who was sentenced to life in prison at the age of eighteen. We write to each other regularly, often reminiscing about growing up in southwest Ohio. There is such a familiarity in our connection, although our time together is limited to a couple of hours during each of my visits to see him. Allen and I grew up as siblings, along with several other first cousins in our large and close-knit family. His mother is my mother's older sister, and child-rearing was very much a group effort that was shared among all the female relatives.

Allen ends all his letters to me in the same way: "Niki, send more pictures. Love, your lil cuz Allen."

His requests for pictures make me think of other populations removed from their loved ones—migrant workers, those in exile or at war, those estranged from their families—who stay connected through letter writing and family photographs. I send him pictures, and he reciprocates. I have a small suitcase of memorabilia from Ohio prisons that includes letters, greeting cards, and prison photographs sent from Allen and other male relatives during their time incarcerated. The photographs are studio portraits taken by

incarcerated photographers whose job in prison is to take pictures. Allen poses in them sometimes with props, always in uniform. The backdrops are painted by incarcerated people, and break up the uniformity and repetition of the prison attire and staged poses. There are also photographs from our visits to see Allen. In most of these, he stands in the center, and we huddle around, hugging him tightly.

In the first few years of his imprisonment, I could not look at these photographs that arrived tucked behind his letters. I dreaded opening an envelope from him if I could feel that the contents included something akin to the thickness and flexibility of photographic paper. I would quickly glance and put the photographs back in the envelope, feeling much more comfortable with the letter. With his words, I had space to process and react. With the pictures, I had difficulty controlling my emotions. Gradually, my looks grew longer. I began to fixate on certain details—his hairstyle, a new tattoo, the shape of his arms and his neck. Then, as an experiment, I decided to hang the photographs around my home—secured by magnets on the refrigerator, tacked to a wall, or taped to the back of a door. After a while, they no longer unsettled me; they were just there, along with other images and possessions in my cluttered home.

These photographs serve as important visual objects of love and belonging structured through the U.S. prison regime.

In some ways, I forgot they were on display until a friend, who is an art historian, visited my home and inquired about one of them. Hanging on my refrigerator was a photograph of another cousin, also imprisoned in Ohio. In the portrait, De'Andre, in his late teens, smiles at the camera; he stands in a blue uniform, while hugging his grandmother (my aunt Frances). The backdrop is a painting of a winter scene, with snow-covered trees and rolling hills. A deer's partial figure animates the landscape. I replied, "That's my cousin De'Andre in prison during a visit from his grandmother—my aunt." My friend was shocked: "Wow. That was taken in prison ... There's so much love in that image. They both look so happy."

My friend had never seen a photograph documenting a family visit to an imprisoned relative and was unaware of how common these images are among groups most affected by mass incarceration—blacks, Latinos, Native Americans, and poor whites. The smiles and hug shared between grandson and grandmother were far from what he associated with prison life and culture. He compared the fantasy backdrops and setting to photographer James VanDerZee's early twentieth-century portraits of black residents of Harlem. Also notable in VanDerZee's work is the intentionality of his photographic subjects to use portraiture to document aspirations for upward mobility, equality, and inclusion. VanDerZee's photographs have a sense of futurity, hopefulness, and often a subtle or explicit claim of the nation (the U.S. flag as prop or black soldiers in uniform); his images document anticipation of a better life for blacks of the time period.

My friend's comments led me to see these photographs as more than documents of my family's pain and loss, our separation from De'Andre, Allen, and other loved ones. Millions of them circulate between incarcerated people and their families and friends, given that there are over two million people incarcerated in the United States. In terms of sheer volume, prison photography is one of the largest practices of vernacular photography in the

contemporary era. Like most vernacular photography, these images are primarily in private collections, housed in shoeboxes, photo-albums, drawers, and closets. These photographs serve as important visual and haptic objects of love and belonging structured through the U.S. prison regime, and provide an important counterpoint to a long history of visually indexing criminal profiles, such as mug shots and prison ID cards. Alternately, these photographs reveal the quotidian familiarity of penal settings for many millions who must navigate familial and intimate relations through prison bureaucracies and surveillance.

Among the most striking features that set these images apart from more publicly circulated photographs of prisoners are the emotive smiles, the imaginative backdrops, and the familial gazes of the photographic subjects that, one could argue, acknowledge their intended audience. Within portrait photography, backdrops tend to be read as signs of aspiration, futurity, and fantasy. In prison portraiture, the backdrops are more varied than the poses and uniforms of the imprisoned photographic subjects. Carceral backdrops project exterior life—a space outside prison walls—and they fall within landscape-painting traditions. While some backdrops reference iconic landmarks, like New York City's skyline, the majority do not project a sense of place or specificity of location. Instead, they represent a sense of nonconfinement, a lack of bars, boundaries, borders—an ungoverned, yet manicured, space.

Until recently, vernacular prison portraits have had little visibility outside of their widespread interchange between incarcerated people and their personal networks. However, in the past few years, these images have circulated more broadly in public culture as art, appearing in exhibitions, catalogs, art auctions, and blogs dedicated to prison culture. David Adler's collection of prison portraits, which has received considerable attention, is one example. Photographer Deana Lawson's series *Mohawk Correctional Facility: Jasmine & Family* (2013) is another. The photographs are of Lawson's cousin Jasmine; Jasmine's incarcerated partner, Eric; and their young children. The name of the series is taken from the prison where Eric was incarcerated—a name that reiterates the dispossession and confinement of indigenous peoples, a carceral facility now primarily occupied by hyperincarcerated young black and Latino men from New York City, and staffed by rural white workers. In the series, we see the power of prison studio portraits to document familial and intimate relations. In some photographs, Jasmine and Eric hold each other affectionately. They kiss and hug. In others, they stand together as a family with their young children. The backdrop is unchanging and more austere than in many prison studios. It is a mural painted on cinder blocks; the lines of the blocks are visible through the paint. Against this backdrop, Jasmine and Eric—and other prisoners with their lovers, families, and friends—make memories shaped by the carceral system.

In one memorable visit, the emotional weight of this form of memory making comes to the fore. It was September 2012 and I was at Ross Correctional Institution with my cousin Eric. We were visiting De'Andre, his son and my cousin. Then twenty-three years old, De'Andre had been in an adult prison for more than six years and had six years left of his minimum sentencing. Eric was visibly uncomfortable. De'Andre had recently been transferred to Ross from another prison that was closer to home. He had written to both of us, depressed and worried about his safety. He had not had a visitor in over a year.

At Ross, the photography studio is right next to the guard's desk and close to the visitors' entrance. The backdrop is of an autumnal setting sun. The sky is a pale shade of pink, and centered at the top of the landscape is a large, warm yellow sun. The outer ring of sun bleeds into the pink and touches the edge of the lone tree on the horizon. The leafless tree stands majestic, peaking up above the sun's rays. It's one of the sparest backdrops I have seen, and its color scheme is unusual.

**Allen, Nicole,
and De'Andre, 2011**
All photographs on pages
76–77 and this spread
courtesy the author

I speak briefly to the photographer while he sets up a shot; communication between the photographer and visitors is not officially allowed, but the guard does not seem to mind. The shift photographer, a middle-aged white man, tells me that he learned to take pictures in prison; he had never given photography much consideration when he was on the outside, he notes. The visiting room experience here feels more casual and less regulated than in most prisons I have visited, and yet this is one of the most restrictive institutions known to house prisoners who have committed serious felonies, or who have had disciplinary records at other penal institutions.

Photoshoots in prison tend to be quick and cursory. The photographer is careful not to spend much time talking with his subjects for fear of scrutiny by the guards, but today the shoots last longer, and those who are posing linger on the bench and chat with each other. Ahead of us, a young Latino couple spends considerable time, staging several images. The photographer walks to our table and tells us that we are next. De'Andre, Eric, and I take two pictures. In one, De'Andre is in the center, Eric is on his right side, and I am on the left. For the second picture, Eric says that De'Andre and I should take one together. De'Andre likes this idea; he has had very

little contact with women in six years. He squeezes me much tighter than I expect when the photographer asks us if we are ready.

I have this photograph collection of Allen and De'Andre aging, maturing, changing in prison. The images of Allen, now almost twenty years into his life sentence, shift from an angry and scared teenager, to a depressed man in his twenties, to a resigned but hopeful man in his late thirties anticipating each time he goes before the parole board that he will be released.

After years of struggling with anger, shame, guilt, and depression about Allen's life sentence at such a young age—his first time being arrested and convicted of any crime, but the judge having said during sentencing that he was making an example out of Allen so that other boys in our community would stay "in line"—his mother and sister work even harder to incorporate him into their daily lives. Allen is brought up with the frequency of one who shares a home with them. Their 2011 holiday card is evidence of this commitment. The photograph, staged in prison against an idyllic winter backdrop, is thickly layered as it circulates through many locations and emotional registers. Allen is the male central figure customary of family portraiture, as the women—his mother, sister, niece, and

Eleanor (the author's mother), Allen, Nicole, and Sharon, 2009

daughter—stand at his sides and lean in toward him. The prison portrait has been enfolded into another narrative and way of marking time—the holiday greeting card. The message on the card reads: "Have a blessed & prosperous 2011. Love, Sharon, Cassandra, Allen, Tanasha, & Mariah."

There is one image of Allen that unsettles me. He poses with his mother, my mother, and me during a visit in June 2009. My mother and I were in town to celebrate the graduation of four younger cousins from high school, a milestone that Allen did not accomplish. In this shot, we stand close to him. He hugs my mother and me tightly on each side of him. Aunt Sharon leans in, and we wrap our arms around each other. The women, all three of us, smile at the photographer. Our eyes are focused on the moment at hand, documenting our visit, a temporary break in Allen's routine, a moment of connectedness. Allen's eyes, his half smile, the creases around his mouth disturb me. His look is painful. It anticipates what will happen after we are finished posing and our visit ends. It will be another year before I see him. He will be here, living in a cell, when we return.

On February 2, 2015, Allen was released from an Ohio prison after serving almost twenty-one years. He walked out of the facility with his mother and sister accompanying him. They walked to the family car and took a group selfie. It was his first photograph outside of prison. In the weeks after his release, Allen used the smartphone that his mother purchased for him and took digital images of many of the photographs that his relatives had sent him over the past two decades. He then sent those photographs to us in text messages and emails with notes of love and playful emoticons. Many of the images that he returned were photographs that we had forgotten about. Allen had archived them. In many respects, he has become the keeper of our family's photographic record. For the next five years, he will be heavily monitored through parole. Nevertheless, he told me to refer to him in this article's conclusion as a "free man."

Nicole R. Fleetwood is Associate Professor of American Studies at Rutgers University. She is currently completing a book on art and mass incarceration. An earlier version of this essay first appeared in *Public Culture* 27, no. 3 (2015).

San Quentin Archive

Nigel Poor uncovers a trove of photographs from
California's infamous prison
Rebecca Bengal

In 1999, at the tail end of a trip to Saint Petersburg, Russia, the artist Nigel Poor found herself standing outside Kresty Prison, the infamous eighteenth-century compound where Leon Trotsky was once held and Anna Akhmatova visited her incarcerated son. Scattered on the ground were dozens of paper cones, weighed down with pieces of bread, small missives tossed out by those behind Kresty's brick walls. Poor bent down, picked up one of the cones, and took it back home to San Francisco. She has never opened it up. "I wanted to live with the mystery," she told me one morning as she sat in her car, preparing to make a now frequent commute to California's San Quentin State Prison.

Since the 1990s, Poor's photographic series of found items, or banned books laundered like clothes, or portraits of the hands of people who visited her studio have navigated the borders between the known and unknown, using objects or visible features as a means of traversing the divide between the two. These days Poor is best known as a cocreator of *Ear Hustle*, a widely acclaimed podcast released in 2017 that was produced entirely inside San Quentin State Prison and takes its name from

prison slang for "eavesdropping." In each episode, Poor and her cohost, Earlonne Woods, and sound designer, Antwan Williams—both of whom are serving sentences at San Quentin—engage prisoners in funny, frank, and devastating explorations of topics such as solitary confinement and finding cellmates, but also what it means to confront love, intimacy, hope, aging, sickness, and death while incarcerated.

"We're not journalists," Woods and Poor frequently tell listeners, an unsubtle reminder that their stories should not be taken as literal documents of what it means to be an inmate at San Quentin. "Our project is about inside and outside people working together, and how we understand each other and misunderstand each other," Poor told me. It's exchanges that interest Poor—the paper cones dropped outside Kresty, her elaborate childhood collections of Popsicle sticks and other things people discarded on the ground, the accidental ways we leave behind impressions of ourselves. In one of the luckiest of those accidents, Poor stumbled on an astonishing visual archive from San Quentin, some ten thousand images depicting prison life at its most murderous and its most mundane. It led to *San Quentin Project #3: Archive Typologies* (2012–ongoing), a project predating *Ear Hustle* that continues to occupy Poor today.

The roots of the San Quentin project stem from 2011, when Poor and her colleague Doug Dertinger began coteaching a history of photography class through San Quentin's Prison University Project. They had to drastically adapt the course they taught at California State University, Sacramento: neither books nor cameras were allowed into the facility. In one exercise, Poor asked her class to create "verbal photographs" instead—describing a memory for which they had no photograph, detailing how they would re-create it, frame it, light it, print it. Her students, she discovered, were keen observers. "If you survive in prison," she told me, "you have to notice everything around you." In another exercise of "mapping," Poor gave each student a 17-by-11-inch photograph, each by a different artist and each printed with a wide margin, where she asked her students to dissect the image and then write a response, formal or creative.

Every image shown in class had to be cleared by administrative officials, who initially deemed anything depicting children, drugs, violence, or emotionally complex issues to be off-limits. "I thought, What's left?" Poor said. She was ultimately allowed to bring in almost all of the photographs she wanted, with the notable exception of a few by Sally Mann and Nicholas Nixon. Her students cataloged minute details of light and angle: A William Eggleston photograph of a Ford Mercury's open hood triggered, for one student, the most evocative and meaningful memories of his life. Joel Sternfeld's *McLean, Virginia* (December 1978) prompted another story of loss and abandonment, as well as a recipe for pumpkin pie. After the first semester, "one student told me he could now see fascination everywhere in San Quentin," Poor said. "That was just so beautiful."

One day, in 2013, Poor noticed a few boxes of photographic paper in the office of Lieutenant Sam Robinson, the public information officer whose voice *Ear Hustle* listeners hear at the end of each episode (he personally approves each broadcast). "That's nothing," Robinson told her. He opened a file storage box; inside were hundreds of 4-by-5-inch negatives, each in a little manila envelope with a date and a cryptic description: "Assaulted in Print Shop," "Football Game," "New Exercise Fence." Poor learned from him that more storage boxes were filling a room. "I'm not exaggerating when I tell you my heart just stopped," Poor told me. She was granted permission to take home a box to scan. This first batch turned up violent images, including one of an assault victim, but also some of men in a classroom and a man

The thousands of images represent the work of corrections officers, who ostensibly made them in a purely documentary sense: to keep a record of incidents and events, weddings and stabbings, Christmas trees, lunchtime, the prison band, the eerie masked dummies some prisoners concocted when they attempted to escape. "It's everything about life in prison that you see when you go in there," Poor said, "the most depressing and funny and bizarre." Poor is assembling an archive of the photographs, for teaching and as part of *San Quentin Project #3* organized under twelve categories that reflect the aching divide between inside and outside. Among her typologies: "Holidays & Ceremonies," "Animals & People," "Escape & Confinement," "Murders & Suicides," "Blood & Evidence," and, her favorite, "The Ineffable."

Poor has discovered no negatives made after 1987. Presumably someone is digitally recording similar scenes in San Quentin now, but it's curious why a true archive was never attempted, or why, in still predigital times, the photographs stopped. "I'm not interested in them as documents. That's someone else's job," Poor said. "But there are so many details in the photographs I sometimes felt I needed an escort to guide me through them." With Lieutenant Robinson's approval, she began asking her students to map onto the San Quentin images too, prompting the kinds of discussions that unfold on *Ear Hustle*, excavating issues of race and violence and humiliation. "Ultimately, I think showing them these pictures is validating their experiences and giving them a way to talk about their trauma, how unfair life can be. It gives them some tangible truth."

But these anonymous photographers, she tells her students, were framing the world too, making implicit choices about what the camera revealed and, most importantly, what it did not. "It may be in this state of not knowing that we are ultimately given the opportunity to engage in the most difficult of life's questions," Poor writes. She calls the *San Quentin Project #3* photographs "unreliable witnesses."

Rebecca Bengal is a writer based in

SAN QUENTIN
SCHOOL
1958

This page:
Football, October 19, 1974

Opposite:
X-mas Tree,
December 28, 1975

All photographs by
anonymous corrections
officers, San Quentin
State Prison
Courtesy the artist
and Haines Gallery,
San Francisco

Solitary Resistance

Jesse Krimes in Conversation with Hank Willis Thomas

Jesse Krimes was an artist before he was a prisoner. But in 2009, when Krimes—who studied studio art at Millersville University and is now an activist for prison reform—was indicted by the U.S. government for a nonviolent drug offense and sentenced to seventy months, his world was dramatically altered. Confined to a cell for twenty-three hours a day during his first year in prison, Krimes turned to art to cope. Until his release, in 2013, Krimes made clandestine works of art, often with ingenious methods of transferring photographic images from newspapers onto prison-issued bars of soap or sheets using hair gel purchased from the commissary, and sent them home, piece by piece, through the mail. Krimes's monumental mural *Apokaluptein:16389067* (2010–13)—the title derives from the Greek origin of the word *apocalypse* and Krimes's Federal Bureau of Prisons identification number—considers heaven and hell through the collaged language of advertising and photojournalism.

Last fall, Krimes spoke with photographer and conceptual artist Hank Willis Thomas about how art can reveal the experiences of incarceration beyond the confines of American jails and prisons.

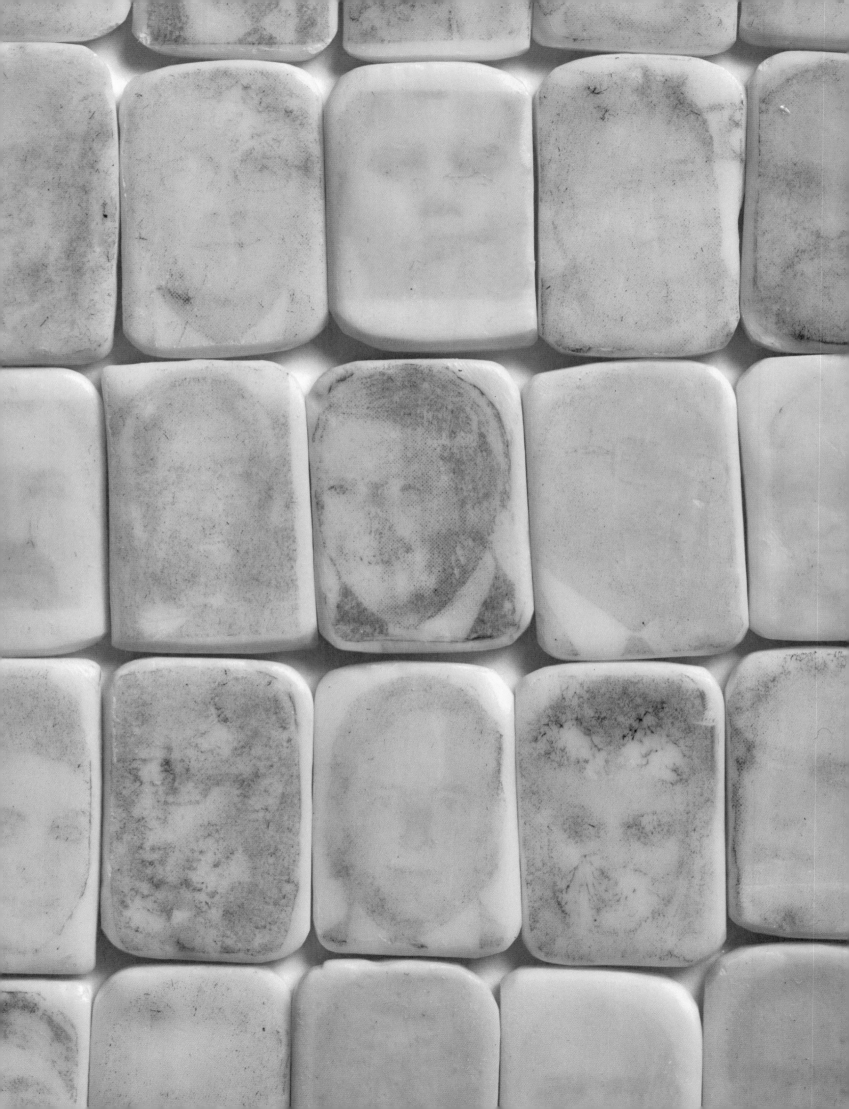

Previous page and below:
Purgatory (details), 2009.
292 hand-printed image
transfers, prison-issued
soap, and playing cards.
Photographs by Joseph Hu

Opposite:
Purgatory, 2009.
Installation view at
Palais de Tokyo, Paris,
2015

Page 96:
Apokaluptein:16389067
(detail), 2010–13.
Hand-printed image
transfers on prison-issued
sheets (thirty-nine panels)
All works courtesy the artist

Hank Willis Thomas: Over the past several years you've used your networks to expand notions of what you, as an artist, could and should do, both through multimedia collaboratives and a very targeted practice. Where did you begin?

Jesse Krimes: Growing up in Lancaster, Pennsylvania, the idea of making a career or living by being an artist was really foreign to me. As an only child, creating was always a way for me to occupy my time. But as I transitioned through life, it helped me learn about what I was interested in and led to other opportunities. And I considered myself an artist before going to prison in 2009.

HWT: **What medium did you start with?**

JK: I graduated from Millersville University, which had a phenomenal bronze-casting foundry and instructors, so most of my practice was working through metalsmithing, bronze casting, and nontraditional material explorations.

HWT: **Were painting and photography part of your practice before you went to prison?**

JK: My art history professor specialized in the media-based collective General Idea and also encouraged me to read Roland Barthes's *Camera Lucida* (1980). So while I didn't practice much photography, it was conceptually influential. But it took going to prison for those concepts to manifest within my practice.

HWT: **When you went in, did you think that you were going to be making art? Or did you realize that you needed to do something with your time, that you needed to find ways to work through some of the issues that brought you there?**

The prison-issued soap has this material language of purification and sanitization, which relates to ideas of the penitentiary and what it was designed to do.

JK: It was primarily an act of self-preservation and resistance against a system designed to make me conform to the idea that I'm less than others. That being said, I was also thinking about art in a critical context. I was still reading *Artforum* and other art journals, which my friends and family would send me.

HWT: **Was that common? Did you meet people who were critically thinking about being there?**

JK: In the beginning, I wasn't aware of anyone else doing that because I was in solitary confinement and locked down twenty-three hours a day. But as I transitioned through the federal system I encountered numerous individuals who were making critically rigorous works through various disciplines.

HWT: **How long were you in solitary?**

JK: I was indicted in 2009, shortly after graduating from college. I was in solitary confinement for a year, before receiving my six-year sentence in 2010. It was intense. They only placed me there because I wasn't willing to cooperate and implicate other people. Solitary is just one prosecutorial tool the government uses to get people to cooperate, or to eventually accept a plea deal, even if you're not guilty, because you just want to get out of solitary.

HWT: **This was before you were sentenced?**

JK: Yeah, before I was even found guilty.

HWT: **Is that legal?**

JK: Unfortunately. That specific solitary unit was also for high-risk violent offenders. And, even though my charges and criminal history all involved nonviolent offenses, they sent me to maximum-security federal prisons after sentencing.

HWT: **You were resolved to not cooperate, and you saw that you had tools of creative expression and time to focus in a way that you didn't before.**

JK: Absolutely. I wasn't willing to get someone else in trouble for my own decisions. I knew I needed to stay focused, whether I got five years or twenty years. Making art twelve to fourteen hours a day created a space where I had autonomy and allowed me to escape mentally and emotionally from my environment.

HWT: **What did you start with?**

JK: The first pieces I made were elements of *Purgatory* (2009). I was reading Foucault's *Discipline and Punish* (1975) and daily newspapers when I started noticing paradoxes between the photographic representations in the newspaper and their textual narratives. I began thinking about being in prison and these mediated sources as the only way to experience the outside world. Considering these texts simultaneously led me to consider the ways in which prison is analogous to the inner workings of society's camera—a place where traces of our social protocols and interactions are captured, archived, and processed through a lens of cultural value. Having been arrested, my mug shot was taken and surrounded by a narrative that negatively depicted

me at one specific point in time. I wanted to disrupt that, and recontextualize some of these one-dimensional depictions in the newspaper.

I began cutting out mug shots of people who were recently arrested and transferring them onto remnants of soap, leaving the inverse trace of the portrait on the surface of the soap. The prison-issued soap has this material language of purification and sanitization, which relates to ideas of the penitentiary and what it, in theory, was designed to do.

HWT: **You were in the midst of an existential crisis, and you started reading about existentialism, and then using the existing materials to create new questions. I think that's the first work of yours I saw, and I remember wondering what kind of education you had, or if this is something that people are teaching within prisons.**

Also, your last name is Krimes. There seemed like an alchemy, literally, with the mixing of the photography onto the soap, an artist named Jesse Krimes in jail for a crime that he knew he was guilty of—all of that.

JK: [*laughs*]

HWT: **Were you aware of these things? Or were you just trying to get by at the time?**

JK: The thing about being in prison is that time shifts from a linear progression—and the idea of yourself and how you exist in relation to the world—to a much more cyclical functioning where meaning and your understanding of self are rapidly constructed and

deconstructed. Every day and every minute are just spent figuring out how to get through that day.

HWT: **Looking at your work and realizing how much photography has informed it—and especially thinking about *Apokaluptein:16389067*, where you have these dancers, you have magazines, you have every element of life, you have mug shots—could you talk about that work and its relationship to where you started in photography?**

JK: I made *Apokaluptein:16389067* during the last three years of my sentence. By that time, I was in general population. I began collecting photojournalistic images almost as Duchampian readymades, without fully understanding what I was going to do with them. But in the process of compiling this large archive, I noticed patterns of paradoxes in the content of the imagery and began transferring them onto prison bedsheets with hair gel and a plastic spoon. Gradually, I came to perceive of prison as a microcosm of our globalized world that is shaped by various systems of capture, containment, and control. The ways in which we experience images, bodies, objects, and artworks are determined by what different systems conceal or reveal. Some of that goes back to *Purgatory* and these individual depictions of people.

HWT: **Can you describe *Purgatory*?**

JK: *Purgatory* is the piece I mentioned earlier where I removed photographs of offenders from the newspaper and transferred them onto pieces of soap while I was in solitary. They were fairly delicate, so I needed to find a way to sneak them out through the mail without breaking. I ended up making a cutting device out of a disassembled AAA battery to cut frames for each portrait from decks of used playing cards other guys would pass me. The cards also became integral parts of the works and vessels for concealment. I cut out the faces of kings, jacks, and queens and replaced them with the soap portraits—basically elevating the offender to that of royalty and lowering the royalty to that of the offender. While I began the series by using mug shots, I started to include images of celebrities, politicians, and other individuals based on the premise that each of us is some type of offender. By the time I left solitary, I had smuggled out 292 pieces.

HWT: **Then that set the foundation for *Apokaluptein:16389067*?**

JK: Yes. Those image transfers of portraits on soap grew into transferring events depicted in the *New York Times* onto prison-issued bedsheets. Then I would blend these different events together with colored pencils and paint to create unified landscapes. Over the course of three years, it grew into *Apokaluptein:16389067*, which is a massive piece on thirty-nine prison bedsheets measuring fifteen feet high by forty feet wide.

HWT: **Were there other people who were part of the process, who were supporters of this process?**

JK: All of this was considered against prison policy. You're not allowed to destroy or deface prison property, which could land you in solitary. So I had to do this entire project in secret. There were guys on the block who would collect newspapers for me. And if an asshole guard was making his rounds, guys would give me a signal so I'd know to hide all of my contraband materials. But over time, some of the better guards became supportive, even to the point of giving me a staff locker to store my materials and works in progress so they wouldn't get confiscated during shakedowns.

HWT: **After five years, by the time you were coming out, you had completed several bodies of work. I don't mean to make light of it, but it seems it was like a grad-school type of experience for you.**

JK: It kind of was. I make light of it sometimes, just to process it. But I often call it an intensive residency program. I was driven to come home better than when I went in—to make work all day, every day, and read about art all day, every day.

HWT: **When they were discussing your parole, was that something that was seen as a good thing on your behalf, or did it come up at all?**

JK: While I was making each body of work—*Purgatory*, the *Master Work* series (2009), *Ink Scaffolds* (2010), and *Apokaluptein: 16389067*—I mailed each element out immediately. So upon leaving the prison, I didn't have any work in my possession. The majority of the staff had no idea I was creating these works. It was something that I kept to myself.

HWT: **You made a fifteen-by-forty-foot piece that is contiguous and people didn't know?**

JK: A lot of the staff didn't know.

HWT: **Did you do it in sections? Did you sketch it out first? How did you know when it was over?**

JK: When I started *Apokaluptein:16389067*, I initially made one landscape panel that was about three by five feet. After I completed that panel, I still had three years left to serve. So, I was like, Fuck, I might as well keep making more.

I was also reading Giorgio Agamben's *The Kingdom and the Glory* (2011) at that time and decided to create a heaven and hell around the earth panels. I used the size of the desk to determine the horizon line on the three-by-five-feet earth panels because that was the only surface area where I could make image transfers. I didn't have an overall diagram of how the thirty-nine panels would specifically fit together because I mailed each panel out upon completion until I was released in 2013.

HWT: **You've been out almost as long as you were in. You're getting to the point where you have more distance to reflect about the experience. Beyond the process, you're also dealing with notions of how art can be restorative, how it can shape and effect social justice.**

JK: Yes, absolutely. All of my work is socially engaged in some way. Some of it is much more overtly engaged and process-oriented. But having gone through that experience, it's impossible for me to make art for art's sake. I try to create artwork that complicates oversimplified and harmful narratives. I don't like to say it's a way of trying to humanize people in prison because they're already human, so that's a very ridiculous thing to say. But I think art can be a way to spark empathy in people and get them to see, feel, and think differently about various issues. It can help viewers understand the space they occupy within the broader sociopolitical systems that feed into mass incarceration.

Hank Willis Thomas is an artist based in New York.

Landscapes & Playgrounds (2017), Sable Elyse Smith's recent artist's book, from which a sequence of pages is excerpted here, is a meditation on two sites of the prison environment after which the book takes its name. Within it, we encounter a world through the eyes of a young protagonist grappling with the prison system.

Smith, an artist working across video, poetry, and performance, is not merely interested in the cataclysmic consequences of mass incarceration that tend to be the focus of our justice dialogues in the United States. *Landscapes & Playgrounds* contains aerial images of prison architecture, surrounding land, and recreational areas such as basketball courts. But we also glimpse, through handwritten letters, the intimacy between an incarcerated father and a daughter that is not theirs alone, but one embedded in surveillance. Not all of the texts from these letters, written on crinkled lined paper, is visible, but the handwritten notes that we can read evoke a gentleness in their direct address. They often begin with a cheerful greeting like "What it do daughter!" and close with an equally heartfelt "Love you, Miss You. Pops. A.K.A. Pa."

Still, the reader should resist a purely autobiographical read of Smith's work. As she stated in the introduction to her recent exhibition *Ordinary Violence* (2017–18) at the Queens Museum, New York, "I am haunted by Trauma. We are woven into this kaleidoscopic memoir by our desires to consume pain, to blur fact and fiction, to escape." Language becomes essential to Smith's cartographical process, to her move away from the *fact* of her father's incarceration while also drawing upon the *truth* of that experience. Amid a series of small photographs that are never quite center-aligned, some awash in hues of turquoise and beige, or overlaid with blocks of solid color, a refrain appears in white letters on a black ground, beginning: "We are a weird triangle of silence and smiles and pauses, of stepping backwards one foot after another after another until we've found the cold corner of a wall." Here we, the readers, must also reckon with the interiority of the sentiment—the feel—that moves us closer to the minutiae of the protagonist's visit.

Smith wades in the slippages between poetic language and family letters, between forensic photographic documents and tender snapshots. Rejecting concretized form, she probes the possibilities of *the feel* so that we might better understand the tactility of syntax and what it signifies through its materials and visions. "The images are made so that I can see the people in them," Smith says of her practice. "So that I can see me."

Sable Elyse Smith

Jessica Lynne

Jessica Lynne is the coeditor
of ARTS.BLACK.

Sable Elyse Smith! June 11

 What it do daughter! (smile)
received the visiting form envelope.
 I had wrote a form to the visiting sgt.
and he called over to the building and
 talked to me about your visiting approval.
He said you are cleared to visit.
 Then changing the paper-work
over to computer some one mistakely
punched in male instead of female.
 He said to have you come on down
they will switch it back over when
 you come. His name visit sgt Black
 But by you submitting new
form it should actually be corrected
before you arrive.
 My moms said you didn't
know if you could make it in
July. She thought because of money.
 She's going to give you her
round trip ticket + 50.00 to
transfer it in your name so
you can use that okay.
 Looking forward to seeing my baby
daughter (SMILE!)
 Love Dad
 A.K.A. Pa

Can a website jump-start conversations about inequality, mass incarceration, and institutional violence?

Prison Index

Pete Brook

What do we know, through images, of prisons and jails in the United States? What do we see of the sprawling, brutalizing, and failed systems? How do taxpayers view *their* prisons? Which images shape our imagination of and future responses to mass incarceration?

In 2008, I founded Prison Photography, an ongoing research project that examines and contextualizes images of U.S. prisons. It started as a blog—a personal inquiry played out in public. By virtue of longevity and quantity, it has morphed into a public resource, a digital archive that, in some ways, serves as a form of memory. When I began, I thought images could serve as a way to draw people into the uneasy conversations about fear, mass incarceration, inequality, institutional violence, and vengeance. Prison Photography's over fifteen hundred posts have scrutinized news, documentary, surveillance, fine art, evidentiary, and collaborative images. Thousands of instructive photographs and hundreds of vital testimonies speak to forty years of tumorous prison growth. Here, I'd like to mention just a few. They include rare prisoner-made images from the '80s; dark color prints from the '90s of forsaken

Texas prisons; collaborative projects that open the door to prisoners' voices; and evidence documents that shape the laws of the land. These are photographs that provide reliable views of prisons for outsiders, or employ strategies that can go some way to empower those inside.

Lorton Reformatory, in Virginia, opened in the early twentieth century as a workhouse. It soon assumed operations as a jail, imprisoning people from adjacent Washington, D.C. Lorton's red brick prison blocks provided relatively freer movement for prisoners, yet also caused significant security problems. Escapes were common. Lorton was known for drugs and violence. In the '90s, particularly, corrupt staff conspired with prisoners in lucrative black markets, and enforced control with intimidation and abuse.

Between 1981 and 1988, Karen Ruckman offered a program of photography workshops at Lorton. F-stops, composition, and darkroom techniques were an escape from the indignities and stresses of prison life. Within their limited surroundings, students made portraits, shot sports activities, and constructed scenes. Such initiatives were rare then and are rarer now. Ruckman's was one of the last camera-based photography workshops offered in a male adult prison in the United States. This curtailment reflects mass incarceration's shift in penal philosophy from rehabilitation to incapacitation. In the prison setting, cameras are not considered tools for art; they are tools for security. Lorton closed permanently in 2001. A documentary Ruckman made of the experience, *In Lorton's Darkroom* (2017), reminds us to make space for prisoners' humanity, as well as for environments that encourage the arts.

The 1990s saw an uptick in the number of socially conscious photographers turning toward prisons—Jane Evelyn Atwood, Morrie Camhi, Ken Light, Alan Pogue, Joseph Rodriguez, and Taro Yamasaki, to name a few. Andrew Lichtenstein gained more access than most, documenting dozens of prisons, most within Texas. Delving into Lichtenstein's archive is like descending into hell: Dark metal benches and iron doors polished smooth by decades of bodies. Dungeon walls dank with sweat and grime. Foggy portraits made through smeared windows and cell bars. Lichtenstein's photographs carry the weight of shackles, restraints, hoods, and heavy air. Natural light is at a premium. It only emerges when prisoners file into fields to work in hoe squads. Or when they are finally released from the hell.

The work took its toll. After eight years of photographing prisons (between 1995 and 2003), Lichtenstein stepped away. He characterizes those years as "lost"; prisons are toxic places for staff, inmates, contractors, volunteers, and visitors alike. Lichtenstein's images accompanied Eric Schlosser's landmark 1998 *Atlantic* article, "The Prison-Industrial Complex." There's much more in Lichtenstein's archive than has been published up until now. The archive deserves a return; pictures that are so singular demand regular and wide distribution.

The increasing restrictions on camera use in prisons have hamstrung our knowledge, but have not obliterated it. Abandoning the possibility of a visit to a prison or jail, some artists have sought to render and celebrate the imaginations of prisoners. The past decade has seen a trend in projects that engage prisoners via mail correspondence in order to create images based upon their instructions and requests.

Outraged by the outsized sentences being handed down to environmental and animal rights activists, artist Kelly Sena contacted these prisoners and offered to photograph a landscape they held meaningful. In her resulting 2012 series, *For the Wild*, a landscape photograph stands witness for an absent activist. It is also Sena's direct statement on the Green Scare and against the use of post-9/11 domestic terrorism laws to crush eco-activists.

Similarly, Tamms Year Ten (TY10), a group of Chicago-based activists, fused the artistic with the political to oppose implementation

These are photographs that provide reliable views of prisons for outsiders, or employ strategies that can go some way to empower those inside.

Above, left:
Alan Pogue, *Don't Kill Gary Graham*, Austin, Texas, 1993
© the artist

Above, right:
Morrie Camhi, *Kenneth X. White, Prisoner*, 1987
© the artist

Right:
Jane Evelyn Atwood, Prisoners rest from backbreaking manual labor. Women's Shock Incarceration Unit, Columbia, South Carolina, 1994
© the artist/Contact Press Images

of new correctional practices. TY10 was established, in 2008, on the tenth anniversary of the opening of Tamms Correctional Center, a supermax prison in Illinois specializing in long-term solitary confinement. The project Photo Requests from Solitary (PRFS) was one of TY10's tactics in a multipronged effort to close the facility. TY10 offered to create an image—real or imagined—for each man inside. Photographers (professional and amateur alike) responded to the prisoners' requests, making an image based on answers to a questionnaire. The intention was always to present the written requests and resulting images as part of public outreach. PRFS resulted in a wild array of images: portraits of the self beyond the prison walls, pictures of families and neighborhoods, Jennifer Lopez, sad clowns, Michael Jordan, visual puns, dolphins, sunsets, and the Chicago skyline. One prisoner asked his supporters to gather on a specific hill and pray for his release; he brought them together. They joined hands.

In 2013, Tamms closed.

Solitary confinement was once sparingly used, but after California opened Pelican Bay State Prison, in 1989, the blueprint for state-operated supermax facilities was set. Other states followed suit and now sixty such prisons operate and specialize in twenty-three-hour-a-day lockdown. Solitary confinement is known to cause permanent psychological and neurological defects. The United Nations defines anything more than fifteen days of isolation as torture. In these institutions, prisoners are routinely held for years.

Amy Elkins wondered what sensory deprivation does to the mind. Between 2009 and 2016, Elkins opened correspondence with seven men who were on death row, were in solitary, or had been in solitary. This project, *Black is the Day, Black is the Night*, borrows its title from a line in a prisoner's poem. Elkins made fuzzy, multiple-layer landscapes and seven pixelated portraits. The amount of degradation (or visual incoherence) in Elkins's constructions is determined by an equation that incorporates both the number of years imprisoned and the length of sentence.

Projects about memory recognize prisoners' rights. They can amplify the voices of those impacted by the system. They ask the audience to step a little closer, emotionally. They aim to shape debate by mobilizing people and getting out in front of the conversation. However, often news about prison struggles and scandals comes too late. The flash across our screens of video and stills from prison CCTV systems usually signals an abuse, or an investigation, or physical harm, or a mix of these things. The recent deaths of Sergeant James Brown in an El Paso jail; Bradley Thomas in Oregon's Lincoln County Jail; Sandra Bland in Waller County, Texas; Joshua Messier at Bridgewater State Hospital, in Massachusetts; and Terrill Thomas at the Milwaukee County Jail are but a handful of the almost nine hundred in-custody deaths (homicide, suicide, overdose, accident) that occur each year in the United States. Negligence and abuse are seen also outside the prison. According to the Bureau of Justice Statistics, each year, another nine hundred people die during the process of arrest.

Some photographers have made evidentiary images for lawsuits, but plaintiffs (usually prisoners) and defendants (usually the state) agree to seal the documents as part of a settlement. On other occasions, photographs are made public. *Prison Obscura*, an exhibition I curated in 2014 of vernacular, satellite, evidentiary, and prisoner-made images, included over two hundred photographs from the original filings and expert declarations of *Brown v. Plata*, a class-action lawsuit brought by the prisoners of California against the state's governor. In 2011, the Supreme Court of the United States ruling on *Brown v. Plata* stated that overcrowding had led to inadequate medical and mental-health care, resulting in preventable deaths and therefore subjecting every one of California's 165,000 prisoners—in violation of the Eighth Amendment—to cruel and unusual punishment.

These low-resolution, authorless, uncensored images require work and some decoding of unfamiliar information: holding cages, bare concrete slabs, visiting rooms converted to doctors' offices, makeshift therapy spaces. They diverge from what we've usually seen of prisons and, perhaps, from what we *think* we know about prisons. Inasmuch as these images played a role in a legal process that changed the daily living conditions of over a hundred thousand prisoners, one could argue that they have had more effect than the images of any single well-meaning, politically motivated photographer.

I don't disregard the significant contributions of individual image makers, but I do want to consider their photographs alongside other images that emerge from the prison-industrial complex. The insightful works of current practitioners such as Gabriela Bulisova, Jacobia Dahm, Brian Frank, Isadora Kosofsky, Jason Koxvold, and Joe Librandi-Cowan, to name a few, continue a tradition of fine art and documentary photography in American prisons that began in earnest in the 1960s and 1970s with Eve Arnold, Cornell Capa, Ethan Hofman, Douglas Kent Hall, Bruce Jackson, Danny Lyon, Ruth Morgan, and others. In knowing prisons, sometimes we'll rely on images by committed individuals coming in from the outside, and sometimes we'll rely on those by prisoners—cellphone snapshots and videos, visiting-room portraits and artworks.

We should pay attention to the publicly circulated images of our public institutions (only 10 percent of U.S. prisons are privately operated). Never before in the history of humankind has a society, during peacetime, locked up such a large proportion of its citizens. What does that even look like? What is our visual memory of past decades of mass incarceration? How do antiprison campaigners wield images for contemporary battles? The longer one looks at the prison system, the clearer one sees its failings. The closer one looks at the failings, the clearer one sees they are society's failings. Imagining alternatives to incarceration is a form of image making, too.

Pete Brook is a writer and curator based in Portland, Oregon.

Joseph Rodriguez

Reginald Dwayne Betts

In 1965, when he was fourteen years old, Joseph Rodriguez, a self-described Brooklyn boy, discovered the photographs of Jacob Riis and Lewis Hine. Their trenchant images of child labor conditions and tenement housing provoked calls for reform in early twentieth-century New York, and became a model for the American tradition of socially concerned documentary photography. "That's still in my heart," says Rodriguez. By the 1980s, after getting into trouble and serving time on Rikers Island, Rodriguez had begun what would become a career-long account of the criminal justice system seen "through the tough streets of New York, through drug addiction, through incarceration."

Ten years ago, Rodriguez read a report published by the Pew Charitable Trusts stating that "1 in 100 adults is now locked up in America." With the idea of interviewing and taking portraits of one hundred previously incarcerated people, he began a series about reentry, focusing on individuals at transitional treatment centers in Los Angeles run by Walden House, which provides behavioral health services for men, women, and children throughout California. The subjects of Rodriguez's photographs at Walden House approach the subliminal space between not wanting to be seen and having little say in the matter. Here, women, in particular, both demand to be made visible and reject the spectacle of being on display. But it would be a mistake to imagine that Rodriguez's work does anything other than dignify by paying attention.

Rodriguez's portraits relay a multilayered narrative. Women at turns stare defiantly away from the camera or into its lens. Children challenge the camera's intrusion or appear with a complete lack of awareness of its presence. Rodriguez notices angles and shadows, presenting the viewer with a snapshot of humanity. In one image, a woman, seemingly oblivious to the camera, touches the head of her toddler. In another, a portrait of Chris "Pepper" Drayton and her friend, the domesticity of a stray flip-flop under a bed is contrasted with a pose so carefully executed it might have taken place in a club on a Friday night. The power of these portraits emerges from their ability to unsettle by illuminating their subjects, not some notion of hardship a viewer might imagine is the sum of their life experiences.

Many of the women Rodriguez met had been incarcerated for drug offenses. "I understand that journey very well. Most of us, when we come out of a situation where we're addicted, we all want to be better," he says. "For me, it's always about redemption." At Walden House, women learn to reenter society through a curriculum that includes classes on family parenting, anger management, and domestic violence prevention. Residents are sometimes taken to the beach—a safe space to think about their pasts and prepare for the future—and return to share their reflections in group meetings. "Not everybody makes it," Rodriguez says. But, he adds, "we don't all stay in this darkness."

Reginald Dwayne Betts is the author of *A Question of Freedom: A Memoir of Learning, Survival, and Coming of Age in Prison* (2010).

At Walden House
FOTEP (Female Offender
Treatment Employment
Program), a young mother
holds her son. El Monte,
California, 2008

Chris "Pepper" Drayton
(with braids), thirty years
old, from Baldwin Hills,
poses with her roommate
JR. Walden House,
El Monte, California, 2008

Angela Martinez, twenty-five years old. She was arrested
for running a methamphetamine lab with her husband
in their home. Both were sent to prison, and their children
were taken away from them by the state of California.
Walden House, El Monte, California, July 2008

Zora J Murff

Ruby Tapia

Corrections

Photographs of incarcerated young people usually depict them with ghosted faces. The state requires that their personal identities be protected, so visual representations of them must take care to blur their most human feature. That's the logic of incarceration: prison erases and dehumanizes. Zora J Murff's *Corrections* (2013–15) puts us cleanly in this space of constructed murkiness. When read as individual photographs or in combination with others in the series, these images of young people stage the contradictions of an intricately surveilled population and a would-be humanizing camera.

As an employee of the Iowa criminal justice system, Murff was, in his words, "the physical manifestation of consequence" for young people subject to electronic monitoring and other modes of control by Linn County Juvenile Detention and Diversion Services. Working as a tracker from 2012 to 2015, Murff played what he acknowledges was a contradictory role: while he was "tasked with building trust with these individuals," in order to facilitate their adherence to their mandated programs, Murff's relationships with them existed because these youth had transgressed the law. This unavoidable fact was the context within which he came to photograph the subjects of *Corrections*.

Murff was beginning to study photography while working at this job and he obtained permission from the state, and some of its subjects, to make images of this environment of surveillance as long as he adhered to their stringent privacy requirements. Many of these photographs index and highlight technologies of defacement: In *Standard Issue: Jumpsuit* (2014) the folded prison uniform is legless, connoting a symbolic amputation or immobilization. *Classroom* (2013) deliberately excludes students and teachers, instead framing video monitoring as the primary instructional mode.

In his portraits, Murff works in a different register, which contrasts with the flatness of uniforms and video cameras. The girls portrayed in *Wendy at 14 and Sheila at 15* (2014) appear dynamic, tense with action, engaged in the posing, protection, and, yes, hug that serves as their defacement, but is here something additional. There is unmistakable tenderness in the literal face of institutional erasure, and yet there is nothing to romanticize. *Corrections* cracks open the appearance of the juvenile justice system, lays bare its own contradictions, and provokes crucial questions. Is that defiance in the turning away seen in *Jerome at 15* (2014) and *Megan at 16* (2014)? Viewers may find themselves hoping so. But what does this defiance mean? How have Jerome's and Megan's gendered and racialized differences made for profoundly different experiences of arrest, sentencing, and detention?

Corrections asks viewers to ponder the conditions of young people involved in the criminal justice system, but Murff also wants us to confront what is common to how the carceral state operates, regardless of the age of its subjects. "The ugly nature of the bureaucracy, inherent bias, and contradictions at its core," as Murff states, is perhaps the most critically illuminating context in which we can consume these visions of institutionalized obscurity, as well as the gestures that defy it.

Page 116:
Jerome at 15, 2014

Previous page, top:
Megan at 16, 2014
Bottom:
Earl at 15 (1:30pm Visit),
2015

Ruby Tapia is Associate Professor of English and Women's Studies at the University of Michigan.

Above:
Classroom, 2013

Above:
Wendy at 14 and Sheila at 15,
2014

Below:
Standard Issue: Jumpsuit,
2014

Below:
My Past Charge, 2013

All photographs from
the series *Corrections*,
2013–15
Courtesy the artist

Above:
Close to Home, 2014

My past charge is assult on
my mother - again nothing wrong.

I've been to foundation two for
five days. I've been to St. Luke's
syc ward for five days. I've
been two the U of I syc ward
for 5 days. I've been to four oaks
for 6 days.

I don't do realationships.

I don't care to remember my
childhood.

I don't have pleasant memories

I do not care about anything.

Emily Kinni

Virginia Grise

Huntsville is a prison town. Situated on over fifty acres of land near the town's center, the Texas State Penitentiary at Huntsville is the oldest prison in the state of Texas, built in 1849, only four years after Texas was annexed to the United States. The Texas Department of Criminal Justice is headquartered in Huntsville, and it is the largest employer in the city. More than fifteen thousand people are incarcerated behind the fifteen-foot red brick walls that surround the correctional facility.

Huntsville prison is a hub. At the end of their sentences, men from other prisons throughout Texas are bused to Huntsville—it is a release center for the region, the largest in the state. About one hundred men are released from Huntsville daily, Monday through Friday. The numbers are highest at the beginning of the month. When the men leave prison, they are allowed a mesh onion bag for their belongings (sometimes two if their stay was long and everything does not fit into just one bag). They are given clothes donated by a local church, some gate money (fifty to one hundred dollars), and a bus voucher.

"I grew up knowing that place, experiencing the different layered aspects of the prison industry. I had family there," the photographer Emily Kinni tells me. "Me too," I respond. "So you know," she says—an acknowledgment of how those on the outside often serve time with their families behind bars, that the "there" Kinni refers to, Huntsville, is not just a geographic place. Excavating memories, Kinni continues, "Growing up, I saw men around town in everyday clothing carrying an onion sack. That's how you knew that they had just been released from prison." Some men on the inside speculate that the Texas Department of Criminal Justice recycles old onion sacks because so many onions are shipped into the prison for meals. Kinni is not sure of its origin, but the image of the onion sack stayed with her—men carrying all of their belongings in a mesh bag.

In her latest work, Kinni photographs recently released men at a Greyhound bus station near the Huntsville prison. If no one is there to pick them up when they get out, the men walk the two blocks to the bus station, where they can cash their check and trade in their voucher for a ticket out of town. The station becomes a threshold for many of these men. Kinni is there to witness and document their transition from one space to another. She has returned to this bus station five times, where she tries to capture that moment—the liminal space of waiting for the next phase of their lives to begin—in a photograph. In exchange for taking their picture, she offers to give them a Polaroid. For some, it is the first time in a long time that they see their own image in a photograph, see themselves outside of prison walls. The prison is behind them now. They pose in front of trees, away from the bus station, away from the prison.

"Do you mind if I write you and let you know that I made it?" some men ask her. It is an earnest question. Some do. She worries about the ones that don't. Did they make it? she wonders. The man waiting to board the bus, the man seated with a stack of books, the man with a bus ticket in his pocket, the man with Abe Lincoln tattooed on his arm. The men carrying onion sacks.

Did they make it?

Are they free?

All photographs *Untitled, Huntsville, Texas*, 2017
© the artist

Virginia Grise is a theater artist and the author of *blu* (2011), *The Panza Monologues* (2014), and *Your Healing is Killing Me* (2017).

Stephen Tourlentes

Mabel O. Wilson

Mass incarceration forms a network of thousands of institutional units of various scales—prisons, courts, private corporations, and a host of government agencies whose tentacles reach across states and outside the borders of the United States. This system is so vast and sprawling it has achieved a sublime dimension that is beyond the comprehension of those Americans not engulfed by its inner workings. Stephen Tourlentes's serial photographic study, *Of Length and Measures: Prison and the American Landscape* (1996–ongoing), documents how this expansive carceral system materializes within local environments of small towns, rural communities, and urban neighborhoods around the country.

Tourlentes strategically shoots the exteriors of prisons at night in order to capture the radiant glow of the high-intensity LED lights that render the facility grounds visible to the armed guards on night duty. The mechanistic 24-7 control of incarcerated bodies produces in its wake an illumination that lights up the night sky and slices across the rural horizon. For Tourlentes, "newly opened prisons utilize modern high technology to control their population in contrast to the stone castles that preceded them."

Taken at an expansive distance to capture the vinyl-sided houses, eerily still bodies of water, empty fields, trees, streets, and electrical lines framing the landscape around prisons,

Tourlentes's photographs echo the aesthetics and themes found in nineteenth-century paintings of the American landscape, particularly the dualities of social progress and expropriation evoked in these large canvases. The fiery glow of the setting sun in Frederic Edwin Church's *Twilight in the Wilderness* (1860), for example, signifies the moral inevitability of Manifest Destiny, while also veiling the violent conquest of nature by an industrializing America and the deadly dispossession of indigenous land by droves of white settlers. The glow of the high-powered lamps in Tourlentes's landscapes, however, signifies the securing of the borders of American towns, homes, and businesses through decades of the War on Drugs, followed by tough-on-crime policies and what Mike Davis has called the benefits of "carceral Keynesianism," which have revived the economies of small towns around the nation.

In *American Technological Sublime* (1994), David Nye writes that the technological sublime "was inseparable from a peculiar double action of the imagination by which the land was appropriated as a natural symbol of the nation while, at the same time, it was being transformed into a man-made landscape." Ten years after Church's painting, Eadweard Muybridge deployed the recent technology of photography to capture images of an American West rapidly being encroached upon by the rapacious mining apparatuses for gold and other precious metals.

Muybridge's approach, along with the work of Carleton Watkins from the 1860s and 1870s, would profoundly influence the sublime landscape photography of Ansel Adams in the following century. This pristine, Romantic view of the American landscape ignored, however, the physical and social degradation wrought by industrialization. Indeed, a hundred years later, the 1975 exhibition *New Topographics: Photographs of a Man-Altered Landscape*, which featured the work of Lewis Baltz, Robert Adams, and Stephen Shore, among other photographers, unfurled a stream of images of suburban tract houses, generic travel trailers, and banal structures that littered America's postindustrial landscape. Somewhere in the distance, recalling both Muybridge and Adams, Tourlentes's images of America's mythic landscapes dwell, as he says, on "an unseen human cargo held in time and place."

The telegraph lines and railroads that unified nineteenth-century America have been replaced today by cellphone towers and freeways that enmesh the towns of Tourlentes's study—from Coxsackie, New York, to Carson City, Nevada, to Florence, Arizona—in a network of mass incarceration. From a distance, these points of light, and their hazy radiance on the horizon, signal the paradoxical role of these correctional facilities in diminishing the lives of those inside, while simultaneously sustaining the lives of small towns and neighborhoods that depend on these institutions for local employment and other revenues. "The rapid constructions of new prisons (a result of overcrowding caused by tough mandatory sentencing laws)," says Tourlentes of this far-reaching economy of incarceration, "are then sold as economic development programs for depressed communities vying to host them." Tourlentes's luminous prison photographs convey the haunting beauty of everyday places and the terrifying truth of what those landscapes hold.

Mabel O. Wilson is Professor of Architecture
at Columbia University's Graduate School
of Architecture, Planning and Preservation
and Associate Director of the Institute
for Research in African American Studies.

*Alabama Death House
Prison, Atmore, Alabama,
2004*

**All photographs from
the series *Of Length and
Measures: Prison and
the American Landscape*,
1996–ongoing**
Courtesy the artist and
Carroll and Sons, Boston

Aperture Beat

*Stories from the Aperture community—
publications, exhibitions, and events*

The Artist's Voice

"Do you dream in black and white or color?" Aaron Schuman asked William Klein in 2015, during an *Aperture* interview at the legendary photographer's Paris apartment. "Black and white, of course," Klein replied. Since the first issue of *Aperture* appeared in 1952, the artist's voice has been central. Celebrating *Aperture*'s sixty-fifth anniversary, *Aperture Conversations* brings together more than seventy interviews —from Klein, Henri Cartier-Bresson, and William Eggleston to Katy Grannan, Gregory Crewdson, and Ava DuVernay—selected from the magazine, Aperture photobooks, and conversations published on Aperture Online. "For this compilation we moved in close," says Melissa Harris, former editor in chief of *Aperture*, "favoring those exchanges that offer a behind-the-scenes, intimate glimpse into an artist's sensibility, motivation, working process, politics, beliefs, and his or her particular dance between photography and life."

***Aperture Conversations: 1985 to the Present* will be published by Aperture in spring 2018.**

William Klein, *Dance group La La La Human steps in Metro, Paris*, 1991
Courtesy the artist

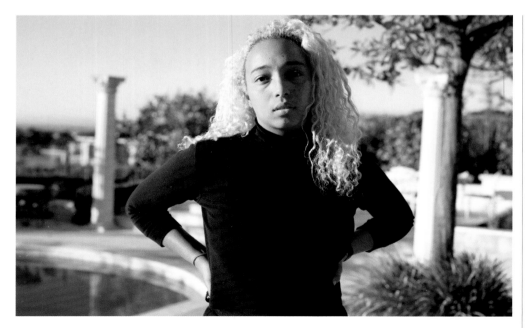

Taysir Batniji, from the series *Home Away from Home*, 2017
Courtesy the artist

From Gaza to Florida

"The state of 'between-ness'—cultural as well as geographic—is an issue that has preoccupied me since I first arrived in France in 1995," remarks artist Taysir Batniji, who was born in Gaza one year before the Israeli occupation began. Though he settled in France, five of his cousins chose to live in the United States. As the third recipient of Immersion: A French American Photography Commission, supported by the Fondation d'enterprise Hermès, Batniji spent time visiting his "American cousins" in Florida and California. The resulting book and exhibition, *Home Away from Home*, will include photographs and portraits, interviews with Batniji's relatives, and sketches from memory of the family homestead in Gaza.

***Home Away from Home* will be on view at the Aperture Gallery, March 14–May 20, 2018; the accompanying book will be published by Aperture in fall 2018.**